Art Nouveau Stephen Escritt

ART&IDEAS

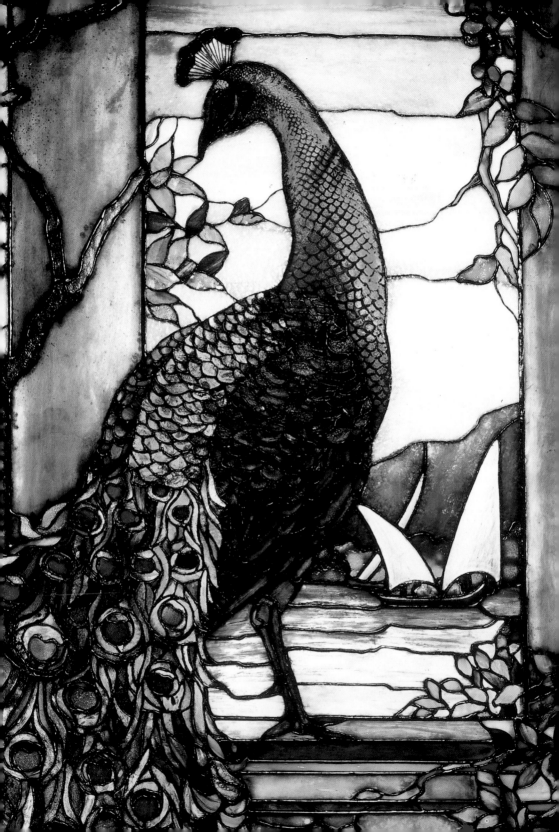

Introduction 4

1 **New Life in Old Revivals** The Genesis of Art Nouveau 9

2 **A Decadent Age?** Belgium, France and Germany 63

3 **Squaring the Circle** Vienna and Glasgow 131

4 **Dreams of Nations** Finland, Russia and Catalonia 189

5 **New Art in the New World** The Americas 249

6 **An All-Consuming Passion** Clients and Customers 297

7 **Artistry and Industry** Old Craft and New Technology 335

8 **A Recurring Allure** Into the Twentieth Century 381

& Glossary 426
 Brief Biographies 428
 Key Dates 433
 Maps 436
 Further Reading 439
 Index 441
 Acknowledgements 446

Opposite
Tiffany Studios,
'Peacock' window
(detail),
1910–12.
Leaded stained
glass;
full window:
283 × 75 cm,
111$\frac{1}{2}$ × 29$\frac{3}{4}$ in.
Private collection

Extraordinary things were afoot in the visual arts at the turn of the nineteenth century. Between about 1890 and 1910 artists, designers and architects from Paris to St Petersburg, from Brussels to Buenos Aires, produced work that evoked the spirit of the age at the same time as provoking the bitterest criticism. Since its brief apogee, this work, which contemporaries labelled Art Nouveau, has continued to fascinate, disturb and inspire us in equal measure.

The mention of Art Nouveau, also then known as the 'modern style', over a century after its triumphal appearance at the Paris Universal Exposition of 1900 conjures up images of feminine curves, organic tendrils and linear forms. In the popular imagination Art Nouveau brings to mind seductive posters for French musical reviews or the sinuous ironwork of the Paris Métro stations. Museums proudly display their examples of opaque naturalistic glassware and contorted carved furniture, representatives of a now alien style that brought the old century to a close and heralded the new.

Yet, the influence of Art Nouveau reached far beyond the streets of Paris, and its aesthetic was far richer than mere organic fantasy. For alongside the tumbling arabesques caricatured in a contemporary cartoon (1), Art Nouveau also encompassed the geometry and radical simplicity of Charles Rennie Mackintosh in Glasgow and the artists of the Wiener Werkstätte (Vienna Workshop). Early centres of the style included Brussels in Belgium, Nancy in France and Munich in Germany, as well as Paris. Moreover, the style also accommodated designers across central and eastern Europe, inspired in part by their own specific national traditions.

The pan-European nature of Art Nouveau resulted in a correspondingly diverse nomenclature. In Germany it was *Jugendstil*, in Austria and Hungary it was the Secession style, and in Barcelona it was part of the broader *Modernista* movement. In Italy it was *La Stile*

Liberty, named after the London shop Liberty's, which was perceived, by the Italians at least, as the fount of the new aesthetic. In England and America practitioners whom we might now describe as Art Nouveau were still considered to be part of the Arts and Crafts Movement. In many of the countries of eastern and northern Europe such craftsmen and designers may have been thought to belong to movements of National Romanticism as much as any international stylistic development. Art Nouveau not only spread across Europe; it manifested itself wherever Europeans went. It became a global style, one that, in different hands, could be both imperial and nationalist.

As well as being aesthetically varied and genuinely international, Art Nouveau was also an incredibly versatile style. Nothing within architecture and the decorative arts escaped its influence, from door handles to chairs, chandeliers to apartment blocks, wallpapers to shop fronts. The style had no respect for the boundaries of class or quality. The finest luxury objects were conceived and handcrafted in the Art Nouveau manner, as was the cheapest jewellery and the most ordinary industrially produced tableware, along with all manner of printed ephemera. This dichotomy meant that Art Nouveau embodied all the tensions within art, design and society at the turn of the century. In its variety of manifestations Art Nouveau was both élitist and populist, private and public, conservative and radical, opulent and simple, traditional and modern.

It is unusual, given the huge extent of its scope and influence, that Art Nouveau retains the name given to it by its contemporaries. Styles are often subjective and fluid things; too fractured to be discernible in any meaningful way at the time, they are often labelled only with hindsight. They emerge with our knowledge of what has followed and the desire to define ourselves against the past. For example, 'Rococo' was a pejorative term coined in the late eighteenth century, 'Neoclassicism' did not appear until the 1890s, and 'Art Deco' was an invention of the 1960s. But in 1900 everyone knew what Art Nouveau was.

The term had emerged in Belgium in the 1880s to describe the work of a group of artists who called themselves 'Les Vingt' (Les XX, 'The Twenty'), and whose aim was the reform of the arts and of society as a whole. In 1884 the editors of the Brussels-based magazine *L'Art moderne* pronounced that they were 'votaries of Art Nouveau'. By 1895 it was institutionalized when the dealer and entrepreneur

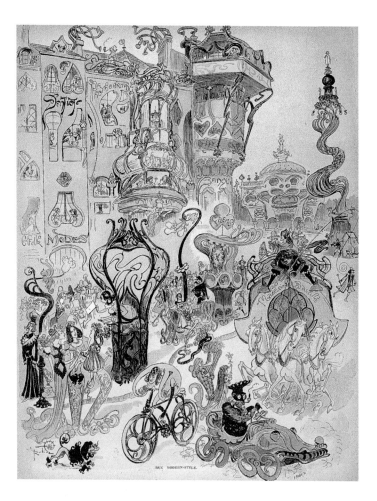

1
Albert Robida,
Rue Modern-Style.
Lithograph in
the journal
L'Album, 1902

Siegfried Bing opened a gallery in Paris devoted to new design and called it L'Art Nouveau. Although Bing was to claim that he never wanted to coin a generic term, this is exactly what happened. Soon Art Nouveau was a byword for contemporary developments in the decorative arts and architecture. Curiously, contemporaries did not apply the term to painting, although

painting played an important role in influencing the style, and many painters actively contributed to Art Nouveau when they dabbled in the decorative arts. By the late nineteenth century the Impressionists had assured contemporary art of its own momentum, and thereafter, painting often had its own exclusive movements. In the twentieth century industrial design and the applied arts rarely played a part in fine art movements, which were increasingly concerned with conceptual rather than stylistic issues.

Copious amounts of ink were spilt by critics at the 1900 Universal Exposition over the merits and failings of Art Nouveau, proof that it was a highly self-conscious style. This peculiar self-consciousness was a product of the role Art Nouveau played in the history of late nineteenth-century design. Heralded as revolutionary by some of its mentors (and damned for the same reason by some of its detractors), it came at the end of a century that for the most part had seen architecture and the decorative arts gradually descend into a rut of increasingly derivative historicism. Past styles were endlessly regurgitated in debased fashions until they resembled pastiche. The great exhibitions of the nineteenth century were characterized by incongruous combinations of Renaissance, Baroque and classical styles that revealed an unease with the progress afforded by the industrial age. Radical Art Nouveau designers set out to shatter historicism and create a style appropriate to their time, the age of cinema, the telephone and the automobile. Yet the more conservative embarked upon a mission to rescue the guiding principles of traditional craftsmanship and elegance, to update them rather than overthrow them.

In either case, Art Nouveau was perceived as being much-needed, and in some ways long-awaited. When it arrived, the style was the product of an extended gestation period and had a brilliant, albeit brief, lifespan. The movement took shape in the 1880s and 1890s, burst onto a wider public at the 1900 Universal Exposition, but was largely eclipsed after 1914. If Art Nouveau saw itself as a reaction against an aesthetically corrupt century, it was also a product of it. In order to explain Art Nouveau it is necessary

to survey a maze of interlinked influences, from the Gothic and Rococo revivals, to the Arts and Crafts Movement and the Aesthetic Movement, as well as the political and economic motives of those who engendered its development.

All these apparently contradictory facets mean that the study of Art Nouveau offers a fascinating insight into the often schizophrenic mind-set of an age. Through the style we can see the fears, anxieties, hopes and dreams of the *fin de siècle*, but Art Nouveau has also lived on as an influence and a propaganda tool for both its friends and enemies. First came the immediate period of disdain. The Modern Movement pilloried the organic ornament of Art Nouveau as the last gasp of bourgeois decorative excess, while claiming the more geometric Viennese tradition as the parent of its own functionalism. What was once so fashionable inevitably fell out of favour – the French even threatened to knock down the Art Nouveau entrances to the Paris Métro in the 1930s. Yet at the same time Art Nouveau effectively evolved into Art Deco, the modern decorative style of the inter-war period (which was equally reviled by the more zealous Modernists).

After World War II, Art Nouveau gradually evolved as a subject fit for scholarly study. Then came the revivals. Although Scandinavian and Italian post-war design never forgot the organic roots it shared with Art Nouveau, it was not until the 1960s that the psychedelic movement on the West Coast of America and Barbara Hulanicki's Biba store in London brought the style back into vogue. As this initial burst of pop-revivalism evolved into an intellectual critique of Modernism, Art Nouveau, together with Art Deco, provided the new alternative decorative history of twentieth-century design.

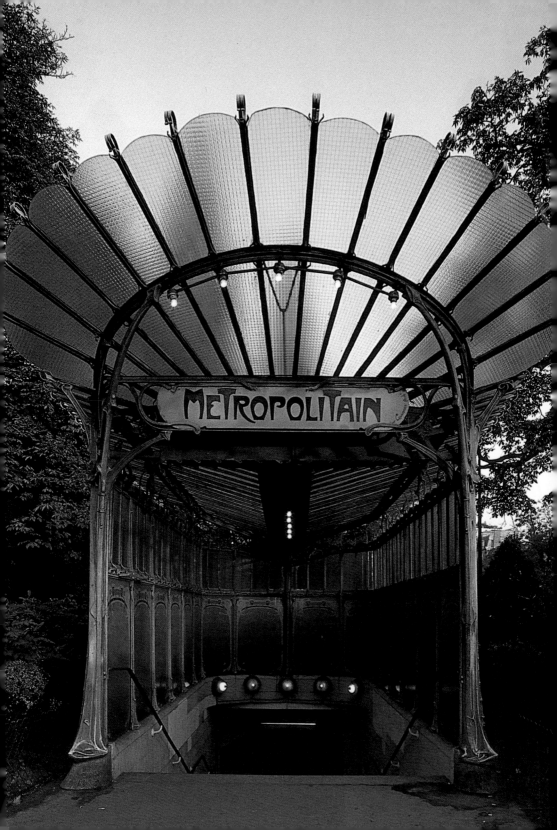

The Universal Exposition, the great world fair that dominated Paris during the summer of 1900, offered an intoxicating cocktail of amusements and exhibits to the millions of visitors who flocked to the city. According to one English guidebook, they could enjoy 'Oriental hareems, Syrian dancers, Siamese jugglers, dioramas, cycloramas' and much more. The setting itself was perhaps the greatest riot of eclectic architectural exhibitionism the world had yet seen. Alongside all this, the style known as Art Nouveau made its presence felt on the world stage.

The new 'modern style', with its fantastical, sinuous, organic forms, was seized upon by critics and commentators. In London the *Art Journal* review of the exhibition proclaimed that 'the old order has almost entirely given way to a freshness of thought'. Artists had 'returned [to] nature, to learn her lessons afresh'. Art Nouveau was distinctively new and encompassed a wide variety of art forms. It manifested itself in architecture and interior decoration, furniture and ceramic design, textiles and jewellery. Its combination of nervous whiplash lines, scrolling asymmetrical tendrils and waif-like figures, sometimes interspersed with stylized geometry and radical approaches to construction and form, created a new decorative language. This language could be used to express many feelings and fears. Art Nouveau could encapsulate both modernity and tradition, anxiety and confidence, decadence and progress, conservative national identities and radical internationalism.

The year 1900 was also the height of what is now known as the French *belle époque*: the three decades before World War I that have been characterized (rightly or wrongly) as an era of middle-class prosperity, of democratic hedonism and of grandiose bourgeois pleasure-seeking – an era which was so brutally shattered in World War I, when a generation of young men were sent to their deaths in

2
Hector
Guimard,
Porte Dauphine
Métro station,
Paris,
1900–1

the trenches of the Western Front. The entertainments at the 1900 Exposition seem to justify a halcyon view of the *belle époque*. An attempt to rival the Eiffel Tower, which had been built for the previous Paris Exposition in 1889, came in the form of the Grande Roue of Paris, a 106 m (348 ft) high Ferris wheel that could carry 1,600 passengers at a time, while another relic from 1889, the by then vacant Galerie des Machines (Gallery of Machines), was filled with a cinema screen measuring 21 x 16 m (69 x 52$\frac{1}{2}$ ft) in front of which a crowd of 25,000 could marvel at the moving pictures being

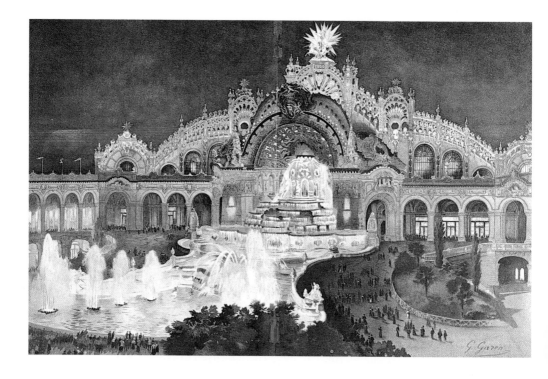

projected on to it. At night the spectacular illuminations of the fantastical Palais de l'Électricité (Palace of Electricity; 3) combined with a 9 m (29$\frac{1}{2}$ ft) wide sheet of water cascading 29 m (95 ft) to breathtaking effect.

Entering the 1900 Exposition through the specially constructed Porte Monumentale, visitors could wander around pavilions, gardens, restaurants and theatres spread across a site that covered 112 hectares (277 acres), just enough space for the incredible 81,000 exhibitors. The Exposition occupied both banks of the River

Seine, covering the space between the place de la Concorde and Les Invalides. The range of exhibits was extremely varied, with tradition and history taking a central place at the fair alongside the stylistic innovation of Art Nouveau and the displays of advanced technology. This fascination with the past was embodied in the amusements, the most popular being a Swiss village comprising a huge artificial Alpine landscape populated by performers in traditional costume, including folk dancers, wrestling shepherds, weavers, wood-carvers and other traditional artisans.

Of course, the purpose of the Exposition was not pleasure alone. 'To the thoughtful', the English guidebook noted, 'it is something more than an ephemeral fairyland, illustrating in the most elaborate manner conceivable the progress made by mankind during the last hundred years in every department of art, science and industry.' The international section saw countries from across Europe, America and the rest of the world proudly displaying their artistic and industrial endeavours on a scale that surpassed all the great international exhibitions of the nineteenth century.

Despite its international flavour, however, the Exposition was first and foremost a French event with nationalism at its heart. The 1900 Exposition was the last of the great fairs that had taken place every eleven years since 1798; it was the third and largest such event to be staged since the democratic Third Republic had been established in 1870. Even in 1900, France was still smarting after her humiliating defeat in the Franco-Prussia war of 1870 to 1871. The brief war, culminating in the seige of Paris from September to January, was disastrous for France's standing as a major European power. Although its immediate cause was a row between the two countries over the succession to the Spanish throne, it took place against France's longer-term concerns about the increasing power of imperial Prussia under Bismarck. But France had seriously underestimated this power, and no one foresaw the totality of the French defeat. The war was followed by the Paris Commune, when disaffected workers took control of the capital, forming a socialist municipal council and forcing the Republican government to

withdraw to Versailles. The Commune, which lasted only three months (from February to May 1871), was eventually suppressed with heavy loss of life.

So the Expositions after 1870 can be seen to have fulfilled a dual purpose. As entertainment spectacles, they provided light relief for the French public and perhaps helped to mask some of the social conflicts that had erupted so explosively with the Commune, while as great exhibitions they both encouraged and celebrated French industrial and artistic progress.

As far as the arts are concerned, it is Art Nouveau for which the Universal Exposition of 1900 is best remembered, despite the fact that it was far from being the dominant style on display there. Art Nouveau objects and decorations could be seen in a number of important and influential exhibits, but there were only two actual buildings that would be immediately recognized as Art Nouveau today: the Pavillon Bleu (Blue Pavilion; 4), a restaurant alongside the Pont d'Iena, at the foot of the Eiffel Tower, and Siegfried Bing's celebrated pavilion which bore the name Art Nouveau Bing (5).

Siegfried Bing, a German-Jewish Parisian gallery owner and art dealer, was a pivotal figure in the development of Art Nouveau. In 1895 Bing had opened his gallery, L'Art Nouveau, in Paris. It brought together new art and design from around Europe – works that, according to the manifesto for the new gallery, were 'no longer incarnations of the past'. At the Universal Exposition he presented a series of six domestic interiors, commissioned from the group of designers he employed, the three most prominent being Eugène Gaillard (1862–1933), Édouard Colonna (1862–1948) and Georges de Feure (1868–1928). The interiors of Bing's pavilion demonstrate at once both the modern and traditional nature of Art Nouveau. The furniture in Gaillard's dining room would have appeared bold and original to most visitors to the Exposition – the chairs, with downswept stretchers accentuated their flowing, naturally inspired forms, and the boldly carved dining table, with its heavy, sinuous legs, offered radical departures from the eclectic historicist forms

4
Gustave Serrurier-Bovy and René Dulong, Pavillon Bleu, Universal Exposition, Paris, 1900

5
Art Nouveau Bing pavilion, Universal Exposition, Paris, 1900

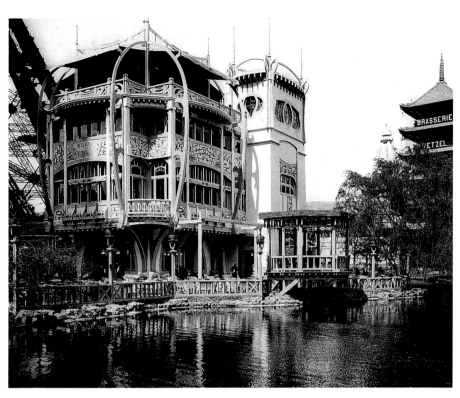

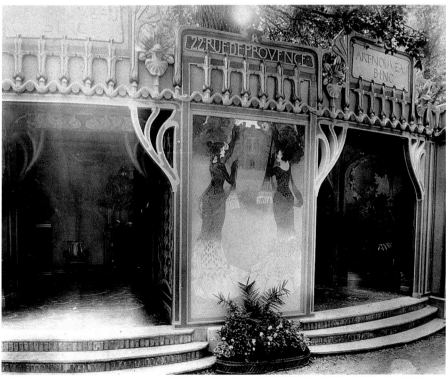

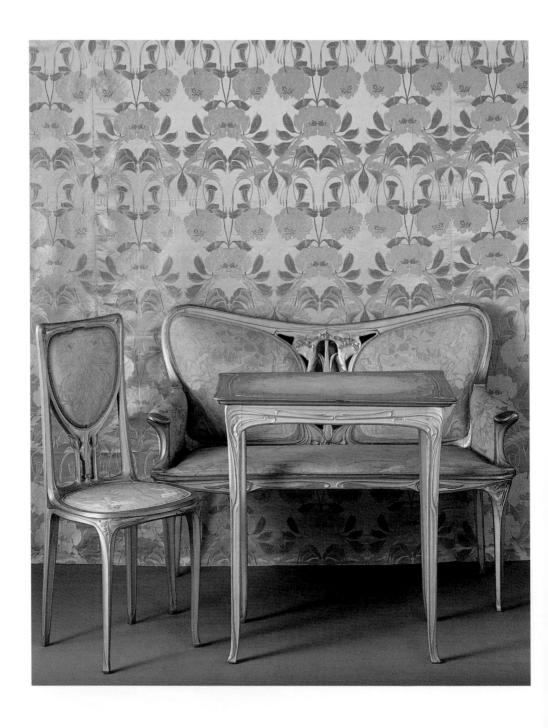

of much nineteenth-century design. This sense of modernity was enhanced by the wall paintings by the Catalan artist José María Sert (1874–1945). Yet at the same time, the furniture de Feure designed for a sitting room was altogether more whimsical. The delicate forms of the chairs and the occasional table recalled the light curves of French eighteenth-century furniture, while such elements as the silk-embroidered upholstery of the chairs combined modern flowing floral patterns with the standards of craftsmanship, luxury and sensuousness expected of traditional French decorative arts (6).

The other obviously Art Nouveau building, the Pavillon Bleu restaurant, provided a platform for one of a group of Belgian designers who played a pioneering role in the development of Art Nouveau in the early 1890s, Gustave Serrurier-Bovy (1858–1910). The dining room in particular was a characteristically flamboyant Art Nouveau interior, featuring metal arabesques and a frieze applied with bold curvaceous decoration.

The pavilion of the Union Centrale des Arts Décoratifs offered an important display of Art Nouveau objects. The Union Centrale was an official body committed to the re-invigoration of the craft movement in France. Concerned with the artistic progress of rival nations such as Britain and Germany (which had only been created from separate German-speaking states in 1871), the Union wanted to modernize French craftsmanship. This was to be achieved, however, by emphasizing its traditional qualities of luxury and quality, rather than by embracing the technological and democratic challenges of the late nineteenth century. The Union Centrale's 1900 pavilion displayed works by such celebrated Art Nouveau makers as Émile Gallé (1846–1904) and Louis Majorelle (1859–1916). There were rooms dedicated to the materials of wood, ceramics and iron, thus promoting the traditional values of the craftsman as artist. Although showcasing modern works, the setting was to be a collector's chamber, a model of privileged patronage, evoking an eighteenth-century world of connoisseurship and aristocratic refinement.

The displays in the Union Centrale pavilion also emphasized intimacy and femininity in domestic interior design. Describing its last section, one English critic noted 'a room which will delight young and old alike, namely the beautiful and sympathetic work of the committee of ladies.' These ladies were largely aristocratic and bourgeois amateurs, however, their presence signified an important aspect of the Union's ethos. A revival of the French crafts meant a revival in the art of interior decoration, and the beautification of the interior was romantically portrayed as a feminine pursuit. In this way, the role of women appeared central to Art Nouveau in France. If bourgeois women as homemakers could be imbued with a taste for the newly regenerated French crafts, then French design might once more regain the supremacy it held in the eighteenth century.

Further examples of Art Nouveau were also displayed by a broad range of firms exhibiting in the French Industrial Arts building, as well as in many of the international pavilions. In the latter, for example the German and Austrian pavilions, alternative versions

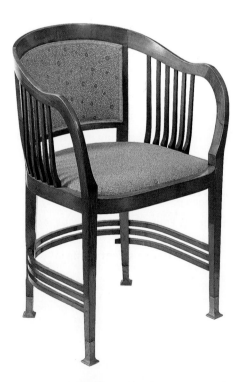

7
Joseph Maria Olbrich,
Chair,
1898–9.
Stained maple,
brass cappings
and upholstery;
h.80 cm,
31½ in.
Victoria and
Albert Museum,
London

of Art Nouveau could be found. The work of such artists as the Viennese architect and designer Joseph Maria Olbrich (1867–1908) displayed a simplicity of form that offered a contrast to the predominant French Art Nouveau. Instead of the bold, exuberant carving of Majorelle's furniture or the refinement of de Feure's interiors, Olbrich showed a tendency towards sparsely decorated geometric forms, particularly in his furniture (7). The critic for the Art Journal was unequivocal in his praise for Olbrich: 'the motive which has inspired the production of these beautiful rooms has evidently been a desire to eliminate the needlessly ornate and to give a feeling of simplicity and quietness of colour.' Olbrich's furniture provided, 'beautiful examples of the latest mode in furnishings ... the phrase Art Nouveau which one hears and sees on every side in the present exhibition, has no better justification than in the exhibits of Austrian furniture.'

It was the French architect Hector Guimard (1867–1942), however, who provided the most public and lasting testament to Art Nouveau at the 1900 Exposition with his series of remarkable structures designed for the stations of the new Paris Métro. The plans for the Exposition were formulated as early as 1895; yet even before the president of the Republic inaugurated the worksite, reports were emerging from the Ministry of the Interior warning that, if the Paris public transport system was not improved, the congested city would grind to a halt during the summer of 1900. As a result of this prediction, the Compagnie Générale des Transports was given permission to build six underground railway lines with a total length of 70 km ($43^{1}2$ miles). The idea of a Métro had been mooted previously, and as early as 1890 speculative designs for possible stations were being put forward. Jean-Louis-Charles Garnier (1825–98), the architect of the sumptuous Neo-Baroque Paris Opéra, was by this time the president of the influential Société Centrale des Architectes. Garnier was adamant in his views on the subject. For him, the stations, the public face of the Métro, should disguise the system's technological and mechanical reality and be conceived in antique styles. Each should provide a lavish array of onyx, gilding and granite. Unfortunately, however, the

faux-grandeur of historicist designs submitted to the competition that was held proved wholly unsuitable for the tiny sites on the streets of Paris.

By contrast, Guimard's designs proposed light structures that emerged at street level with a suitably unimposing grace (see 2). Some were notable for the futuristic glass and iron shelters protruding from them like mutated insect wings, while all were characterized by sinuous, naturalistic ironwork, whose curvaceous forms exuded the new decorative style. The use of wrought iron and glass not only allowed Guimard to fashion the flowing curves and sharp lines for which the stations are today celebrated, it also enabled him to use a visionary modular system which meant that five different station designs could be created from a variety of component parts. So Paris acquired its subtly spectacular Art Nouveau street architecture not for stylistic reasons: Guimard's Art Nouveau triumphed because it was cheaper and more appropriate.

At the time of the 1900 Exposition, it was a popular contemporary misconception that Art Nouveau was a revolutionary aesthetic movement that had sprung from nowhere. It was often the designers themselves who were the most prominent propagators of this myth. Many were keen to divorce themselves from the staid historicism of mainstream nineteenth-century design, and, at the same time, were not averse to a degree of heroic self-promotion. August Endell (1871–1925), a Munich-based architect and designer, was typical of his contemporaries in his poetic expression of self-belief. He wrote in 1898:

Knowledgeable people see quite clearly that we stand not only at the beginning of a new stylistic period, but at the inception of an entirely new art – the art of using forms that, although they signify nothing, represent nothing and recall nothing, can move the human soul as profoundly and irresistibly as only the sounds of music have been able to do.

But of course Art Nouveau did recall many things. It drew on a range of diverse associated traditions that together combined

contrasting elements of luxury, decadence and romanticism with moralistic social reform and the regeneration of traditional craftsmanship in the face of growing industrialization. To complete the paradox, Art Nouveau could also embody aspects of new technology and industrial production. Five sources of inspiration were particularly important to Art Nouveau: the Rococo and its nineteenth-century revivals, the Gothic Revival, the Arts and Crafts Movement, the Aesthetic Movement, and Symbolist painting and writing. To understand Art Nouveau it is important to look at the influence of each of these on its varied manifestations.

Art Nouveau shared with the Rococo style of the eighteenth century a fascination for nature, fantasy and the exotic East, and a decorative vocabulary that included stylized organic forms. Like Art Nouveau, its hallmarks in the decorative arts were asymmetry and fantasy; and in the mid-eighteenth century, when Paris was the undisputed fount of fashionability in the arts, it stood for the cultural supremacy of France. After the Rococo gave way to Neoclassicism, the austere style that heralded a return to the decorative vocabulary of antiquity, it suffered an inevitable period of condemnation, before undergoing a series of revivals in the nineteenth century. Most important in the development of Art Nouveau was the revival that began in the 1870s and continued throughout the *belle époque*.

The aesthetic similarities between Neo-Rococo and Art Nouveau become apparent when comparing the work of two celebrated French furniture makers of the 1890s and 1900s. A writing desk with delicately flowing form made around 1900 by François Linke (1855–1945), the leading Parisian Neo-Rococo cabinet-maker of the time, characterizes the Rococo Revival (8). The elaborately cast foliate gilt-bronze mounts and rich tulipwood and kingwood veneer show Linke proudly placing himself within the esteemed tradition of eighteenth-century French craftsmanship, with all the associated connotations of quality, luxury and fashionability.

Louis Majorelle, the cabinet-maker whose Art Nouveau furniture was so admired in 1900, had emerged from the same tradition as Linke. At the end of the 1870s the young Majorelle, who was

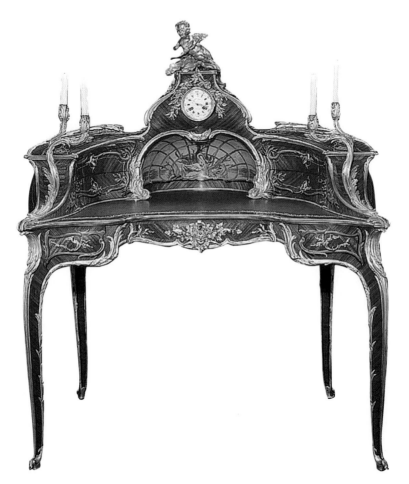

8
François Linke,
Writing desk,
c.1900.
Tulipwood and
kingwood
marquetry with
gilt-bronze
mounts;
136 × 117 ×
70 cm,
53$\frac{1}{2}$ × 46 ×
27$\frac{1}{2}$ in.
Private
collection

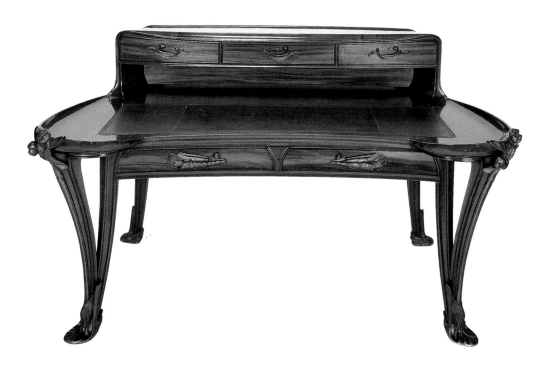

9
Louis Majorelle,
'Water lily' desk,
made for the
Universal
Exposition,
Paris, 1900.
Mahogany,
veneer and
leather with gilt-
bronze mounts;
99 × 132 × 84 cm,
39 × 52 × 33 in.
Musée de l'École
de Nancy

following the same profession as his father, took control of the family firm in Nancy, where he supervised the production of furniture in the old eighteenth-century styles. Furniture he had exhibited at the 1889 Universal Exposition was carved with cherubs, grotesque beasts and scrolls, illustrating the heights of unrestrained fantasy that Neo-Rococo could attain. Yet by the mid-1890s, Majorelle was at the vanguard of the new style. His furniture, however, retained many of the elements so prized in the work of eighteenth-century French furniture (9). The luxury of the veneers was often enriched by inlaid designs in the tradition of the great *intarsia* (decorative inlay) artists of the *ancien régime*. Furthermore, the bold abstracted, plant-like carving was echoed in the finely cast gilt mounts, giving the pieces the kind of organic feeling possessed by the more extravagant examples of Rococo furniture.

Displayed together, as at the 1900 Exposition, Linke and Majorelle's pieces must have complemented each other rather than created aesthetic tension. The prize-giving juries were certainly accepting of both tendencies. Linke won a gold medal for one of his writing desks, while Majorelle was appointed Chevalier de la Légion d'Honneur by the state after the triumphant reception of his work at the Exposition. Furthermore, when Art Nouveau was praised by the French critics, it was often for its affinity with the past. Writing in the *Revue des Arts Décoratifs* in 1900, the writer and art critic Gabriel Mourey praised Siegfried Bing's pavilion as 'a source of French inspiration', rekindling the 'treasures of grace, elegance and delicacy bequeathed to us by the eighteenth century'.

The relationship between historicism and a broader nostalgia, and much of the French Art Nouveau on display at the 1900 Exposition comes as no surprise, given the official effort to revive the decorative arts in France at the time, in the interests of national identity and economic prosperity. It is no coincidence that those who encouraged this renaissance were also the pioneers of the revival of Rococo scholarship in the 1870s and 1880s. The standard-bearers of the Rococo Revival among the French upper middle classes were the brothers Edmond and Jules de Goncourt, though the latter did not

live to see the height of this revival as he died in 1870. Novelists and art historians, the brothers were unashamedly élitist aesthetes. They celebrated not only the style of the eighteenth century but also its spirit – or at least the nineteenth century's romantic perception of it. For them, the Rococo meant languor, even decadence, cultural refinement and the rendering of the interior as a work of art, qualities that later French Art Nouveau too would be seen to embody.

The Goncourts championed eighteenth-century painters of romantic scenes such as François Boucher (1703–70) and Jean-Honoré Fragonard (1732–1806), whose work had long been regarded as frivolous and lightweight. This was part of their personal crusade to re-evaluate eighteenth-century French art, from painting to furniture and textiles. One of the results was the growing importance of the Rococo to the decadent tastes promoted by many French writers in the 1880s and 1890s. These connotations were most famously expressed by the novelist J K Huysmans in his book À Rebours (Against Nature), first published in 1884. When deliberating on the appropriate décor for the bedroom of his house, Huysmans describes how the novel's hero, Jean, duc des Esseintes, considered that the Rococo,

… was the obvious choice for people of delicate sensibility, exhausted by mental stimulation … The eighteenth century is, in fact, the only age which has known how to envelop woman in a wholly depraved atmosphere, shaping its furniture on the model of her charms, imitating her passionate contortions and spasmodic convulsions in the curves and convolutions of wood and copper.

As well as having a stylistic impact (as celebrated society figures, the Goncourts played an influential role as tastemakers), this rehabilitation of the Rococo also had a political dimension. In the wake of France's defeat in the Franco-Prussian war in 1871, the Goncourts' reinterpretation of nationalism in the applied arts of the halcyon days of pre-Revolutionary grandeur provided a model for the artistic and economic reinvigoration of their embattled country. It was this model that shaped official French government policy towards the decorative arts after 1889.

Edmond de Goncourt's promotion of the Rococo did not, however, automatically lead to his approval of Art Nouveau, partly because of its initial associations with foreign craftsmen. He was scathing about the objects by Belgian designers displayed in Bing's L'Art Nouveau gallery in 1895. Furniture such as that by the architect and designer Henry van de Velde (1863–1957), which was characterized by a robust and sometimes rustic crafts aesthetic, did not suit the delicacy of his refined taste. Such 'Anglo-Saxon and Dutch furniture' seemed to Edmond to be 'hard angular stuff that appears to have been made for crude cave and lake dwellers'. France, he maintained, should be 'heir to the coquettish and curving furniture of eighteenth-century languor'. Such public criticism encouraged the development of this approach to the extent that, by 1900, Bing's pavilion at the Exposition appeared to have acceded to the advocates of Rococo refinement. Gone was the work of Van de Velde, who had dominated the gallery in 1895, to be replaced by such men as de Feure, whose furniture evoked the Rococo in a manner of which the late Edmond de Goncourt would surely have approved.

In reality, the furniture produced by Van de Velde and other Belgian designers such as Serrurier-Bovy, with their emphasis on honest construction and simple lines, had its roots in a movement of a very different character. They had much in common with the sometimes austere architectural theories of the Gothic Revival, a return to medieval building styles that had swept through many European countries in the nineteenth century and even earlier. The curvilinear stylization of their organic decoration recalled the foliate cusps of Gothic decoration.

One of the leading Gothic Revivalists in France was the architect and theorist Eugène-Emmanuel Viollet-le-Duc (1814–79). Viollet-le-Duc was most celebrated for his restoration of the medieval castle at Pierrefonds, the country retreat of Napoleon III (r.1852–70), and the cathedral of Notre Dame in Paris. The murals that adorned the walls of the cathedral chapel (10) were characteristic of his work in the medieval manner, yet at the same time their stylized natural forms foreshadowed some elements of the Art Nouveau aesthetic.

Viollet considered the curse of nineteenth-century design to be its predilection for historicism. In the first of a series of influential and widely published lectures, Viollet lamented that his generation were 'shackled by prejudice and traditions and accustomed to confusion, [with] both ideas and principles wanting'. He could well have been speaking of the creators of the architectural hotchpotch that dominated most of the site of the Universal Exposition. His vision of the state of design was apocalyptic: 'The arts are diseased,'

10
Eugène-
Emmanuel
Viollet-le-Duc,
Design for
a mural in
the Saint
Guillaume
chapel, Notre
Dame, Paris,
c.1844–64.
Musée d'Orsay,
Paris

he bemoaned, 'architecture is dying in the midst of prosperity ... We have seen designs presenting the most grotesque medley of styles, fashions, epochs and means of construction, but not suggesting the least symptom of originality.'

In his own work, Viollet's passion for medieval architecture and decoration was matched by his appreciation of the possibilities of new materials. His lectures were illustrated with diagrams depicting the freedom of form made possible by iron when its properties were

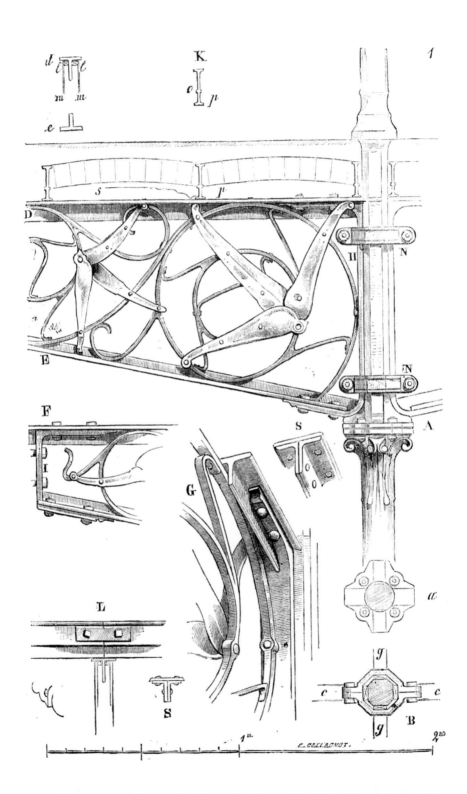

K.

D

H N

E

N

A

F

G S

L ι

S B

1ᵐ 2ⁿᵈ

E. COLLADMOT.

exploited imaginatively (11). Hector Guimard was one of a number of
Art Nouveau designers who cited the importance of Viollet, first for
his clarion call for a break with confused historicist pastiche; second
for his advocacy of new materials such as iron and glass; and finally
for his adventurous and innovative interpretation of the Gothic
Revival, an undoubted influence on the evolving Art Nouveau
aesthetic. There are clear visual similarities between Viollet-le-Duc's
drawings and the decorative ironwork of designers such as Guimard.
For example, in Viollet's plan for a street market published in 1872,
the building was supported on angled iron struts – the cast-iron
braces in which the supports rest were even decorated with
pseudo-medieval floral motifs. This was an idea that Guimard
put into practice when he designed the École de Sacre Coeur in
1895. Indeed, Guimard made no attempt to hide these influences.
In an article for the Architectural Record in 1902 he proposed that, 'the
principles of the Middle Ages and those of the nineteenth century,
added to my doctrine, should supply us with a foundation for a French
Renaissance and an entirely new style.' While drawing strongly on
Viollet, Guimard certainly could not be accused of lacking originality,
and his adventurous linear forms seemed genuinely new, finally
breaking free from the constraining influence of past styles. Viollet
had distilled his concerns into a single question when he asked,
'Is the nineteenth century destined to close without possessing
an architecture of its own?' Guimard's Art Nouveau architecture
ensured the answer was an emphatic 'no'.

It was in England, however, that the Gothic Revival had its greatest
impact. Here the style was given unmistakable moral overtones
by its most celebrated pioneer, Augustus Welby Northmore Pugin
(1812–52). A committed Catholic, Pugin saw the Gothic style as the
visual manifestation of the Middle Ages, whose benevolent religious
and social order contrasted – as he saw it – with the artistic, social
and moral chaos of the nineteenth century. Although he is now
best remembered for his Gothic Revival designs for the Palace of
Westminster in London (the seat of Parliament), which he carried
out in conjunction with the architect Charles Barry (1795–1860),
it is Pugin's designs for ornament that again illuminate the

11
Eugène-
Emmanuel
Viollet-le-Duc,
Proposal for a
wrought-iron
bracket, from
Entretiens sur
l'architecture,
1872

historic roots of the fascination with natural forms that were central to the work of many Art Nouveau designers.

In 1849 Pugin published a portfolio of designs entitled *Floriated Ornament* comprising a series of stylized pattern designs based on natural forms. He believed that 'the God-given natural forms of leaves and flowers etc. must be more perfect and beautiful than any invention of man.' While Pugin turned to the ecclesiastical decoration of the Middle Ages to find such reverence for nature, he also saw the great potential that this principle of design held for the future. Pugin threw down the gauntlet to his contemporaries: 'The same inexhaustible supply is open to us,' he maintained, 'and if we go to the fountain head, we shall produce a multitude of beautiful designs treated in the same spirit as the old, but new in form.' Indeed, by going to this fountainhead, Pugin produced designs that, in their stylization and abstraction of nature (12), display hints of the Art Nouveau style of almost fifty years later.

The British architect, designer and theorist Owen Jones (1809–74), a contemporary of Pugin's, shared a comparable reverence for nature. Jones's definitive theoretical work was his *Grammar of Ornament*, first published in 1856, which is in many ways the quintessential document of nineteenth-century design reform. Providing examples of decorative designs from the Stone Age to the Renaissance, from the South Seas to Arabia (13), it embodied eclecticism, yet was far from being a haphazard amalgamation. Jones was committed to design reform and advocated the unification of aesthetics and industry. To this end he provided a series of 'Propositions' to guide designers. His purpose was to discover the universal truths of design that would offer a way out of historicism for its own sake.

Time and again in the *Grammar of Ornament*, this quest leads back to natural forms. Proposition XI, 'a law derived from the study of the Orient', could almost be a visionary manifesto for Art Nouveau, instructing the reader that, 'In surface decoration all lines should flow out of a parent stem. Every ornament, however distant, should be traced to its branch root.' Proposition XIII encourages the

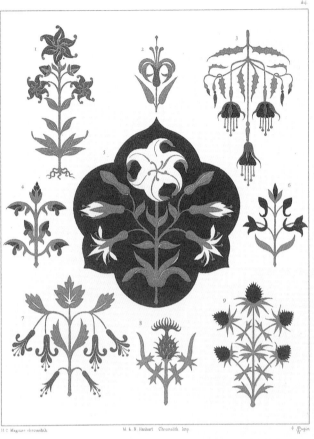

12
A W N Pugin,
Page from
*Floriated
Ornament*,
1849

H C Maguire chromolith.　　　　　　M & N Hanhart Chromolith Imp　　　　　✝ Pugin

1. Lilium Saracenicum 2. Persoonia flexifolia 3. Fuchsia gracilis 4. Sytyrium triphyllon 5. Lilium album
6. Triorchis major mas 7. Ribes triflorum 8. Carduus lanceolatus 9. Bryngium Alpinum cœruleum

abstraction of natural forms themselves: 'Flowers or other
natural objects should not be used as ornaments, but conventional
representations founded upon them sufficiently suggestive to
convey the intended image to the mind, without destroying the
unity of the object they are employed to decorate.' In relation to
Art Nouveau, Jones is perhaps most revealing in the final chapter,
the plates of which are devoted to 'leaves and flowers from nature'.
'I have endeavoured to show in the twentieth chapter', wrote Jones,
'that the future progress of ornamental art may be best secured by
engrafting on the experience of the past, the knowledge we may
obtain by a return to nature for fresh inspiration.'

Pugin and Jones were not alone in nineteenth-century Britain in their advocation of nature as the primary source for an artist. In his book *The Stones of Venice*, the writer and art critic John Ruskin (1819–1900) proclaimed that 'All beautiful works of art must either intentionally imitate or accidentally resemble natural forms.' Ruskin's writings proliferate in sometimes tortuous analyses of the curving forms of rocks and leaves, which he implored artists to study in minute detail. Like Pugin, Ruskin saw the work of God in the aesthetic beauty of nature, imbuing nature, and thus art derived from it, with a strong moral dimension. Ruskin, whose extensive writings, especially on painting and architecture, dominate the cultural landscape of nineteenth-century England, also shared Pugin's distaste for the less attractive aspects of modernity. He went even further than Pugin in his total rejection of the use of machines in art, describing 'the use of cast or machine-made ornaments of any kind' as one of the three main categories of architectural deceits.

While many European Art Nouveau designers encountered both Viollet-le-Duc and Ruskin in their formal artistic training, the influence of the English Gothic Revival and design reform tradition of Owen Jones and Ruskin was largely filtered through the designers of the Arts and Crafts Movement and the associated artists of the Pre-Raphaelite circle. (The Pre-Raphaelites looked back to the art of the Middle Ages, to before the time of the Italian High Renaissance painter Raphael.) The Arts and Crafts Movement, characterized by the work of the designer William Morris (1834–96) and his many followers, proved central to the development of Art Nouveau.

13
Owen Jones,
'Arabia' from
the *Grammar of
Ornament*,
1856

Like Pugin and Ruskin, Morris promoted a revival in traditional craft techniques as a response to the faceless march of industrial expansion, and emphasized the need for artistic pleasures in the everyday life of ordinary people. His designs combined vegetal motifs and 'medieval' simplicity with modern comforts. The 'Honeysuckle' room in Wightwick Manor is decorated with wallpaper, carpet, tiling and furniture all designed and produced by his firm Morris and Co (14). Morris also prompted in many Art

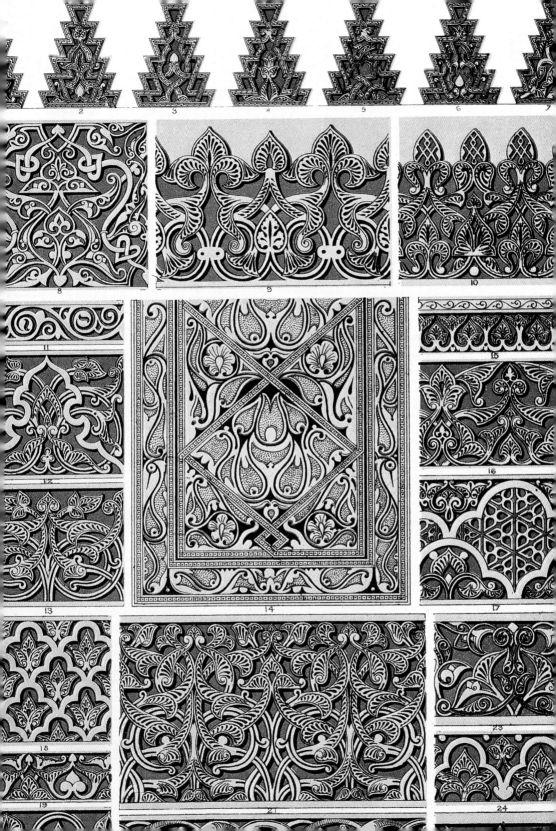

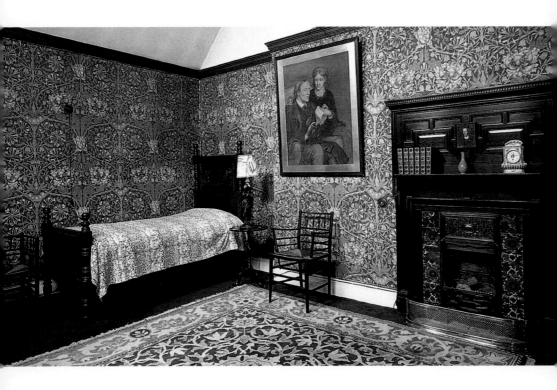

**14
William
Morris**,
Honeysuckle
room,
Wightwick
Manor,
Staffordshire,
1887–93

Nouveau artists the desire to abolish the hierarchy of disciplines within the arts. The fine arts of painting and sculpture had traditionally been regarded as being on an altogether higher level than the applied arts, which were seen as merely decorative. Morris aimed to elevate the applied arts to the level of fine art, and it was the beginning of this quest that encouraged and enabled painters such Van de Velde to turn to the design of furniture and patterns.

In addition to the abolition of hierarchies, the teachings of Morris and his followers in the Arts and Crafts Movement bequeathed an alternative ethos of design and manufacture to that of the eighteenth-century traditions that were taken up by many French designers. While the French approach emphasized luxury, elegance, refinement and private patronage, the Arts and Crafts Movement, drawing on the Gothic Revival, advocated using materials that were appropriate to their function, honesty of construction and the organization of craft workers' guilds together with egalitarian notions of 'art for all'.

Although, with a few notable exceptions, mature Art Nouveau had a limited impact in England, the English Arts and Crafts Movement had a significant influence on Art Nouveau. There is much in the work of Arts and Crafts architects and designers such as Charles Robert Ashbee (1863–1942), Charles Francis Annesley Voysey (1857–1941) and Arthur Heygate Mackmurdo (1851–1942) that shares features of the Art Nouveau aesthetic. Indeed, it is Voysey and his friend Mackmurdo who demonstrate most unequivocally the English aesthetic influence on Art Nouveau. Voysey's decorative designs, in particular, show a combination of naturalism and stylization. His design for a textile depicting lilies, their wave-like sense of motion enhanced by a marine setting (15), was conceived as early as 1883 and appears almost visionary. Encouraged by Mackmurdo, Voysey began to produce designs for wallpapers and textiles in 1881 to supplement his architectural practice.

Examples of Voysey's furniture also provide evidence of his role in the genesis of the new style. Most intriguing is his 'Swan' chair (16), which was designed in 1883 but is not known to have been made until

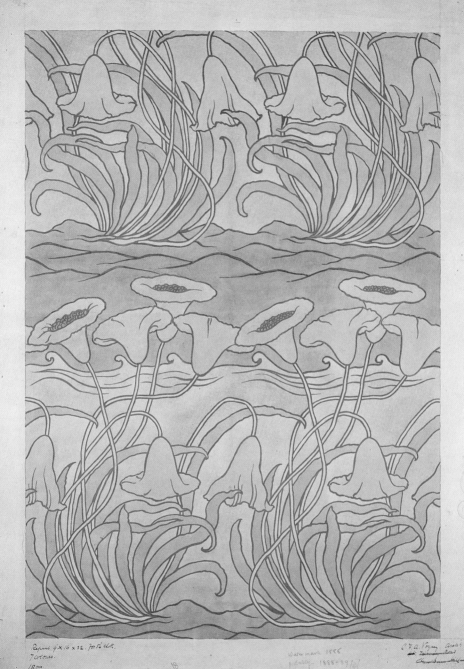

1896. The raw structural form of the chair, on which the construction pegs are unashamedly exposed, place it firmly within the Gothic Revival tradition of Pugin, yet at the same time its curvaceous form is liberating in comparison with the pared-down rustic simplicity of much run-of-the-mill Arts and Crafts furniture of the day. This early example of the freedom of line in three dimensions proved to be a false dawn, however, as far as Voysey was concerned. He remained committed to the Puginian principles of utility, pursuing

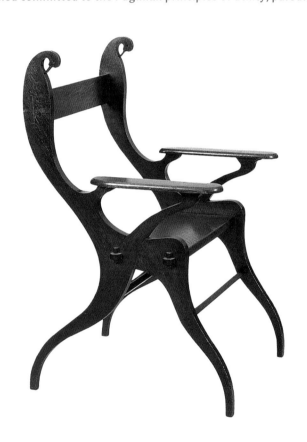

15
C F A Voysey,
Design for 'Lily' textile,
c.1888.
Wash on paper;
78 × 56 cm,
30³⁄₄ × 22 in.
British
Architectural
Library, London

16
C F A Voysey,
'Swan' chair,
designed
1883–5,
made c.1898.
Oak;
h.96·5 cm,
38 in.
Cheltenham Art
Gallery and
Museums

them to extremes in his own personal tastes. Voysey advocated 'the effect of a well-proportioned room, with white-washed walls, plain carpet and simple oak furniture and nothing in it but necessary articles of use, and one pure ornament in the form of a simple vase of flowers.' Nevertheless, Voysey did operate within a decorative tradition, and his work of the later 1890s, such as a writing desk, with a shaped pierced mount depicting

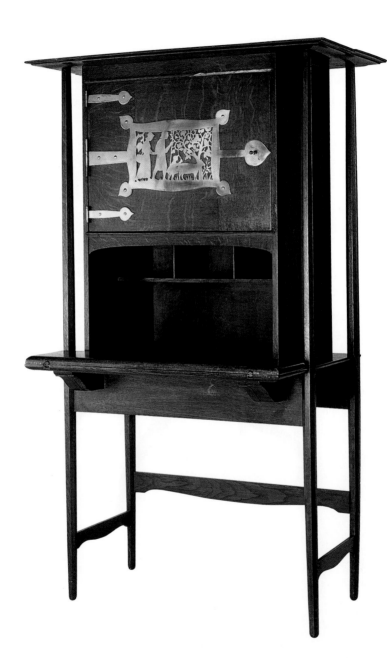

17
C F A Voysey,
Writing desk,
late 19th century.
Oak and brass;
h.167·5 cm,
65⁷⁸ in.
Victoria and
Albert Museum,
London

a romantic rustic scene that softens the stark geometric form (17), is characteristic of the way in which English designers shared some of the decorative themes of Art Nouveau, but explored them in a much more understated manner.

Mackmurdo, Voysey's mentor in the field of pattern design, was more flamboyant in his decorative approach. In the same year that Voysey designed his 'Lily' textile, Mackmurdo produced the famous cover for his own book, *Wren's City Churches* (18), which shares its fluid sense of movement with Voysey's fabric. Significantly, Mackmurdo saw fit to let this sense of movement transfer from his illustration and decorative work into some of his designs for objects. In this respect his most celebrated pieces are his dining chairs of around 1882–3 designed for the Century Guild (19), of which Mackmurdo was a founder member. Made by the progressive London furniture firm Collinson and Lock, the chairs provide an early example of the rhythmic movement in fabric and wallpaper design being transferred into three dimensions, although the chair still retains a traditional overall form.

Mackmurdo's decorative innovations are all the more interesting because he was more closely involved with the Arts and Crafts Movement than Voysey. He had travelled in Italy with Ruskin and was involved in the Society for the Protection of Ancient Buildings with Morris. In 1882, Mackmurdo set up the Century Guild, a group of craftsmen of varied skills, with a set of aims that were imbued with Ruskin's fervent views on the abolition of the hierarchy of the arts. Mackmurdo proclaimed that the Guild would 'render all branches [of the crafts] the sphere no longer of the tradesman, but of the artist', and 'restore building, decoration, glass-painting, pottery, wood-carving and metal to their rightful places beside painting and sculpture'. But, in a departure from the generally sober rhetoric of the Arts and Crafts Movement, Mackmurdo and other members of the Guild, who tended to be young rather than established designers, continued to work in an expressive manner. They experimented with the sinuous naturalistic decoration that would come to be recognized as one of the defining characteristics of

Art Nouveau. Mackmurdo's 'Cromer Bird' fabric design of around 1884 (20), for example, displays the same wave-like sense of motion as Voysey's 'Lily' pattern (see 15). Mackmurdo had a limited influence on his contemporaries in England, although a few companies, such as the Manchester firm of James Lamb, produced occasional pieces of furniture 'after' Mackmurdo, which display the same delicacy of line. However, the work of Guild members largely

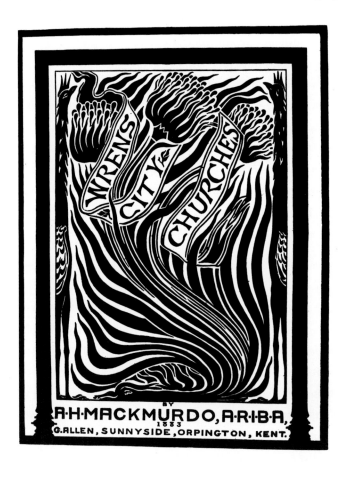

18
Arthur Heygate Mackmurdo, Title page for *Wren's City Churches,* 1883

19
Arthur Heygate Mackmurdo, Chair, c.1882–3. Mahogany and leather; h.96·5 cm, 38 in. William Morris Gallery, London

existed in a stylistic vacuum. As with many of the more adventurous late nineteenth-century English designers, Guild members such as Mackmurdo and the young pattern designer Selwyn Image (1849–1930) received the attention they deserved only in continental Europe. Two other English designers who were influential in the evolution of Art Nouveau on the continent, as well as central to its development in England, were the architect and designer Charles

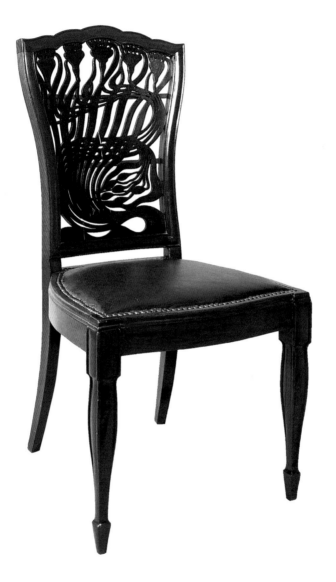

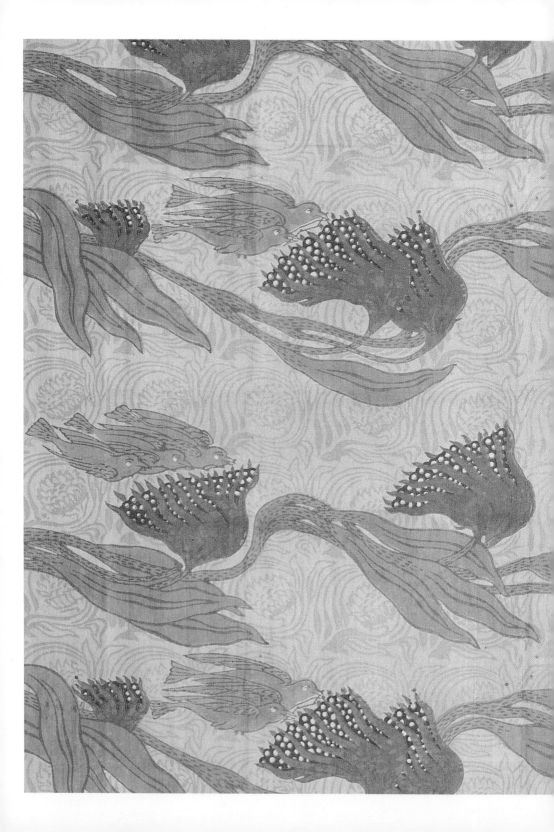

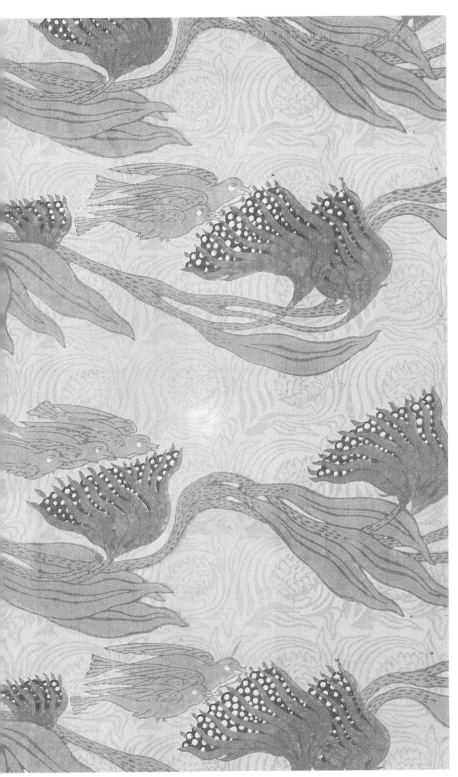

20
Arthur Heygate Mackmurdo, 'Cromer Bird' fabric, c.1884. Printed cotton cretonne. Victoria and Albert Museum, London

Robert Ashbee and the illustrator Walter Crane (1845–1915).
Along with Mackmurdo, Crane's Arts and Crafts credentials were
impeccable. He was a member of the Socialist League with Morris
(he designed the cover of the League's manifesto in 1885), and was
chairman of the Arts and Crafts Exhibition Society. Like many of
Morris's immediate followers, however, he expressed hostility to
Art Nouveau, describing it as a 'strange decorative disease'.
Crane's voice was one of many which contributed to the furore that
followed the gift to the Victoria and Albert Museum in London of a
collection of French Art Nouveau objects purchased at the 1900
Exposition by the dealer Sir George Donaldson. Crane had just been
appointed as the head of the Royal College of Art, and the Council

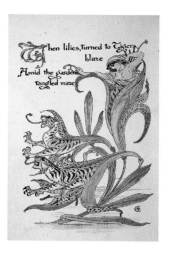

of the College promptly pronounced that, 'if these pieces are
offered to Art students [for study] they will do nothing but harm.'

Despite this, however, Crane was the first English artist and
designer of the 1890s to exhibit in Brussels, one of the earliest
centres of Art Nouveau design in Europe. Here he showed his
children's book illustrations in 1891. Illustrations such as his now-
famous *Flora's Feast* (21), first published in 1889, display a sense of
movement inspired by natural subjects that appealed to the Belgian
public, something which Crane himself acknowledged when he
noted that 'In Belgium particularly … the work of the newer school
of [book] designers has awakened the greatest interest.' And for

Dear Reader, Books by Phaidon are recognised world-wide for their beauty, scholarship and elegance. We invite you to return this card with your name and e-mail address so that we can keep you informed of our new publications, special offers and events. Alternatively, visit us at **www.phaidon.com** to see our entire list of books, videos and stationery. Register on-line to be included on our regular e-newsletters.

Subjects in which I have a special interest

☐ Art ☐ Contemporary Art ☐ Architecture ☐ Design ☐ Photography

☐ Music ☐ Art Videos ☐ Fashion ☐ Decorative Arts ☐ *Please send me a complimentary catalogue*

Mr/Miss/Ms Initial Surname

Name

No./Street

City

Post code/Zip code Country

E-mail

This is not an order form. To order please contact Customer Services at the appropriate address overleaf.

Please delete address not required before mailing

PHAIDON PRESS LIMITED

Regent's Wharf

All Saints Street

London N1 9PA

PHAIDON PRESS INC.

180 Varick Street

New York

NY 10014

Return address for USA and Canada only

Return address for UK and countries
outside the USA and Canada only

all his apparent hostility to Art Nouveau, Crane can also be credited with writing one of the most eloquent contemporary expressions of the new aesthetic in his 1900 pamphlet entitled *Line and Form*. Crane talked of 'a kind of progression in the expressive possibilities of the line ... the line of waves which lends expression to the strong upward spiral, the meander, the flowing line approaching the horizontal, or the sharp contrast and clash of right-angles. The artist can without doubt unleash a great expressive force in his mastery of the pure line.'

21
Walter Crane,
Illustration
from *Flora's
Feast: A Masque
of Flowers*,
1889

22
Charles
Robert
Ashbee,
Decanter,
c.1904–5.
Glass and
silver;
h.27 cm,
10⅝ in.
Private
collection

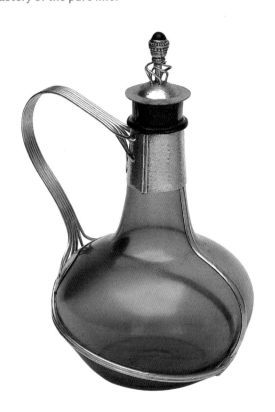

English designers in the Arts and Crafts tradition were certainly capable of producing work easily recognizable as Art Nouveau. Between about 1898 and 1904 Ashbee and his Guild of Handicraft, which he had set up in 1888 (see Chapter 7), produced a series of claret decanters (22) that represent some of the most delicate and beautiful forms produced by an English maker of the Art Nouveau period. Their varied handles are as sinuous and tensile as the most adventurous European Art Nouveau objects. It was first in his

co-operative ideals growing up in our midst, and we shall find in the development of the workshop the solution of the problems of style and criticism in Art and Craft. Finally, we must have, in our exhibitions, schools, and polytechnics, complete representation from workmen in their societies. Thus alone can the workshop be reconstructed, and a noble national Art in the end be created. The great question of the consumption of its commodities—the question from the point of view of the public outside, which I touched upon in my second chapter, and leave for later consideration; but the workshop from within may suggest ways and means for this also. The destinies of British Art, Craft, and Industry must eventually be decided by the British working classes; even as they are at present slowly and surely solving our social and economic questions, and in the end it may yet be told how, from the obscene bulb of the plutocracy, sprang the tulip of the new civilisation.

CHAPTER 5.—AN INDUSTRIAL DIALOGUE BETWEEN MR. ARCHIBALD PUSHINGTON, M.P., AND MR. THOMAS TRUDGE, TRADE UNIONIST.

In the last two chapters I have dwelt upon the remoteness of the problems of Art and its education from the problems of the workshop and its re-construction; let me point a little to the reasons of this.

I once tried very hard to bring Mr. Pushington and Mr. Thomas Trudge together. Not from Quixotic motives, but from a mere love of fighting. There were a few questions I wanted to hear them argue out, for they had both heckled me with problems, and made a sort of mental middle man of me. But I could not do it. Mr. Pushington merely shrugged his shoulders and said, "*que faire!*" Mr. Trudge laughed, and knocked the ashes out of his pipe with "You bet!" So I was obliged to become an imaginary Dragoman to them, and dish up the questions in occasional and alternate scraps.

"Next time you see your friend—what's his name—Trudge —of whom you talk so much, just put him a few straight questions from me," said the Member for S.W. Kensington. Ask him where all this Unionism is going to end. Ask him how an industry is to be conducted without the employer of labour who has been specially trained for it. Ask him whether he, as a free Englishman, has no sense of right and wrong in the matter of compelling men to work according to a definite rule laid down by a Union whose action is constantly hampering and endangering trade. Ask him whether he would like his standard of comfort lowered by having to accept the wage of the German, or what he would do if it were a choice between that, and going out of work altogether; or, better still, ask him what he would do if I closed one of

23
Charles Robert
Ashbee,
*A Few Chapters
in Workshop
Re-construction
and Citizenship*,
1894

graphics and primarily his furniture, however, that Ashbee had an early impact on the development of the style. For the illustrations in his book *A Few Chapters in Workshop Re-construction and Citizenship*, published in 1894 (23), Ashbee exploited the possibilities of metal process blocks to escape from the thick lines necessitated by more traditional wood-engravings. As a result, Ashbee was able to reproduce more delicate linear designs, similar to Crane's.

Yet it was Ashbee's increasingly rectilinear furniture, produced from the mid-1890s onwards, which had perhaps the greatest international impact of any English designer's work. In the mid-1890s the Guild of Handicraft expanded, taking on more designers, and in 1896 Ashbee and the Guild exhibited five examples of their furniture at a show organized by the Arts and Crafts Exhibition Society. One of these was a simple music cabinet that hinted at the direction Ashbee's work was about to take. But the piece of furniture that represents the apogee of Ashbee's flirtation with Art Nouveau is a writing cabinet he designed around 1898 (24). This was unveiled at the Arts and Crafts Exhibition Society's show

24
Charles Robert Ashbee, Writing cabinet, c.1898. Mahogany and holly; h.136·1 cm, 53½ in. Cheltenham Art Gallery and Museums

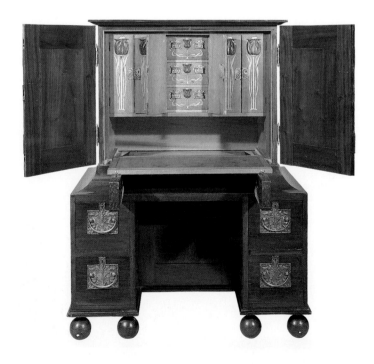

in London in 1899, before being displayed at the Eighth Secession exhibition in Vienna in 1900, where it was sold to a Viennese family. With its dark mahogany exterior raised on old-fashioned ball feet, the cabinet draws heavily on English vernacular traditions of furniture making. The first hints of contemporary fashionability can be felt, however, in the elaborate pierced foliate mounts that form the handles on the lower drawers, together with the flowing foliate relief decoration on the rectangular escutcheons and bands applied to the upper doors. When these upper doors are opened, the full extent of Ashbee's Art Nouveau styling is revealed. Six holly doors inlaid with stylized tulips are again enhanced by the use of pierced silvered lock-plates of stylized foliate forms. Ashbee's cabinet embodies the restraint of English Art Nouveau. Outwardly traditional, it is almost ashamed of its decorative modernity, although this modernity is undeniably present.

Ashbee's relationship with Art Nouveau's contemporaneity must always be qualified by his rejection of modern methods of manufacture. His Guild of Handicraft was an ostensibly commercial workshop that was run along utopian socialist lines, with the primacy of the craftsman and his happiness and satisfaction as its underlying principle. Originally located in the East End of London, the Guild moved to Chipping Campden in Gloucestershire in 1902 when its lease in London expired. The radical nature of this move, leaving London for the Cotswolds, reveals Ashbee's underlying romanticism, and his unease with the onward march of modernity.

The Aesthetic Movement, which reacted both against industrialization's ugliness and Arts and Crafts' social moralizing, made an equally important English contribution to Art Nouveau. Attracting support among a fashionable stratum of English upper and middle-class society between the 1870s and 1890s, it promoted the supremacy of beauty and the notion of 'art for art's sake', a philosophy that often spilled over into the kind of hedonism characterized in the lives of the playwright Oscar Wilde and the artist Aubrey Beardsley (1872–98). It was in fact a Frenchman, the poet Théophile Gautier, who coined the phrase 'l'art pour l'art'

when discussing Symbolist poetry, but it was in England that this religion of beauty was most widely applied to the visual arts. In 1873 Walter Pater, an Oxford don and mentor of Aesthetes such as Oscar Wilde, famously invoked the aesthetic spirit in his *Studies of the History of the Renaissance*. Pater wrote of 'the desire for beauty, the love of art for art's sake' and proffered his celebrated advice to youth to strive 'to burn with a hard gem-like flame'. Taken as the manifesto of decadent nonconformity, Pater's writings did much to shape what would become the dominant *fin-de-siècle* philosophy in certain artistic circles. It was undoubtedly a philosophy that contributed much to the romantic individualism of Art Nouveau.

The Aesthetic Movement comprised a modish circle of artists and writers who were based mainly in London. Including such figures as Wilde and his friend the painter James Abbott McNeill Whistler (1834–1903), the Aesthetes saw Pater's maxims as central to their taste and lifestyle. Noted for their dandyish style and hedonistic pursuits, Aesthetes turned to the decorative arts of the Orient as a source of inspiration. The most lavish example of an Aesthetic interior is the Peacock Room, designed by Whistler in 1876–7 for the London home of Frederick Leyland, a wealthy Liverpool entrepreneur, and now in the Freer Gallery of Art in Washington, DC (25). The room was in fact a work of art in itself, with peacocks based on a Japanese print painted onto the walls in gold leaf and a metal-panelled ceiling decorated with a pattern based on peacock feather motifs.

Many of those involved in the Aesthetic Movement cultivated an interest in Japanese forms and decoration which Art Nouveau artists maintained. The United States had initiated commercial relations with a previously isolated Japan in 1853 when Commodore Matthew Perry sailed the first US Navy ships into Tokyo Bay, winning trading rights through diplomacy and a firm display of arms. In the years that followed, European and American knowledge of Japanese art grew and was hugely influential on avant-garde art movements, including the Impressionists and the Symbolists, as well as the Aesthetes. As early as 1862 tastemakers

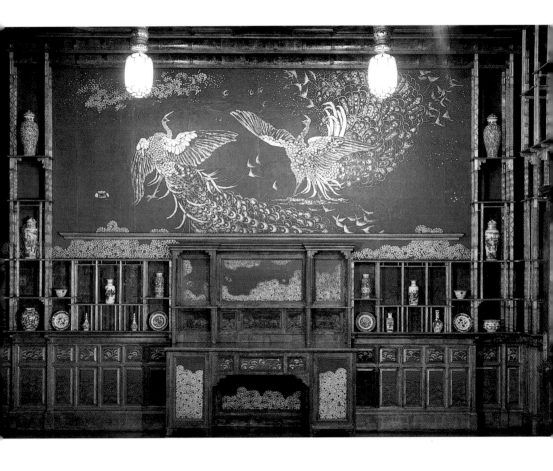

25
**James Abbott
McNeill
Whistler,**
The Peacock
Room,
1876–7.
Freer Gallery
of Art,
Washington, DC

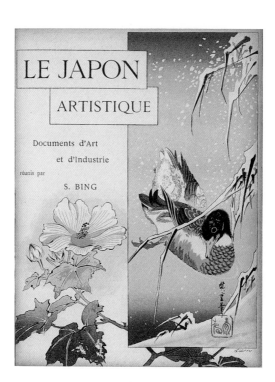

26
Cover of
*Le Japon
Artistique*,
May 1888

27
Émile Gallé,
Vase,
1878.
Glass;
h.28 cm,
11 in.
Musée des Arts
Décoratifs,
Paris

in England such as the painter and poet Dante Gabriel Rossetti
(1828–82), the furniture designer Edward William Godwin (1833–86)
and the architect William Burges (1827–81) had acquired Japanese
prints and objects which were sold off after being shown at the
influential South Kensington exhibition of that year. In Paris in the
1870s, Bing had promoted Chinese and Japanese art through shops
dealing in Oriental artefacts and through his own activities as a
collector. Between 1888 and 1891 he edited the monthly journal
Le Japon Artistique (26), which also appeared in English and German
editions. The impact of what was called *Japonisme* on Art Nouveau
is perhaps most evident in the ceramics of Émile Gallé. According
to the critic Henri Frantz, writing in 1897, 'It was from Japanese art
that [Gallé] derived the general system, the fundamental principle
of his style.' Some of Gallé's vases carried the inscription 'alla
Japonice', while others directly imitated Japanese models in their
simplified abstraction or in their use of motifs such as carp and
oriental plants (27). Gallé's fascination for Japan was fostered by
Takacyma, a Japanese student at the École Forestière de Nancy

between 1882 and 1885, whose drawings he greatly admired. Yet it is also likely that Gallé's visit to London in 1871 provided a formative Orientalist experience. Here he would have been aware of the fashion for Japanese art among artistic circles associated with the burgeoning Aesthetic Movement.

The influence of Aesthetic ideals on Art Nouveau, however, went much further than a predilection for the refined and exotic. The Aesthetic Movement also had a significant impact on middle-class taste. By encouraging the appreciation of beauty in the domestic interior, the Aesthetic Movement complemented the more sober Arts and Crafts practitioners in stirring a desire among the prosperous middle classes to beautify their homes. Despite promoting contrasting tastes and ethics, both movements were preoccupied with beauty, and the Aesthetic Movement in particular, with its celebration of fashion and luxury, helped to create a market that Art Nouveau, in its more populist forms, was to exploit. The decorative arts were being democratized as a bourgeois market for them appeared. The most celebrated example of this process was the

success of the London firm Liberty & Co (see Chapter 6), which began by supplying imported Oriental ceramics and textiles to aesthetically aware Londoners in the 1870s. The shop soon commissioned its own designs and sold other English 'artistic' wares. Liberty expanded by opening a shop in Paris in the 1880s, and selling their lines across Europe. By 1900 the store was promoting fairly affordable Art Nouveau products, a sign of the progression from Orientally inspired Aestheticism to Art Nouveau, as well as of the commercialization of the new style.

The Aesthetic Movement in England culminated in the short career of the illustrator and graphic artist Aubrey Beardsley, who died at the age of twenty-five from tuberculosis, which he had suffered from since childhood. In general, the utopian moral values of the Arts and Crafts Movement worked against the development in England of a high Art Nouveau tradition of the type that evolved in France with its associations of luxury and élitism, but Beardsley's work provides the one true exception to this rule. He offered proof that the French did not have a monopoly on decadence and flamboyance.

Beardsley worked in relative stylistic isolation in England, but by the early 1890s his illustrations displayed many characteristics that would come to define Art Nouveau. His drawings were populated by stylized waif-like figures with flowing hair and robes. Stylistically he embraced a bold, simplified linear manner, which his almost exclusive devotion to black and white enhanced. This linear style enabled him to produce drawings that were at once delicate and aggressive, beautiful and grotesque. Finally, his subject matter, for example his suggestive illustrations for Wilde's play *Salomé*, or his later drawings of decadent eighteenth-century scenes from Alexander Pope's poem *The Rape of the Lock*, ensured that all the ingredients of Art Nouveau were in place. By February 1893, in a letter to his old schoolfriend G F Scotson-Clarke, Beardsley confidently proclaimed: 'Last summer I struck for myself an entirely new method of drawing and composition.' But Beardsley did at least begin to acknowledge his influences, describing his style as 'something suggestive of Japan, but not really japonesque'.

In 1893 Beardsley's work was featured in the first issue of a new monthly journal, the *Studio*, 'an illustrated magazine of fine and applied art'. Among his illustrations was one intended to accompany Wilde's *Salomé*, which had been written in French and was to appear the following year in English translation. The illustration, entitled *J'ai baisé ta bouche* ('I kissed your mouth'; 28), depicted a floating demonic Salome holding the dripping Medusa-like head of John

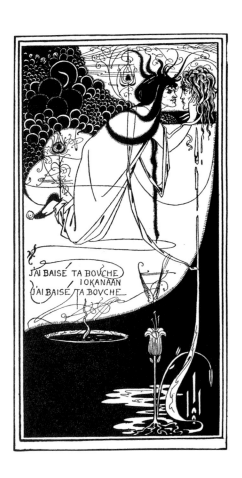

28
Aubrey
Beardsley,
J'ai baisé
ta bouche,
Jokanaan,
from *Salomé*,
1894.
Line block print;
28 × 15 cm,
11 × 5⁷⁄₈ in

the Baptist. The *Studio*, which circulated both in Britain and Europe, gave Beardsley an international platform, and his name soon became associated with the new style.

In England Beardsley's work was received with unease, even hostility, outside the artistic circles in which he moved. Oscar Wilde's trial, conviction and imprisonment in 1895 for indecency

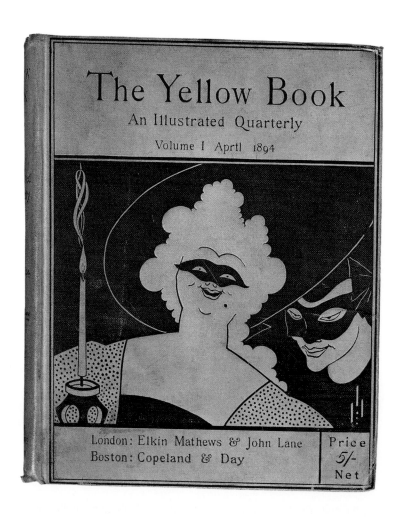

The Yellow Book

An Illustrated Quarterly

Volume I April 1894

London: Elkin Mathews & John Lane
Boston: Copeland & Day

Price 5/- Net

because of his homosexuality added moral outrage to the existing public misunderstanding of the decadent Aesthetes of the 1890s. Beardsley and the new style suffered by association with Wilde, and when *Salomé* appeared in 1894 with illustrations by Beardsley, the *Art Journal* warned its readers that the book was 'for the strong minded alone, for it is terrible in its weirdness and suggestions of horror and wickedness'. In the same year Beardsley's work also appeared in the *Yellow Book*, a publication that rapidly gained a notoriety shared by its most famous illustrator (29). Perhaps the most celebrated condemnation of the *Yellow Book*'s allegedly dubious morals came from the *Westminster Gazette*. Beardsley's illustrations were branded an 'excess hitherto undreamed of', and the critic implored Parliament 'to make this kind of thing illegal'.

It was not only Beardsley's style that was provocatively and self-consciously new, however. Technologically, he also embraced the latest innovations, most notably the photomechanical techniques of reproduction, such as the line-block, which replaced the expensive and labour-intensive practice of woodcut engravings. While Morris was ensuring the survival of woodcutting as an authentic craft tradition with his Kelmscott Press publications, Beardsley's publisher, J M Dent, intended his edition of Sir Thomas Malory's *Le Morte d'Arthur* (written c.1460 and first published by Caxton in 1485) to be available to a wider public by using modern, more economical methods.

Beardsley's work constitutes one of the earliest mature expressions of Art Nouveau in a country whose artists never really took the style to heart. His subject matter also underlines the importance of the final major nineteenth-century tradition that fed into Art Nouveau: Symbolism. To Scotson-Clarke in 1893, he wrote of his illustrations:

The subjects were quite mad and a little indecent. Strange hermaphroditic creatures wandering about in pierrot costumes or modern dress; quite a new world of my own creation. I took them over to Paris with me and got great encouragement from Puvis de Chavannes, who introduced me to a brother painter as 'un jeune artiste anglais qui a fait des choses étonnantes'. I was not a little pleased I can tell you.

29
Aubrey
Beardsley,
Cover of *The
Yellow Book*,
volume 1,
1894

Pierre-Cécile Puvis de Chavannes (1824–98) was a leading artist of the French Symbolist movement, and the growing influence of the eroticized and decadent Symbolist world-view can be discerned in the development of Beardsley's style throughout the 350 or so designs he produced for Dent's edition of *Le Morte d'Arthur*, as his knights change from Pre-Raphaelite heroes to strangely mischievous *fin-de-siècle* dandies.

Like Beardsley, many French practitioners of Art Nouveau drew on and shared the sense of decadent sensuality in the work of Symbolist and some Post-Impressionist painters of the 1880s and 1890s. Post-Impressionist painters, such as Henri de Toulouse-Lautrec (1864–1901), often focused on the underworld of modern society (see 55), while the Symbolists, breathing the last gasp of nineteenth-century romanticism, displayed a preoccupation with mysticism, eroticized dreamworlds and mythological and pseudo-religious imagery. In this sense they shared an affinity with the Pre-Raphaelites in England and, looking further back, with William Blake (1757–1827), the English artist, poet and mystic whose dream-like illustrations and engravings have much in common with Symbolism and Art Nouveau. In certain contexts Art Nouveau artists, like the Symbolists, consciously recalled mystical folk traditions. Artists and designers in both movements rejected the hierarchy of the arts that placed painting and sculpture above other art forms, and many created decorative art objects. A vase with Breton scenes by Paul Gauguin (1868–1914), made in 1887, shows how he transferred his painting style to ceramics (30). He evokes the natural spirituality of the peasant women using planes of colour glaze broken with delicate lines of gold that are startlingly similar to Art Nouveau styles that were then emerging.

The illustrator and designer Eugène Grasset (1841–1917) brought together an interest in medieval decoration with an increasingly Symbolist outlook to create a distinctive Art Nouveau aesthetic. Grasset had been a pupil of Viollet-le-Duc and his early work was strongly influenced by Gothic styling. By the 1890s his subject matter had turned to the kind of wistful maidens favoured by the

30
Paul Gauguin,
Breton scenes
decorating a
vase by Émile
Chapelet,
1887.
Painted,
engraved and
gilt brown
ceramic
stoneware;
h.28·5 cm,
11¼ in.
Musées
Royaux d'Art
et d'Histoire,
Brussels

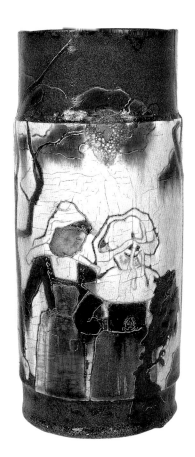

Symbolists and he developed a fashionable flat Japanese-inspired style. Typifying Art Nouveau's challenge to the hierarchies within the arts, Grasset also designed ceramics, tapestries and, perhaps most successfully, stained glass. Grasset made a theoretical contribution to the new style in the publication of his book *The Plant and Its Ornamental Applications* (1897), which comprised colour plates of botanical drawings followed by examples of how to apply their forms to decoration. Although by the time it was published Art Nouveau had reached its stylistic maturity, Grasset's book was the product of a lengthy teaching career and his ideas must have had a significant impact on the evolving movement in the preceding years.

The best place to see the impact of Symbolist art at the 1900 Universal Exposition was in Siegfried Bing's L'Art Nouveau pavilion. Its six interior ensembles were primarily the work of three designers,

all of whom displayed the characteristic fluidity of disciplines that the anti-hierarchical philosophy of Art Nouveau encouraged. Édouard Colonna switched from jewellery to porcelain to furniture, while Eugène Gaillard (who originally trained as a lawyer) designed lighting, carpets and furniture. However, it was the third of the trio, Georges de Feure, a painter turned interior decorator and furniture designer (see 6), who personified the link between Art Nouveau and the aesthetic and spirit of Symbolism.

De Feure's paintings decorated the exterior of the pavilion, and his stained glass panels featured inside. Both confirm the close ties between Symbolism and Art Nouveau. His exterior paintings (see 5) depicted seductive women each representing one of the decorative arts. Jens Thiis, a Norwegian museum director who set up a weaving studio in Trondheim that spearheaded the revival of tapestries in Norway and produced Art Nouveau designs, saw in the paintings 'the same composition of exaggerated slenderness and seductive exuberance, which is the charm of de Feure's furniture style. Over all of it shines an anaemic beauty and a whiff of over-refined sensuousness, which is the essence of the decadent colouring of his interiors.'

The themes of decadent eroticism and nature, along with the strong mystical overtones that recur in Art Nouveau, can be discerned both in de Feure's earlier painting and in the Symbolist oeuvre as a whole. De Feure had spent a decade as a painter and had shown work at the first two exhibitions of the Salon de la Rose+Croix in 1892 and 1893 (see Chapter 2). The wistful painting *The Daughter of Leda* (31) has a delicacy of line that is characteristic of Art Nouveau. The rarified atmosphere combines disconcertingly with our knowledge of the Greek myth behind the image – the rape of Leda by Zeus, who had transformed himself into a swan. Jens Thiis sensed the decadence of Symbolism in the elegant élitism of de Feure's Art Nouveau. 'Rather than the rising sun of the coming century, this "new art" appears to symbolize the evening twilight of refinement, which has settled over French intellectual life and which, with a worn but still not worn out catchword, calls itself "*fin de siècle*".'

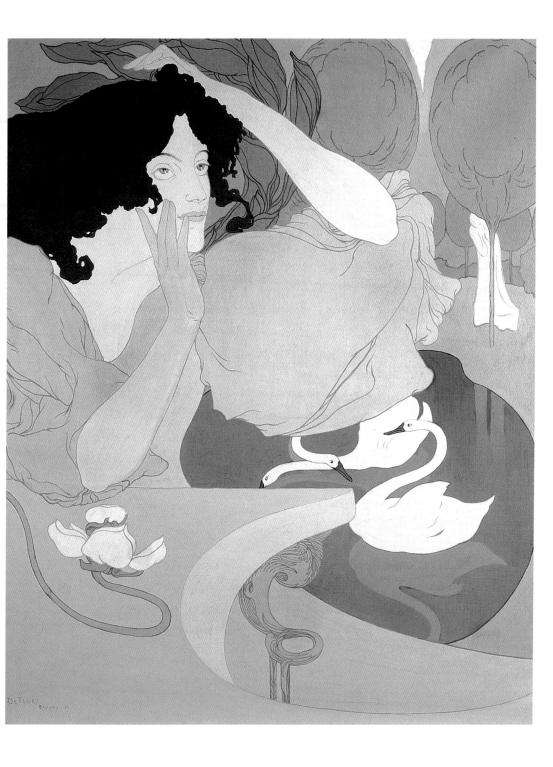

These justified accusations of *fin-de-siècle* languor remind us that Art Nouveau, despite a very real sense of innovation, was a style of the nineteenth century. It was the result of a synthesis, rather than the revolution some of its protagonists and critics believed it to be. Although the style was sometimes seen as a radical response to the failure of eclecticism in the nineteenth century, it was this very eclecticism, encompassing such seemingly paradoxical revivals of the Rococo and the Gothic, that provided such fertile ground for Art Nouveau.

Art Nouveau was never one homogenous movement. Its diverse roots fed varied manifestations. The impact of Neo-Rococo ideas and motifs was greatest in France, while in Belgium and the German-speaking countries, the English design reform tradition was particularly influential. Meanwhile, the unique combination of Gothic Revivalism and uncompromising modernity promoted by Viollet-le-Duc directly inspired the more individualistic Art Nouveau designers such as Hector Guimard. Nevertheless, Guimard's acknowledgement of Viollet's influence, as opposed to that of Pugin, Ruskin or Morris, does not mean that English influence was confined to Belgium, Austria and Germany. Although the French would have been loath to admit it, the work of designers such as Voysey and Morris, and those they influenced, for example Van de Velde, was as much part of French Art Nouveau as the Rococo Revival. Louis de Foucard, a French critic at the 1900 Universal Exposition, recognized that Art Nouveau was 'highly composite', describing it as 'a mixture of Gothic and Japanese, of rustic and super-refined, which came from England having passed through Belgium'. It is to the manifestations of Art Nouveau in Belgium and then France and Germany to which we turn next, to explore the meanings of the new style in the places where it reached its apogee.

2

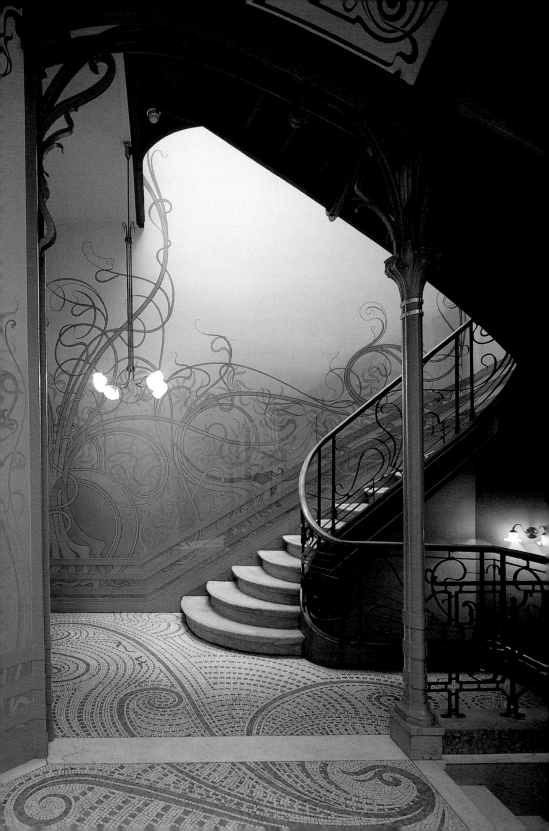

The medley of hopes and fears that characterized European culture at the turn of the nineteenth century was embodied in the phrase *fin de siècle*. Technological progress and the rapid expansion of industrial cities created both new possibilities and economic and political tensions. The campaign for women's rights in the fields of education and politics created uncertainty about traditional gender roles. The rapidly developing fields of psychology and sociology subjected both the individual and society to analysis and theorizing on an unprecedented scale, while scientific and medical discoveries pushed back the frontiers of knowledge. Only a few decades earlier, Charles Darwin had put forward his theory of evolution in *The Origin of Species* (first published in 1859). If Darwin was right about the idea of genetic progress, some writers saw *fin-de-siècle* developments as proof that the opposite process was also possible – that mankind was capable of regression as well as evolution.

The *fin de siècle* could be destabilizing or invigorating depending on one's attitudes. Many people were filled with a foreboding sense of degeneration, believing that they were witnessing a decline comparable to the swansong of ancient Rome. Others looked forward to the dawning of a twentieth-century utopia, to be achieved through science, technology or political revolution. Conservatives and radicals alike shared a common anticipation of impending crisis. Art Nouveau was part of this moral and intellectual ferment. The complex interplay of artistic influences that shaped the new style (see Chapter 1) is important, but it should not obscure the immediacy and relevance of Art Nouveau in the brief period in which it dominated. Highly fashionable, the style was also profusely symbolic, its layered and sometimes contradictory meanings offering a chaotic visual manifesto of the age. Art Nouveau could express a progressive modern sensibility, appealing to those with left-wing political ideas,

32
Victor Horta,
Wrought-iron
staircase and
mosaic floor,
Tassel House,
Brussels,
1893–5

while its incorporation of traditional decorative themes could also embody conservative values. Certain Art Nouveau depictions of women expressed a misogynous fear of their changing role in society, though images of dreamlike maidens also contributed to the atmosphere of *fin-de-siècle* decadence. The evocation of dream worlds in the decoration of the domestic interior showed an awareness of the emerging science of the subconscious, and Art Nouveau's preoccupation with natural plant forms reveals an affinity with the sciences of botany and biology. These branches of science also overlapped with esoteric spiritual ideas, as well as right-wing nationalist politics. This chapter looks at the story of Art Nouveau in three European countries where it flourished most vibrantly, in Belgium, France and Germany, and through this survey all these themes and contradictions will emerge.

In England, two contrasting strands of embryonic Art Nouveau – the simple and the luxurious, the righteous and the decadent, best represented by Ashbee and Beardsley respectively – both fed into European Art Nouveau, primarily through the interest of Belgian artists of the 1880s and early 1890s in English art and design. It was in Belgium in the early 1890s that the style reached maturity, just as it had been in Belgium that the phrase 'Art Nouveau' was first used. Apart from English influence, Belgian artists were also well placed to absorb artistic influences from France, particularly from Symbolist and Post-Impressionist painting. Belgian Art Nouveau architecture also drew heavily on the country's own eclectic tradition of historic and historicist buildings, for instance the Rococo style that dominated in towns such as Ghent.

The political climate in Belgium helped make Belgian artists susceptible to the radical political dimension of English art and design. Since the 1840s the Belgian political scene had been dominated first by the liberals and then by Catholic conservatives. Political discontent was never far from the surface and was fuelled by the country's extremely restricted electoral franchise. In 1886 there had been workers' uprisings and demonstrations in Liège

and other cities. Universal male suffrage was introduced only in 1893, when it replaced a system that had allowed only 137,772 people to vote out of a population of some six and a half million. Women's suffrage, opposed by the Church in Catholic countries such as Belgium, had to wait until 1948.

Many aspiring young bourgeois politicians who, a generation earlier, would have found their natural home in liberal politics, were now drawn to the socialists, the Belgian Workers' Party, who had led the suffrage campaign. Under the new system, the Belgian Workers' Party began to win more seats and press for greater reforms against a Catholic government that represented the antithesis of their scientific and humanist ideals. The Workers' Party was unusual among the major socialist parties of Europe in that it actively encouraged connections with the artistic avant-garde. It had a vibrant cultural education programme, which included public lectures by artists, and many artists and architects responded by aligning themselves with socialism. Against this background, the English radicalism of Ruskin and Morris provided a natural source of artistic inspiration.

The interest in English and French art was fostered by an assortment of exhibition societies and associated publications. In the 1890s societies such as the progressive artists' association La Libre Esthétique ('The Free Aesthetic') provided a powerful impetus in the promotion of Art Nouveau. La Libre Esthétique grew out of the group of artists that called themselves the Société des Vingt (Les XX). Both were established by a lawyer, Octave Maus, as was their influential journal *L'Art moderne*. Founded in 1884, Les XX was primarily a platform for Post-Impressionist and Symbolist painters, although it also encouraged work in the applied arts. Between 1891 and 1893 its exhibitions included ceramics by Gauguin (see 30), posters by Toulouse-Lautrec, a screen by the painter Émile Bernard (1868–1941) and a tapestry by Van de Velde. It was the editors of *L'Art moderne* who first coined the phrase 'Art Nouveau'. La Libre Esthétique strengthened the links between the English tradition and Belgian Art Nouveau, offering Ashbee his first opportunity to

show his work on the continent in the society's début exhibition of 1894. The following year Ashbee was again invited to exhibit in Belgium, this time by Serrurier at his L'Oeuvre artistique exhibition in Liège, an event to which Charles Rennie Mackintosh (see Chapter 3) was also invited. In 1894 Edmond Picard, who had been a co-founder of L'Art moderne, opened a gallery in Brussels called La Maison d'Art. Housed in his own mansion, it comprised a series of domestic interiors; Siegfried Bing visited the new gallery, and the following year, when he opened his Paris shop L'Art Nouveau, he placed the same emphasis on the role of room settings.

Alongside L'Art moderne, magazines such as La Société nouvelle and Van nu en straks (Of Present and Future) promoted new artistic and social doctrines. In 1894 Van de Velde wrote in La Société nouvelle:

The hope of a happy and egalitarian future lies behind these new decorative works; we find evidence of this in the writings of Walter Crane and William Morris, two of the movement's leading lights. Artists may only be visionaries, but sociologists lend these prophecies scientific support.

Van de Velde proved to be the greatest advocate of Morris's socially aware design reform, and he emerged as the most versatile and internationally acclaimed of the Belgian Art Nouveau designers and architects.

He began his career in the 1880s as a painter, influenced by the work of the Post-Impressionists Georges Seurat (1859–91) and Vincent van Gogh (1853–90), which he saw exhibited at Les XX, but he seems not to have encountered the ideas of Ruskin and Morris until 1892, when the Belgian painter and ceramicist Alfred William Finch (1854–1930) discussed them at the opening banquet of an exhibition organized by Les XX. The influence of socialism and anarchism (then associated with ideas of replacing the existing order with loosely federated, mutually supporting groups) encouraged Van de Velde to abandon painting in favour of the applied arts. His style in the many fields of design he turned to was characterized by a linear freedom of the kind that was to become a hallmark of international Art

Nouveau, Van de Velde designed tapestries, furniture, silverware, porcelain and pattern designs, as well as interiors. One of his earliest attempts to create a complete designed environment was in 'Bloemenwerf', the house he built for his wife and daughter near Brussels in 1896. Externally the house drew on English vernacular influences, but inside the pared-down yet freely curving furniture and the patterned wallpapers, also designed by Van de Velde, reveal the totality of his evolving Art Nouveau vision (33). In his furniture and graphics, Van de Velde avoided the sensuous and over-refined female motifs that were to characterize French Art Nouveau and

33
Henry van de Velde,
Wallpaper,
1895

concentrated on flowing, abstract forms, as in his famous poster of 1897 for the Tropon Chocolate Factory (34).

In his own reminiscences, Van de Velde recalled that he was not the first Belgian designer to interpret English Arts and Crafts taste. That honour was reserved for the furniture designer Serrurier: 'The Liège designer Serrurier was the first to design furniture influenced by the neo-Morris movement,' wrote Van de Velde, 'and he introduced into Belgium the fabrics, wallpapers, lamps and prints made by members of the Arts and Crafts Movement. Hankar,

Horta and I immediately followed suit.' According to a 1911 article on Serrurier, he had attended classes at schools run by some of the guilds of the Arts and Crafts Movement in England.

Serrurier had originally trained as an architect in the 1870s, only later taking up furniture design. After his marriage in 1884, he opened a shop in Liège offering interiors in the 'English and American style'. A second shop in the city stocked Liberty's goods, as well as some of his own furniture. In the later 1890s and 1900s, Serrurier's furniture progressed from the obvious Gothic Revival and Arts and Crafts influences of his earlier work to freer, more

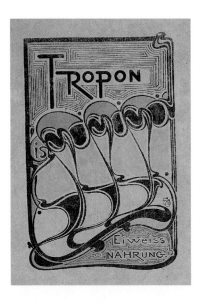

34
Henry van de Velde, Poster for the Tropon Chocolate Factory, 1897. Lithograph; 51·4 × 32 cm, 20^14 × 12^58 in

35
Gustave Serrurier-Bovy, Bed, c.1899. Mahogany; 279 × 211 × 240 cm, 109^78 × 83 × 94^58 in. Musée d'Orsay, Paris

expressive forms of Art Nouveau. His oak furniture of the early 1890s has a simplicity of form and honesty of construction that places it within the tradition of Voysey's 'Swan' chair (see 16), and before that the furniture of Pugin. In comparison, Serrurier's mahogany bed (35), dating from around 1899, departs from these Arts and Crafts roots to embrace the unashamedly bourgeois comfort of Art Nouveau. The use of mahogany rather than oak signifies a move towards luxury, which is confirmed by the grand contours of the curving canopy, its panels decorated with stylized floral motifs. Significantly, the surroundings in which the furniture was exhibited also changed. While an oak suite was shown in 1895

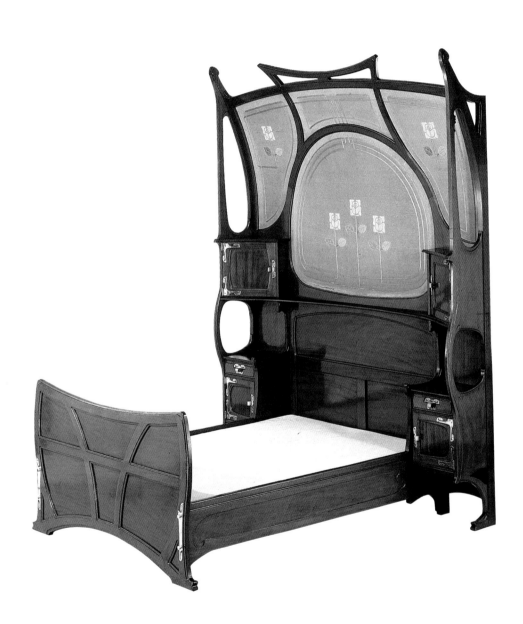

at the exhibition of La Libre Esthétique, the bed was displayed at the Paris shop that Serrurier opened in 1899. The shop, named L'Art dans l'Habitation ('Art in the Home'), was arranged as a series of staunchly bourgeois room displays, a far cry from the 'artisan's room' he had designed furniture for earlier in the 1890s.

Although the influence of English design on Art Nouveau was felt most strongly in the work of Van de Velde and Serrurier, it is in the work of Victor Horta (1861–1947) that the most complete early expression of the style can be found. His buildings and interiors are also a pragmatic example of how the radical political influence of the English design reform tradition could be combined with the élitist aestheticism of the Neo-Rococo style and the technological advances afforded by the use of iron and glass in architecture. Horta was a graduate of the Brussels École des Beaux-Arts, where he had trained under a highly regarded Belgian architect, Alphonse Balat (1818–95), and studied alongside Paul Hankar (1859–1901), who also made his name as an Art Nouveau architect. Horta owed as great a debt to Balat as to Morris, Ashbee or Beardsley. Balat was particularly skilled in adapting to new technologies, as is shown by the cupola of his royal glasshouses (36) built in Laeken in 1874–6, buildings that must have inspired Horta (see 44). Horta's own familiarity with the architectural possibilities of such materials as iron and glass, which were so characteristic of his work, also stemmed from his time as an assistant to the Belgian architect Ernest Hendrickx (1844–92), who made much use of visible metal elements in his buildings.

When it came to design reform, Viollet-le-Duc was just as influential a presence in francophone Belgium as Pugin and Ruskin. Horta's library included all Viollet's books, and he later cited Viollet as a major influence. Interestingly, he viewed what he called 'The English School' – the medieval-inspired teachings of Pugin, Ruskin and Morris, which he had learnt during his studies – with the same dissatisfaction as the staid Beaux-Arts education itself. On building his first house, Horta later claimed that he ignored the theories he had been taught 'partly as a reaction against the teachings of the

École des Beaux-Arts and also against the English School. I myself was an architect influenced by Viollet-le-Duc.' Horta's architecture had other links with France. Horta had been fascinated by the Rococo architecture of his home town of Ghent, and as a young man he had spent over a year in the Parisian district of Montmartre, working as a stucco artist at a time when the Rococo was very much in vogue. This time in Paris also opened his eyes to the sheer variety of art and architecture: 'my walks, the visits to the monuments and the museums, had all opened the doors of my artistic heart.'

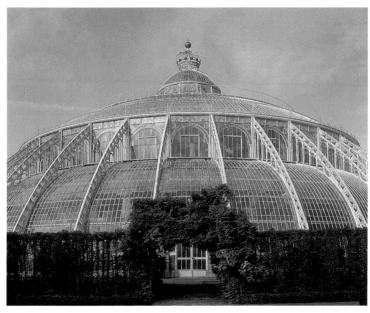

36
Alphonse Balat,
Royal
glasshouses,
Laeken,
1874–6

A brief survey of Horta's work in the 1890s reveals that, in keeping with the diversity of his influences, his projects embodied tensions at the heart of Art Nouveau. Some of his houses were designed for radical lawyers, others for government ministers. They were aesthetically progressive, but also stunningly luxurious and certainly beyond the means of the ordinary people who voted for the Belgian Workers' Party, with which Horta and many of his clients were associated.

Horta met his first clients, Eugène Autrique and Émile Tassel, after joining the Brussels masonic lodge, Les Amis Philanthropes, a

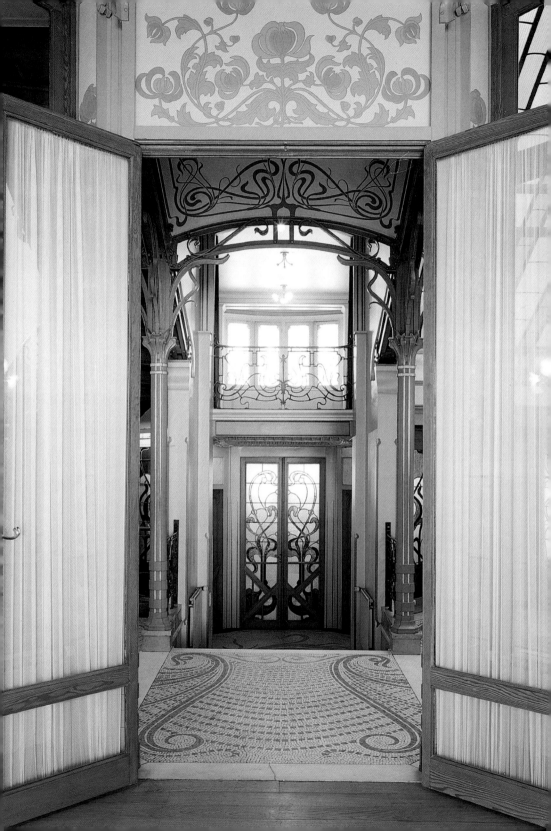

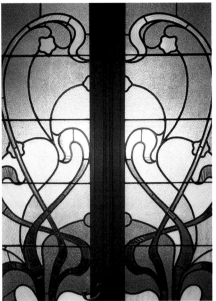

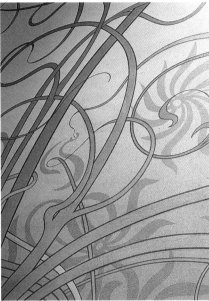

37–41
Victor Horta,
Tassel House,
Brussels,
1893–5
Opposite
Main entrance
viewed from
the salon
Above right
Stained glass
of the main
entrance door
Above far right
Stairway mural
Below right
Handles on the
door to Tassel's
study
Below far right
Stairway
ironwork and
mural

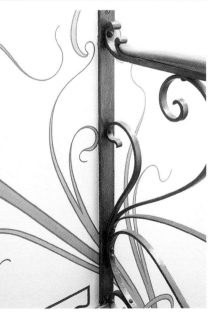

secret society that provided a meeting-place for many Brussels intellectuals and that was instrumental in founding the city's university. The lodge was one of many links between freemasonry and Art Nouveau, and provided Horta with the kind of contacts most young architects could only dream of. In his *Mémoires* he recalled a cultural and aesthetic streak common to many lodge members:

After joining the lodge to devote myself to the public good, I in fact only made friends there with people whose profession prevented them from taking public action or taking any interest in political matters and whose direct character led them more towards privacy and beauty than towards the masses and general vulgarity.

Autrique, for whom Horta built a town house in 1893, was an engineer, and Tassel, who commissioned Horta to design a house in the same year, was a mathematician and keen amateur photographer. Tassel, it seems, desired a home with a rarefied environment: Horta later recalled his brief for a house for 'a bachelor who ... took great pleasure in entertaining his close circle of friends, which only scholars and artists could join.'

Tassel House in Brussels reflected its owner's intellectual and social pursuits. Its entrance is dominated by a curvaceous wrought-iron staircase, dramatically writhing wall decorations and vibrantly coloured mosaic floor (32, 37–41). The main room was the study, while the mezzanine was equipped with a laboratory for Tassel's photographic experiments. Tassel hosted soirées at the house, at which he gave illustrated lectures in the dining room, projecting slides on to the back wall; a guest bathroom and smoking room were built nearby for such occasions. As well as being a professor of descriptive geometry at Brussels University, Tassel was a music enthusiast and a connoisseur and collector of Japanese art. The importance of the English influence in Brussels in the early 1890s is evident in the decorative scheme. Horta dropped the original Egyptian-inspired interior for the drawing room in favour of English wallpapers, which were obtained from Van de Velde. For the dining room he chose another English paper, created by Voysey and entitled *Elaine*. For upholstering the chairs he designed for the

drawing room, Horta turned once more to London and used a fabric patterned with daffodils that had been designed for Liberty's.

Between 1894 and 1905 Horta designed houses for five lawyers, at least two of whom, Léon Furnémont and Max Hallet, had impeccable radical political credentials. Furnémont was a local councillor in Brussels from 1891 until 1913. Originally a liberal, he joined the Belgian Workers' Party in 1894; he was also prominent in the rationalist movement and was involved with a number of radical political newspapers. In 1890 he was elected president of the Brussels group Libre Pensée ('Free Thought'). Like Furnémont, Hallet, for whom Horta built a house between 1903 and 1905, was also a liberal who had defected to the Belgian Workers' Party in 1894. He became a city councillor in 1896, and then pursued a career in national politics, maintaining his keen interest in social problems.

As socialists, Furnémont and Hallet were supporters of many progressive causes, including universal suffrage (rather than merely universal male suffrage), the hallmark of *fin-de-siècle* political modernity. By commissioning an unashamedly modern young architect to design their homes, they further allied themselves with progressive ideas. So, in Brussels at least, Art Nouveau was capable of being the visual expression of intellectual and political liberty. It was the ideal aesthetic for dashing young bourgeois radicals who wished to pronounce their independence from the kind of historicist grandeur that characterized Belgian architecture at the time, without having to sacrifice style, artistry and luxury.

Horta also designed a multi-purpose meeting hall and office complex for the Belgian Workers' Party itself. He described his Maison du Peuple (which was built between 1895 and 1899, and later became a victim of the disregard for Art Nouveau by developers in the 1960s) as:

[a building] enjoying the luxury of air and light so long absent from the slum houses of the workers; a building to house party administration, the cooperatives' offices, offices for political and professional meetings, a café, lecture rooms to develop education and, crowning it all, a vast

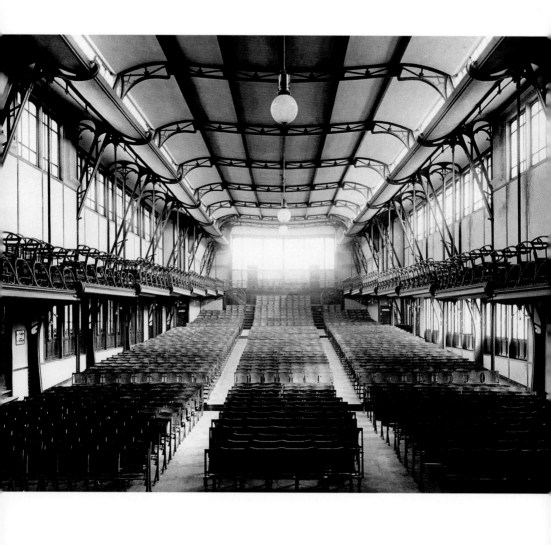

meeting room for political discussions and party congresses and also for musical and dramatic entertainment for members.

The Maison du Peuple was a large, uncompromisingly modern, public building with a skeletal, iron-spanned meeting hall (42), decorative railings and sweeping glass façade. It shattered the notion that Art Nouveau was simply an interior style favoured by elements of the bourgeoisie. Founded in 1885, the Belgian Worker's Party had moved away from the revolutionary socialist doctrines of its founders in the 1890s, in so doing attracting the kind of young liberals for whom Horta worked. His own political sympathies lay with the Party, and he was clearly well connected with some of its most influential figures. Nevertheless, he always maintained, not surprisingly, that he was chosen not for political reasons, but 'because they wanted a building in my aesthetic style.' Although the project forced Horta to abandon the trappings of luxury that characterized his domestic interiors, it enabled him to demonstrate the modernity at the heart of his Art Nouveau vision by using mass-produced elements, as in the meeting hall, to produce a public building appropriate to its social function in both budget and flexibility of use.

Not all Horta's clients were political radicals. One of his most celebrated projects, the town house for Baron van Eetvelde, was designed for Belgium's then Minister for the Congo. In 1885 King Léopold II acquired a vast swathe of central Africa that became known as the Congo Free State. Although not strictly speaking a Belgian colony, as it was the personal property of the king, it was perceived as such by other powers, particularly Britain and the United States. Belgium was criticized for Leopold's mismanagement of the Congo, which included appalling treatment of the indigenous population, and the merciless exploitation of the land and its resources by a series of monopolistic companies to which the state was effectively leased. This was all carried out by the king and his agents against a backdrop of apathetic disinterest, even disapproval (43), by most Belgians. Clearly, Art Nouveau was not exclusively a badge of radicalism; moreover, it seems that Horta

42
Victor Horta,
Meeting hall,
Maison du
Peuple,
Brussels,
1896–9.
Demolished
1965

had no difficulties in working for a client who was not only an unreconstructed establishment figure, but was a confidant of the king himself. Indeed, Horta's house for Van Eetvelde was to some extent a visual realization of the spoils of colonialism (44), making use of such Congolese woods as bilinga, mahogany and okoume, as well as incorporating various African-inspired natural motifs into the decorative scheme.

43
The Production of Free Labour, from *La Trique,* 25 February 1906

44
Victor Horta, Interior view, Van Eetvelde House, Brussels, 1895–7

Horta also entered a proposal (which was eventually rejected) to design the Congo pavilion at the Paris Universal Exposition in 1900, just as international criticism of Belgian exploits in Africa was gaining ferocity. Incidentally, he was not alone among Belgian Art Nouveau designers in his association with Léopold's dubious African exploits. In 1897 Van de Velde, Serrurier and Hankar were all commissioned by Van Eetvelde to contribute to the Congo display at the Brussels Universal Exposition of that year. The king also promoted ivory in order to stimulate trade in the Congo by

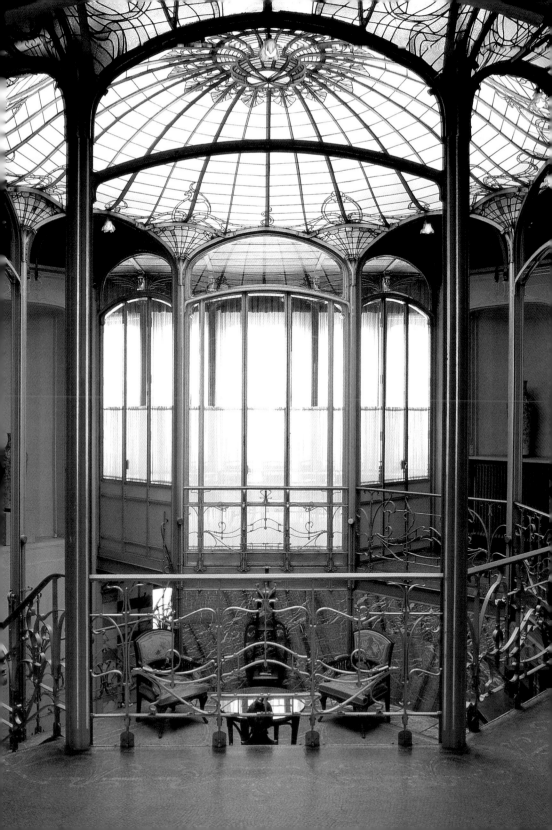

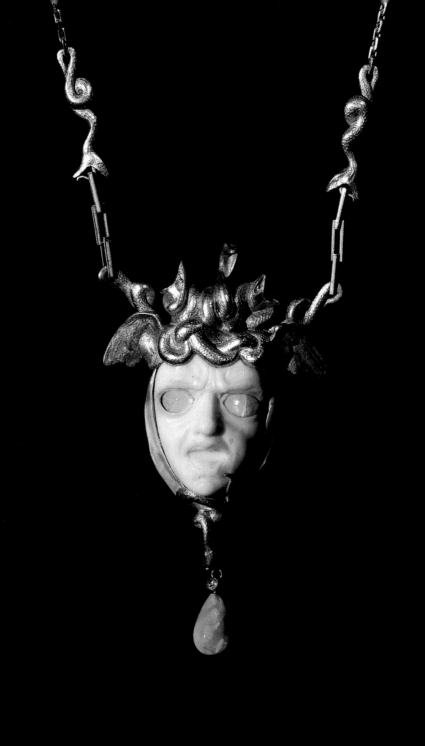

offering free tusks to artists in the hope of making the material fashionable. The result was a boom in ivory art objects to the extent that they dominated the displays at the 1897 Brussels Universal Exposition. The jewellery designer Philippe Wolfers (1858–1929) won special acclaim for his Symbolist-inspired Art Nouveau creations making use of Congo ivory. His 1898 'Medusa' pendant combines an ivory mask with gold, opal and enamel elements (45).

Intriguingly, even Horta's radical and enchanting interiors – such as those of Tassel House and Van Eetvelde House – are hidden behind relatively austere and conservative façades. Perhaps this concealment of fantasy within supports Horta's thesis that his clients were really inclined towards 'privacy and beauty rather than towards the masses.' But public vigour and private peace were not seen as mutually exclusive, quite the opposite: contemporary theories on the role of the home in the modern world suggested that an active public life needed to be sustained by an aesthetically pleasing, comfortable domestic environment. One of the preoccupations of fin-de-siècle medicine was the mental strain that work placed on modern man, particularly on well-to-do intellectuals. In 1891 the French physician Fernand Levillan warned that:

45
Philippe
Wolfers,
'Medusa'
pendant,
1898.
Ivory, opal and
gold;
10 × 5·2 cm,
4 × 2 in.
Private
collection

Intellectual work is one of the most fatiguing forms of nervous activity ... Every man of average intelligence who exceeds ten hours a day in intellectual work, and above all, who doesn't vary this work and combine it with some sort of physical activity, puts himself in the most favourable condition for nervous exhaustion.

Horta himself noticed the 'nervous disposition' displayed by Baron van Eetvelde when he visited the architect in 1895 to commission the new town house. Van Eetvelde's nerves were apparently 'consequent upon the work exacted by the King from those who chose to serve him,' Horta noted in his Mémoires. Such observations suggest that he was well aware of discussions on the 'psychology of rooms' that appeared in French journals such as L'Art décoratif and Art et décoration, and which insisted that domestic interiors should be serene oases of calm and beauty. In this context it is certainly possible that, despite the modern radicalism of his

clients, some of Horta's projects were commissioned to create refuges from the stresses of modernity. A 1901 article in L'Art décoratif summed up contemporary attitudes when it argued that,

The function of décor is not to arouse particular emotions, but to give the milieu a character in accord with the man who must live there without compelling his thoughts to focus on one image of concrete reality, without forcing them to be objective when the hour of subjective refuge awaits them.

Such concerns were among the *fin-de-siècle* anxieties that found fertile soil in France at the end of the nineteenth century. And it is to France that we must now turn to chart the development of Art Nouveau through the 1890s to the Paris Universal Exposition of 1900. The shift of the epicentre of Art Nouveau from Brussels to Paris can be traced through the activities of some of the leading Belgian designers. In 1895 Henry van de Velde showed in Siegfried Bing's new Parisian gallery L'Art Nouveau, rather than in Brussels, and by 1898 Serrurier too had moved part of his operation to Paris. Horta had a profound influence on the French architect Guimard (see Chapter 1), who visited him in 1895, inspiring him to move away from his earlier Gothic Revival style to a more fully evolved Art Nouveau aesthetic. Horta was also asked by Bing to contribute to the design of his gallery L'Art Nouveau, although his suggestions were never incorporated. The early flowering of Belgian Art Nouveau and the continuing success of Van de Velde and Serrurier in other European centres ensured that their contribution to the movement was never forgotten, yet in the years following the opening of Bing's gallery, Paris became recognized as the most important centre for the new style.

France at the turn of the century was coming to terms with the decline of its power in Europe. Still smarting from defeat in the Franco-Prussian War and with painful memories of the Paris Commune, many French citizens looked nostalgically to the past, while at the same time attempting to forge a modern identity. The work of French scientists had gained worldwide recognition. Louis Pasteur's research into microorganisms revolutionized food

preparation through the process now known as pasteurization, and provided vaccines against diseases such as rabies; Pierre and Marie Curie were carrying out pioneering research into radioactivity, which was to win them a Nobel prize in 1903. In the competitive arena of imperial power politics, France was acquiring a colonial empire in Africa and Asia that, it was hoped, might rival Britain's. While there were many achievements to be proud of, however, there was also a tangible fear that the nation was degenerating.

All was not well in the *belle époque*. Two scandals, in particular, tore into the political and cultural fabric of France in the 1880s and 1890s. The Panama scandal revealed widespread corruption in the government and press in their relations with the ailing Panama Canal Company before its eventual failure. This episode heightened popular cynicism towards authority and offered ammunition to the socialists. The Dreyfus affair further rocked France in 1894. Captain Alfred Dreyfus, an army officer of Jewish descent, was sentenced to life imprisonment in exile on charges of military espionage for Germany. Successive leaked documents suggested his innocence, but his conviction was repeatedly upheld on appeal. By 1898 the issue had divided France. Intellectuals such as the novelist Émile Zola campaigned on behalf of Dreyfus, while the Church and those on the right sided with the army, stirring up anti-Semitic feeling. It was only in 1906 that Dreyfus was finally exonerated.

At the same time, the long conflict in French society between the Roman Catholic Church and the State was in 1900 only just approaching resolution. Ever since Louis XVI (r.1774–92) was guillotined in 1794 and the traditional status and privileges of the Second Estate, the clergy, were swept away during the French Revolution, successive French republics had attempted finally to secularize French society. It was not until 1905 that the Church and State were definitively separated, helping to remove this source of tension. Despite all the scientific and imperial progress of the age, poverty was still rife – among both the rural and emerging urban working classes. Labour struggles were laced with anarchist violence, underlining the fragility of the post-1870 Third Republic.

The changing role of women is an aspect of *fin-de-siècle* society that had a particular relevance to Art Nouveau in France, where the female figure became a central decorative motif. Such changes were felt in both political and artistic circles in the 1890s and 1900s, and led to a new phrase being coined – the *femme nouvelle* ('new woman'). Women had gained access to French universities in the 1860s, and the Ferry laws of the 1880s extended secondary education for women. In 1885 female doctors won the right to practise medicine in public hospitals. This noticeable, if slow, advancement was accompanied by political agitation by the French feminist movement, who had gained increasing recognition after the first Congrès International du Droit des Femmes (International Congress for the Rights of Women), held in Paris in 1878. Initially, middle-class liberals within the feminist movement shied away from campaigning for universal suffrage, but by the 1880s such moderates were being superseded by radicals such as Hubertine Auclert. The denial of women's voting rights was felt particularly acutely on the French left as one of the aims of the French Revolution had been to create political equality among French citizens. In 1881, Auclert founded the weekly newspaper *La Citoyenne* (*The* [female] *Citizen*), whose aim was 'to claim the equality of woman and man ... We ask for woman not only the civil rights of a French citizen but also the practical rights of the citizen.' Conservatives viewed all such changes as a rejection of women's traditional roles and linked them to France's declining birthrate, which was seen as particularly worrying while Germany's population boomed. This economic and nationalist dimension ensured that the *femme nouvelle* remained a heated political issue in the 1890s.

Biologists and anthropologists were cited in the debate, providing scientific justifications for the domestic role of woman. In his *Lectures on Man* (1864), Carl Vogt, Professor of Natural History at the University of Geneva and an avowed Darwinist, had sought to explain the differences between men and women through the study of skulls, claiming that: 'the female skull approaches, in many respects, that of the infant, and in a still greater degree, that of the lower races.' Physicians and psychologists also pronounced

on the 'truths' of female sexuality. 'Masochism', for example, a term invented by the psychologist Richard von Krafft-Ebing in his 1886 book *Psychopathia Sexualis*, was only deemed perverse in men. 'In women', Krafft-Ebing maintained, 'voluntary subjection to the opposite sex is a physiological phenomenon.' Krafft-Ebing shared an idea that preoccupied some nineteenth-century scientists that abnormal sexual behaviour had a direct link to the wider process of social degeneration: 'episodes of moral decay always coincide with the progression of effeminacy, lewdness and luxuriance of nations.' He saw cities not only as the venues of squalid iniquity, but also as places where both poverty and luxury were concentrated, and thus where degenerative neurological disorders would inevitably prosper. This was a notion that already had currency in literary and artistic circles, and had been articulated by Charles Baudelaire in 1857 in his collection of poems *Les Fleurs du mal* (*Flowers of Evil*), set in contemporary Paris.

Such forthright opinions were matched by those in the French arts world who shared the views of Edmond de Goncourt (see Chapter 1). In 1894 the writer and collector Octave Uzane championed the historic role of decoratively minded Parisian women, the 'queens of elegance', who made the city a 'garden of delights'. Drawing on the Goncourts' nostalgic romanticism for the *ancien régime*, which had inspired the Rococo Revival in France in the 1880s, these sentiments were echoed in Symbolist circles. In the artistic journal *La Plume*, which had championed Symbolist painting in the 1880s, the writer Victor Jozé deplored the 'illusory emancipatory ideas which are unrealizable and absurd'. 'Let woman remain what Nature has made her', he argued, 'an ideal woman, the companion and lover of a man, the mistress of the home ... let there be no androgynes.' French feminists had long recognized that one of the forces of oppression they faced was the art world. Writing in 1869 in the first issue of *Le Droit des Femmes* (*The Right of Women*), a moderate feminist weekly, the feminist activist Maria Deraismes (who went on to use her personal wealth to finance the feminist congresses of 1878 and 1898) argued that: 'What women want is not to be brought up, educated, moulded according to some conventional image;

an image conceived in the brain of poets, novelists or artists and therefore unreal.' For Deraismes such cultural stereotyping resulted in an 'arbitrary, fictitious distribution of human faculties that affirms that man represents reason and woman represents emotion.'

During the early 1890s in some circles it was hoped that a promotion of women's traditional homemaking roles might encourage the regeneration of French arts and crafts. In 1894 the National Congress of the Union Centrale des Arts Décoratifs identified one of the crucial areas for development as 'the role and influence of women in the artistic development of our country.' In 1892 the Union staged an exhibition of the 'Arts of Woman'. This was reviewed in the *Revue des Arts Décoratifs* by Louis de Foucard, who offered a conservative response to the *femme nouvelle*, and at the same time provided a prophetic manifesto for the relationship between Art Nouveau and women, as both consumers and subjects:

What a woman suggests is worth more than what she conceives ... technically a woman excels at small tasks ... she is a born upholsterer, seamstress, refined decorator of intimate space, an inexhaustible orchestrator of worldly elegance. For everything else, her lofty function is to be an inspiration, even when she does not know it.

For Edmond de Goncourt, contemporary women were so unsatisfying that 'men's interests have shifted from the charming beings to pretty, inanimate objects, with a passion charged with the nature and character of erotic love.' On the one hand, the 'new woman' was bad for the arts because she was out at work or studying instead of busying herself with beautifying the domestic interior. On the other, this very failure of the 'new woman' was seen, at least by Goncourt, as the factor that impelled men to seek beauty in *objets d'art*. According to this logic, the aesthetic desire to covet objects with the kind of erotic zeal previously reserved for women was an inevitable result of female emancipation.

Against a background of such commentary and debate, the female figure joined plant tendrils and dragonflies as an embodiment of nature in Art Nouveau objects (46). Suggestive both of 'ideal'

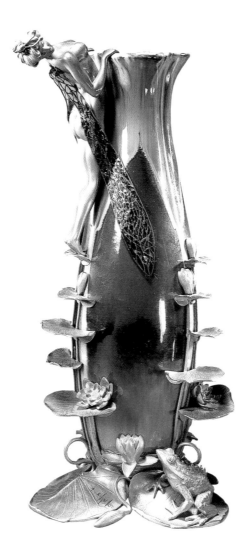

46
Louis Chalon,
'Water lily fairy'
vase,
1898.
Bronze;
h.46·5 cm,
18³⁄8 in.
Private
collection

feminine beauty and of fears regarding the *femme nouvelle*, these
representations of women could serve as metaphors for anything
from purity and tranquillity to evil and temptation. While the
Impressionists had broken new ground from the 1860s onwards by
portraying modern women in the real world, at cafés and galleries,
at home and in shops, many Art Nouveau artists continued to use
a stereotypical vocabulary that was shared by Symbolist (47) and
academic painting of the late nineteenth century. These stereotypes
included the nymph, the *femme fatale* and occasionally the *femme
nouvelle* herself. However, writing in 1901, the social critic Marius-Ary
Leblond was emphatic:

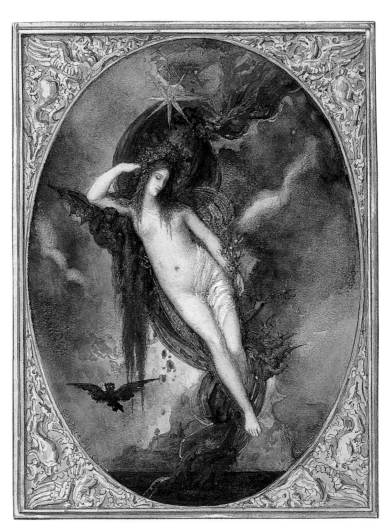

47
**Gustave
Moreau,**
Night,
c.1880.
Watercolour;
26·3 × 20·9 cm,
10³⁸ × 8¹⁴ in.
Pushkin
Museum of Fine
Arts, Moscow

48
*To the Feminist
Congress,* from
Le Grelot, 1896.
Caption reads:
'I'm going to
the Feminist
Congress! Make
the dinner for
exactly eight
o'clock, you
hear me? And
above all, make
sure nothing
goes wrong!...'

The new woman is not beautiful. She looks rather like a boy, and
illustrates more than anything the expression of a firm character, a
serene soul, a robustly harmonious body ... And nothing suits them
better than heavy and sombre colours ... that express firmness ...
roughness, and decisiveness.

With their flowing hair, long robes and delicate bodies, the women
portrayed by Art Nouveau artists in France generally provided a
reactionary contrast to the *femme nouvelle* (48).

An enamel and silver brooch set with opals entitled *Eve* by
Henri-Ernest Dabault, 1901 (49), characterizes one strand of Art

26e ANNÉE — N° 1.306 FRANCE **15** CENTIMES 19 Avril 1896

BUREAUX
5, Cité Bergère, 5
PARIS
—
ABONNEMENTS
FRANCE
UN AN......... 8 fr.»
SIX MOIS...... 4 fr.»
TROIS MOIS.... 2 fr.»
15 c. le numéro
—
PARAIT LE DIMANCHE
—
ADRESSER
Lettres et Mandats à M. J. MADRE
Administrateur

BUREAUX
5, Cité Bergère, 5
PARIS
—
ABONNEMENTS
ÉTRANGER
UN AN......... 10 fr. »
SIX MOIS...... 5 fr. »
TROIS MOIS.... 2 fr. 5(
20 c. le numéro
—
PARAIT LE DIMANCHE
—
PUBLICITÉ
*Les Annonces sont reçues
aux Bureaux du Journal*

LE GRELOT

Voir en tête de la deuxième page les conditions auxquelles on peut recevoir gratuitement le GRELOT

REVENDICATIONS FÉMININES

-- Je vais au Congrès féministe! tu prépareras le dîner pour huit heures précises,
tu m'entends? et surtout, que rien ne cloche!...

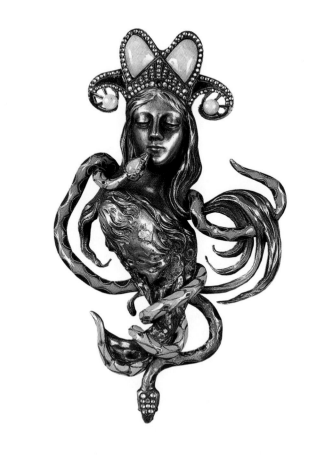

49
Henri-Ernest Dabault,
Brooch entitled
Eve,
1901.
Silver, enamelled
and gilt, opals
and coral pearls;
h.10·5 cm,
4¹⁸ in.
Private collection

50
René Lalique,
Brooch entitled
The Kiss,
1904–6.
Silver and
moulded glass;
l.7 cm,
2³⁴ in.
Musée des Arts
Décoratifs, Paris

51
René Lalique,
'Siren' diadem,
1897–8.
Antique bronze,
emeralds and
opals;
l.14 cm,
5¹² in.
Musée des Arts
Décoratifs, Paris

Nouveau imagery that featured biblical figures. The brooch depicts the temptation of Eve by the serpent in the Garden of Eden, which led to her taking the forbidden fruit from the Tree of Knowledge and to humankind's expulsion from paradise into a world of sin and toil – she is the epitome of weakness and vulnerability, temptation and degeneracy. Ancient mythology provided models for the *femme fatale*. The siren (51) was a favourite Art Nouveau figure and a popular subject for jewellers such as René Lalique (1860–1945). In one of his first forays into glass (a medium for which he was equally

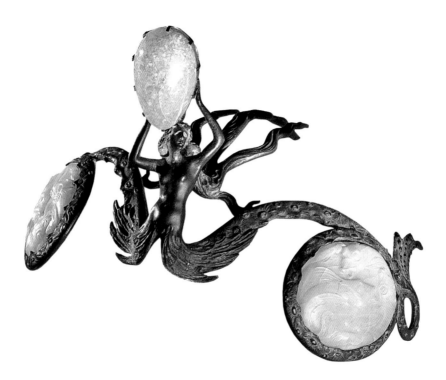

celebrated in the inter-war Art Deco era), Lalique produced a brooch entitled *The Kiss* (50), which depicted an amorous encounter between two almost mirror image lovers bedecked in floral wreaths. Given that the traditional role of jewellery is to enhance and beautify fashionable women, such choices of imagery might seem odd. It certainly seems that there was a demand for jewellery with a hint of erotic danger and exoticism. The use of such symbolically loaded imagery, moreover, reminds us of the ambiguities of Art Nouveau. Artists rarely adopted the overt moralistic standpoint of scientists,

psychologists, politicians and critics, and often seemed to be hedonistically revelling in the moral panics of the day. At the same time, the demands of clients and markets often aligned their work with conservative values.

To what extent was French Art Nouveau merely an exercise in male fantasy? The work of the controversial sculptor and furniture-maker François Rupert Carabin (1862–1932), although far from being a typical expression of Art Nouveau, suggests that this was at least sometimes the case. His furniture made structural use of boldly sculpted nude female figures, yet he rejected the fashionable waifish stylizations of nymphs in favour of fuller rustic figures, which supported the seats of chairs (52) or crouched to form the trestles of tables. Carabin's naked figures, often agonizingly contorted into submissive positions in order to support weight, might today be considered misogynist fantasies. Yet once again, a sideways look at contemporary painting suggests that they were part of a broader late nineteenth-century artistic trend, though in the fine arts mythical or historical scenes showing women captives, or Orientalist fantasies depicting female slaves were usually

52
Rupert Carabin,
Chair,
c.1895.
Walnut and
wrought iron;
h.122 cm,
48 in.
Musée d'Art
Moderne et
Contemporain,
Strasbourg

53
Jules Chéret,
Olympia,
1892.
Lithograph;
117 × 82 cm,
46 × 32¼ in

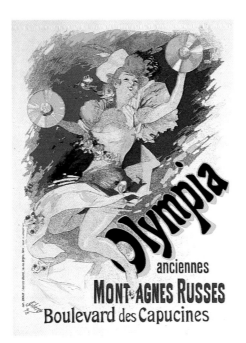

presented under the guise of allegory or progressive criticism of despotism. While Carabin's vision is offensive by today's standards, what troubled contemporary critics was not his sculpted women themselves, but his inappropriate decorative use of the figures on functional objects such as chairs and tables.

Edmond de Goncourt was among those to criticize the demise of certain romantic representations of the French woman: 'Formerly there was an attempt among pastellists to show the charms, the gaiety and the smile of a woman,' he reminisced, almost certainly referring to the work of his friend the poster artist Jules Chéret (1836–1932), whose carefree, fun-loving women graced the streets of Paris from the 1870s onwards (53). In contrast to images such as Chéret's, Goncourt condemned, 'fashionable artists [who], with their chillblained pinks and heavy violets, only want to depict confusion, the baffled heart, and all the physical and moral maladies that can be shown on the face of a woman.'

Goncourt may well have been thinking of Henri de Toulouse-Lautrec. Although now primarily considered a Post-Impressionist painter of

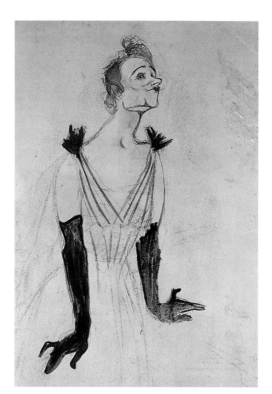

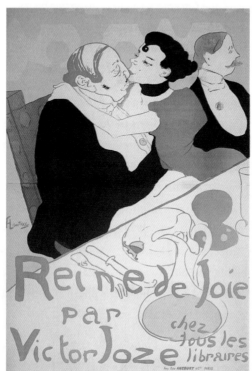

urban life, Toulouse-Lautrec also made a significant contribution to Art Nouveau poster design. Legislation passed in France in 1881 had eased the censorship of posters in many public places and the medium expanded rapidly, providing the evolving new style with its most widespread forum. Toulouse-Lautrec produced an album of prints for the celebrated actress Yvette Guilbert in 1894 (54), and later designed posters for her, though not all of them met with approval. In one case Guilbert wrote to Lautrec complaining: 'For heaven's sake, don't make me look so horribly ugly! A little less, please ... lots of people who have been here have screamed out loud when they saw the design for the poster.' Like his paintings, Lautrec's posters conveyed a sinister, often lascivious mood. His poster advertising the writer Victor Jozé's *Reine de Joie* (55) encapsulates the excesses that many of his contemporaries were beginning to see as characteristic of the last decade of the century.

Yet for all the exploitation of the female form in French Art Nouveau in particular, two of the great female icons of the movement were far from being the helpless waifs their images sometimes suggested. The name of the actress Sarah Bernhardt has become synonymous with the exotic and erotic excesses of Parisian Art Nouveau through the series of posters for her plays by the Czech graphic artist Alphonse Mucha (1860–1939). In his posters for Bernhardt plays such as *Gismonda* (56) he depicted the actress in a bold stylized way. Bernhardt's flowing costumes suited Mucha's intricate and detailed linear style, which seemed perfect for the two-dimensional printed form of the poster. For the Parisian public of the mid-1890s, Mucha's images were both original and arresting, and his portrayals of Bernhardt did much to popularize the idealized *fin-de-siècle* woman.

Bernhardt herself needed certain artistic modifications in order to conform to this dreamlike quality. In his poster for *La Samaritaine* (57) Mucha used Bernhardt's flowing locks as the central decorative motif, enabling him to indulge in sinuous lines and curves, a task that would have been more difficult had he depicted the reality of her tight dark curls. Many of Mucha's posters also show Bernhardt's

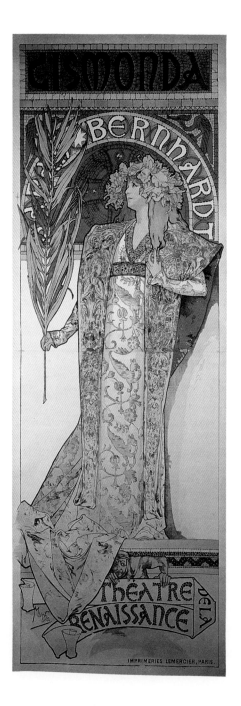

56
Alphonse Mucha,
Gismonda,
1894.
Lithograph;
216 × 74 cm,
85 × 29⅛ in

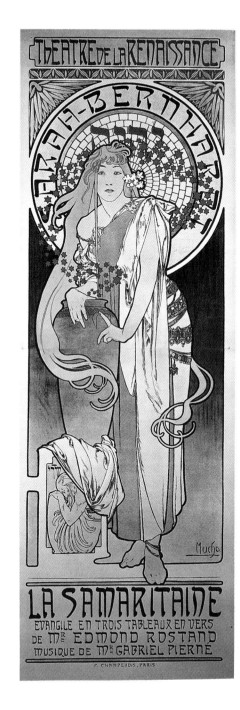

57
Alphonse
Mucha,
La Samaritaine,
1894.
Lithograph;
169 × 54 cm,
66¹₂ × 21¹₄ in

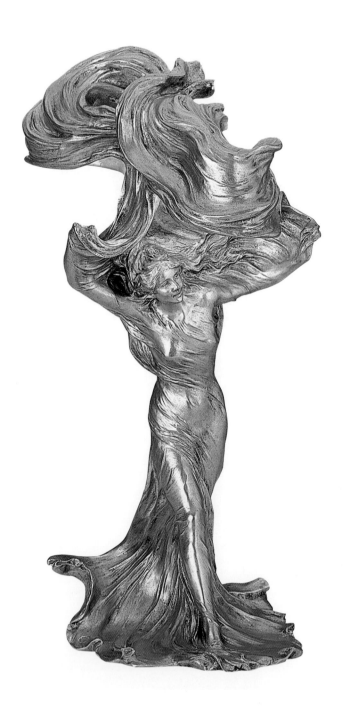

body in an elongated manner. In fact, he added Bernhardt's head to drawings he had done from life models in order to fulfil the *fin-de-siècle* ideal.

Bernhardt was far from being Mucha's passive aesthetic plaything, however. She was already the most famous actress in Paris when he was introduced to her in 1894. It was Bernhardt personally who enthusiastically approved Mucha's first poster *Gismonda*. In so doing, she effectively plucked him out of obscurity, overruling

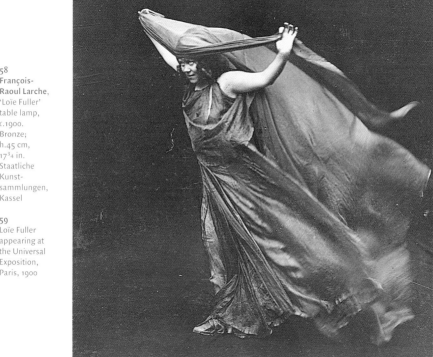

58
François-Raoul Larche, 'Loïe Fuller' table lamp, *c.*1900. Bronze; h.45 cm, 17³⁄₄ in. Staatliche Kunst-sammlungen, Kassel

59
Loïe Fuller appearing at the Universal Exposition, Paris, 1900

the scepticism of her printer, and throughout their partnership she retained the power of veto. Bernhardt was a successful career woman who used Mucha's talents for her own self-promotion.

The case of Loïe Fuller, popularly regarded today as the embodiment of Art Nouveau, offers a similar tale of a successful woman creating and using artistic fashion to her own advantage. Fuller was an American actress who made her Paris début on the stage of the

Folies-Bergère in 1892. She developed an innovative series of expressive dances that combined revolutionary lighting with myriad layers of veils to create an undulating, ever-changing visual display. Fuller danced on a glass floor lit from below, the stage surrounded by sheets of mirrored glass, with electric lights shining through lengths of silk as she whirled around the stage to the music of Chopin, Schubert and Debussy. She was idealized by writers and critics with Symbolist tendencies, as well as by artists. The Belgian Symbolist poet Georges Rodenbach hailed her dance as a 'miracle of endless metamorphoses'. 'The dancer proved that woman can, when she wants, become the universe: she was a flower, a tree in the wind, a changing cloud, a giant butterfly, a garden with paths of pleated fabric.'

Fuller's lasting association with Art Nouveau was ensured by the bronze sculptures of her made by François-Raoul Larche (1860–1912). Larche's models were part of the 1890s fashion for small portrait figures, and a vast range of imitators in France and elsewhere produced Loïe Fuller sculptures of varying quality. As with Mucha's renditions of Sarah Bernhardt, Larche allowed himself considerable artistic licence when it came to Fuller's figure (58). Photographs reveal the difference between his creations and reality (59). In a contradiction typical of Art Nouveau, Bernhardt and Fuller embodied elements of the *femme nouvelle* in their working careers, while at the same time providing critics and artists with raw material with which to reassert the dominant ideal of natural female grace and beauty.

The preoccupation with the position of women in society was only one of a number of contemporary themes that are reflected in French Art Nouveau. Towards the end of the nineteenth century there was a particularly vigorous interest in dreams and the unconscious, manifested in either the anti-rationalism of mysticism or the new studies of psychology and neurology. A fascination with both worlds can be detected in the imagery of Art Nouveau. Mucha was one of many who cultivated an interest in esoteric philosophy, the occult, spiritualism and hypnotism. During the 1890s, he met Albert de Rochas, who was then involved in psychic research.

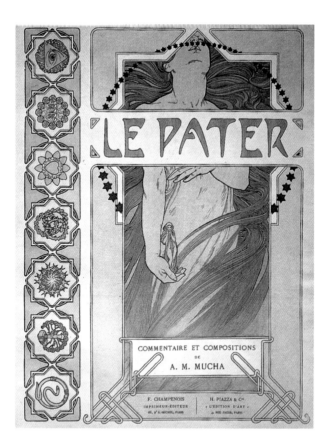

60
Alphonse
Mucha,
Cover of
Le Pater, an
edition of the
Lord's Prayer,
1899.
Lithograph;
47·3 × 34·7 cm,
18⁵⁄₈ × 13⁵⁄₈ in

As Mucha's studio was spacious, he was persuaded to allow de
Rochas to conduct his researches there alongside his associate,
the astronomer Camille Flammarion. By 1899 newspapers were
printing accounts of Rocha's séances in Mucha's studio, and Rocha
was publishing articles about them in the journal *La Nature*. As well
as flirting with the occult, Mucha was involved in freemasonry
(he returned to his native Prague in 1911 and became Supreme
Commander of the city's masonic lodge in 1920).

These anti-rationalist tendencies emerge in some of Mucha's
work. The figures on his posters (see 56, 57) often appear to have
a halo-like aura formed from the decorative background, giving
them a religious appearance. More overtly, Mucha's cover plate
for *Le Pater*, an edition of the Lord's Prayer of 1899, prominently
displays a series of seven masonic and Hebrew symbols, each within
a star (60). Such an apparently non-Christian cover design for the

Lord's Prayer is typical of the eclectic approach to religion in *fin-de-siècle* artistic circles. In *Le Pater* Mucha uses a crescent moon and Oriental-style script, possibly a reference to the importance of Eastern mysticism. The use of Hebrew symbols is probably a response to the Cabbala, an ancient Jewish mystical tradition that enjoyed a resurgence of interest as the nineteenth century drew to a close.

In art, such esoteric subjects first found favour among the Symbolist painters. The Nabis were an international group of artists, established in Paris in 1888–9, that emerged from the Symbolists. They included Pierre Bonnard (1867–1947), Maurice Denis (1870–1943) and Paul Ranson (1864–1909), and had the strong support of Gauguin, though he never actually joined, having left for Tahiti in 1891. The Nabis' choice of name for their 'secret brotherhood' derived from the Hebrew word for 'prophets'. Regular meetings were held at which the artists would occasionally indulge in mystical rituals. These are evoked by a portrait by a founding member, Paul Sérusier (1863–1927), of *Paul Ranson in Nabi Costume*. Sérusier depicted Ranson, dressed in priestly attire and surrounded by a halo, reading from what appears to be a Hebrew book, again suggesting Cabbalistic interests.

This Symbolist preoccupation with arcane theology was also embodied in the Salon de la Rose+Croix. The salon was run by Joséphin Péladan, who had undertaken to revive Rosicrucianism, an esoteric society centred on the legendary fifteenth-century visionary Christian Rosenkreuz, and employing emblems of the rose and cross as symbols of Christ's resurrection and redemption. The salon provided a stage for many Symbolist artists to exhibit their work in Paris, as their work was often rejected by the regular state-sponsored Salon exhibition, which had shown officially sanctioned art since its founding in the seventeenth century. By this time alternative Salons, which were first held by the radical artist Gustave Courbet (1819–77) and later by the Impressionists, had quite a respectable genealogy. The first Salon de la Rose+Croix was held in 1892 and attracted members of the Nabis, as well as

artists from outside France, such as the Swiss painter and printmaker Carlos Schwabe (1877–1926) and the Belgian painter Fernand Khnopff (1858–1921).

The strict set of guidelines for entrance to the Salon de la Rose+Croix declared that, 'The Order favours the Catholic ideal and mysticism.' The list of acceptable subjects included, 'Legend, Myth, Allegory, the Dream, the Paraphrase of great poetry and finally all Lyricism'. Such subject matter led to images that had much in common with the emerging Art Nouveau aesthetic. Schwabe's poster for the first Salon (61) shows two graceful, elongated female figures ascending a heavenly staircase from which spring lilies and other flowers. From the waters below a nymph rises, her hands metamorphosing into seaweed. The evocation of dream worlds such as that suggested by Schwabe might seem to be simply a romantic, anti-rational response to the loud and dangerous realities of modern life. Yet at the same time science and medicine were exploring this field, paradoxically providing artists with inspiration while attempting to demystify the sources of such spiritual mysticism.

The practices of hypnotism and suggestion, the idea that the presentation of an idea to a receptive individual can lead to acceptance of the idea, were important to Symbolist painters who were attempting to convey intuitive emotions or spirituality through images. Hypnotism had been pioneered in modern Europe by the German physician Friedrich Anton Mesmer in the second half of the eighteenth century. However, his explanatory theories of what he termed 'animal magnetism', which he developed into a system of hypnotic treatment known as mesmerism, had been officially discredited in Vienna and France by the 1790s and were ridiculed as magical dabblings by scientists in the early 1800s. By the latter part of the century, however, modern medicine had rehabilitated hypnotism. It was thought that it could help those with mental and nervous disorders, enabling suggestion to work as a legitimate treatment. In strictly medical terms it had a limited use in dealing with such maladies as hysteria, but in literary, political

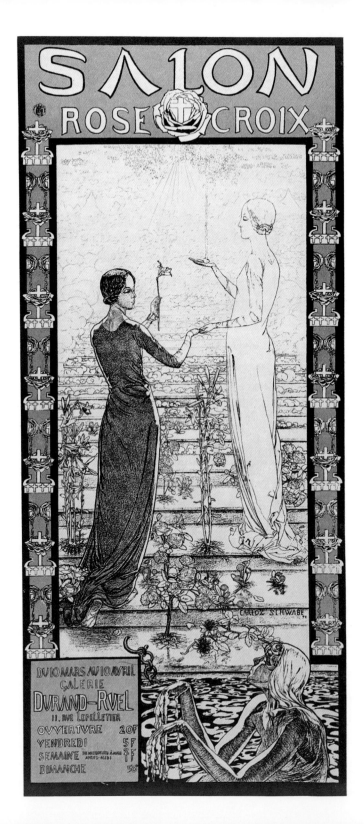

61
Carlos
Schwabe,
Salon de la
Rose+Croix,
1892.
Lithograph;
191 × 82 cm,
75¼ × 32¼ in

and artistic circles the new psychology of the unconscious had broader relevance to society as a whole.

Two French neurologists with close links to Art Nouveau were Jean-Martin Charcot and Hippolyte Bernheim. Though their views on hypnotism varied considerably, both men linked the nervous over-stimulation caused by modern city life with a variety of mental disorders. Charcot too identified the domestic interior as a site for the calming of nervous disorders provoked by the city. The relevance of his ideas to the art world was enhanced by the fact that, as well as being a leading neurologist, he was also a collector and art lover. When Sigmund Freud, a pupil of Charcot's, visited his home he was amazed by 'the magic castle in which he lives'. Charcot knew the Goncourts, and his wife was involved in the women's craft movement, exhibiting alongside Émile Gallé and the ceramicist and carver Georges Hoentschel (1855–1915) in the pavilion of the Union Centrale des Arts Décoratifs at the Universal Exposition of 1900. For Bernheim, the visual was central to the practice of suggestion, which he argued had a relevance beyond the strictly medical. In his view, suggestion was the 'transformation of ideas into images'. Both Gallé and Hoentschel evoked the new science of neurology in designs that encapsulate the pulsating energy of nerves and tissues (see 64).

Such was the importance of the new psychology, that a congress on the subject was held at the 1900 Exposition, at which Charcot's ideas reached a wide audience through coverage in such publications as L'Illustration and La Revue. The popular impact of these theories influenced the development of the Art Nouveau interior. As we have already seen, Victor Horta may have been drawing on the notion of the psychological interior when he designed and decorated the house of Van Eetvelde (see 44), and French artistic periodicals constantly referred to the connection between the domestic environment and mental well-being.

The reconciliation of the apparent opposites of Symbolism and science in the fascination with dreams and hypnotism can also be found in the widespread use of natural sources in Art Nouveau. This was best characterized in France by the work of Gallé, one

of the major figures of French Art Nouveau, whose workshops in Nancy produced glass, furniture and ceramics. Gallé's work embodied the importance of nature to Art Nouveau: his glass and furniture often employed very direct references to botanical sources, such as his 'Inkcaps' lamp (62). Of course, designers such as Gallé were not the only artists to turn to nature. Earlier design reformers – Pugin, Ruskin, Owen Jones and Viollet-le-Duc – all advocated nature as a font of inspiration (see Chapter 1). In Belgium stylized natural forms were central to the work of Horta and Van de Velde, among others. In Paris too a stylized, abstracted rendition of natural forms could be found in Guimard's technologically advanced modular Métro stations. Yet artists like Gallé, as well as others in his circle in Nancy, took Art Nouveau's dialogue with nature furthest. It is unlikely that Jones or Viollet-le-Duc, two great proponents of stylization, would have approved of anything so literal as the 'Inkcaps' lamp, and it is the studied accuracy with which designers such as Gallé approached nature that is unique to Art Nouveau. The archives of the École de Nancy, which was founded by Gallé and others in 1901, provide a wealth of designs that show how analytical watercolours of plants were worked up into designs for vases (63). They also contain many botanical photographs of flowers and plants that were used as sources.

62
Émile Gallé, 'Inkcaps' lamp, 1902. Blown-glass lamp, cast-iron base; h.82 cm, $32^3 8$ in. Private collection

Gallé's use of botanical inspiration dated from his student days, when he had studied both botany and mineralogy in Germany. Moreover, just as Horta had drawn on plants from the Congo as decorative sources for Van Eetvelde's house, so too Gallé's choice of imagery had a political dimension. He was particularly drawn to the flora and fauna of France's Lorraine region, a disputed eastern area that had borne the brunt of German aggression in 1870. At the 1889 Paris Exposition Gallé spoke patriotically of his display being inspired by 'the fauna and flora of our countryside'. Natural forms could also have esoteric religious meanings. In 1893 Gallé designed a cabinet entitled The Fruits of the Spirit that was based on the teachings of St Paul. Explaining the decorative themes of the cabinet, Gallé gave a detailed account of the symbolic meanings natural forms could have:

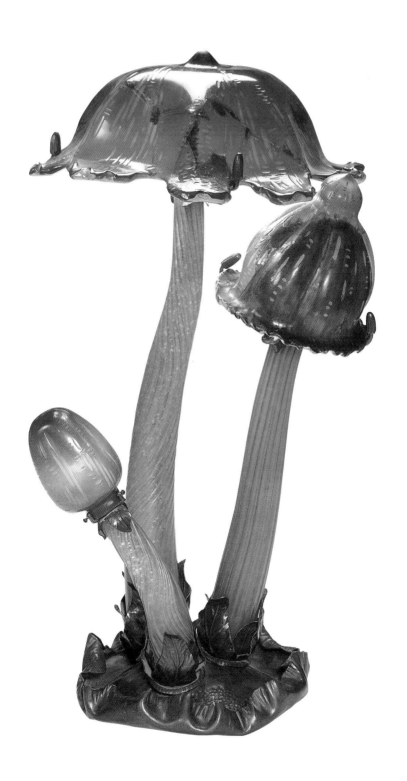

The mystic corn is charity and goodness, the grapes symbolize the blood of the Eucharist; the olive tree is peace ... The fruit of the generous fig tree represents gentleness, that of the palm tree moderation. The benevolent bee, gathering for others, is kindness, the myrtle is joy, the narcissus and dandelion [are] symbol[s] of spring and of forgiveness in the soul. Veronica is the flower of faithfulness.

As well as the influence of botany, the new science of the nerves can also be related to the sinuous appearance of some of Gallé's work. A glass hand he exhibited at the 1900 Exposition (64) evoked the scientific wonder of an anatomical model, with the surface of

63
Émile Gallé,
Design for a
crystal vase,
c.1899–1900.
Pencil and
watercolour
on paper;
30·7 × 24·1 cm,
12 × 9½ in.
Musée d'Orsay,
Paris

64
Émile Gallé,
The Hand,
1903–4.
Streaked and
marbled blown
glass with
applied
decoration;
h.27 cm,
10⅝ in.
Musée de
l'École de
Nancy

65
Émile Gallé,
Vase entitled
*Tranquillity in
Solitude,*
1900.
Carved glass
and cast
bronze;
h.47 cm,
18½ in.
Private
collection

the glass crafted into the form of creeping tendons and spreading nerves. Again, Gallé's imagery was never merely scientific. As well as traditional French and Oriental values (see Chapter 1) and esoteric symbolism, it displays a sense of the importance of tranquillity for the overwrought psyche. In his *Ecrits pour l'Art* (*Writings on Art*), Gallé stated, in words that echo Bernheim's definition of suggestion, that in the decoration of a vase, as in medals, statues and painting, 'it is always [a question of] the

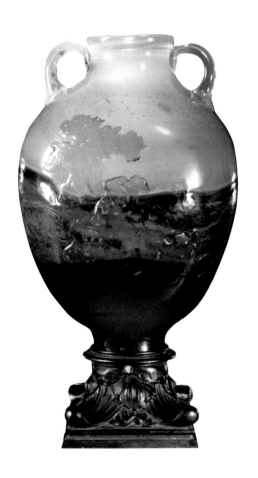

translation, the evocation of an idea by an image.' Discussing the 1900 Exposition, he described how the decorative arts offered 'an atmosphere of tranquillity ... very much needed to calm our nerves'.

In the light of what we know about the science of psychology and neurology in *fin-de-siècle* France, Gallé's writings reveal a new layer of meaning in the naturalistic curves and sinuous lines of much French Art Nouveau. As well as providing the basis for a new and appropriate style, which gave a modern emphasis to elements derived from Gothic Revival, Arts and Crafts, and other revivalist tendencies, the use of natural forms gave artists a visual vocabulary for suggesting to the embattled modern subconscious positive ideas of tranquillity and beauty. Gallé's stunning use of colour and abstract decoration in his glasswork offers the clearest evocation of these ideas. For Roger Marx, writing as early as 1889, Gallé managed to 'project his creations into the pure regions of the spirit, liberated from the contingencies of matter.' Looking at a vase such as the wistfully titled *Tranquillity in Solitude* (65), shown at the 1900 Exposition, with its rich, swirling colour and shimmering, abstracted naturalistic decoration, we can begin to understand the enthusiasm of the critic Louis de Foucard for Gallé's work:

66
Victor Prouvé,
*Portrait of
Émile Gallé*,
1892.
Oil on canvas;
158 × 96 cm,
62¹⁄₄ × 37³⁄₄ in.
Musée de
l'École de
Nancy

A very special art; its every manifestation provokes dreams and enchantment! The crystal's translucence is charged with reflections where memories of flowerings and flowerings of memories palpitate. For some, this amounts to nothing more than pleasurable refinements and voluptuous eyefuls. Others will find the delights of suggestion, an abandonment to the fluid thread that springs from our interior source.

The famous portrait of Gallé at work in his studio, painted in 1892 by Victor Prouvé (1858–1943; 66), a painter and designer who had joined the Gallé workshop as a boy, re-emphasizes the energy of beauty in the best of Gallé's glasswork. Gallé is depicted almost as if in a hypnotic trance, possessed by a quest for beauty, his staring eyes and wild hair suggesting the fictional stereotype of the deranged scientist. Seated in his studio, he is surrounded by plant forms, from which he models his pieces, and the coloured glass he has produced. When he visited the studio, de Foucard

was enthralled by the colour of the glass against the grey walls: 'Here and there amethysts, opals, burnt topaz, clear sapphire smiled in their soft pallor at the blood-red flash of ruby, the sparkling green of an emerald.'

Natural forms played an important part in the work of the other great Nancy glassmakers, Daum Frères. Auguste Daum

(1853–1909) entered his father's glassmaking firm in 1879, and was followed by his brother Antonin (1864–1931), who graduated as an engineer and became responsible for production when he joined the company in 1887. Following Gallé's success at the 1889 Paris Exposition, the company opened a decorating studio and

67
Daum Frères,
'Hydrangea'
vase,
c.1904.
Smoked
opaline glass,
gold, enamel
and applied
decoration;
44·6 × 12·7 cm,
17¹₂ × 5 in.
Musée des
Beaux-Arts,
Nancy

began to produce artistic glassware in the Art Nouveau style. One
of Daum's most gifted designers was Henri Bergé (1870–1937), a
botanical watercolourist whose closely observed paintings were often
directly transposed onto glassware, such as Daum's 'Hydrangea'
vase (67), which is based on Bergé's watercolour study (68).

A less literal interpretation of natural forms was promoted by the
Nancy cabinet-maker Louis Majorelle. Majorelle worked closely
with Daum, who produced glass shades for Majorelle's naturalistic
wrought-iron lamps (see 217). Majorelle began experimenting with
the new style around 1894, adopting a more abstract, stylized
interpretation of natural forms. Clearly derived from organic sources,
his furniture was much bolder in conception than Gallé's rather
delicate idiom. Majorelle preferred darker woods defined by the
profuse use of either gilt-bronze or wrought-iron mounts, continuing
his appreciation of eighteenth-century French furniture (see 9).

68
Henri Bergé,
Study of
hydrangea,
1904.
Watercolour
and ink on
paper;
53 × 35.5 cm,
20⁷⁄₈ × 14 in.
Musée des
Beaux-Arts,
Nancy

In Germany a number of Art Nouveau centres sprang up, including Munich, Darmstadt and Dresden, as well as the capital Berlin. Here, in contrast to France, the style was born of a spirit of regeneration and optimism. A more positive, even revolutionary, manifestation of *fin-de-siècle* ideas prevailed, for *Jugendstil* (as German Art Nouveau came to be known) was shot through with ideas of the heroism of youth, racial purity and mysticism.

National optimism in the newly united Germany of the late nineteenth century was not without justification. After inflicting military defeat on France in 1871, the Prussians had pushed for the unification of German lands outside Austria, making treaties with the major southern German states of Bavaria and Württemberg. The same year, Wilhelm I of Prussia was proclaimed Kaiser ('emperor') with Otto von Bismarck as chancellor. The period of the German Empire, although it ended ignominiously with defeat in World War I,

saw Germany rapidly acquiring all the features of modern statehood. Law, currency and administration were harmonized in the 1870s, and in the 1880s paternalistic social measures, including compulsory insurance and old age pensions, were introduced to lessen the appeal of liberal and socialist parties, which were growing in popularity, and to avert social unrest. Germany's position as a world power was emphasized by a series of limited colonial adventures between 1883 and 1885. By 1898, when Kaiser Wilhelm II acceded to the throne, Germany's self-confidence was reflected in a massive programme of naval expansion that eventually placed the Germans on a military collision course with Britain.

Of course, these events need not have resulted in vibrant expressions of new art and design. Indeed, the authoritarian nature of the German Empire was confirmed by Wilhelm II's conservative opinions on art, made clear in a speech in 1901 in which he implored Germans to maintain traditional aesthetic values against the corrupting influence of the new:

Art that disregards the laws and limits ... is no longer art: it is factory work, trade ... Whoever ... departs from the laws of beauty, and from the feeling for aesthetic harmony that each man senses within his breast ... is sinning against the original wellsprings of art.

The new and vigorous art of *Jugendstil* that was emerging from decadent, avant-garde artistic circles was championed in the magazines *Pan* in Berlin and *Jugend* in Munich. *Pan* was first published in 1895 and was edited by the writer Julius Meier-Graefe, who in 1899 opened an Art Nouveau emporium in Paris called La Maison Moderne that rivalled Bing's gallery (see Chapter 6). But while *Pan* was an exclusive publication with only 500 subscribers by 1900, *Jugend* commanded a circulation of 30,000 copies a week from its launch in 1896. At the height of its popularity, *Jugend* had a readership of 200,000, testimony to its tremendous cultural importance.

Jugendstil is often translated as 'young style', from the German *jugend* ('youth'), a name that defines the aesthetic simply in terms of its novelty. It can also be read as 'style of youth', a phrase that

offers a far greater insight into the art and design of *fin-de siècle* Germany. For *Jugendstil* was not only novel; it had a vigorous manifesto of youthful energy that *Jugend* helped to foster. Early issues of the magazine are full of images extolling the spirit of youth and nature. The freedom and energy of youth is often pitted directly against the reactionary force of old age. A *Jugend* cover dated March 1896 depicts two young girls forcibly pulling a cantankerous-looking blind old man through a meadow (69).

The federal nature of the German state, and especially the fiercely regional identity of Bavaria and its cosmopolitan capital, Munich,

69
Ludwig von
Zumbush,
Cover for *Jugend*,
1896.
Lithograph;
29 × 22·5 cm,
11³⁄₈ × 8⁷⁄₈ in

ensured that official attitudes could not hope to challenge the rapidly developing expressions of modernity in the arts. In the 1890s and 1900s, pluralism was fostered in Munich, where there was a relatively liberal attitude towards the arts. It is in this context of local liberalism and confident authoritarian nationalism that *Jugendstil* flourished in the city.

By 1897, the cult of youth and its stylistic manifestation were clearly enough defined for the architect, painter and designer Bruno Paul (1874–1968) to satirize them in *The Munich Fountain of Youth*. Paul's drawings appeared in the Munich satirical weekly

Simplicissimus. The *Fountain of Youth* depicts an Art Nouveau structure to which respectably dressed bourgeois ladies are coming to drink the *Jugendstil* elixir (70). Emerging on the other side, the women are transformed into stylized, contorted figures, their hair and gowns loosely flowing. Paul was evidently not prepared to take the craze of idealized youthful feminization too seriously; above this scene of metamorphosis he wrote, 'why try to cure the world by cutting and cauterizing it, when you can bring painless relief by stylizing it?' In the same year, Paul, with the furniture designer Richard Riemerschmid (1868–1957) and others, founded the Vereinigte

Werkstätten für Kunst im Handwerk ('United Workshops for Art in Handcraft'), a commercial organization intended to foster *Jugendstil* in Munich (see Chapter 7).

The first issue of *Jugend* left its readers in no doubt of the centrality of youth to its message. It provides some valuable insights into the connotations this ideal of youth held for contemporaries. The magazine's opening manifesto pronounced that 'Youth is joy in being, the capacity for enjoyment, hope and love, faith in people –

youth is colour, form and light.' More significantly, perhaps, it gave the word spiritual and political overtones that, with hindsight, have disturbing implications. The manifesto begins:

Youth! Youth!
The word is one of those magical utterances which light up our hearts at one strike, before we have found time to contemplate their meaning. Every language has a few such words. In German they are: youth, spring, love, mother, homeland.

Each week the cover of *Jugend* proclaimed the journal's subject matter to be *Kunst und Leben* ('art and life'), a more serious agenda than that dictated by the whimsical transience of bourgeois fashion. As in France, the influence of science and spiritualism emerge as central themes of *Jugendstil*, once again creating a fusion of the rational and anti-rational.

70
Bruno Paul,
*The Munich
Fountain of
Youth*,
drawing for
Simplicissimus,
1897.
Ink, watercolour
and pencil;
38 × 60.5 cm,
15 × 23⁷⁸ in.
Staatliche
Graphische
Sammlung,
Munich

The main source of scientific influence can be found in the botanical drawings of the German biologist and philosopher Ernst Heinrich Haeckel (1834–1919), whose writings confirm the direct link between science and art. Haeckel describes how 'the great advance of microscopic research in the second half of the century', together with 'the discovery of the marvellous inhabitants of the deep sea', have 'suddenly introduced to us a wealth of hidden organisms beyond all anticipation, the peculiar beauty and diversity of which transcend all the creation of the human imagination.' In 1899, Haeckel published the first set of his unbound folio illustrations, *Kunstformen der Natur* (*Art Forms in Nature*), in which his aim was 'to select a number of these beautiful forms for more popular description.'

Haeckel's illustrations depicted artistic arrangements of little known classes of animals such as *tubulariidae*, *protozoa* and *siponophora*, as well as seaweed, jellyfish and starfish (71). The shapes would have appeared utterly alien to many viewers, and as such they provided artists with strangely abstract yet natural forms, as fantastic as any product of the *Jugendstil* imagination. The work of Hermann Obrist (1863–1927), now regarded as a father figure to the *Jugendstil* movement, shows how the use of apparently abstract natural forms

71
Ernst Haeckel,
Plate from
Kunstformen in Natur,
1904

72
Hermann Obrist,
'Whiplash' tapestry,
c.1895.
Wool with silk embroidery;
119 × 183 cm,
46⁷⁸ × 72 in.
Stadtmuseum, Munich

was often symbolic, even representative of, the advances in biological knowledge brought to the wider public by Haeckel. The Swiss-born Obrist had won a gold medal for his ceramics at the 1889 Universal Exposition in Paris, but caught the attention of the international artistic community when in 1896 he exhibited thirty-five embroideries he had designed in Munich, his newly adopted city. Most notable was the monumental 'Whiplash' tapestry (72). Executed by Obrist's long-standing embroiderer Berthe Ruchet, its flailing tortile forms are suggestive of some kind of alien, exotic seaweed.

Obrist might have disapproved of any attempt to see something so literal in his work. After all, his writings proclaimed that the dynamics of nature rather than nature itself should be the subject of art. Among his unpublished papers, *Ecstatic Vortex* is a kind of stream of consciousness recording of multifarious thoughts and images without logical sequence that is characteristic of the apparent abstraction of his work:

Dynamic, energies, forces
to make visible through strength
or weakness of the means – –
Curve intensity / ...
the intensity of convexity
through strengthening of the line,
through / multiplication ...
machineatomic, sculpted
cigarette smoke, rococo chapel volute
torrent, Zermatt, vortex around cliffs
play of ecstasy around vortex
seagulls flight, butterfly vortex, humming-birds ...

**Among Obrist's collection of photographs and other images were an
x-ray of a snail shell and enlargements of primitive microorganisms.
Obrist alluded to Haeckel's illustrations in his own writings when
he asked, 'what can stir our vital emotions more strongly than**

the graceful, long, sinuous, linear tentacles of a jellyfish swaying in water?' Haeckel himself perceived that Obrist's work was not merely an abstract fantasy. In his book *Riddle of the Universe*, the zoologist argued that there was a literal link between advances in scientific knowledge and the new aesthetics of the *Jugendstil*:

The remarkable expansion of our knowledge of nature, and the discovery of countless beautiful forms of life, which it includes, have awakened quite a new aesthetic sense in our generation ... affording an entirely new inspiration for painting, sculpture, architecture and technical art.

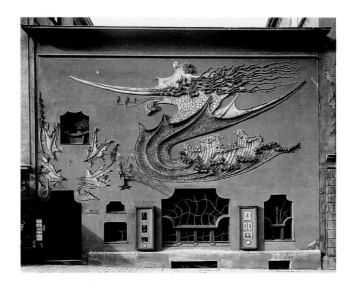

73–74
August Endell,
Elvira
photographic
studio,
Munich,
1897–8.
Destroyed 1937
Left
Exterior
Opposite
Stairwell

The architect and designer August Endell was strongly influenced by Obrist and also embraced Haeckel's fantastical natural forms. The façade of his architectural masterpiece, the Elvira photographic studio in Munich (73), was adorned with a wild, abstract plaster decoration that seemed to draw on the same zoological sources as Obrist. Inside, the stairwell is decorated with similarly fantastical shapes: the end of the wrought-iron banister metamorphoses into an elaborate light-fitting (74). Despite his early work on floral and biological textile designs, however, Endell was keen to distance his work from direct comparisons with natural forms. He was perhaps more adamant than any other Art Nouveau designer in his belief

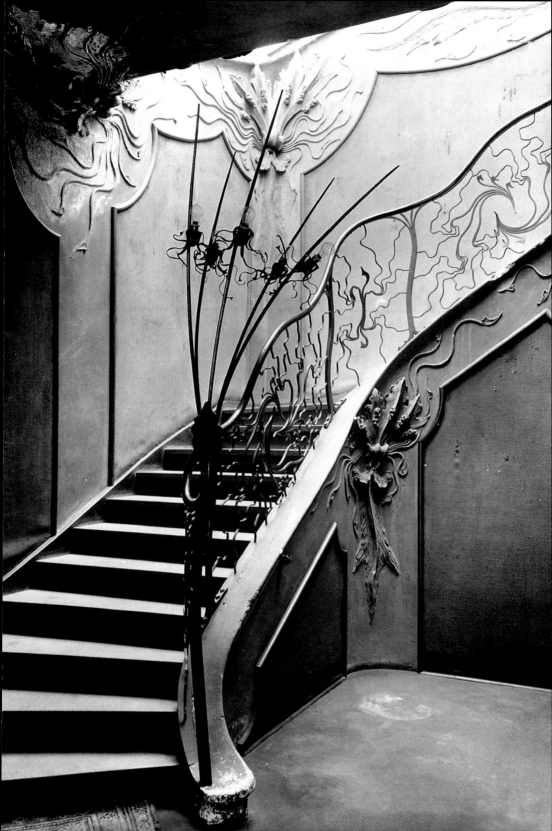

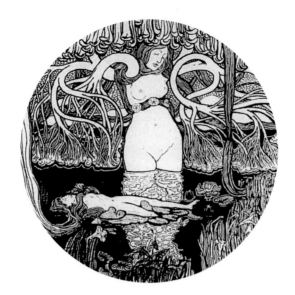

that art and design must be rid of objective sources and free to create 'visual impressions without associations'.

The use of natural motifs had mystical as well as scientific meanings. The links between the cults of nature and youth can be seen in the work of the furniture designer Bernhard Pankok (1872–1943). Pankok made the transition from relatively uninspiring figurative graphic art to much more interesting and flamboyant designs for furniture. Not only does he provide a further example of the tendency of Art Nouveau artists to transcend the traditional divisions of artistic disciplines, but his work also illustrates how realistic two-dimensional themes could be represented abstractly in the decorative arts.

Pankok's graphic work first appeared in *Jugend* in 1896. Its overburdened linear style, depicting the standard subjects of nude maidens and satyrs in lush forests, was unadventurous. The most successful of his illustrations, however, offered a glimpse of how his work would progress. The *Tree of Life* (75) depicts the metamorphosis of the female body into natural forms and hints at Pankok's talent for abstraction, which was to come to the fore when he turned to furniture design in 1897. The cupboard he designed in 1899 for Obrist's country villa (76) displays a disregard for the conventions of form in cabinet-making. Its flared expanse and

75
Bernhard
Pankok,
Tree of Life,
from *Jugend,*
1896

76
Bernhard
Pankok,
Cupboard,
1899.
Walnut, spruce
and glass;
167 × 107 × 41 cm,
65³⁄₄ × 42¹⁄₈ ×
16¹⁄₈ in.
Stadtmuseum,
Munich

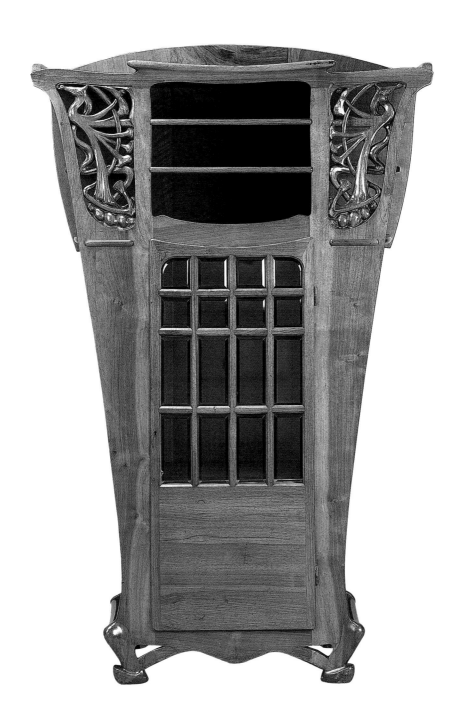

corners filled with vigorous abstract natural carving demonstrate a vitality that was curiously absent in Pankok's graphics.

The interpretation of nature in the work of Obrist and Pankok embodied the Monist world view of the unity of man, God and nature, which was particularly strong in Munich's artistic circles. Monism, like Theosophy, was an esoteric belief that enjoyed a resurgence of interest at the end of the nineteenth century. Theosophy is a religious philosophy that gained worldwide significance after 1875 when Mme Helena Blavatsky founded the Theosophical Society in America. Mme Blavatsky claimed to have revived various mystical traditions dating back to ancient times, which centred on a belief in a spiritual reality that could be contacted through intuition or meditation. Theosophists searched for hidden meanings in antiquarian and obscure texts, and maintained a fascination with the occult and the supernatural. Monism is a broad philosophical tradition that reduces all reality to a single unity. Both Monism and Theosophy promote the mystical belief that the creator and creation are one. Unlike Christianity, Monism maintains that God is the world and the world is God, thus imbuing man and nature with unrivalled spiritual significance. But while Monism is a general term that can be applied to any theory that explains all phenomena by one unifying principle, in this period it had certain extremist associations, propounded by Haeckel and the Monist League, an organization he helped set up in 1904.

Haeckel's views on Monism were popularized in his book *Riddle of the Universe* (1899), which dealt with the *fin-de-siècle* insecurities that fed into Art Nouveau. He argued that it was natural for 'a man of science' such as himself to hold spiritual views, and that the all-encompassing and free-thinking nature of Monism made it the one belief-system that was compatible with modern science. He dismissed the strictures of Catholicism in order to make way for a Darwinist norm, including a hierarchical view of the human race that placed the Caucasian male at the apex. Through his use of Haeckel's forms, Obrist directly associated his work with Haeckel's Monist beliefs, and it is therefore impossible to ignore the influence

77
Fidus,
Waltz,
1894.
Lithograph;
35·9 × 24·1 cm,
14⅛ × 9½ in

of Monism on *Jugendstil* images of nature and youth. When Haeckel established the Monist League, his co-founders included Georg Huth, editor of *Jugend*, while Obrist gave lectures to the league.

The more pernicious aspects of Haeckel's theories had unavoidable implications for the politics of *Jugendstil*. One of the more outlandish artists whose work and lifestyle embodied the style's ethical and political associations was the illustrator Fidus (Hugo Höppener; 1868–1948). Fidus's work dominated the early issues of *Jugend*, and he continued to work in a similar figurative manner for the rest of his career, far beyond the time in which it was fashionable. The central themes of his work were unambiguous. The recurring subjects are tall, sparsely clad or naked Germanic folk, at one with nature and united by it. *Waltz* of 1897 (77) is representative of his earlier more dreamlike work; it depicts a naked young woman dancing ecstatically against a swirling linear abstract design, her right leg entwined in a creeping thistle. His illustrations for *Jugend* in 1896 constitute a parade of pre-pubescent girls romping through meadows, riding on horseback or staring wistfully out to sea.

His later works show more overtly political scenes. *Unity is Essential*, dating from around 1913 (78), is particularly politically explicit, showing a group of naked male warriors staring heroically into the middle distance, with admiring women at their feet.

With knowledge of the brutal episode of German history that so quickly followed the *Jugendstil* period, it is easy to see Fidus's figures as images of 'racially pure' Aryans, particularly in the context of his political and racial beliefs. Like many other artists of the period, he had read Julius Langbehn's book *Rembrandt als Erzieher* (*Rembrandt as Educator*) as soon as it was published in 1890. This work, which had reached its thirtieth edition by 1928, eulogized the purity of the German race and the heroism of the peasant who tilled the land, at one with nature. Langbehn was shamelessly anti-Semitic, aggressively nationalist and zealously anti-modern. In his opinion, 'The ancient Germans were politically, socially and morally a pure peasant people. Such ancient Germans still exist ... in the Boer Republic [of South Africa] ... Boers and Prussians are politically related and morally equal ... Prussia should borrow its creative powers from this peasant and Boer spirit.'

It was not only these dogmatic ideas of racial purity that resonated through Fidus's work, however. He was a nudist, a vegetarian and a member of the Lebensreform ('life reform') movement, which advocated a return to natural lifestyles. From 1892, he lived in a commune outside Berlin, where he and his friends attempted to live out this naturist ideology, while practising alternative religious beliefs such as Theosophy and Monism. Although he was untypical in embracing alternative lifestyles, this association with Monism links him with Obrist, Pankok, and even the Belgian designer Henry van de Velde, who also turned to Monism later in his career when he worked predominantly in Berlin, as well as the more politically eccentric views of Haeckel and Langbehn.

Van de Velde had been encouraged to move to Berlin by Meier-Graefe, and in 1899 he gained the first of five commissions in the capital, the Villa Hohenhof, designed for Karl Ernst Osthaus, the aesthete son of a rich industrialist. Although demonstrating a much simplified

style, the Villa Hohenhof still contains some of the linear forms of Van de Velde's earlier work (see 236). Other *Jugendstil* centres flourished throughout the *fin-de-siècle* period. Also in 1899, Grand Duke Ernst Ludwig von Hessen founded an artists' colony in Darmstadt (see Chapter 6). Here he invited a group of artists including the designer Peter Behrens (1868–1940) from Munich and the architect Joseph Maria Olbrich (1867–1908) from Vienna. In parallel with the Munich Vereinigte Werkstätten für Kunst im Handwerk, Dresden too had its Werkstätte, to which Riemerschmid moved after he left Munich to develop his proto-Modernist 'Maschinenmöbel' ('machine-made furniture'; see Chapter 6).

Art Nouveau's flexibility of meaning emerges as its keynote through this brief survey of the style in Belgium, France and Germany. In Brussels, Art Nouveau could be a badge either of progressive

78
Fidus,
Unity is
Essential, from
Adalbert
Luntowski's
Menschen,
c.1913.
Ink on paper;
9 × 14 cm,
3¹⁄₂ × 5¹⁄₂ in

politics or of decidedly unsavoury colonial adventure. The Art Nouveau of Mucha and Gallé, as well as the work of Obrist, reveal how rationalist and anti-rationalist meanings could be reconciled through the study of nature, which could be both scientific and spiritual. Obrist's Monism sat happily with his appreciation of Haeckel's scientific discoveries. In France, the fascination with the unconscious found expression in both occultist symbolism and neurologically inspired natural imagery. In different hands and in different places nude maidens could represent either the fear of female emancipation or the vision of a pre-modern fatherland. Similarly, sinuous carving of natural forms could celebrate the wonders of microbiology, extol the religious sanctity of nature, or allude to the importance of nervous energy, and the need to imbue calm in the modern city-dweller through the powers of suggestion. Art Nouveau emerges as a multi-faceted style with a varied and complex range of meanings. It will also become clear, in surveying its manifestations in other parts of Europe, that it could be merged with specifically national and regional styles.

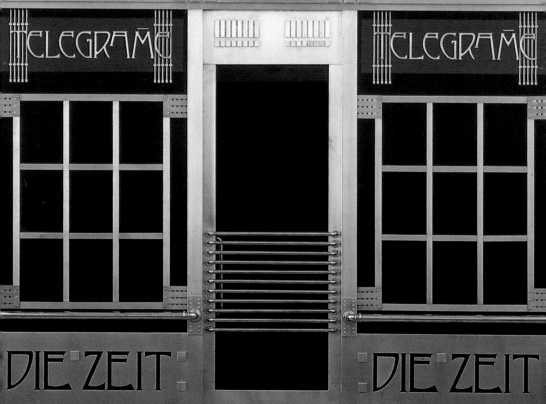

The Art Nouveau of Belgium, France and Germany shared a number of common characteristics. Among them were a fascination with nature, a preoccupation with abstract curvilinear forms, an esoteric interest in symbolism and spiritualism, and a desire to be 'modern'. At first glance, two of the other great centres of Art Nouveau, Vienna and Glasgow, present a different proposition. In aesthetic terms, those who were creating modern art in these cities displayed an increasing tendency towards geometry in both form and decoration. Their work represents a contrasting vision to the whiplash lines and naturalistic carving of the archetypal Art Nouveau of Paris and Nancy. In Vienna and Glasgow stylization became increasingly angular and ornament appeared to be in retreat. Until recently these aesthetic developments have been interpreted as the symptoms of the rationalism that was beginning to take hold in the early years of the twentieth century – the rationalism that was to evolve into the Modern Movement. The geometry of Josef Hoffmann (1870–1956) and Charles Rennie Mackintosh has been seen as the beginning of a functional design in which decoration played no part and fitness for purpose was all. By 1936 both had come to be seen, in the words of the architectural historian Nikolaus Pevsner, as 'pioneers of modern design'. Yet this geometry was far from merely functional. It often displayed a subtlety and elegance that betrayed its decorative roots (79). To contemporaries in 1900 there was no polarization between the geometry of Vienna and the curvaceous linearity of France. Both were considered as contrasting parts of the same movement.

The similarities between work produced in Glasgow and Vienna has raised the question of who influenced whom. Early studies often placed Glasgow first, tracing its impact in Vienna. More recent research has suggested that influence might in fact have flowed the other way. Or that perhaps Mackintosh and his colleagues in Glasgow and Hoffmann and his in Vienna were

79
Otto Wagner,
Replica of the
dispatch office
for the
newspaper
Die Zeit,
Vienna,
1902.
Museen der
Stadt Wien

133 Vienna and Glasgow

responding to similar circumstances and models, including the work of the English designer Ashbee (see Chapter 1). Whatever the case, the aesthetic similarities between the design produced in both cities warrants their consideration together.

Vienna, in particular, has subsequently gained a reputation for its intellectual and artistic radicalism in the early twentieth century, prior to 1914. In 1900 Sigmund Freud published *The Interpretation of Dreams*, a text that revolutionized psychology and established psychoanalysis. In a parallel development, during the first decade of the new century the composer Arnold Schoenberg (1874–1951) completed his *Five Orchestral Pieces*, in which he finally rejected the tonal system and the notion of repetition in his music. Meanwhile, the architect Adolf Loos (1870–1933) embarked on his own crusade in the visual arts. In 1908, the year before Schoenberg composed *Five Orchestral Pieces*, Loos first published his polemic essay *Ornament and Crime*, in which he forcefully argued that decoration was a barbaric phenomenon favoured by primitives and criminals, and that the sign of a civilized society was its rejection of unnecessary ornament. These three examples show that Viennese intellectual and artistic radicalism were flourishing as the new century dawned. It would be wrong, however, either to see Vienna simply as a radical city, or to see Viennese Art Nouveau, with its restraint and relative simplicity, as part of the uncompromising Modernism advocated by Loos.

By 1900 the Universal Exposition had certainly cemented popular associations with Art Nouveau and the French decorative arts, but it is important not to forget the *Art Journal* critic's eulogy of Joseph Maria Olbrich's relatively austere work exhibited at the fair (see Chapter 1). Artists such as Olbrich were creating an alternative Art Nouveau, born of concerns and contradictions parallel to those in Paris, Munich and Brussels. Rather than as a forebearer of functionalism, Art Nouveau in Vienna is better seen as a style that combined a sense of international modernity with the city's long-established classical artistic tradition. Indeed, given the strength of tradition in Vienna, and its position as the ancient

centre of the Austro-Hungarian Empire, it is surprising that such a vibrant and radical decorative style flourished in the city. The cultural conservatism of *fin-de-siècle* Vienna was legendary, even to contemporaries – the composer Gustav Mahler famously joked, 'When the end of the world comes I shall go back to Vienna because everything arrives twenty years too late.' Paradoxically, however, it is within the social, political and artistic fabric of this conservatism that the roots of the new art can be found in Vienna; and exploring this helps to explain why classicism was such an appropriate point of departure for the city's Art Nouveau.

Although Vienna was a large city (quadrupling in size from 1850 to become the fourth largest city in Europe by 1900), it lacked the dynamism of London or New York. By 1900, the Habsburg Empire covered a vast swathe of central and eastern Europe, stretching from Innsbruck in the west to Transylvania in the east, from Prague and Cracow in the north to Zagreb in the south. The rule of the Habsburg family in Austria could be traced back to the thirteenth century; but by the late nineteenth century the ageing Emperor Francis Joseph, who had acceded to the throne in 1848, presided over an increasingly fragile union of nationalities. The empire was ailing, and Vienna was no longer its epicentre. The loss of Viennese interests in northern Italy coupled with military defeat by Prussia in 1866 confirmed Austria-Hungary's declining power in European affairs and increased domestic pressure for change. There had been political agitation in Hungary, and in an attempt to accommodate these ideals Hungary had been afforded equal status in the empire, through the political settlement known as the *Ausgleich*, or compromise, of 1867, enhancing the position of Budapest as a centre of power within the Empire.

Other nationalities within the Empire, such as the Czechs, also wanted similar rights and, towards the end of the nineteenth century, there was a mounting sense of political crisis in Austria's ruling liberal order. In nineteenth-century Europe, liberalism was dedicated to the primacy of the individual rather than democracy in the modern sense, and sought to maintain the status quo. After

the new constitution of 1867, the small Austrian electorate, limited by property qualifications, had tended to return a broadly liberal political class who shared with the Emperor a desire to retain a centrally administered empire rather than succumb to federalism. This pragmatic attempt at stability was seen as the only way to keep together an ethnically disparate, geographically huge and factious empire through a period of technological progress and political tension. So, although a sense of material advancement did exist in Austria, it was curiously allied to social paralysis – in sharp contrast, for instance, to the social liberation of technological progress in the United States. Vienna had all the hallmarks of modernity, such as electric lighting, its own commuter rail network and, by 1900, a burgeoning automobile culture, but Viennese society remained characterized by a cosseted predictability and stifling bureaucracy. It was after a career in a semi-governmental insurance office in Prague in the final years of the empire that the novelist Franz Kafka wrote his nightmarish tales of frustrating and faceless officialdom, while in Vienna the sense of tedium was most perceptively expressed by the poet and novelist Stefan Zweig in his autobiography, *The World of Yesterday* (1943):

80
Buildings along part of the Ring, the arterial road of Vienna. Photographed c.1905

Everyone knew just what he possessed and what he would inherit, what was allowed and what was forbidden. Everything had its norm, its specific mass and gravity. The man of means could calculate exactly how much interest per annum his fortune would bring him, the civil servant or officer with equal exactitude the year in which he would gain promotion and the year in which he would retire ... everything in this great realm had its fixed, immovable place; and in the highest place of all the aged Emperor; but should he die, one knew (or thought one knew) that another would take his place, and nothing would change in all this carefully planned order ...

Progressive artists and intellectuals opposed the stagnation embodied by a liberal order that had symbolically rebuilt the city's great arterial road, known as the Ring, in historicist styles (80). It was a stagnation whose staid predictability dominated official institutions and demanded artistic mediocrity. As a result, a

breakaway group of artists, drawn to the international avant-garde of Symbolism, Post-Impressionism and Art Nouveau, resigned from the dominant artists' organization, the Kunstlerhausgenossenschaft ('Artists' House Association'), in protest at its commercial exhibitions, stultifying hierarchy and monopoly on art in the city. The Kunstlerhaus owned what was effectively the only exhibition space in Vienna and the conservatism of its exhibition committees ensured it could never become a forum for radical young artists. At first, some of the younger members of the Kunstlerhaus, such as

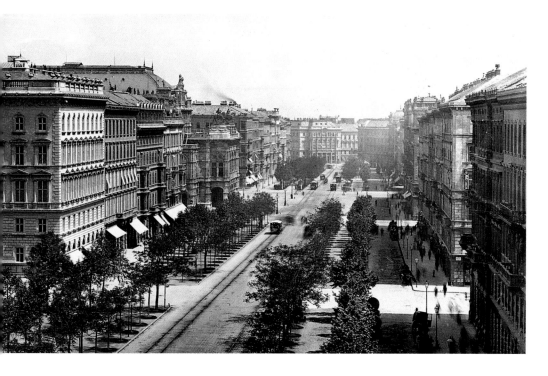

the painters Adolf Böhm (1861–1927) and Alfred Roller (1864–1935), Hoffmann, Olbrich and the artist and designer Koloman Moser (1868–1918), discussed new ideas in café societies. Then, after the Kunstlerhaus appointed a new, staunchly conservative president, Eugen Felix, in 1896, the younger artists recognized that their only means of exhibiting on their own terms was to form a new organization. In 1897 the Vienna Secession was born. Its first president, the painter Gustav Klimt (1862–1918), wrote to the Kunstlerhaus, putting forward a manifesto for the new body:

As the committee must be aware, a group of artists within the organization has for years been trying to make its artistic views felt. These views culminate in the recognition of the necessity of bringing artistic life in Vienna into more lively contact with the continuing development of art abroad, and of putting exhibitions on a purely artistic footing, free from any commercial considerations; of thereby awakening in wider circles a purified, modern view of art; and lastly, of inducing a heightened concern for art in official circles.

In addition to these aims, the Secession also differed from the Kunstlerhaus in its attitude towards architecture and the decorative arts. The presence of Hoffmann, Olbrich and Moser among the founder members emphasized the inclusive nature of the Secession. This notion that the fine and applied arts should be integrated was embodied in the first exhibition, for which Hoffmann designed a room named after the Secession's periodical *Ver Sacrum* ('Sacred Spring').

Despite their avowal of a 'purified, modern view of art', a peculiarly Viennese dilemma faced the members of the Secession. An important feature of their new organization was its embodiment of one of the core values of the *Ausgleich*: its members were drawn from geographically disparate backgrounds – Olbrich was born in Silesia and Hoffmann was from Moravia, for instance. By espousing the ideas of modern internationalist art and design, they set themselves against the nationalist and racist elements that were corroding the unity of the empire, and thus, paradoxically, won friends in establishment circles.

For all the democratic rhetoric of the liberal order, the new political freedoms it granted had actually encouraged a series of populist, reactionary and ethnically divisive nationalist movements. The Czech Nationalists wanted to secede from the empire, while the Pan-German movement wanted to unite the western Habsburg lands with Bismarck's Germany. Nationalist movements tended to thrive on xenophobic solidarity; by the 1880s, for example, the Pan-Germans had developed a strong streak of anti-Semitism. During the 1880s and 1890s a more successful mainstream political

party, the Christian Socials, came to the fore, combining Catholicism, socialism and anti-Semitism into a populist agenda that began to win elections. In 1895 Karl Lueger, the leader of the Christian Socials, was elected Mayor of Vienna, but the Emperor refused to ratify his appointment until the Viennese reaffirmed their choice in a second election. Liberals, including Sigmund Freud, found themselves in the unusual position of endorsing the Emperor's use of his autocratic veto. The political factionalism of the populist reactionaries then spread to the parliament, and as a result, liberals also found themselves welcoming the return of eighteenth-century style enlightened despotism, when the Emperor dissolved parliament in 1900 to govern by decree.

Vienna was witnessing the political progressive's nightmare scenario: benevolent autocratic rule taking a stand against a wave of popular intolerance. It was the emergence of these unsavoury alternatives to the status quo that prompted the old Habsburg Empire to act as patron to the young progressive artists of the Secession, who also – though for different reasons – opposed divisive nationalism. In 1899 the Austrian Ministry of Culture set up an Arts Council to promote officially approved tendencies in the arts and their unifying potential: 'Although every development is rooted in national soil, yet works of art speak a common language, and, entering into noble competition, lead to mutual understanding and reciprocal respect.' Austria's most prominent architect Otto Wagner (1841–1918), the graphic artist and painter Alfred Roller and his fellow painter Carl Moll (1861–1945) were all involved with the Secession, and, though prone to complain about the philistinism of the authorities, continued to benefit from official patronage. For instance, before the Secession was founded, Otto Wagner held the chair in architecture at the Academy of Fine Arts, and was artistic adviser to the Viennese Transport Commission. After he had allied himself with the Secession, he nevertheless received major public commissions, such as the Post Office Savings Bank (see 90–92) and St Leopold's Church at Steinhof (1905–7). Roller and Moser worked on state projects too: in 1908 Moser redesigned the imperial postage stamps, and Roller was the stage designer

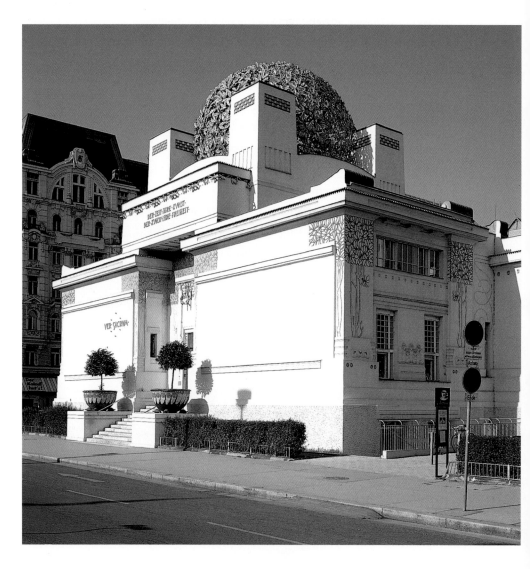

at the Imperial Court Opera under Gustav Mahler. Moreover, when the new Crafts School was opened in 1899, many of the Secessionist designers, including Hoffmann, Moser and Roller, were given teaching posts. So, while the relationship between the old guard and the young, modern artists and designers was undoubtedly uneasy, it allowed the latter a unique opportunity to work and flourish.

It was the Vienna Secession that commissioned one of the first and most public expressions of Art Nouveau in 1898, from the young Joseph Maria Olbrich, who had worked in Wagner's office.

81
Joseph Maria
Olbrich,
Secession
Building,
Vienna,
begun 1898

82
Joseph Maria
Olbrich,
Drawing for the
Secession
Building,
1897–8.
Pen, ink wash
and watercolour
on paper;
4·8 × 5·4 cm,
1¹⁄₈ × 2¹⁄₈ in.
Kunstbibliothek,
Staatliche
Museen,
Berlin

83
Members of
the Vienna
Secession,
photographed
in the Secession
Building, 1902.
l to r: Anton
Stark, Gustav
Klimt (seated
in chair),
Koloman Moser
(with hat),
Adolf Böhm,
Maximilian Lenz
(lying), Ernst
Stöhr (with hat),
Wihelm List,
Emil Orlik
(sitting),
Maximilian
Kurweil (with
cap), Leopold
Stolba, Carl
Moll (lying),
Rudolf Bacher

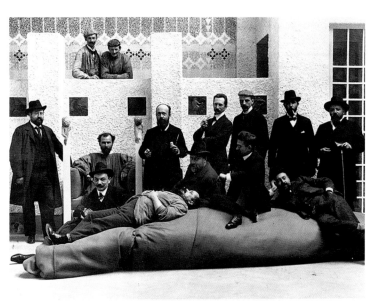

The Secession Building (81) was conceived as an exhibition space for the Secessionists and, like the artists themselves (83), the new building, which was to house their now famous series of exhibitions, struck a confident and radical pose against the bombastic mid-nineteenth-century historicism of the surrounding Karlsplatz and nearby Ring. Its white-painted geometric mass was sparingly adorned with stylized symbolic decoration and crowned with a gilt-bronze cupola pierced into a net of swirling foliage. According to the writer Hermann Bahr, the progress of the new gallery was avidly followed by a curious public:

If these days you pass by the River Wien in the early morning ... you can see behind the Academy a crowd of people standing around a new building. They are office people, workmen, women who should be on their way to work, but instead stop in amazement unable to tear themselves away. They stare, they interrogate each other, they discuss this 'thing'. They think it strange, they have never seen anything of the kind, they don't like it, it repels them. Filled with serious reflections, they pass on their way, and then turn around yet again, cast another look backwards, don't want to depart, hesitate to hurry off about their business.

The perceived exoticism of the Secession Building was reflected in its nicknames: 'Mahdi's Tomb', 'The Assyrian Convenience' and most famously, after the cupola had been raised, 'The Golden Cabbage'. It represented a challenge to convention that the Viennese public, brought up on their city's particularly grand Baroque and nineteenth-century historicist architecture, were reluctant to accept.

For all the sceptical fascination of the Viennese citizens with the unfamiliar forms of the Secession Building, there remains a classicism at its heart. In Olbrich's own words, the Secession Building was designed as a 'temple of art that would offer the art lover a quiet, elegant place of refuge'. Its domed cupola and simplified geometric façade give it the air of a Neoclassical temple or mausoleum, the sort of grandiose retreat with which English aristocrats adorned their landscaped gardens in the eighteenth century. This effect is enhanced by the high portico with its panelled ceiling, the heavy stepped frieze, even the fluted panels to the base of the blocks flanking the cupola.

A clearer sense of the stylistic roots of the Secession Building can be gained from Olbrich's original drawings for the project. Initially, the Secessionists had proposed to build their exhibition hall on the Wollzeile, a more prominent and prestigious site facing on to the Ring. Olbrich responded with a design that was reminiscent of Wagner's distinctive style of imperial Baroque classicism, a concept that stood a realistic chance of being

accepted by the architecturally cautious planners on Vienna's city council. When the proposed site was moved to Karlsplatz, however, a less prominent position out of direct sight of the Ring, Olbrich responded to the new location with a greatly simplified design. Even this version, as a preliminary drawing he made in 1898 shows (82), had significantly more classical features than were eventually realized. For instance, the main doorway is divided into three by tapering pilasters of tripartite classical form, while the two wings of the façade are also flanked by pilasters headed with what appear to be wreaths joined by swags applied to the frieze of the building. Not all these classical features survived into the Secession Building as it was eventually constructed, but it is clear from the design process that it was the product of a classical mind-set.

For most Viennese citizens two new apartment blocks, at 38 and 40 Linke Wienzeile, a few streets further out of town from the relatively central position of the Secession Building, were yet more difficult to comprehend. Also begun in 1898, they were the work of Otto Wagner himself, the established master rather than the rebellious pupil. In 1894 Wagner had won the official competition to design the city's new Stadtbahn railway network, which consisted of a series of stations and bridges across the city. The result was a number of historically styled buildings designed to fit in with their surroundings, enlivened with stylized sunflower motifs and linear decoration that were probably carried out by Olbrich, who was then working in Wagner's office (84). The Stadtbahn project was the most prestigious public commission of its day and, as a result, both Wagner and his work became familiar to the man in the street. Those with an interest in architecture would also have been aware of some of his smaller projects from the 1880s and 1890s. Wagner's first villa was built in 1886 on the outskirts of Vienna, and for a time was his home. It was an amusing essay in suburban grandeur, with its grand colonnaded façade and delicately styled garden. Throughout the 1890s he built a succession of unassuming Baroque–classical residential and commercial buildings, including a department store on the Kärntnerstrasse.

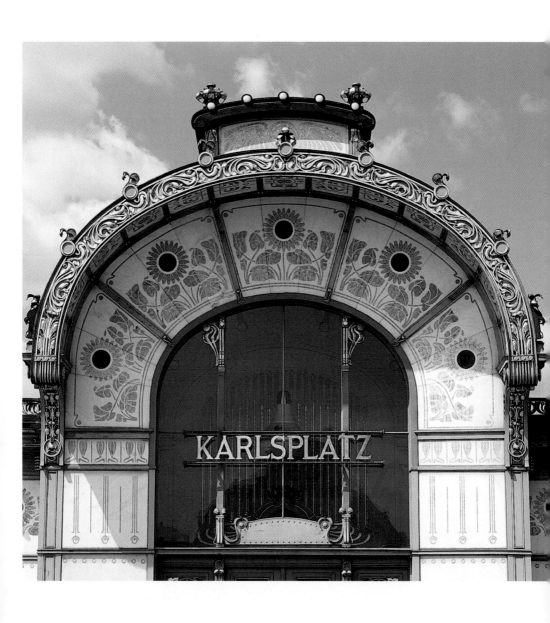

Given his existing body of work, the two Linke Wienzeile façades, nos 38 and 40 (85–88), must have been particularly surprising. Both were enthusiastically decorated with Jugendstil ornamentation of the type that was having such an impact in Munich. The polychrome façade of no. 40 was covered with upwardly sprawling waves of tendrils and flowers. It rapidly earned the nickname 'The Majolica House' as its decoration comprised thousands of ceramic tiles (majolica is a type of pottery with brightly coloured glaze), while no. 38 was clad in stucco with striking gold decoration. Inside, Wagner's adoption of the new decorative style could be seen in the stairwell and the furnishings and fittings, such as the ceramic stoves fitted in the apartments (89). Decorated with foliate fretwork and relief work, these elements of the interior design demonstrate the resolution of geometry and swirling organic lines achieved by Viennese Art Nouveau.

Like Olbrich's Secession Building, Wagner's two apartment buildings on Linke Wienzeile combined radical, modern ornamentation with more traditional forms. Behind the applied façade decoration, particularly on no. 40, the more aggressively Jugendstil of the two, are buildings of fundamental classical simplicity. Moreover, both buildings display an impressive range of elements culled straight from the vocabulary of classical architecture and ornament. Both have an overhanging cornice applied with rosettes and acanthus leaves. The upper windows of the Majolica House are interspaced with lion masks, each surmounted by a fluted volute, while next door, roundels adorned with feathers and hung with festoons decorate the upper storey, and the whole building is topped with female statuettes.

There is no doubt that Wagner embraced what was then considered modern in architectural terms. His book, Moderne Architektur, originally written for his students at the Academy of Fine Arts and published in 1896, reads like a blueprint for twentieth-century modern architecture. Wagner promoted the maxim Artis sola domina necessitas ('Necessity is the sole mother of art') and wrote at length about the importance of appropriate materials, especially iron, which he

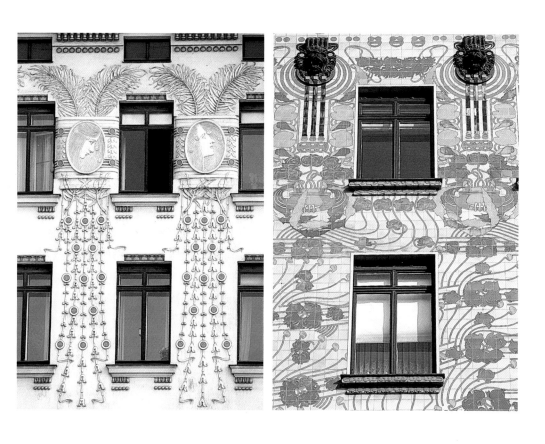

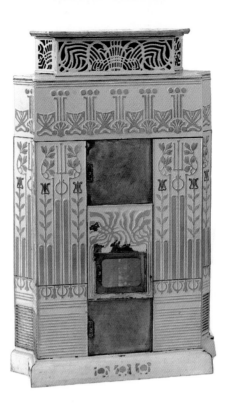

89
Otto Wagner,
Stove for the
Majolika
House,
1898–9.
Cast iron and
enamel;
78 × 130 cm,
$30^3/4 × 51^1/8$ in.
Private
collection

believed gave the architect an unparalleled freedom. Yet in his Linke Wienzeile apartment blocks, and even in his most radical building, the Post Office Savings Bank in Vienna (91), Wagner's promotion of modernity did not mean the wholesale rejection of tradition. Certainly the bank's central hall, with its iron-spanned arched glass roof (92), its austere detail and obsessive simplification of forms, was hailed as a glimpse into the future of architecture, even by contemporary critics. Ludwig Hevesi, a critic who advocated modern art and architecture, was shown around the building before it was officially opened by Wagner and the bank's proud chairman. Afterwards he wrote: 'In such an environment, modern man appears so much in his native habitat, so almost unexpectedly natural, that it is well nigh impossible to comprehend how one could build otherwise.'

Wagner's modern lightness of touch, however, was combined with a monumentality that complemented the building's historicist surroundings. Outside, the lower storey was rusticated with granite slabs, while the entrance porch was 'supported' by metal columns

that in fact have no structural function. Again, it is interesting to look at the development of the designs for the building, which reveal that it was initially intended to be crowned with a massive Neo-Baroque glazed cupola, centred by an elaborate wrought-iron cartouche bearing the bank's coat-of-arms (90). In the event, this was abandoned in favour of a geometric balustrade, but this was still hung with laurel wreaths and flanked by two stylized versions of classical allegories, which had initially been designed as surrounds for the cupola, but which survived Wagner's later simplification. The monumentality continues inside on the public staircase, while the manager's office again demonstrated an affinity to classicism, with panelled walls, bergère-form chairs, and an angular panelled desk with fluted legs.

Wagner, who was sixty-five by the time the Post Office Savings Bank was completed in 1906, was a generation older than most of the Secessionists, and he carried the flame of the classical tradition into fin-de-siècle Vienna. For a while, his work set the visual tone, at least in architecture and the decorative arts. He was, in fact, the latest exponent of a classical tradition that had remained predominant in Austria throughout the nineteenth century. Vienna had been the centre of the so-called Biedermeier era (from bieder, 'plain', and meier, a common surname), the post-Napoleonic period in which the middle classes had prospered. Biedermeier classicism was free of grandeur and pomposity. In painting new emphasis was placed on the domestic interior; and in the furniture and interior decoration, Biedermeier styles took the form of simple, stripped-down classicism that could be produced on a relatively large scale and was therefore affordable. This particularly Viennese style of the 1820s and 1830s underwent a revival at the same time as Viennese Art Nouveau was flowering. In 1898 the architects Hellwig and Haiger exhibited work in the Biedermeier style at the Glaspalast in Munich, and a series of favourable articles about the Biedermeier period appeared in the Viennese magazine Das Interieur between 1900 and 1901. The second of these was didactically entitled 'Biedermeier als Vorbild' ('Biedermeier as model').

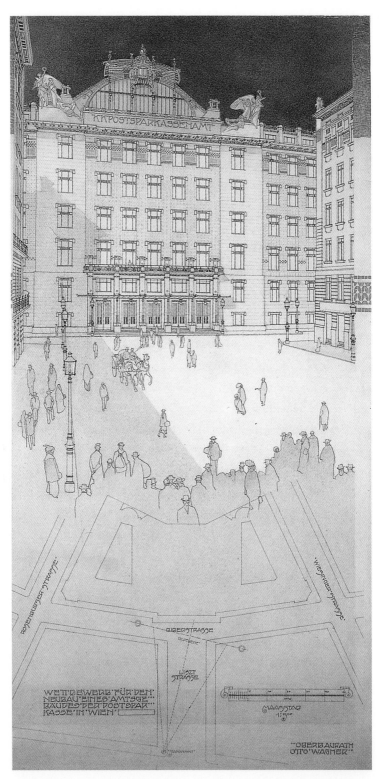

90
Otto Wagner,
Competition
design for the
Post Office
Savings Bank,
1903.
Pencil, ink and
watercolour on
drawing card;
136·3 × 45·4 cm,
53⁵⁄₈ × 17⁷⁄₈ in.
Östereichische,
Postsparkasse,
Vienna

91–92
Otto Wagner,
Post Office
Savings Bank,
Vienna,
1904–6
Above
Exterior
Below
Central Hall

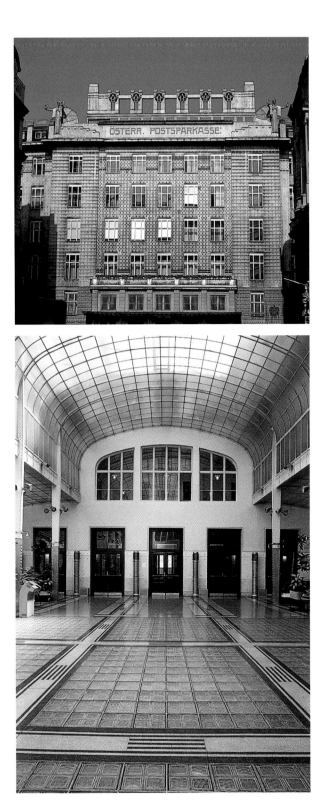

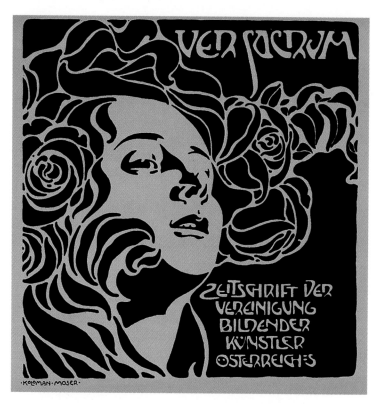

93
Koloman
Moser,
Front cover for
Ver Sacrum,
1899.
Lithograph;
29·5 × 25·7 cm,
11⁵⁄8 × 10¹⁄8 in

Alongside the Biedermeier style, the other great Germanic
expression of classicism in the nineteenth century was the work of
the Neoclassical architect Karl Friedrich Schinkel (1781–1841). Otto
Wagner would have encountered Schinkel's ideas during his training
at the Bauakademie (Academy of Architecture), which was designed
by Schinkel in Berlin in the 1850s, and it is intriguing to compare
Schinkel's views on the relevance of antiquity to modern architecture
with Wagner's later work, as well as that of Hoffmann and Olbrich.
Schinkel saw the ideal of a truly integrated and harmonious art form
in Greek architecture, especially when compared to the confusion
of aims and ideas that seemed to him to be the aesthetic burden of
mid-nineteenth-century modernity. However, this posed to him a
central dilemma: if the harmony of the Greeks was a potential
aesthetic saviour, was it not also true that just such reliance on
tradition was what troubled contemporary architecture and design?
Schinkel rarely resolved this question in his own work. He ended
his career with a series of megalomaniac, thoroughly classical

fantasies. Schinkel's prediction of the arrival of a new style, fit for the nineteenth century but drawing on past traditions, rings curiously true for the classically inspired architecture of Wagner and his contemporaries in *fin-de-siècle* Vienna:

[The new style] will not so stand out from all present and previous styles that it is like a phantasm, striking and incomprehensible to everyone ... its greater merit will lie in the cogent use of a multitude of inventions made over the course of time, that previously were not capable of being brought together in an artistically convincing way.

The Secession too was underpinned by a play on classical themes, as we have seen in Olbrich's Secession Building. References to classicism were not only visual, however. The uneasy, paradoxical relationship between modern artists and designers and the classical tradition is encapsulated most clearly in the choice of name for the Secession's periodical *Ver Sacrum*. Translating as 'Sacred Spring', the title was intended to have much the same rhetorical effect as *Jugend* in Munich, and its graphic style did much to ally the Secessionists with the evolving German *Jugendstil*. Moser's cover for an 1899 issue depicts an enraptured young woman with flowing hair metamorphosing into roses (93). *Ver Sacrum* helped to place those working in the visual arts in the tradition of other Viennese intellectuals who had adopted the mantle of youth in the preceding two decades. For example, in the late 1870s the left wing of the Constitutional Party had adopted the name Die Jungen, and the literary movement of the early 1890s, which reacted against the moralizing conventions of contemporary literature, was known as Jung-Wien ('Young Vienna'). Yet there is a further layer of meaning in *Ver Sacrum*: the title was derived from a mythical pre-Roman ritual intended to ensure the vigorous expansion of the society that enacted it. At a time of population growth, children born at a certain time – the 'sacred spring' – were, on maturity, sent away to find new lands and to propagate the tribe's culture and language. Viennese artists of the *fin de siècle* saw themselves as the modern equivalent of this chosen generation, dedicating themselves to rescuing culture from the suffocating grip of their elders and

propagating new ideas. The Secession's self-image was more than a romantic notion of the freedom of youth and the creative potency of the individual; it was a positive, distinctly political vision of the new as saviour of a faltering society.

As a dissident group, the Secession again found a classical precedent in the Roman *secessio plebis*. According to classical history, the plebs, Roman citizens who were not part of the patrician ruling class, rejected the rule of the patricians by withdrawing to a hill outside the city. This gesture of defiance, known as the secessio, mirrored the actions of the modern Secessionists, protesting against the artistic orthodoxy by withdrawing from its institutions. In a poster for the first Secession exhibition in 1898, Gustav Klimt chose another classical analogy for this revolt when he portrayed Theseus slaying the Minotaur in order to liberate the youth of Athens (94). Klimt also adopted Athena, protector of the *polis* or city-state, and the official symbol of the Austrian parliament, to preside over this scene. Once again, rather than rejecting nineteenth-century historicist classicism, Klimt appropriated it in the service of modernity and rebellion. As a statement of rebellion, the poster was ironically undermined by the Viennese censors, who forced Klimt to print over the nude figure of Theseus. The later version features an incongruous tree trunk covering the hero's genitals.

94
Gustav Klimt,
Poster for the
first Secession
exhibition,
1898.
Lithograph;
97·2 × 69·9 cm,
38¹4 × 27¹2 in

The ability of artists and architects to be inspired by classicism, while at the same time rejecting historicist classicism, was most eloquently summed up by Josef Hoffmann in a lecture he gave in 1911. He recalled a sketching trip he had made to Italy:

At last I came also to Pompeii and Paestum. I saw the Doric temple, and suddenly it fell from my eyes like scales why I did not like the stuff learned at school. There we learned only the proportions of the average of fifty temples and their columns and their entablatures. Here I saw columns with capitals almost as wide as the height of the column, and I was simply transfixed with admiration. Now I knew that what mattered above all was the proportion and that even the most accurate application of the individual forms of architecture meant nothing at all. In Vienna, where I returned, much had changed greatly

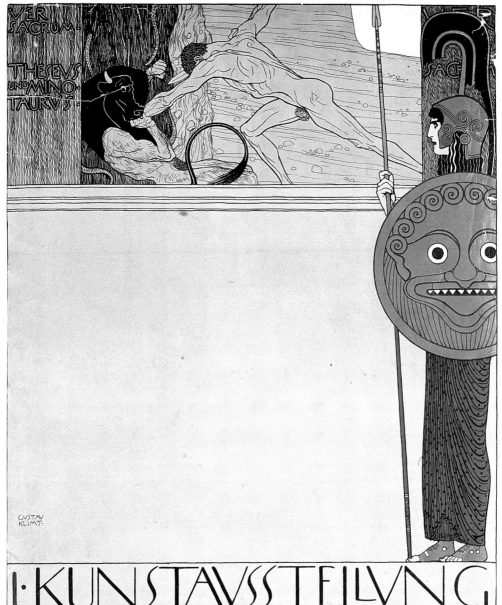

VER
SACRUM

THESEVS
UND MINO-
TAVRVS

SAC

GVSTAV
KLIMT·

I· KUNSTAVSSTELLVNG
DER VEREINIGVNG BILDENDER KÜNSTLER ÖSTERREICHS·
SECESSION
EROFFNUNG·ENDE MÄRZ
SCHLVSS: MITTE JVNI·
I· PARCRING ·12·
GEBÄUDE DER K·K· GARTENBAU GESELLSCHAFT

in the meantime. The Secession was founded, the whole modern progress suddenly became known to us, and we stood on the threshold of those events which gave Vienna for a time the character of a true city of art. We worked with great enthusiasm.

When considering the Art Nouveau of the Secession, and then of the Wiener Werkstätte (Vienna Workshops), an architecture and design firm set up by Hoffmann and Moser in 1903 along the lines of Ashbee's Guild of Handicraft in England (see chapters 1 and 7), it is therefore more useful to think of the Vienna of Mahler, Klimt

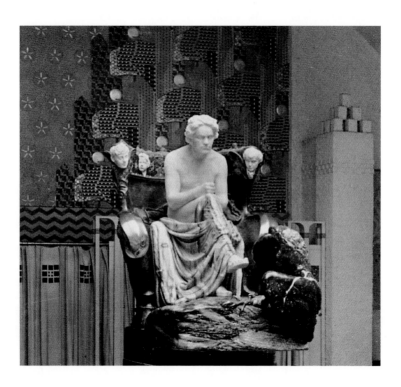

and Wagner, rather than of the concurrent Vienna of Schoenberg and Loos. We have already seen how Wagner's continuing classicism qualified his association with the radicalism of the younger generation. Similarly, Klimt was an ambiguous figure in modern painting and illustration, who never came to terms with the rejection of bourgeois splendour advocated by some elements within the Secession. While Klimt dealt with issues such as eroticism and death, themes that would have been disturbing to many of his

contemporaries, his aesthetic stylizations and use of opulent ornament cushioned their impact. This tendency contrasts with that of younger Secession artists, including Egon Schiele (1890–1918), whose contorted figures confront the viewer with their sexuality and fleshiness. Parallels with these attitudes also emerge in the music of Mahler. The composer had arrived in Vienna in 1896 to take up his new position as principal conductor to the Imperial Court Opera. Although the Viennese loved him as a musical director, his own compositions were often deemed too unconventional. But while characterized by unexpected dislocations, Mahler's music was still firmly within the late Romantic tradition of Richard Wagner and Franz Lizst. For instance, his Seventh Symphony, composed in 1904–5, plays with the Austrian musical traditions of marches and waltzes in a manner akin to Olbrich and Wagner's relationship with classicism. In music, as in art and design, the adaptation of traditional elements went beyond mere historicism and pastiche to create a distinctly new idiom.

The work of Klimt and the other Secessionists was brought together with that of Mahler at the fourteenth Secession exhibition in 1902. Centred around the sculpture of Beethoven by Max Klinger (1857–1920), the exhibition embodied an avant-garde uneasy with its own radicalism. The 'Beethoven Exhibition' was a new departure for the Secessionists in that it was themed around one work rather than being a mixed exhibition of the usual kind. Klinger's sculpture depicted a seated Beethoven, his face sombre and intent; it was embellished with ivory and precious stones, in a combination of classical severity and Romantic freedom. The staunchly figurative *Beethoven* statue was cordoned off in the central room (95), which was decorated with spectacular abstracted murals by Roller and Böhm entitled *Sinking Night* and *Dawning Day*. Today, however, the exhibition is best remembered for Klimt's monumental wall painting, the *Beethoven Frieze* (96). Intended as a temporary decoration to be destroyed after the exhibition, the frieze, now restored and once again adorning the walls of the Secession Building, is regarded as one of Klimt's masterpieces. With its final panel featuring quotations from the *Ode to Joy* by the eighteenth-century

95
Central room of the fourteenth Secession exhibition, with Max Klinger's *Beethoven* statue and Alfred Roller's *Sinking Night* mural decoration, 1902

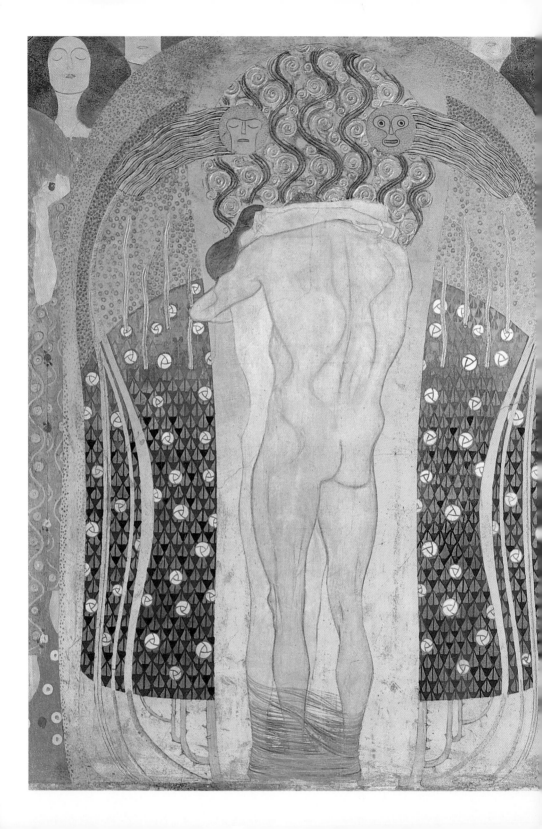

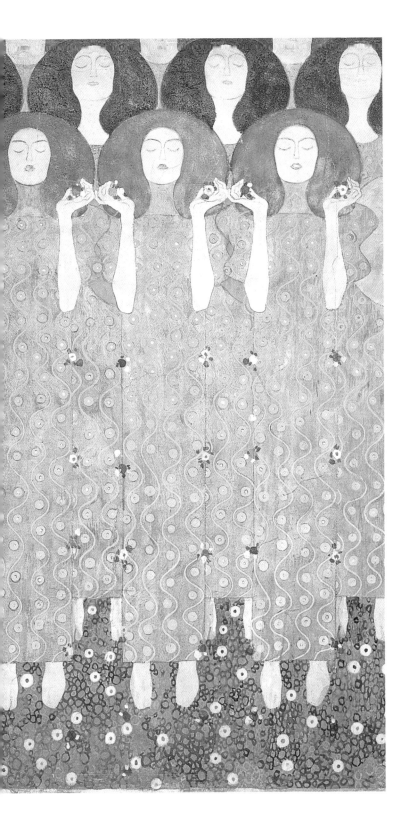

96
Gustav Klimt,
*Choir of Heavenly
Angels*, detail
from the
Beethoven Frieze,
1902.
Paint on stucco,
inlaid with
various
materials;
h.220 cm,
86⅝ in.
Österreichisches
Galerie, Vienna

German writer Friedrich Schiller, the frieze has been interpreted as a visual accompaniment to the last movement of Beethoven's Ninth Symphony, in which Schiller's words were set to music. Steeped in a sensuous *fin-de-siècle* eroticism, the frieze was described in the exhibition catalogue in terms of the strongly Romantic narrative of the redemption of humanity through a heroic struggle against evil and impurity, one of the central themes of Germanic art and philosophy in the nineteenth century:

First long wall opposite the entrance: longing for happiness. The sufferings of Weak Humanity, who beseech the Knight in armour as

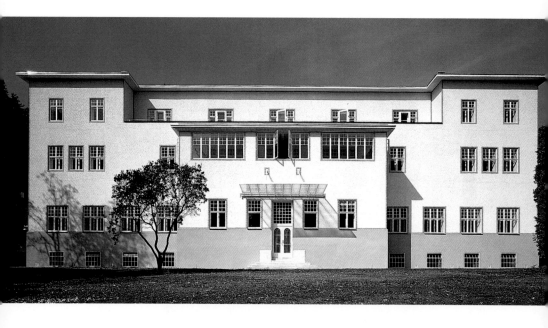

external, Pity and Ambition as internal, driving powers, who move the former to undertake the struggle for happiness. Narrow wall: The hostile powers. The giant Typhon, against whom even the Gods battle in vain; his daughters, the three Gorgons. Sickness, Mania, Death. Desire and Impurity, Excess. Nagging care. The longings and desires of mankind fly above them. Second long wall: longing for happiness finds repose in Poetry. The Arts lead us into the Kingdom of the Ideal, where alone we can find pure joy, pure happiness, pure love. Choir of Heavenly Angels. 'Freude, schöner Götterfunke'. 'Diesen Kuss der ganzen Welt.'

At the opening of the show Mahler conducted members of the Viennese Philharmonic Orchestra in his own new arrangement of the final movement of Beethoven's Ninth Symphony – a fitting accompaniment to such a celebration of Viennese culture, loaded as it was with symbolic imagery and the tensions between the traditional and the modern.

The continuing visual expression of this tension can be discerned in the Purkersdorf Sanatorium (97), Josef Hoffmann's most celebrated Viennese building, and the Palais Stoclet in Brussels (see 101). The Purkersdorf Sanatorium was the first true opportunity for the artists and craftsmen of the Wiener Werkstätte to work together to produce a *Gesamtkunstwerk*, or 'total work of art'. This concept, originally espoused by Richard Wagner, informed many great interior schemes of the *fin de siècle*. A founder member of the Secession, Hoffmann had represented the Secession and the Austrian School of Arts and Crafts at the Paris Universal Exposition of 1900 with rooms that were characterized by the bold, organic lines of *Jugendstil*. Although he was the presiding architect of both buildings, they must actually be considered as the work of the Wiener Werkstätte. The Werkstätte was an attempt to improve the quality and availability of design by giving designers the opportunity to go into business themselves rather than have their work exploited and debased by existing manufacturers. While Hoffmann and his colleagues were grappling with that most modern of artistic dilemmas, namely how to make artistic wares available to those outside the traditional élite, they almost inevitably ended up catering for that very élite. Nevertheless, their aesthetic experimentation was unrivalled.

The Purkersdorf Sanatorium, completed in 1906, was built as a retreat for members of Vienna's wealthy bourgeoisie suffering from the stresses of modern urban life. Such an appropriately *fin-de-siècle* function placed the building at the heart of two of the great projects of Art Nouveau: it was both an exercise in *Gesamtkunstwerk*, and a purpose-designed response to contemporary psychological concerns. In order to calm the nerves of the Sanatorium's clientele,

97
Josef
Hoffmann,
Purkersdorf
Sanatorium,
Vienna,
1904–6

Hoffmann and his primary collaborator Koloman Moser opted for greater simplicity than they had previously attempted. The building's flat roof, geometric mass and plan, and concrete structure take classical simplicity to its extreme, with the two faience figures on the east façade providing the only example of traditional decoration.

For Ludwig Hevesi, the Purkersdorf Sanatorium was 'without the lies told by dishonest ornament, by pillars and gables; no dazzling display of colours disturbs the simple harmony.' The idea that modern design could be 'honest', and that architecture and design could have a moral dimension, was appropriate to both the aesthetic of Moser and Hoffmann and the all-encompassing approach of the Wiener Werkstätte. As early as 1901, Hoffmann had written an essay urging readers to 'avoid the love of show in everything and constantly strive for better material and more perfect execution, since our own life, in as much as it is to be taken seriously, acquires its dignity through simplicity, honesty and uprightness.' The glimpses of the interiors at Purkersdorf provided by contemporary photographs reveal the full extent of the elegant

98
Josef
Hoffmann,
Entrance hall,
Purkersdorf
Sanatorium,
Vienna,
1904–6

99
**Koloman
Moser,**
Plantstand,
c.1905.
Painted wood
frame and
painted metal
dishes;
h.92 cm,
36½ in.
Metropolitan
Museum of Art,
New York

classical unity that governed the design. In the entrance hall, Moser's cube-shaped chairs with checked cane seats were arranged in geometric positions that complemented the concentric square design of the tiled floor (98). This precise placement of objects continued in the dining room. Hanging lights gave an extra dimension to the square design of the ceiling, while the rows of pierced-back dining chairs along the walls and tables created further geometric patterns as they contrasted with the whiteness of the walls and tablecloths. The plantstands (99) designed for the sanatorium were also vehicles for the most intricate geometry, playing on the contrast created with the natural forms they held. Such objects earned Hoffmann his nickname 'Quadratl-Hoffmann' ('Little-square Hoffmann').

In the year that the Purkersdorf Sanatorium was completed, Koloman Moser elevated his passion for geometry to new heights in an exhibition at the Wiener Werkstätte's new showroom entitled Der Gedeckte Tisch ('The Laid Table'). In his quest for the ultimate aesthetically pleasing dining experience, Moser went as far as

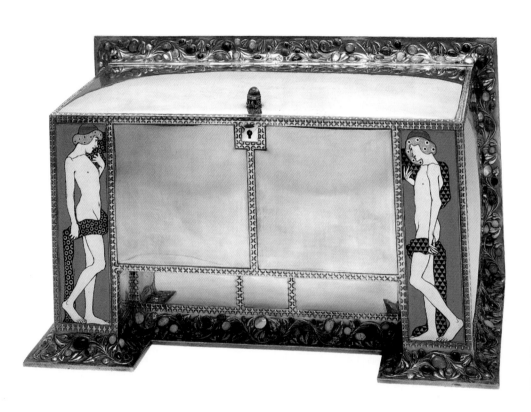

designing geometrically shaped pastries and biscuits, an innovation that inevitably led to ridicule by a sceptical press. A satirical article soon appeared in the *Neues Wiener Tagblatt* speculating that:

the new grace at mealtimes will surely have to be: 'Bless these lines which we are about to receive' ... Two parallel strands of macaroni can only be bisected in infinite space ... for which a theoretical grounding and practical tutorials are first necessary ... To carve the beef with stylistic correctness, you need a ruler and dividers; the dumplings are hand-turned by a craftsman, and the only stylistically pre-black-and-white desserts are the poppy-seed puddings improved by Koloman Moser ... here madness marries geometry.

Paradoxically, in the years preceding World War I, Viennese Art Nouveau increasingly rejected geometry in favour of sumptuous decoration, an illustration of the danger of looking for a seamless continuity from the more disciplined Viennese Art Nouveau to the Modern Movement. This is not entirely surprising, as many in Vienna had shared an affinity with foreign artists who represented the decadent *fin-de-siècle* tradition, as well as the more sober Arts and Crafts influence. Beardsley's work was shown at the 1899 Secession, and Fritz Waerndorfer, a supporter of the Wiener Werkstätte, had a sizable collection of his work. Even Moser, who was celebrated for his stark geometry, designed furniture with bold inlays of luxurious woods, mother-of-pearl and other materials, as well as exquisite smaller objects, including a silver presentation casket with a border of semi-precious stones surrounding two ethereal figures framed by geometric embossed decoration (100). After Moser left the Werkstätte in 1907, the company produced even more opulent and decorative designs. It is fitting, then, that the crowning glory of Viennese Art Nouveau, the Palais Stoclet (101–103), was completed after the departure of Moser. Built in Brussels, it was an uncompromisingly bourgeois commission. The Wiener Werkstätte's crowning *Gesamtkunstwerk* was a large private villa for one of Europe's wealthiest industrialists, the rail and coal magnate Adolphe Stoclet.

At first glance, the Palais Stoclet seems to share its roots with the Purkersdorf Sanatorium, in its use of blocks of white geometric

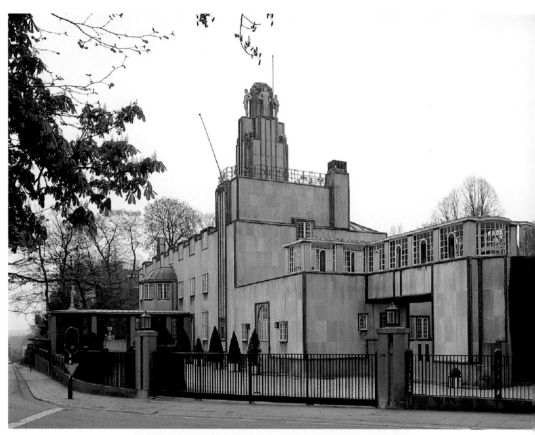

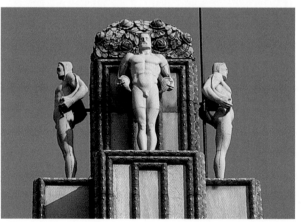

forms enclosed by darker borders. Hoffmann's early drawings of the interiors, executed in 1905, just after the building was commissioned, suggested that the resulting building would be unremittingly stark. But the finished interiors of the Palais Stoclet ensure that it stands as a celebration of ostentation rather than an icon of austerity (103). No expense was spared in the construction and decoration of this monument to wealth, and the house and its interiors represent the quintessential expression of the ethic of Art Nouveau, as well as the apogee of its classicizing idiom. The totality of Hoffmann's vision was encapsulated by Adolphe Stoclet's son, Jacques, in a speech he gave in 1955:

To be able to give free flight to his imagination and his talent as regards the realization of this ensemble, in such a way as to create a perfect unity out of the smallest details of the architecture of the house and garden, the ironwork, the means of illumination, the furniture and flooring, the carpets and even the silverware, and, moreover, using the most costly materials, represents for an architect, even for a genius like Professor Hoffmann, an ideal, a dream which one cannot realize more than once in a lifetime.

101–102
Josef
Hoffmann,
Palais Stoclet,
Brussels,
1905–11
Below
Detail of the
'sculpture
tower'

As Jacques Stoclet suggested, his father's house was, like Purkersdorf, an expression of the idea of the *Gesamtkunstwerk*, this time on an unprecedentedly extravagant scale. The combined artists of the Wiener Werkstätte were again able to fulfil their mission of creating the complete artistic arena for living. At the same time, the employment of Gustav Klimt alongside Hoffmann and the other Werkstätte craftsmen and women embodied another underlying principle of Art Nouveau: the equal unification of the fine and applied arts. Both Hoffmann and Olbrich were particularly committed to this; indeed, the two men had quit the Secession in 1905 over accusations that they and others were seeking to undermine traditional easel painting by their emphasis on architecture and the decorative arts.

Gustav Klimt, who had also left the Secession for the same reason, contributed a series of wall panels to the Palais Stoclet. The *Stoclet Frieze*, as these paintings became known, was a landmark in Klimt's

career that helped to define his relationship with Art Nouveau. Its eclectic, decorative pictures drew on a wide variety of non-European art – the ancient civilizations of Byzantium and Egypt, and the exoticism of Japan – and were executed with the flat stylization with which Klimt finally left behind the sinewy *Jugendstil* figures of his Secession poster of 1898 and the *Beethoven Frieze* (see 96). This is not to say, however, that all aspects of Symbolism had been abandoned by Klimt. On the contrary, the *Stoclet Frieze* is rich in symbolic and erotic content, again showing Klimt's affinity with the *fin-de-siècle* spirit. The paintings designed for opposing walls depict *Expectation* (104), in the form of a young woman standing in half-profile, and *Fulfilment* (105), an embracing couple seen again in Klimt's most famous painting, *The Kiss* of 1907–8. The panels towards the entrance on both walls depict the spreading, scrolling branches of the *Tree of Life*, echoing the kind of Monist ideas that permeated the *Jugendstil* of Munich artists such as Bernhard Pankok.

While the gilded exotic opulence of Klimt's dining room decorations, the sumptuous marble walls and the elaborate inlay of the drawing room floors represent one of the great expressions of Art Nouveau decadence, the bathroom and kitchen are characterized by stripped-down functionalism, as suggested in the more austere elements of the exterior. Different elements of the *Gesamtkunstwerk*, then, embody the ambiguous relationship of Art Nouveau and its exponents with the modern.

103
Josef
Hoffmann,
Dining room,
Palais Stoclet,
Brussels,
1905–11

One of Hoffmann's tactics for resolving this tension between *belle époque* decadence and austere modernity was the combination of geometry with natural motifs. He did not abandon or reject natural forms, one of the hallmarks of decorative excess, but trained them through geometry. Just as Klimt's swirling *Tree of Life* is contrasted with the tightly chequered marble floor of the dining room, so, on the central tower, Hoffmann's foliate cupola and decorative floral swags are contained by geometric borders and four figures of Atlas by Franz Metzner (1870–1919). The foliate cupola provides a visual link with Olbrich's Secession Building, and the underlying classicism of Viennese Art Nouveau can be seen elsewhere on

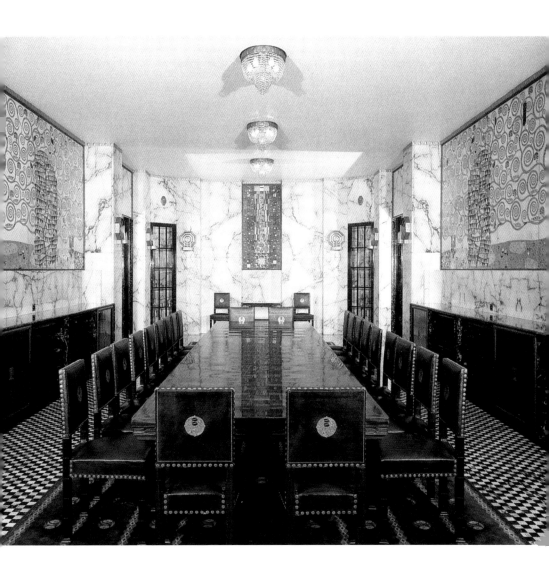

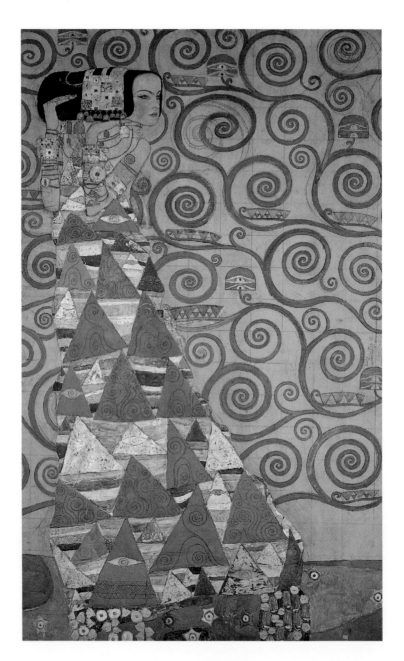

104
Gustav Klimt,
*Expectation, c.*1905–9.
Tempera, water-
colour, chalk, pencil,
gold and silver leaf
on wrapping paper;
195 × 120 cm,
76³⁄₄ × 47¹⁄₄ in.
Palais Stoclet,
Brussels

105
Gustav Klimt,
Fulfilment, c.1905–9.
Tempera, water-
colour, chalk, pencil,
gold and silver leaf
on wrapping paper;
195 × 120 cm,
76³⁄₄ × 47¹⁄₄ in.
Palais Stoclet,
Brussels

the exterior of the Palais Stoclet: the 'Pallas Athena' by Michael
Powolny (1871–1954) guards the entrance, and a group of female
figures by Richard Luksch (1872–1936) stands in the garden. A final
ironic touch is to be found in the garden, where a single classical
column was positioned in the centre of a rectangular pond.

Central to the Secession's project was the desire to reinvent Vienna
as a crossroads for international art and design. In line with this
philosophy, the work of British designers was shown at Secession
exhibitions, most notably the eighth Secession show of 1900. It was
staged in the Secession Building and was devoted to the decorative
arts, featuring work by Ashbee and his Guild of Handicraft, and
the artists of the Glasgow School: Charles Rennie Mackintosh, his
wife and artistic collaborator Margaret Macdonald (1864–1933),
her sister Frances (1873–1921) and Herbert MacNair (1868–1955).
Hevesi was impressed by the originality of Ashbee in particular:
'Next to the Viennese, on this occasion a mixture of Wagner's
complex splendour, Hoffmann's elegant logic and Moser's poetic
refinement, it is extraordinary how Ashbee's furniture designs
stand out, as if they came from a rectangular planet … everything
vertical, at right angles, ninety degrees.'

The invitation to Mackintosh to exhibit at the eighth Secession
show had followed contact between him and an enthusiastic
Hoffmann and Fritz Waerndorfer, an anglophile businessman
and financial backer of the Wiener Werkstätte. Mackintosh and
Macdonald exhibited their 'Scottish Room' at the exhibition to
critical acclaim. The room included such pieces as Macdonald's
May Queen panel, destined for the Ingram Street Tea Rooms in
Glasgow, on which he and his wife were working at the time, and
a full-length white mirror from their own Mains Street apartment,
also underway in 1900. The work of Mackintosh and Macdonald
was lauded in the *Neues Wiener Tagblatt*: 'The tea room by Doctor
Mackintosh and his wife must be counted among the most striking
achievements that modern art has created.' Moreover, in the same
year Mackintosh and Macdonald were invited to contribute to a
special issue of *Ver Sacrum*, largely devoted to their work. The impact

of the rooms on Secession artists and designers can be gauged by the fact that in the ninth Secession exhibition, designed by Alfred Roller, the relative clutter of the earlier shows was rejected in favour of a Mackintoshesque white interior. In addition, the distinctive way that Macdonald's panels were hung, butting up to the ceiling, has been linked to the corresponding position of Klimt's *Beethoven Frieze*, exhibited two years later. Mackintosh and Macdonald seem to have endeared themselves to the Viennese: they were invited to exhibit jewellery in 1902 (they declined, citing overwork), and in the same year Fritz Waerndorfer commissioned Mackintosh to design the music room in his new villa. In contrast to anecdotal claims that they were carried through the streets of Vienna by admiring students, however, not all Vienna went wild for the Scots. A review in the *Neue Freie Presse* was particularly scathing of the foreign exhibits at the eighth Secession show: 'The foreign "moderns" already debauch. Opulently they indulge in pretend simplicity … prehistoric magic images, hiding boxes of the sorcerer, furniture for fetishes.'

Those who favour the view that Glasgow influenced Vienna have argued that Mackintosh began using square motifs as early as 1898, before the geometricizing tendency in Vienna. However, there has been some dispute as to whether Mackintosh's geometry did indeed predate that of Hoffmann, Olbrich and Moser. It is certainly apparent that the room displayed at the eighth Secession exhibition by Mackintosh and Macdonald was more sensual and Symbolist than their more geometric work at the Hill House in 1902–4 (see 116, 117). Contemporary accounts suggest that Ashbee's display was viewed as more radical and was more highly praised. The fact that Mackintosh's later works were much more geometric than his exhibit at the eighth Secession show could also suggest influence flowing from Vienna to Glasgow. In the end, it is more useful to assess Glasgow's achievements alongside those of Vienna, rather than as a game of who influenced whom.

On the face of it, late nineteenth-century Glasgow was a very different city from Vienna. Lacking the obvious cultural heritage

of the seat of the Habsburg empire, the work of Mackintosh and the Glasgow School has often been cast in relief against a background of heavy industrial ugliness (106). One commentator described a visit to the home of Mackintosh and Macdonald in 1910 in these terms:

It is far away in that mist-encircled, grim city of the north which is filled with echoes of the terrible screech of the utilitarian, and haunted by the hideous eyes of thousands who make their God of gold. Vulgar ideals and the triumph of the obvious, are characteristic of the lives of the greater proportion of its population; and yet in the midst of so much that is incongruous and debasing, we find a little white home, full of quaint and beautiful things and a little white studio.

It was, however, precisely those who were successful at making their 'God of gold' who could afford to commission work from artists and designers such as Mackintosh and Macdonald. While the couple only ever attracted a small band of clients, they were committed to their work and made repeated commissions. Without the economic dynamism that powered Glasgow during this period, it is unlikely that an enterprise such as theirs could have succeeded.

106
Bridgegate
from the corner
of Market
Street,
Glasgow.
Photographed
1899

During the nineteenth century, Glasgow underwent a massive social and geographical expansion, and as a result of such expansion, the city, like Vienna, had a growing and prosperous bourgeoisie, some of whom became patrons of Art Nouveau. They were also both international cities: Vienna was the centre of an ethnically disparate empire, and Glasgow was a thriving port and commercial centre, then considered the second city of the British Empire. As such, it was host to a cosmopolitan blend of visiting foreigners, whose goods and wares were imported from and exported to the far-flung corners of the world. Moreover, like Vienna, Glasgow had a robust city authority that encouraged a strong sense of identity and pride in the city. According to an article in The Times in 1902, Glasgow 'was more responsible than any other town or city in the UK for the spread of the various forms of municipal progress'. Many of Mackintosh's early, unbuilt

designs and competition entries are for buildings that reflect this ethos, such as public halls, museums and schools. A glance through the built and unbuilt projects by Otto Wagner reveals a similar preoccupation (Wagner, of course, made his name through the building of the Viennese Stadtbahn network). In many ways, Mackintosh's Glasgow School of Art represents the marriage of the city's strong industrial and municipal traditions. The

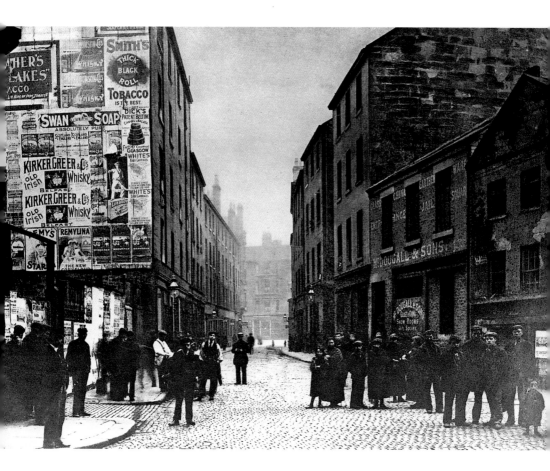

shipbuilding industry employed countless draughtsmen and designers to create everything from the hulls of cargo ships to the light-fittings of luxury liners, and it was partly as a response to the needs of local industry that the governors of the existing art school were able to relocate to a new site and commission a purpose-designed building to replace their cramped accommodation on Sauchiehall Street.

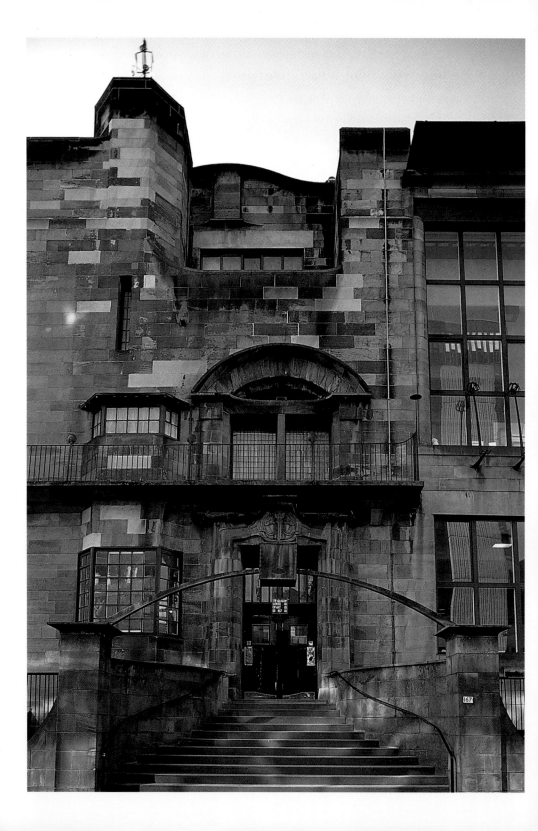

Glasgow School of Art provides an ideal beginning for a consideration of Mackintosh's work, because it was built in two stages and thus offers a commentary on his stylistic development. The main body of the school (107) was designed in 1896 in response to a competition run by its governors and was built in the following three years. At this time, Mackintosh was still working for the Glaswegian architectural firm of Honeyman and Keppie, and his own name was not automatically associated with the building by contemporaries. And although the school has subsequently attained classic status, contemporary reaction was muted. Its sober, utilitarian nature provoked no reactionary outcry. It was exactly this utility that critics praised: the *Citizen* reported that 'The building appears to be in every way suitable for the requirements of art education', while another commentator proudly asserted that Glasgow now possessed 'one of the most commodious and best-equipped art schools in the kingdom'.

In his designs for the School of Art, Mackintosh drew on a range of antecedents, none of which could be considered outlandish. The exterior of the building displays the austere stone severity of much nineteenth-century Glaswegian architecture, and, in another parallel with Vienna, it can be considered in loosely classical terms, with two wings centred on a portico. At the same time, it displays a number of other influences. Most notable are the Scottish vernacular, discernible in the similarities between the central section and Scottish 'Tower Houses', and the developing English Arts and Crafts style, based on inventive and imaginative use of vernacular architectural traditions. As well as making trips to Italy in 1891, Mackintosh made some fourteen sketching tours of southern England from 1894 onwards, where he would have seen the kind of vernacular architecture that provided inspiration for many Arts and Crafts architects.

The concurrent influence of Symbolism is apparent in some of the detailing on the School of Art. The rose-like ironwork along the windows of the north front (108) bears more than a passing resemblance to the floral elements in Mackintosh's linear

Symbolist-influenced watercolours of the mid-1890s, such as *Part Seen Imagined Part* (109) of 1896, in which a floating female figure surrounded by a halo is entwined by plant stems, some headed with stylized rose flowers in varying stages of bloom. The flowing figures above the school's main entrance (see 107) also evoke this element in Mackintosh's work and, more overtly, the work of Margaret and Frances Macdonald. Comparison of this particular cameo with Frances Macdonald's beaten tin mirror entitled *Honesty*, made around 1896 (110), demonstrates Mackintosh's already powerful affinity with the Macdonalds' work by this date (three years after they had met; Mackintosh and Margaret Macdonald married in 1900). At this stage, they were producing Symbolist objects and watercolours in their studio, together with their art college colleague Herbert MacNair. As MacNair later explained, 'not a line was drawn without purpose, and rarely was a single motif employed that had not some allegorical meaning.'

As a tough industrial city, Glasgow might seem unlikely ground for the growth of Symbolism. There was, however, a strong streak of Symbolist influence in the 1890s and 1900s that was closely linked with Mackintosh's work. As early as 1890, the group of painters collectively known as the 'Glasgow Boys', an informal name that they encouraged because it did not have the homogenous stylistic implications of the word 'school', had been exhibiting internationally, particularly in Munich. Some of their number, including George Henry (1858–1943) and Edward Hornel (1864–1933), were producing Symbolist works similar to those of artists from the French group the Nabis (see Chapter 2). Hornel and Henry's collaborative painting of 1890, *The Druids Bringing Home the Mistletoe* (111), is an example of how they loaded their work with Celtic mysticism. Such ideas, which were the perfect raw material of Symbolism, still had strong romantic associations within rural areas close to Glasgow, such as Galloway, where the two painters worked. In 1901 these ideological links with continental Symbolism were cemented by the appointment of the Belgian painter Jean Delville (1867–1953) as Professor of Painting at the Glasgow School of Art. Delville had exhibited at the Salon de la Rose+Croix (see Chapter 2) and was

108
Charles Rennie Mackintosh, Detail of ironwork, north front, Glasgow School of Art, begun 1896

109
Charles Rennie Mackintosh, *Part Seen Imagined Part*, 1896. Pencil and watercolour on tracing paper; 39 × 19.5 cm, 15^3⁄8 × 7⁵⁄8 in. Glasgow Museums and Art Galleries

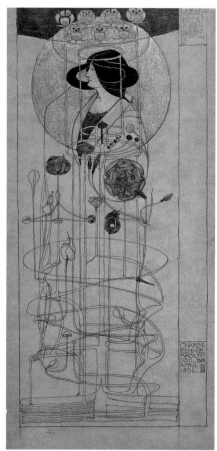

also an enthusiast of Theosophy. He doubtless found the spiritualist milieu of *fin-de-siècle* Glasgow sympathetic. Furthermore, in architectural terms, Mackintosh is known to have been influenced by the book by the Arts and Crafts architect William Richard Lethaby (1857–1931), *Architecture, Mysticism and Myth* (1891); a lecture given by Mackintosh in 1893 was highly derivative of Lethaby's plea for symbolic architecture.

Returning to the School of Art, it is fascinating to contrast the vernacular and Symbolist elements of the north front with the almost industrial monumentality of the later west front, which was added by Mackintosh and completed in 1909 (112). Here Mackintosh was

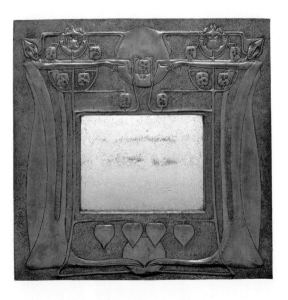

110
Frances Macdonald, *Mirror: Honesty,* c.1896. Beaten tin and wood; 73 × 73·6 cm, 28³⁄4 × 29 in. Glasgow Museums and Art Galleries

111
Edward Hornel and George Henry, *The Druids Bringing Home the Mistletoe,* 1890. Oil on canvas; 152·4 × 152·4 cm, 60 × 60 in. Glasgow Museums and Art Galleries

much more inventive in his use of mass, for instance the three massive oriels possess a muscularity that gives the façade a sculptural form. Nearby the geometric stepped surrounds of the massive windows echo the extraordinary door-surround with its proto-Art Deco decorative form (113). The contrast between the two stages of the building can also be followed in their respective interiors. The curvaceous white simplicity of the interior of the director's office with its vernacular-style furniture (115), which looks out onto the north front, is a world away from the profusion of angles and heavy geometric forms of the library in the north

front (114). While many of Mackintosh's contemporaries in Britain, such as the architect Edwin Lutyens (1869–1944), had by this time retreated from the Arts and Crafts idiom towards a modern classicism, Mackintosh remained constantly inventive.

The Hill House, Mackintosh and Macdonald's most celebrated domestic commission, built between 1902 and 1904, displays with more clarity some of the contrasting decorative themes that can

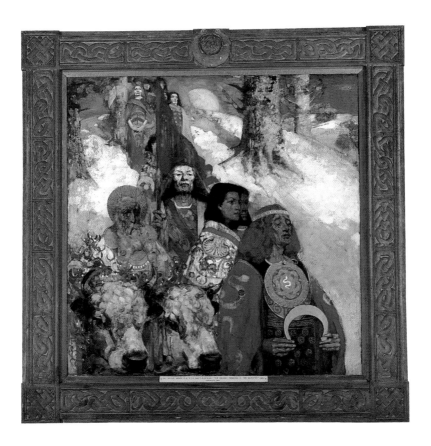

be discerned in the Glasgow School of Art – lightness and mass, symbolism and the vernacular. Situated in the prosperous town of Helensburgh outside Glasgow, the house was commissioned as a family home by Walter Blackie, a wealthy Glasgow publisher. The bleak grey plasterwork of the exterior (116), with its Scottish vernacular connotations, contrasts with the sumptuous and sophisticated decoration within. The interiors are a testament to the collaborative partnership between Mackintosh and Macdonald,

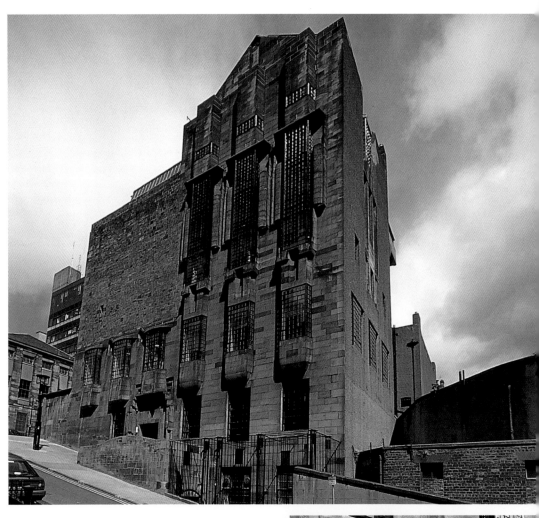

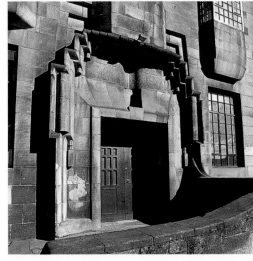

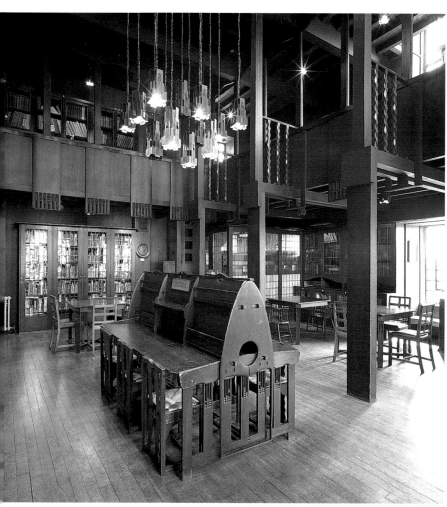

112–115
Charles Rennie Mackintosh, Glasgow School of Art, 1907–9
Opposite above
West front
Opposite below
Main entrance, west front
Above
Library
Below
Director's office

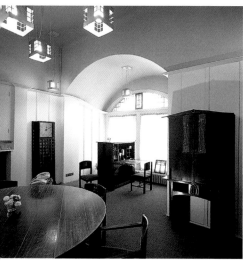

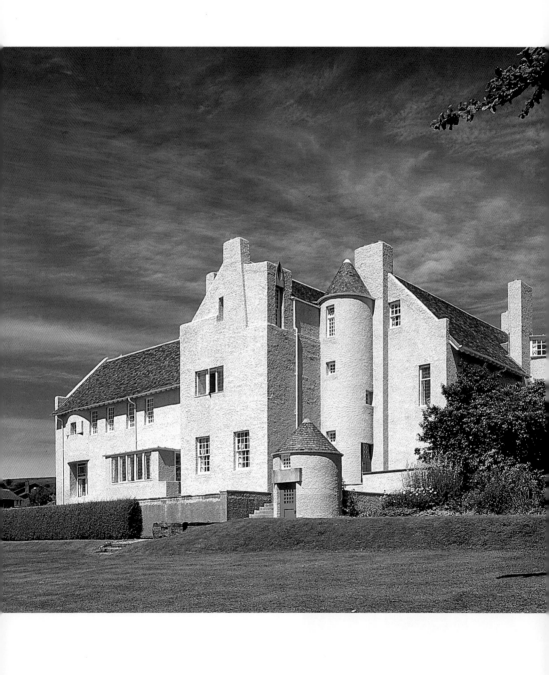

and demonstrate the symbolic meaning around which they conceived their schemes.

It is usually thought that the design of the interiors at the Hill House is based on a Symbolist notion of colour coding, relating to supposedly masculine and feminine characteristics. Of the four rooms that were given the fullest attention in the scheme, the library and the principal bedroom are the most masculine and feminine, respectively, while the hallway and drawing room are less strictly defined areas. The library is decorated with dark, angular features, attributes that have traditionally been associated with masculine environments – gentlemen's clubs or the gunrooms of stately homes, for instance. The dark-stained doors and bookcases are decorated with inlaid squares of purple glass, and the cane-seated chairs, also in dark wood, have a stocky vernacular character. Although decoratively original, this scheme would have conformed to contemporary convention, which dictated that homes contained 'masculine' and 'feminine' rooms – a book published by Blackie's firm in 1899 entitled *Principles and Practice of Modern Home Construction* had advised that libraries should be 'thoroughly masculine.'

The darkness of the library can be contrasted with the softened ivory-white of the principal bedroom (117). The walls are decorated with stylized pink roses, a symbol that had been overtly linked with female sexuality and the life-giving properties of the womb in Margaret Macdonald's painted gesso panel entitled *The Heart of the Rose* (118), shown at the First International Exposition of Modern Decorative Art in Turin in 1902, the year before the Hill House was designed. Most of the bedroom furniture is finished with ivory-coloured lacquer and displays both a delicacy of form and a use of gentle curvaceous shapes; embroidered panels depicting dreaming women originally hung above the bed.

However, there are a number of elements in the Hill House that warn against too rigid an interpretation of the symbolism of dark (masculine) and light (feminine). The two extremely angular, black ladder-back chairs in the principal bedroom are a case in point:

116
Charles Rennie Mackintosh,
The Hill House,
Helensburgh,
1902–4

they have been interpreted variously as a masculine element in the room because of their geometry and colour, and as representative of the trellis upon which the decorative roses could 'grow'. Their slender skeletal form has also been likened to the waif-like figures of women in the Macdonald sisters' Symbolist paintings. Irrespective of any possible gender connotations, it is clear that the chairs are primarily highly stylized decorative pieces, and their angularity is far from the functionalism that later twentieth-century writers and designers have claimed for them.

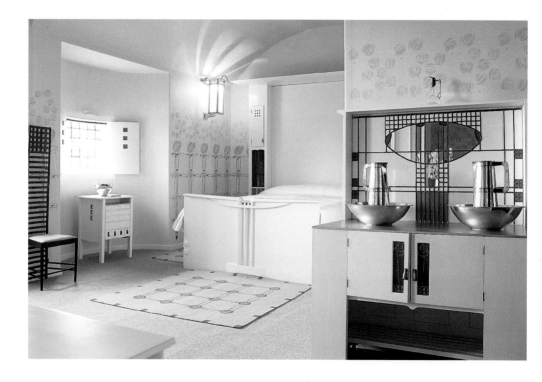

As a whole, the Hill House fits both chronologically and aesthetically between the two parts of the Glasgow School of Art. The geometry embodied by the ladder-back chairs from the principal bedroom continues throughout the Hill House, to the extent that the carpet in the drawing room was even decorated with small squares, which indicated the precise intended layout of the furniture when the room was being used for different purposes. More comprehensive use of angular motifs is seen elsewhere and its occurrence well after the 1900 Secession exhibition, and the shift towards severe

geometric forms in Viennese design, have been used to support
the theory that Mackintosh is more likely to have been influenced
by his Viennese contemporaries rather than vice versa. In addition,
it signals Mackintosh's continued development in this direction.

Whatever the chain of influence, similarities of approach between
Mackintosh and the Viennese are apparent. While Hoffmann and
Olbrich had both worked to repay their debt to Germanic classicism,
so Mackintosh demonstrated his own familiarity with British
vernacular styles and Glaswegian traditions. As the Purkersdorf
Sanatorium and the west front of the School of Art show, this
respect for tradition was combined with a fearless drive to innovate
through the use of new juxtapositions of forms. These works also
display a willingness to promote the two apparently contrasting
ideals of utility and symbolism, proof that, with sufficient will
and ingenuity, the two could be deftly combined. Modernist
interpretations of Scottish and Viennese Art Nouveau have sought
to play down the symbolic content of work by Hoffmann, Mackintosh
and their colleagues. Writing in 1952, Mackintosh's first biographer,
Thomas Howarth, went as far as describing his decorations as, 'little
more than the flotsam of the "nineties"', attributing such 'trivia'
to Margaret Macdonald. But just as Klimt's symbolic decoration of
the Palais Stoclet cannot be divorced from its classical exterior, so
Mackintosh's austere and monumental façades can be understood
only alongside both his and Macdonald's interest in the delicacy of
Symbolism. We can only begin to get a complete picture of events
in Glasgow and Vienna by looking at them as part of the broader
fin-de-siècle scene – by considering the Secession and the Glasgow
School both as integral to Art Nouveau.

The Hill House, like the Purkersdorf Sanatorium and the Palais
Stoclet, was also an attempt to produce *Gesamtkunstwerk* – the
'total work of art' that should serve as an artistic arena for living.
Although the idea of the *Gesamtkunstwerk* in architecture anticipates
the modernist idea of the functionally designed interior, the Art
Nouveau *Gesamtkunstwerk* was essentially a decorative project,
a successor of the Aesthetic Movement's drive to create artistic

117
Charles Rennie
Mackintosh,
Bedroom, the
Hill House,
Helensburgh,
1903–4

interiors. As Mackintosh himself acknowledged in a lecture to the Northern Artworkers' Guild in Manchester in 1902, his aim was a 'synthesis or integration of myriads of details', the product of 'a discriminating thoughtfulness in the selection of appropriate shape, decoration, design for everything, no matter how trivial.'

Art Nouveau had emerged in France as an interior style, against a background of concerns about the nervous tensions of modern life. In Vienna and Glasgow, too, the decorative harmony of a building's interior was considered to be an integral part of every architectural project. That it was the Art Nouveau vision of decorative aestheticism that stood at the heart of all this work is underlined by the harsh words that Hermann Muthesius (1861–1927), one of the first advocates of functional design reform, reserved for the Hill House in his book *Das Englische Haus* (*The English House*): 'Even a book in an unsuitable binding would disturb the atmosphere simply by being left on the table; indeed the man or woman of today treads like a stranger in this fairy-tale world.'

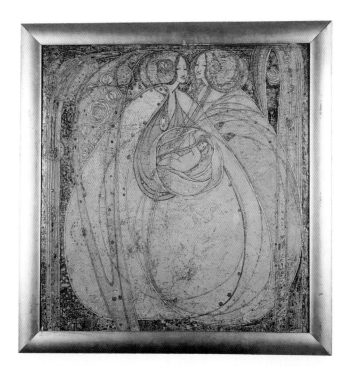

118
Margaret
Macdonald,
*The Heart
of the Rose*,
1902.
Paint on gesso
panel;
97 × 94 cm,
38⅛ × 37 in.
Glasgow
School of Art

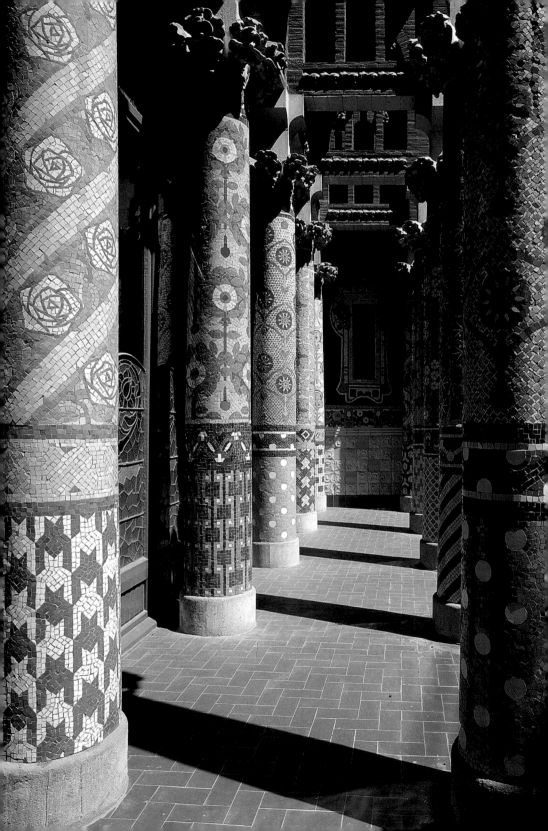

For all the importance to Art Nouveau of universal concerns such as nature, science, spiritualism and mysticism, its manifestations in European countries such as Finland, Russia and Catalonia serve to reiterate the ever-present element of nationalism as a driving force in the work of many artists and designers. The power of these ideas has already been encountered, first in France and then in Germany. Nationalism was the catalyst for the 1900 Universal Exposition in Paris. This event was an exercise in national posturing by the French, in which the supremacy of France's decorative arts allowed her a much needed expression of smug superiority over her neighbours, particularly her recent foe Germany. In Germany itself *Jugendstil* embodied a national sense of youthful vigour prompted by the emergence in the 1870s of a united fatherland after centuries of division.

By looking away from the major centres of Art Nouveau, however, the influence of the politics of nationhood can be further examined. In Russia the conflicting desires of pan-Slavism and Western modernization were both fulfilled by Art Nouveau. In Catalonia the style gave Barcelona, a city that strove to be metropolitan rather than provincial, a cosmopolitan European identity distinct from that of the rest of Spain. And in Finland Art Nouveau provided a far-reaching panacea; it expressed the desire for nationhood by simultaneously evoking Romantic tradition and European modernity.

Part of Art Nouveau's appeal in a country such as Finland was that it was not classical. While the influence of classicism was central to the Art Nouveau of Vienna (see Chapter 3), for the Finns the style was anti-classical. As a movement that claimed to stand for the eradication of historicism, Art Nouveau was bound to find appeal in a country free from the shadow of a great classical tradition in the visual arts, especially when such classicism as did

119
Lluís
Domènech i
Montaner,
Colonnade,
Palau de la
Música
Catalana,
Barcelona,
1905–8

exist was associated with centuries of effective occupation. Before the Russian annexation of 1808, Finland had endured centuries of Swedish domination. The Swedish language remained the language of the intelligentsia and the ruling bourgeoisie well into the final quarter of the nineteenth century, and the powerful Swedish classical architectural tradition was the aesthetic manifestation of this cultural imperialism.

After centuries as the eastern province of the Swedish kingdom, the Russian invasion of 1808 led to Finland becoming the western part of the great tsarist empire. Tsar Alexander I (r.1801–25) established Finland as a quasi-independent Grand Duchy owing allegiance to Russia. But this relatively liberal state of affairs was not to last. The last decade of the century heralded the advancement of expansionist pan-Slavist ideas in Russia, and in 1894 Tsar Nicolas II (r.1894–1917) appointed a new governor of Finland, Nicholas Bobrikov. Bobrikov's regime saw the introduction of Russian into Finland's schools and the merging of the Finnish army into Russia's. In 1899 it was decreed that legislation was to be the sole province of the Tsar, an act which provoked a mass petition in Finland that gained 523,000 signatures, nearly half the country's adult population, in a week. Finland's plight inspired international concern with a thousand European statesmen and intellectuals putting their names to another petition, 'Pro Finlandia'. Against the background of these turbulent political events, which were resolved only when Finland gained independence in 1917, it is easy to appreciate the importance assumed by the Finnish national pavilion in 1900 for Finns and foreigners alike.

Not surprisingly, under the initial quasi-independence of Russian 'protection', artists, writers and musicians began to search in earnest for a truly Finnish tradition. At first the Russians saw this quest for Finnishness as a positive trend. It was distinctly anti-Swedish and, by looking to the peasant traditions of Finland's eastern wilderness, was seen as bringing the country closer in spirit to Russia. Yet as Russian policy towards the Finns hardened during the 1890s, the quest for national identity became freshly politicized.

120
**Akseli
Gallen-Kallela**,
*Kaukola Ridge
at Sunset*,
1889–90.
Oil on canvas;
116·5 × 83 cm,
45⁷⁸ × 32⁵⁸ in.
Ateneum,
Helsinki

Finnish Art Nouveau was given its nationalist narrative and its
national aesthetic by the country's Symbolist painters. In the
work of the two most prominent Finnish painters of the 1890s,
Albert Edelfelt (1854–1905) and Akseli Gallen-Kallela (1865–1931),
influences from abroad combined with a fascination for rural
Finnish culture. As the decade progressed, this marriage was
to produce a specific aesthetic that, when transferred to the
applied arts, heralded a characteristically Finnish variant of
the international Art Nouveau style.

By the early 1890s both Edelfelt and Gallen-Kallela had begun to
concentrate on subjects with strongly nationalist overtones. To
begin with, the serene drama of the Finnish landscape was the
pre-eminent vehicle for national sentiment. Paintings such as
Gallen-Kallela's *Kaukola Ridge at Sunset* (120) depicted unpopulated
vistas – vast expanses of natural wilderness. It seemed that the
natural beauty of the land itself was enough to evoke a national
identity, an association that augured well for the emergence of Art
Nouveau in Finland, a style of decoration with nature at its heart.

From the mysterious tranquillity of the landscape grew an increasing
fascination with its ancient peoples and their traditional ways of

life. The remote and undeveloped region of Karelia in eastern Finland was 'discovered' by artists as a rich source of traditional culture. It was here that the spirit of the epic poem the *Kalevala* ('Land of the Heroes') was believed to dwell. Far from being a truly traditional work, the *Kalevala* was, like so much that we regard as 'traditional' today, a product of the nineteenth century. First published in 1834, it was compiled by the philologist Elias Lönnrot, who explored Karelia in search of folk poetry or runes, which he published as the *Kalevala*. This work was both a testament of Finnish

traditions and a crucial factor in the artificial creation of a unified Finnish language. In order to achieve a wide readership, Lönnrot had written the *Kalevala* using a combination of eastern and western Finnish dialects, and it was this hybrid which evolved into a national written language that provided an alternative to Swedish.

As a result of the political and cultural impact of the *Kalevala*, Karelia attracted patriotic artists such as Gallen-Kallela, who visited the region on his honeymoon in 1890. Throughout the following decade

the people and their mythology came to dominate his work. In 1895 Edelfelt provided the illustrations for *Kung Fjalar*, a poetic tale of Viking adventure by the leading Finnish poet Johan Runeberg, and in the mid-1890s Gallen-Kallela produced his celebrated series of large-scale depictions of heroic Finnish mythology. Based on stories from the *Kalevala*, *The Defence of the Sampo* (121), the opening painting of the series, depicts the fierce battle between two rival tribes for the Sampo, a mysterious machine said to bring good luck. It was intended as one of four pictorial panels by different artists made for the dining room of a private patron. Painted in tempera on a canvas specially woven from rustic linen, the flat, linear style of the picture evokes the effect of a tapestry. Gallen-Kallela was using Symbolist stylization and national mythology to create art that was unashamedly decorative. As such, it provided the beginnings of a style that, when fully explored by others, enabled the creation of entire interiors in a distinctively Finnish Art Nouveau style.

Finnish Symbolism and Art Nouveau were more than purely national styles, however. They were part of broader international trends within the arts. The fashionable visual language of international Symbolism could not be disguised by an intellectual preoccupation with the homeland. Both Edelfelt and Gallen-Kallela travelled widely in the 1880s and 1890s, and by the late 1880s there was a well-established Scandinavian artists' colony in Paris, which Edelfelt visited. In a letter home in 1888, he showed an awareness of the spiritual milieu of the artistic community, recounting tales of 'the new mysticism whose representatives even included important artists'.

Gallen-Kallela received his training in Paris between 1884 and 1889 at the Académie Julian and in the studio of the academic painter Fernand Cormon (1845–1924), an experience that thrust him into the heady atmosphere of seances and demonstrations of hypnotism by Dr Charcot (see Chapter 2). As a result of his time in Paris, Gallen-Kallela could count Gauguin and Toulouse-Lautrec among his broad range of acquaintances. The cosmopolitan nature of

121
Akseli
Gallen-Kallela,
*The Defence of
the Sampo*,
1896.
Tempera on
canvas;
122 × 125 cm,
48 × 48¹⁄₄ in.
Taideteollisuus-
museo,
Helsinki

Paris at this time made it a hotbed of ideas that were rapidly disseminated around Europe as artists travelled between the major centres and their homelands. The web of connections created in this way seems endless; Väninö Blomstedt, a director of the Friends of Finnish Handicraft, for example, studied in Paris with Gauguin.

In his decorative tastes and ethics, however, Gallen-Kallela was perhaps more influenced by his travels to Germany and England during the 1890s. During a four-month stay in Berlin in 1895 he held a joint exhibition with the Norwegian artist Edvard Munch (1863–1944; see 133) and learned printing techniques, mixing with the circle of the literary and artistic magazine *Pan*. Through *Pan*, he became familiar with developments in Munich, where he later exhibited as part of the Russian section at the exhibition known as the Munich 'Secession' in 1898. Visiting London in 1896, Gallen-Kallela learned about the latest developments in English industrial arts, including new glass-painting techniques. He purchased a graphic press and a kiln, which he took back to Finland, together with the obligatory stash of writings by William Morris and John Ruskin. Not only was Gallen-Kallela taken by the quality and cut of English suits and the bewildering array of tobacco available, his sketchbook from this visit also shows that he made diligent copies of Morris textile designs. Moreover, his introduction to Charles Holme, editor of the *Studio*, led to the appearance of his works in the magazine over the coming years.

The point at which Gallen-Kallela's artistic nationalism was translated into architecture and the decorative arts was a decisive moment in the development of Finnish Art Nouveau. In 1895, the year before *The Defence of the Sampo* was painted, Gallen-Kallela's log studio, 'Kalela', was built, furnished and widely published in European art journals. 'Kalela' was one of the earliest and most complete architectural expressions of National Romanticism. The concept of National Romanticism had emerged in the mid-nineteenth century and its core belief – that the traditional arts and history of a nation contribute to the spiritual and political

survival of its people meant that it had particular significance for circumscribed ethnic groups such as the Finns. A deft combination of traditional forms and materials with contemporary architectural ideas, 'Kalela' was conceived as a complete work of art in the spirit of the English Arts and Crafts Movement, and of the Art Nouveau style of Paris and Brussels. The interiors made great use of textiles that, although traditional, were composed of stylized patterns and embodied the pared-down simplicity that came to characterize Finnish Art Nouveau (122).

Among the designers in Gallen-Kallela's circle was the furniture designer Louis Sparre (1863–1964) who, curiously enough, accompanied Gallen-Kallela and his wife on their honeymoon to

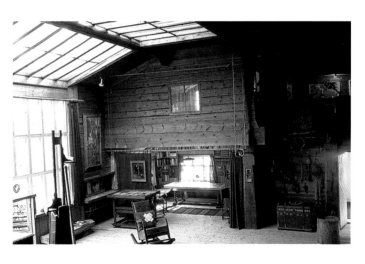

122
Akseli
Gallen-Kallela,
Interior,
'Kalela'
Wilderness
Studio,
Ruovesi,
1894–5

the wilds of Karelia in 1890. Sparre was a suave European aristocrat of part-Swedish, part-Italian descent. This distinctly un-Finnish heritage made him an unlikely hero of nationalist design, but he soon became enthralled by the romanticism of Gallen-Kallela's vision. In 1891 he decided to settle in Finland, where he married a young bookbinder and leather-worker called Eva Mannerheim (1870–1958), who became the most important Finnish artist in these fields. Originally a painter during the early 1890s, Sparre gradually turned to the decorative arts, first through book illustration and then through furniture. In 1894 'Finnish-style dining room furniture' designed by Sparre was awarded a prize in a Friends of Finnish

Handicraft competition, while a *Studio* article in 1896 discussed both Eva and Louis's bookbindings, an indication that the couple were beginning to gain international recognition.

Sparre's furniture shared with 'Kalela' the concept of simplicity. He was influenced by Finnish tradition in that he aspired to use his materials (usually stained Karelian birch) honestly. He rejected much of the nervous movement of French Art Nouveau, yet the undeniable modernity of his pieces revealed his cosmopolitan upbringing (123). The similarity of his mature work to that of Charles Rennie Mackintosh, and some of the more restrained continental Art Nouveau, is evident, and he was probably directly influenced by these sources. Like Gallen-Kallela, he had travelled widely, visiting Belgium, France and Holland as well as England in 1896. He was particularly impressed with the array of goods displayed at Liberty's, a shop that to him embodied the successful combination of art and industry.

During a career that included designing textiles, furniture and complete interior ensembles, Sparre's most celebrated venture was the founding of the Iris Workshops in 1897, an enterprise in which he and his co-founder, Gallen-Kallela, hoped to put into practice some of the ideas about art and industry he had encountered in

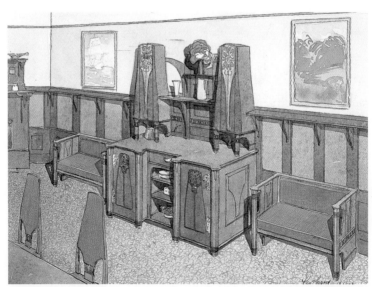

123
Louis Sparre,
Design for a
dining room,
1903.
Watercolour;
27 × 24 cm,
10^{5}_{8} × 9^{3}_{8} in.
Taideteollisuus-
museo,
Helsinki

England. Although short-lived (the Workshops had folded by 1902), Iris aimed to produce and market high-quality objects and decoration for Finnish homes (124). The Iris Workshops created an outlet for the products of Liberty and Morris & Co in Scandinavia, as well as introducing a series of wares that exemplified the combination of tradition and modernity in Finnish Art Nouveau, perhaps most importantly the work of the Belgian ceramicist Alfred William Finch. It was during another trip abroad, to the Brussels Universal Exposition of 1897, that Sparre met Finch, whom he invited to Finland to run the ceramics production of the Iris Workshop.

It is perhaps appropriate that Finch completes, with Sparre and Gallen-Kallela, the triumvirate of prime movers in Finnish Art Nouveau. A Belgian of English parentage, he too was an unlikely Finnish hero, yet nationality and background had served to place him at the epicentre of Art Nouveau in the early 1890s. Finch had introduced Henry van de Velde to the ideas of Ruskin and Morris at the beginning of the decade, and had exhibited his ceramics alongside Van de Velde's furniture in some of the earliest Art Nouveau exhibitions in Brussels (see Chapter 2). Like Sparre's furniture, Finch's ceramics displayed a primitive simplicity (125). Their forms shied away from the gravity-defying delicacy of some of the wilder incarnations of Art Nouveau. Instead, they constituted a confident understatement; Finch's use of flowing shapes was generally confined to decoration rather than form and often appeared almost naïve in its bold stylization of nature.

It was in architecture, a field in which there already existed a limited Finnish tradition, that National Romanticism achieved its most historically accurate manifestation. Consequently, it was in the work of architects that Art Nouveau found its most specifically Finnish expression, the most complete example of which was the Finnish national pavilion at the 1900 Paris Exposition. Of all the national pavilions, the Finnish building (126, 127) was perhaps the most celebrated by contemporaries. The first major commission for the Helsinki architects Eliel Saarinen (1873–1950), Herman Gesellius (1874–1916) and Armas Lindgren (1874–1929), it took the traditional

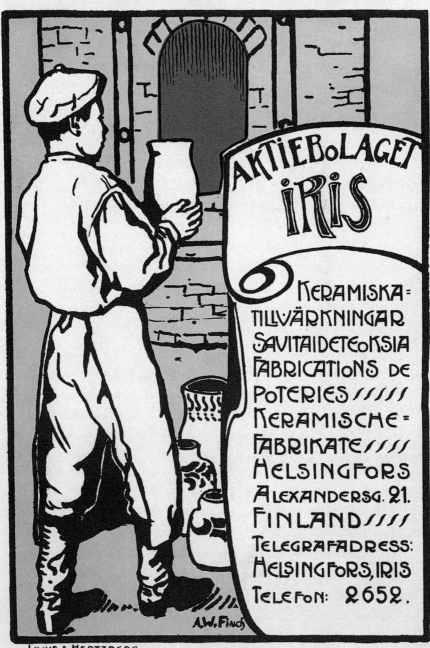

AKTIEBOLAGET IRIS

KERAMISKA=TILLVÄRKNINGAR
SAVITAIDETEOKSIA
FABRICATIONS DE
POTERIES /////
KERAMISCHE=
FABRIKATE ////
HELSINGFORS
ALEXANDERSG. 21.
FINLAND ////
TELEGRAFADRESS:
HELSINGFORS, IRIS
TELEFON: 2652.

A.W. FINCH

LILIUS & HERTZBERG,

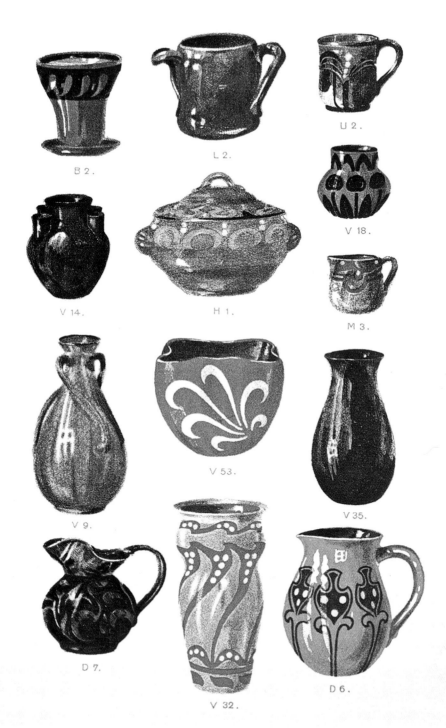

B 2.

L 2.

U 2.

V 18.

V 14.

H 1.

M 3.

V 9.

V 53.

V 35.

D 7.

V 32.

D 6.

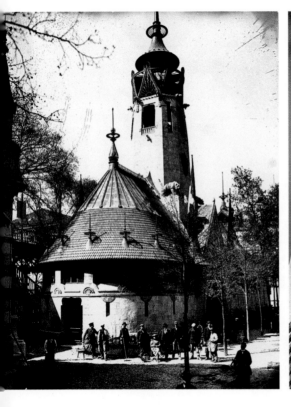
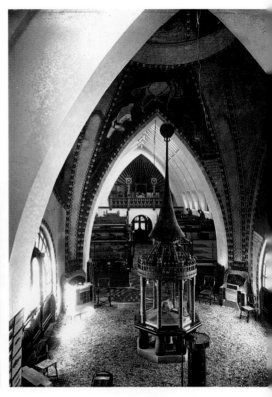

form of a Finnish church as its starting point. The exterior was dominated by its heavy, imposing granite walls and tower, the steep shingle-tiled roof sparsely embellished with archetypal Finnish decorative motifs, such as pine cones and squirrels. These time-honoured elements were complemented by the modernity of the pavilion's glass roof and its distinctively contemporary curvilinear ironwork.

Inside, this combination of the modern and the traditional continued (127). The interior space was dominated by lofty Gothic arches surrounding a font-like structure that continued the ecclesiastical theme. At the same time, however, the decoration of the interiors attested to the Finns' awareness of international trends in art and design. The murals by Gallen-Kallela depicted

126–127
Gesellius,
Lindgren &
Saarinen,
Finnish
Pavilion,
Universal
Exposition,
Paris, 1900
Far left
Exterior
Left
Interior

128
Gesellius,
Lindgren &
Saarinen,
Sectional
drawing of
the north and
south gables
of the north
wing of
Hvitträsk,
Kirkkonummi,
c.1902.
Ink and wash
drawing;
56.5 × 99 cm,
22^14 × 39 in.
Suomen
rakennustaiteen
museo,
Helsinki

the great Finnish mythological epics in a stylized, Symbolist manner. Gallen-Kallela also designed the 'Iris Room', dedicated to the products of the Iris Workshop and the Friends of Finnish Handicraft. In particular, the ceramics by Finch and the furniture designed by Sparre received widespread critical acclaim. According to Art et décoration, 'the Finnish pavilion is one of the most alluring and profoundly interesting structures of the whole exhibition … we are in the presence of a genuine national art, and yet it is clearly something new.'

After 1900, Gesellius, Lindgren and Saarinen were responsible for a series of country houses that came to embody the new style. With the prize money awarded for the 1900 pavilion, the three architects

designed and built for themselves 'Hvitträsk', a shared country retreat with living quarters and studios, at Kirkkonummi outside Helsinki (128). Nestling by Lake Hvitträsk, the house applied the archaeology of Finnish architecture to a domestic/studio setting. The stark angularity of the pitched roofs contrasts with the adjoining squat circular tower with its domed cupola. The lower storeys are of rough-hewn granite blocks, deeply set with arched, almost medieval windows, perhaps attempting to suggest that the house had evolved over the centuries rather than having been

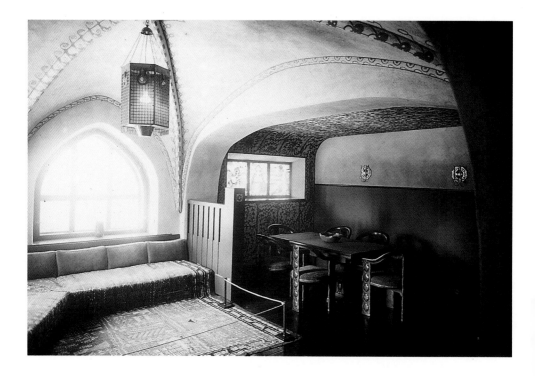

designed as a single modern building project. If granite blocks had been identified as a traditional Finnish material, the same can also be said for the tarred logs of the upper section, which was a deliberate evocation of rural Finnish farmhouses.

The interior was conceived as an artistic whole, combining a traditional aesthetic with utopian Arts and Crafts ideals and simple, contemporary furniture and fittings. The combination of large-scale open-plan spaces linked by shallow steps between different levels

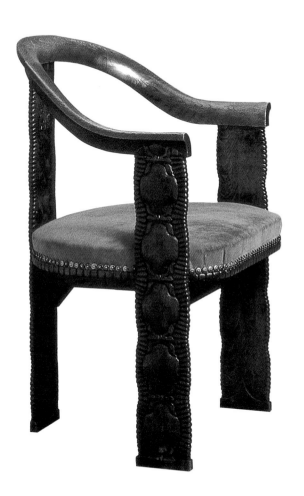

129
**Gesellius,
Lindgren &
Saarinen**,
Dining room,
Hvitträsk,
Kirkkonummi,
c.1903.
Photographed
in its original
condition

130
Eliel Saarinen,
Chair,
1918.
Oak and
leather;
h.85 cm,
33¹₂ in.
Hvitträsk
Foundation

with smaller enclaves, enhanced the rustic ideology of the house. The decorations, which included ceramics by the Iris Workshops and abstract wall paintings by Gallen-Kallela, as well as furniture specially designed by the architects, complemented this. A chair by Saarinen (130), with its simplified form and carved ornamentation, gives the appearance of being the product of a centuries-old craft tradition.

At the same time, the international and contemporary nature of the interiors is clearly announced by the geometric polychrome decoration in the dining room (129), while a Symbolist-inspired sculpture that surmounts one of the protruding wooden pillars indicates an engagement with the mainstream European *fin-de-siècle* scene. It is intriguing to speculate on the degree to which Saarinen himself and his colleagues viewed all this as 'modern'. While some elements of 'Hvitträsk' were conceived as contemporary, the fact that the house was a rural artistic retreat rather than an urban bourgeois villa suggests that modernity was not necessarily Saarinen's primary aim. To this must be added the fact that discussions of 'National Romanticism' and a 'Finnish style' were a minority activity in *fin-de-siècle* Helsinki. Nevertheless, the architectural renaissance that Saarinen and others spearheaded was viewed very much in international terms. It was considered as part of Art Nouveau, and the undeniable sense of national pride was derived not from architecture finding a traditional Finnish style, but from the sense that Finnish Art Nouveau was gaining European recognition. This was a very modern form of national pride.

Modernity and tradition were certainly thrust together in two commercial buildings designed by Gesellius, Lindgren and Saarinen in Helsinki. In both the Nordic Incorporated Bank (131) and the Polijoka Insurance Company (1899–1901), the same traditional elements can be seen: rough-hewn, rusticated granite carved with 'traditional' Finnish motifs. Instead of a romantic, retiring country retreat, however, these buildings express a muscular solidity appropriate to the financial activities of the institutions they housed. The new national style, also used for railway stations and other commercial buildings, was being given

an uncompromisingly modern role. Such architecture proclaimed that Finland was an economically developed European nation, not the land of heroic folklore and ancient traditions that had initially so captivated Gallen-Kallela.

Finnish Art Nouveau evoked nature through a lack of artifice rather than an overburdened sinuous complexity, but how much of the national tradition it drew on was history and how much was invention? Although there was a genuine ethnographic strand to

131
Gesellius,
Lindgren &
Saarinen,
Nordic
Incorporated
Bank, Helsinki,
1903–4

Karelianism, elements such as the revival of the *Kalevala* can also be viewed as exercises in High Romanticism, comparable to Richard Wagner's reinterpretation of the German myth of the Rhine Maidens in the *Ring* cycle. Certainly, there was a large component of what is now termed the 'invention of tradition' at play.

This was a tendency that was to be found throughout Scandinavia, though it did not always display the subtlety of the more considered Finnish Art Nouveau. In Norway in the 1890s Gerhard Peter Munthe

(1849–1929) worked in the 'Viking Style', which drew on Norse mythology, resulting in such objects as boldly carved fantastical chairs (132). Jens Thiis's workshop at Trondheim, established to revive traditional weaving techniques, produced tapestries to designs by Munthe and the textile designer Frida Hansen (1855–1931). While much of the subject matter was derived from fairytales and myths, Hansen in particular was also influenced by international developments in Art Nouveau. Norway's closest links with European Symbolism came in the work of Edvard Munch. The centrality

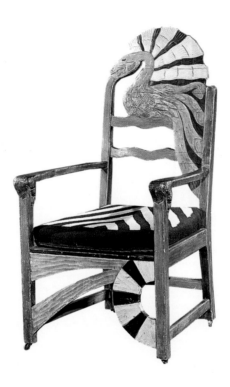

132
Gerhard Peter Munthe,
Chair from the 'Fairytale Room', Tourist Hotel, Holmenkollen, 1898.
Painted wood; h.124 cm, 48⁷⁄₈ in.
Norsk Folkemuseum, Oslo

of Symbolist themes and stylizations is evident in such works as *The Dance of Life* (133), which shows a midsummer dance in the Norwegian setting of Asgardstrand, but is concerned with ideas of sexual psychology and Monist spirituality. The painting conveys human destiny through the theme of the three ages of woman, represented by a virginal young female in white, a flame-like woman in red, symbolizing carnal knowledge, and an old and bitter-looking figure in black. Munch spent much of his time in the 1890s and 1900s in Paris and Berlin, where he was friends with

Meier-Graefe, the editor of Pan and later proprietor of La Maison Moderne in Paris (see Chapter 6).

In Russia, which lacked the concentrating focus of crusading nationalism in the face of foreign domination, Art Nouveau came to embody the contradictions and confusions of a country simmering with social and political tensions, a creaking empire teetering on the verge of violent revolution. Far removed from the quasi-feudal economy based on oppression and hardship that has become the historical stereotype of tsarist Russia, some aspects of life in Russia were sympathetic to Art Nouveau. As events in Finland showed, two of the elements needed for Art Nouveau to flourish were an active artistic intelligentsia and patrons to employ its members. Russia had both. In the years following the social and economic liberalization of 1861, in which Tsar Alexander II (r.1855–81) had allowed the serfs to buy their freedom, Russia achieved unprecedented rates of economic expansion that outstripped those in much of the rest of Europe. No longer tied to feudal lords, the sons and daughters of liberated serfs came to the big cities. Some set up in business, some trained as artists; and two generations down the line, at the turn of the century, there was a small yet aggressively wealthy urban industrial bourgeoisie matched with young architects and designers who could provide the aesthetic adventure demanded by a *nouveau riche* clientele.

Overleaf
133
Edvard Munch,
The Dance of Life,
1899–1900.
Oil on canvas;
125·5 × 190·5 cm,
49$\frac{1}{2}$ × 75 in.
Nasjonal-
galleriet, Oslo

As in Finland, the twin elements of modernity and tradition can be discerned in Russian Art Nouveau, or *Stil' Modern* as it was known. In Russia the two themes can be seen to equate roughly with the dichotomy between the two major centres of production, St Petersburg and Moscow. St Petersburg was the relatively new tsarist capital, benefiting from the court culture and artistic patronage which went with that status. Furthermore, its quest to become one of the great European cities alongside Paris, Vienna and Berlin led to an increasingly Western cultural outlook. This drive was no doubt in part related to the international pedigree of the royal family, the Romanovs. The Russian Tsarina Alexandria, for example, was the sister of Grand Duke Ernst Ludwig von

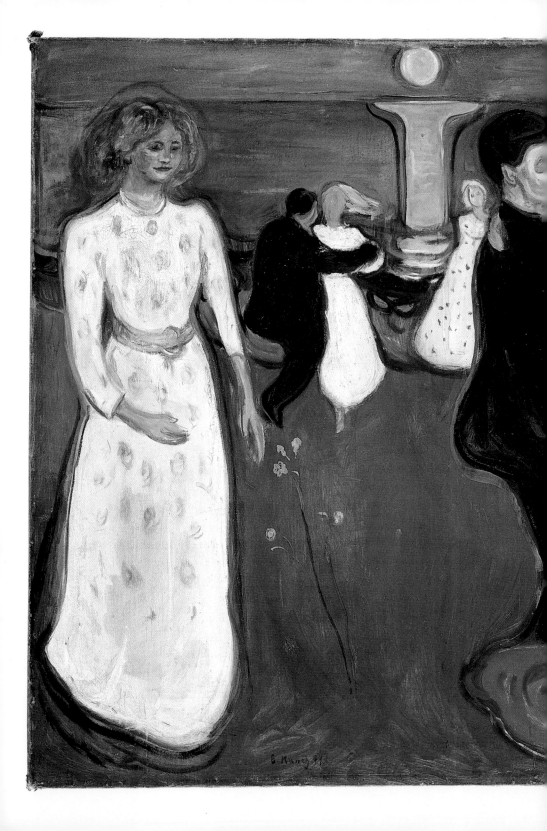

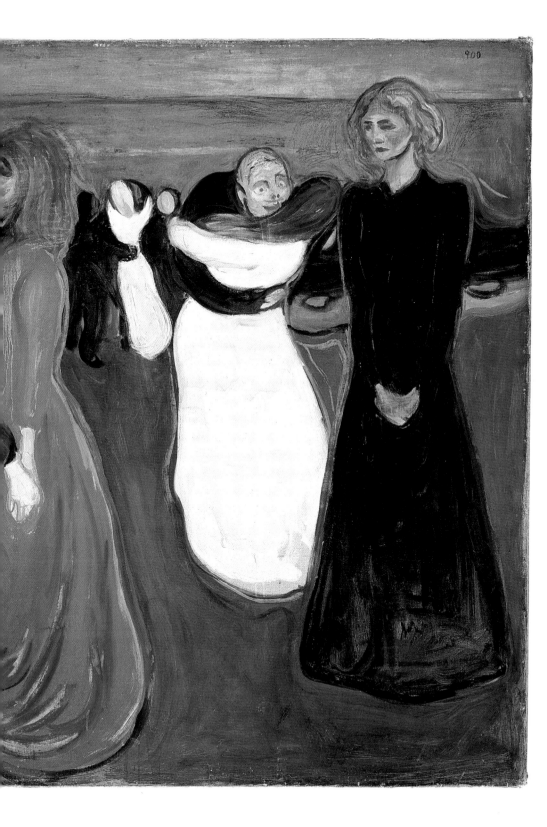

134
Konstantin Korovin,
Cover for
Mir Iskusstva,
issues 1–12,
1898–9.
33·2 × 26 cm,
13 × 10¹₄ in

135
Léon Bakst,
Cover for
Mir Iskusstva,
issues 5–6,
1902.
30·9 × 24·5 cm,
12¹₈ × 9⁵₈ in

Hessen, who set up the Darmstadt artists' colony in Germany (see Chapter 7). Moscow, on the other hand, defined itself in contrast to the capital and its Eurocentric ways. While many St Petersburg artists, such as jeweller Carl Fabergé (1846–1920), who then worked in the new style, were patronized by the court, those in Moscow looked to the evolving ideals of pan-Slavism and indigenous artistic traditions.

The vanguard of Art Nouveau in St Petersburg was an art journal, Mir Iskusstva (World of Art). Published from 1898 to 1904, the periodical grew out of a group of artists of the same name who had been active from the late 1880s. The journal and the group's exhibitions are perhaps best remembered today for having provided the earliest international exposure for the work of Sergei Diaghilev (1872–1929) and Léon Bakst (1866–1924), who went on to tour the ground-breaking Ballets Russes around Europe before World War I. Yet it was as a forum for new Russian art and design, rather than the performing arts, that the magazine had its contemporary impact.

Unconstrained by rigid stylistic allegiances, Mir Iskusstva had among its editors and contributors such 'Westernizers' as Bakst, who admired the Art Nouveau of France, with its acknowledgement of the great European decorative tradition, as well as 'Russophiles' (including Diaghilev), who sought a more specifically Slavic expression of modernity. Artists in the latter faction looked both to developments in Finland and to experiments in more specifically neo-Russian art and architecture. The early covers for the magazine by the painter and designer Konstantin Korovin (1861–1939) suggested that, if anything, the 'Russophiles' had the upper hand at first (134). After 1902, however, the magazine became more overtly Western, its publication of drawings by Aubrey Beardsley emphasizing their influential affinity with the meticulously conceived work of Bakst (135).

The applied arts were receptive to the new style and were open to the twin approaches of its Western and Russian variants. Particularly notable in Russia was the silver industry. Traditionally successful and well patronized, the work of Russian silversmiths had been dominated by historicism for many years. This meant that there

136
Orest Fedorovich Kurliukov,
Tea and coffee set,
c.1908–16.
Enameled silver;
teapot:
h.13·5 cm, 5³⁄₈ in;
coffee pot:
h.19·5 cm, 7⁵⁄₈ in;
creamer:
h.9·4 cm, 3³⁄₄ in;
sugar bowl:
h.13 cm, 5¹⁄₈ in;
dish:
l.16·3 cm, 6³⁄₈ in.
State Historical Museum, Moscow

were craftsmen of great skill and technical ability, whose historicism presented a problem when it came to creativity and originality in design. In 1902, a critic in the journal *Art Treasures of Russia* cast an envious glance at the West, where he found that, 'the artist, the manufacturer and the technician' all contributed to the design of new objects. He contrasted this somewhat rose-tinted image of an industrial idyll with Russian manufacturers, who merely copied Western models or, 'what is worse, entrust the artistic side to unqualified people who mangle styles in the worst barbaric fashion'.

Such shortcomings were recognized both by the government and by many of the major silver companies, who instituted a series of measures aimed at improving their design skills to match their craftsmanship. Many firms set up their own schools, and the government created the Russian Industrial Art Society and the Society for the Encouragement of the Arts, the latter administering its own school and decorative art workshops. That the authorities were driven by national interest is clear from the name given to the third body they set up, the 'Society for the Rebirth of Artistic Russia'.

The work of a number of Moscow firms characterizes the search for a credible Russian version of the *Stil' Modern*. An enamelled silver tea and coffee set made by the firm of Orest Fedorovich Kurliukov

(136) for a Muskovite businessman combines simple flowing shapes with architectural forms reminiscent of traditional Russian buildings. The decoration is undisguised National Romanticism. The cameos present a *bogatyr* (a legendary knight) in a suitably Eastern landscape with a neo-Russian style monastery in the background. The knight's wife and children strike an equally populist chord, recalling the romantic scenes depicted on postcards that were highly fashionable at the time.

The new creative approach to form that was brought to both Westernized and Russified Art Nouveau can be seen by comparing glass-holders made by two other Moscow firms between 1905 and 1917. A piece by Pavel Dmitrievich Amerikantsev (137) gives the traditional cup form an exaggeratedly curved Art Nouveau handle replete with foliate scrolling, while the holder by Mikhail Yakovlevich Tarasov (138) adopts an archaeologically primitive form. Decorated with images of ancient warriors, it has the rough-hewn finish of a recently discovered ancient artifact. Jewellery was particularly susceptible to the direct influences of international trends; dragonflies and nymphs featured among the motifs of Russian Art Nouveau brooches and necklaces.

Nevertheless, there can be little doubt that the *Stil' Modern* in Russia reached its apogee in a series of bourgeois-commissioned artistic interiors. While Finnish artists had designed such interiors for their own homes and studios, in Russia they tended to be commissioned by enlightened capitalist patrons, high-rolling beneficiaries of the economic liberalization Russia had enjoyed since the 1860s. The most celebrated architect who worked for what has been called 'Russia's forgotten class' was Fyodor Shekhtel' (1859–1926), who was, like many of his clients, of humble origin. A look at some of his most celebrated works reveals how both Western and Russian elements could be combined by the same architect, and could even be found side by side in a single building.

Shekhtel' has often been associated with the Russified wing of Art Nouveau, and not without reason. His mentor was the traditionally inspired painter, designer and graphic artist Viktor Vasnetsov

137
Pavel Dmitrievich
Amerikantsev,
Glassholder,
1908–17.
Silver;
h.11·5 cm,
4¹₂ in.
State Historical
Museum, Moscow

138
Mikhail
Yakovlevich
Tarasov,
Glassholder,
1899–1908.
Silver;
h.10·7 cm,
4¹₄ in.
State Historical
Museum, Moscow

139
Viktor Vasnetsov,
Tretyakov Gallery,
Moscow,
1900–5

(1848–1926) whose designs, such as the façade of the Tretyakov Gallery in Moscow (139), are testimony to his fascination with Russian folklore. Shekhtel' was certainly not averse to working in this mode; he designed a number of buildings at the turn of the century that rework such traditional Russian features as cupolas and spires.

Furthermore, Shekhtel''s private clients often had conservative views that were sympathetic to his own. The house he designed

for the young industrial heir Stepan Ryabushinsky (built 1900–2, now the Gorky Museum) boldly proclaimed itself the most contemporary and fashionable of its day (140). Yet it was underpinned by a number of distinctively Russian features, befitting a client who owned one of the finest collections of icons in Russia. The plan of the house, which placed all the rooms around the massive central stairwell, drew its inspiration from a form of medieval Russian church. This church type consisted of a series of spaces following from a main

140
**Fyodor
Shekhtel'**,
Ryabushinsky
House (now
the Gorky
Museum),
Moscow,
1900–2

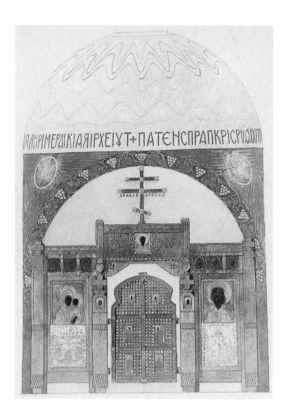

central area below a cupola, the windows around which would
have lit the church. Correspondingly, in the Ryabushinsky House,
Shekhtel' employed a modern skylight and an evocatively
ecclesiastical stained glass window to light the staircase. Some
lesser features, such as the prominent porch, were similarly
modern versions of ancient prototypes, in this case the entrances
to seventeenth-century Muscovite churches.

The ecclesiastical inspiration of the Ryabushinsky House is better
understood after considering the one element that is divorced from
its overall arrangement: the family chapel. The Ryabushinskys were
Old Believers, a conservative sect who clung to a morally orthodox
vision of Russia's future. Old Believers were renowned for their love
of icons, an interest that Shekhtel' shared, and one that he could
aesthetically exploit in the chapel (141). The dome was painted with
traditional religious allegories, and Shekhtel' is also thought to
have designed a carved icon screen that no longer survives.

141
Fyodor
Shekhtel',
Drawing of
the chapel,
Ryabushinsky
House,
Moscow,
1904

142
Fyodor
Shekhtel',
Stairway and
lamp (view
from the
dining room),
Ryabushinsky
House,
Moscow.
Photographed
c.1903

Russia's Old Believers can be compared to the Quakers in Britain, in that they seem to have had a penchant for business, and held a firm belief in the post-liberalization meritocracy of which many of their number had so successfully taken advantage. The apparent dichotomy between piety and commerce is reflected in the Ryabushinsky House, and it is this that enabled Shekhtel' to combine tradition and modernity so deftly. For all the restrained spirituality of the chapel and the subtle quotations from ecclesiastical architecture, the Ryabushinsky House also displayed the gaudy flamboyance of the successful meritocrat. The massive central staircase, made out of an artificial marble material, is baroque in its scale and grandeur, dominating the interior (142). Yet at the same time its undulating mass, terminating as it does in a spider-like electric light-fitting, demonstrates the same spirit of adventure as Endell's stairwell at the Elvira photographic studio in Munich (see 74), with its imaginative use of the possibilities of electricity. The ceilings of the library and the panels over the windows and doors

П. Рябушинскій, Столовая

in the dining room (143) employ lashing tendrils reminiscent of Obrist's work. The exterior of the house, which has been compared to buildings by Olbrich, is relatively austere, but is enlivened by a vivid polychrome frieze depicting lilies and other flowers, all naturalistically painted against a radiant blue sky. Even the piety of the chapel was penetrated by decorative swirls recalling the paintings of Klimt.

In contrast to the confident bourgeois display of the Ryabushinsky House, Shekhtel''s next project – to create the official artistic vision of Russia at the 1901 Glasgow International Exhibition – was state-

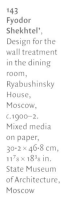

143
Fyodor Shekhtel', Design for the wall treatment in the dining room, Ryabushinsky House, Moscow, c.1900–2. Mixed media on paper, 30·2 × 46·8 cm, 11⁷⁸ × 18³⁸ in. State Museum of Architecture, Moscow

144
Fyodor Shekhtel', Russian pavilions, Glasgow International Exhibition, 1901

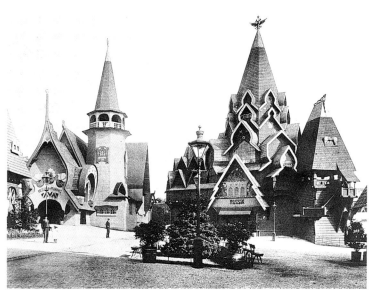

sponsored, and promised a return to the safety of the traditional Russian idiom. Nevertheless, the series of pavilions he built there (144) represents a parallel achievement to Gesellius, Lindgren and Saarinen's Finnish pavilion in Paris in 1900 (see 126). The group of pavilions together formed an artificial Russian village, transplanted from the northern forests to the Clyde. The buildings were characterized by a combination of forms that, although based on Russian architectural traditions, were united with the flowing linearity of *Stil' Modern*. Loosely based on the wooden buildings found in far northern villages, Shekhtel''s were adventurous flights

of fancy. The Central Pavilion's fabulous array of arches, spires and gables offered visitors to the exhibition site a curiously exotic landmark loaded with Eastern fantasy. Contemporary accounts record the polychrome effect of Shekhtel''s buildings, in which modernity was embodied in the architect's creative adaptation of traditional ideas to completely new forms.

On one level, the exercise of building temporary structures for the Glasgow Exhibition allowed Shekhtel' to play with ideas and forms that he could later employ more permanently. In the Agricultural Pavilion, with its startling combination of geometry and asymmetry, towering entrance and steeply pitched roof, was a prototype for

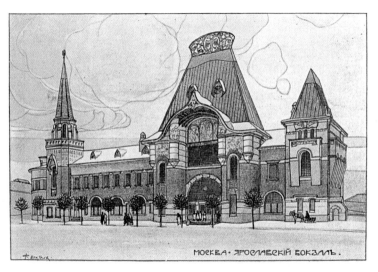

МОСКВА · ЯРОСЛАВСКІЙ ВОКЗАЛЪ .

145
Fyodor
Shekhtel',
Sketch for
Iaroslavl
Railway
Station,
1902.
From
*Ezhegodnik
Obshchestva
arkhitektorov-
khudozhnikov*,
1906

146
Fyodor
Shekhtel',
Detail of the
entrance
façade,
Iaroslavl
Railway
Station,
Moscow, 1902

what was perhaps Shekhtel''s most accomplished combination of tradition and modernity, his 1902 Iaroslavl Railway Station in Moscow (145). The spires and towers of the Iaroslavl Station were all anticipated in the Glasgow pavilions, yet the station is bolder in its use of modern features. The curving lines of the entrance (146), with its monumental pillar-like buttresses and polychrome ceramic decoration, make it much more adventurous and less rustic than the original central entrance to the Agricultural Pavilion. Similarly, the projecting geometric window arches on the right-hand tower provide a challenging contrast to the ecclesiastical spire at the opposing end of the building.

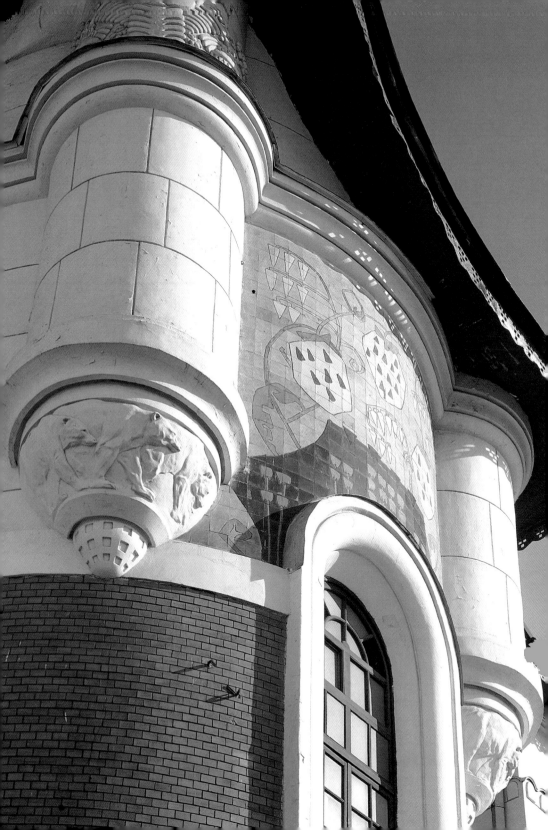

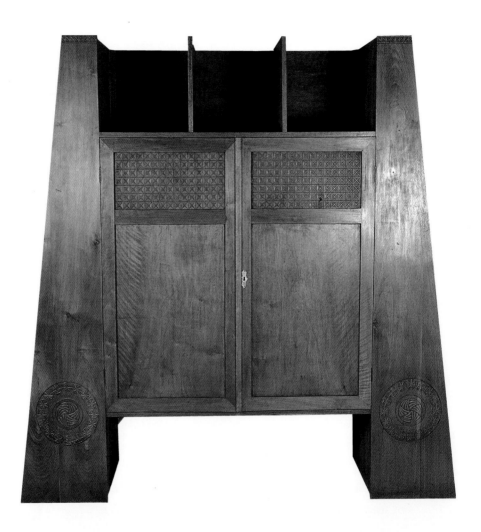

2 Art Nouveau

147
Ivan Fomin,
Cupboard,
1902.
Carved walnut;
180 × 180 × 54 cm,
$70^7/8 \times 70^7/8 \times 21^1/4$ in.
State Historical
Museum, Moscow

Despite his adherence to traditional Russian architectural forms, Shekhtel' was not simply an architectural conservative, determined though he was to Russify the new style in the interests of a peculiarly Russian blend of capitalism and Orthodox Christianity. He was, after all, an enthusiastic reader of such periodicals as *Stroitel* (*The Builder*), a vehicle for new ideas that also promoted new architecture from outside Russia. One early piece on this subject that Shekhtel' probably read on its publication in 1899 included illustrations of work by such international Art Nouveau architects as Guimard, Horta and Olbrich.

The next five years brought to Russia widespread coverage of contemporary developments across Europe, Britain and even America. In 1902 a major design exhibition in Moscow, organized by Diaghilev, who was working in Shekhtel''s office at the time, brought together the work of leading architects and designers from Russia and abroad. Muscovites had the chance to view the work of home-grown designers such as Shekhtel', Konstantin Korovin and Ivan Fomin (1872–1936), who was employed by Shekhtel', alongside the likes of Mackintosh and Olbrich. The cupboard exhibited there by Fomin displays an awareness of developments in European furniture design, particularly in the monumental trapezoid shape, though its stylized carving is also characteristic of Russian *Stil' Modern* (147).

According to Shekhtel', the purpose of the exhibition was to show the local population that there was 'a Russian style that is appropriate to the requirements of modern life and contemporary technology'. This idealism was endorsed to some extent by the large audiences that visited the show, yet the press coverage was not always favourable. One reviewer was particularly vicious, describing Olbrich's dining room ensemble as 'Flabby ... as if for a special race of small, affectionate and spineless human beings', and Margaret Macdonald's drawings as 'a page from a sexual psycho-pathology'. The new style, then, could appear perniciously degenerate and, perhaps more worrying, foreign. The same critic further admitted that he 'could not understand for whom the white

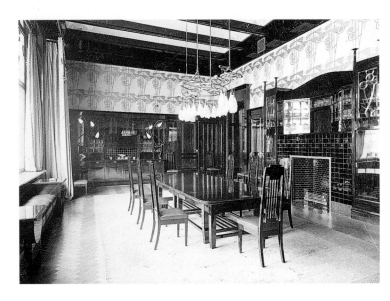

148
**Fyodor
Shekhtel'**,
Dining room,
Derozhinskaia
House,
Moscow, 1902

drawing room by Charles and Margaret Mackintosh was created.
It reminds one of an operating theatre or a Moscow hairdresser's.
Staying in it was very boring and wearisome.'

Despite the critics, however, Shekhtel' was clearly influenced
by such international developments. He visited Glasgow in 1901
to oversee work on the Exhibition there, and, although there is
no evidence that he met Mackintosh, he is almost certain to
have encountered his work at first hand. The interiors of the
Derozhinskaia House, which Shekhtel' designed in 1902, had
rectilinear furnishings and wall-mounted fittings (148) that echo
both Mackintosh and contemporary developments in Vienna. The
memoirs of a junior architect who worked with Shekhtel' contain
a telling insight into his pan-European approach: he apparently
'went abroad every year, read a great deal, spoke languages, and
worked persistently'. Moreover, 'He had a very good library from
which he drew motifs for his architecture. This library was an
important stimulus to us all in our work and we used it constantly.'
The *Stil' Modern* in Russia showed the same tensions between
national tradition and international modernity as Art Nouveau in
Finland – proof that it could equally represent a flagging empire
and a nation state struggling to be born.

At first glance, the situation of Catalonia appears to have more in common with Finland than the mighty tsarist empire of Russia. Like Finland, Catalonia was a province rather than a nation state, although it harboured strong nationalist aspirations. The Catalan language had endured a period of prohibition in the nineteenth century, at the end of which the province experienced a time of great economic expansion. During a single generation the population of Barcelona nearly doubled, from 350,000 in 1878 to 587,000 in 1910. This demographic growth was accompanied by an increasing national cultural awareness, the so-called 'Renaixença' movement, many of whose members were involved with the journal of the same name founded in 1881.

It was in the 1880s that *Modernista* architecture emerged. Often mistakenly used as a synonym for Art Nouveau, the *Modernista* movement did include manifestations of the new style, but much else besides. Originally a theological and then literary term, '*Modernista*' was later applied to painting and sculpture, as well as architecture and the decorative arts. It began to gain widespread attention with the publication in 1891 of the *Modernist Almanac of Catalan Literature*, and from 1892 onwards the painter Santiago Rusiñol (1861–1931) began to hold so-called *festes modernistes* in the town of Sitges, where he and his circle were based. Furthermore, the *Modernista* period lasted beyond Art Nouveau, spanning the years 1888–1925, and thus encompassing more changes and transformations. Despite its breadth, the term still serves well to describe the meeting of the modern and the romantic already seen in *fin-de-siècle* Finland and Russia.

As in most of the other artistic centres of Europe, the artists and designers of Barcelona succumbed to an outbreak of the *fin-de-siècle* desire to set up a plethora of art periodicals and to stage industrial art exhibitions. The city marked its appearance on the world stage by hosting a World Exhibition in 1888, an event that galvanized Barcelona's artistic and industrial communities in their search for a visual expression of both the city's illustrious heritage and the exciting sense of cultural and economic dynamism of the day.

Perhaps the most influential figure in this connection was
the architect Lluís Domènech i Montaner (1849–1923). In 1894
Domènech established the Barcelona Centre for Decorative Arts,
a series of workshops and studios which also published its own
journal, El Arte Decorato. The centre was housed in the building he
had designed as the café-restaurant for the 1888 exhibition, and
the project at its heart was a revival of the traditional skills of
craftsmanship needed for the physical realization of the Renaixença.

149
Ramón Casas,
Figure of a
Woman Reading.
Poster for
Pèl & Ploma,
1900.
Lithograph;
44 × 31 cm,
18³⁴ × 12¹⁴ in

150
Alejandro
de Riquer,
Poetry (detail),
c.1900.
Stained glass
window;
142 × 60 cm,
55⁷⁸ × 23⁵⁸ in.
Theatre
Museum,
Barcelona

Echoing Gallen-Kallela and Louis Sparre's visits to the Finnish
wilds of Karelia, Domènech and his fellow architect Antoni Gaudí i
Cornet (1852–1926) journeyed to rural Valencia to persuade an old
ceramicist named Casany, the last surviving practitioner of local
ceramic techniques in the town of Manises, to come to Barcelona
to pass on his expertise. This in turn led to technical developments
that updated old techniques, the most influential innovator in this

field being Jaime Pujol, who created new glazes for ceramic tiles that were used by designers in the Centre for Decorative Arts and became a favourite ornamental resource for *Modernista* architects.

It was in the applied arts, especially graphics, furniture and metalwork, that the *Modernista* style achieved its greatest affinity to mainstream European Art Nouveau. An article in the London magazine the *Poster* in 1899 noted the appearance of this trend in the graphic arts:

Leaving far behind the routine prevailing in other Spanish towns, Catalonian art was for a long time inspired by the French school of painting, as well as by the beauty and grandeur of native rural scenery, until at length it was given an entirely fresh impetus by the works of English and Belgian artists. A new field of decoration was opened up to Barcelona's painters and designers ... many have succeeded in it to admiration, showing both taste and originality.

As in Finland, the spread of the international styles of Symbolism and Art Nouveau was assisted by a number of artists who visited Paris during the late 1880s and 1890s. Two of the most important were the painters Ramón Casas (1866–1932) and Santiago Rusiñol. Before spending long periods in Paris from 1889, Rusiñol painted mostly traditional landscapes, yet he soon joined the progressive milieu of Symbolists and Impressionists, with whom he exhibited at the Salon of 1894. Casas was in Paris at the same time as Rusiñol and was perhaps more influential in terms of the spread of Art Nouveau in Catalonia because of his prodigious poster work, particularly for Els Quatre Gats ('The Four Cats') cabaret and for the magazine Pèl & Ploma ('Pen & Pencil'; 149).

The painter Alejandro de Riquer (1856–1920) could be described as the Catalan answer to Gallen-Kallela. Like the Finnish artist, he also turned to the decorative arts, designing metalwork and stained glass as well as painting. His allegorical stained glass window Poetry, dating from around 1900 (150), illustrates his adaptation of the flat decorative style of Symbolist painting for the applied arts. De Riquer's affinity with Gallen-Kallela also extends to his interest in the artistic scene in England, particularly the Pre-Raphaelite painters and the Arts and Crafts Movement. He had first visited England in 1879, and after a longer stay in 1893 he became a leading advocate of the Pre-Raphaelites in Catalonia. Meanwhile, the work of Gaspar Homar (1870–1953), a cabinet-maker who had a studio in the Centre for Decorative Arts, perhaps best illustrates the Catalan engagement with the applied arts of Paris and Nancy. His sofa-cabinet of 1904 (151) takes the form of a typically Art Nouveau innovation, his execution of the marquetry panels (from drawings by the Catalan painter and graphic artist Josep Pey i Farriol; 1875–1956) recalling the whimsical figurative symbolism of Émile Gallé's inlays (see Chapter 2). Nevertheless, the vocabulary of international Art Nouveau was not the dominant aesthetic in Modernista Barcelona. It is significant that it is the work of architects that dominates the story of the Catalan decorative arts, and it is surely the unique bone-like sculptural forms of Gaudí's buildings and furniture or the modernized Gothic

151
Gaspar Homar
Sofa cabinet with marquetry panel designed by Josep Pey i Farriol
c.1904.
Wood and other materials;
268 × 259 × 50 cm
105¹⁄₂ × 102 × 19⁵
side panels each
176 × 91 cm,
69¹⁄₄ × 35⁷⁄₈ in.
Museu Nacional d'Art de Catalunya, Barcelona

style of the architecture of Josep Puig i Cadafalch (1867–1956) that truly embody the Catalan ideal.

Architecture was in the ascendancy in Barcelona at the end of the nineteenth century. The new School of Architecture was established by its composition teacher and first director Elías Rogent (1821–97) in 1869, two years before the reopening of Barcelona University, another symbol of the city's renewed intellectual vibrancy. It was here that both Gaudí and Puig trained and Domènech taught. This revival of architecture was aided by the massive expansion

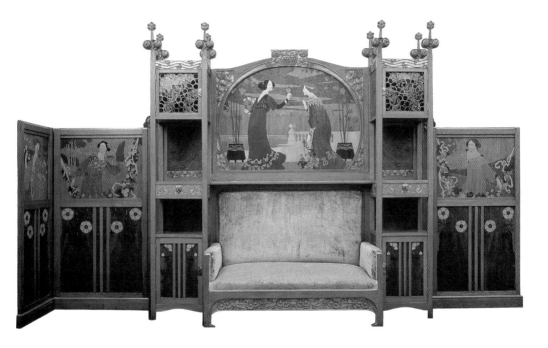

of the city necessitated by its ever-growing population. A vast new urban area, planned on a grid format and christened 'L'Exaimple' (literally, 'the extension'), was grafted on to the medieval city built around the ancient port. The demand for new architecture was unprecedented, and the building boom it created means that Barcelona today offers one of the densest concentrations of *fin-de-siècle* buildings in the world.

Like Shekhtel''s buildings, the work of the three main *Modernista* architects of the period, Gaudí, Domènech and Puig, was eclectic,

unpredictable and often contradictory. The point of departure for all three was the combination of Gothic and Moorish forms that dominated medieval Catalan architecture. They owed a debt to the great French Gothic Revivalist Viollet-le-Duc (see Chapter 1), who was much admired by Rogent. Rogent was an enemy of historicism, of the endless regurgitation of Renaissance and classical forms, a trait that was particularly unappealing in Catalonia because the seventeenth and eighteenth centuries were low points in the nation's history, when it suffered domination, first at the hands of Bourbon France, and then Spain. In place of such historicism, Rogent argued for a kind of creative eclecticism that had at its heart a typical *fin-de-siècle* uncertainty:

We fully understand that the doubt and vagueness that consume us make it impossible for us to return to the paths of the lost tradition (medieval architecture as a traditional, national and Christian form of architecture). Since we cannot go back we must become eclectic, like it or not – by which I mean that we must wander constantly in search of the unknown.

Domènech too was a keen historian and an advocate of the synthesis of ideas as a way out of historicism. Of all his buildings, the Palau de la Música Catalana (152), built between 1905 and 1908, best encapsulates the combination of the historical and the modern to produce a specifically Catalan building that, at the same time, is clearly an Art Nouveau building. With its minaret tower, pointed arches and colonnaded façade, the Palau de la Música has an unmistakably Moorish feel, adapting such features from Spain's Islamic architecture of the eighth to fifteenth centuries. The columns around the building (see 119) are decorated in ceramic mosaic with stylized floral motifs and are headed with stone capitals carved with organic forms. The use of mosaic continues inside with a series of floating female musicians on the walls of the auditorium (153). Together with the use of such traditional materials as ceramic and stone, Domènech employed modern methods of iron construction and made imaginative use of stained glass with electric lighting, most spectacularly in the elaborate central light in the auditorium, with its abstracted sunburst, edged with female masks (154).

As Rogent had suggested, and Domènech had shown in the Palau de la Música Catalana, 'modern uncertainty' did not replace the fundamental desire for a national architecture. What is more, it did not displace the longing for architecture to have a specifically Christian element, something that is reflected by the power of Catholic ideas in the arts and politics of Catalonia in the 1880s and 1890s. Antoni Gaudí's expressionist fantasies were steeped in his own idiosyncratic brand of Catholic mysticism, and Gaudí was himself involved with two Catholic political and artistic organizations. Together with Domènech and Puig, he was a member of the Lliga de Catalunya, a nationalist political group formed by conservative Catholic aristocrats in 1887 who argued for the increased autonomy of Catalonia within Spain. But while Domènech and others became involved in progressive public projects, such as the Palau de la Música and the Hospital de Sant Pau, which Domènech built between 1902 and 1926, Gaudí's projects tended to be either socially exclusive or religiously pious. Gaudí also belonged to the Circol de Sant Lluch, a society of Catholic artists and intellectuals founded in 1893. With its motto 'Artisans of Beauty', the Circol promoted a craft-based approach to the arts with strong moral overtones. In this respect, parallels can be drawn with the ideology of the *Stil' Modern* in Moscow, rather than Scandinavian National Romanticism. If Finnish nationalism was a nationalism from below – one of log cabins and peasant folklore – then Catalan nationalism shared with pan-Slavism an evocation of an old order based on conservative religion and nostalgic ideas of the medieval period.

The Catalan Gothic tradition, with its expansive, dramatic use of space, was a strong influence on Gaudí. The most audacious *Modernista* adaptation of the Gothic came in the Palau Güell, Gaudí's extravagant town house for the textile magnate Eusebio Güell, built between 1886 and 1889. The Palau Güell (155) is unusual among the new bourgeois mansions of the period in that, rather than appearing in one of the new suburbs, it nestles in the heart of the old city, in a street just off La Ramblas. Externally the Gothic influence is felt in the house's castellated profile and in the tracery of the windows

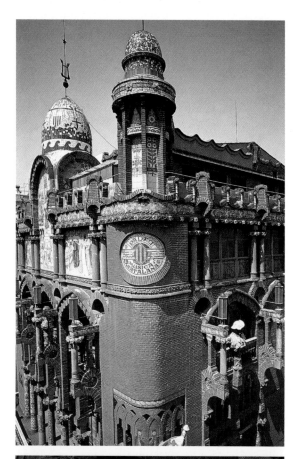

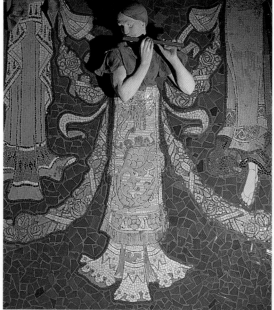

152–154
Lluís Domènech i Montaner, Palau de la Música Catalana, Barcelona, 1905–8
Above
Exterior
Below
Female flutist, detail of the auditorium mosaic
Opposite
Stained glass central light, auditorium

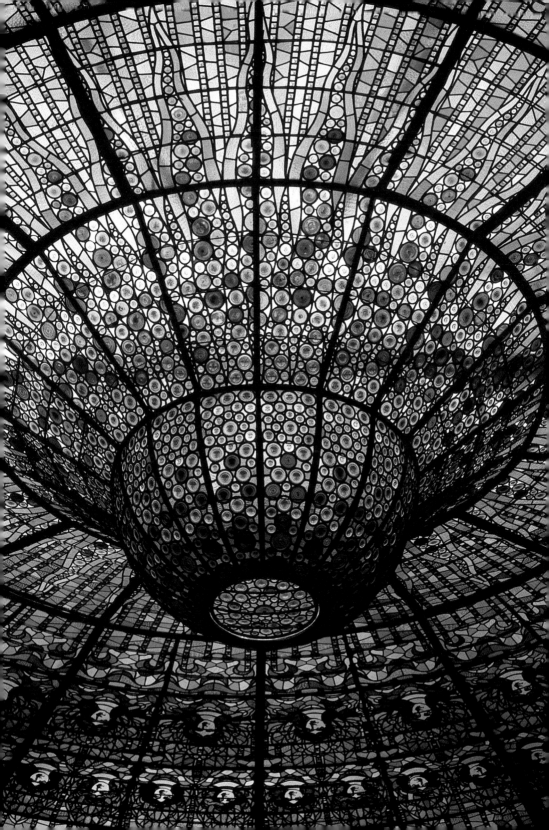

above the main entrance. Inside, the heavy stone walls and carved wood panelling, combined with the use of Gothic Revival and old Spanish furniture, gave interiors such as the main drawing-room a baronial feel. It is the atmosphere of a cathedral, however, that is most spectacularly evoked inside in the central hall (156). With its arched ceiling rising the entire height of the building to the cupola on the roof, the hall provides a breathtaking pseudo-religious space in what was, after all, an urban domestic dwelling, an early revelation of Gaudí's awareness of the power of drama in architecture.

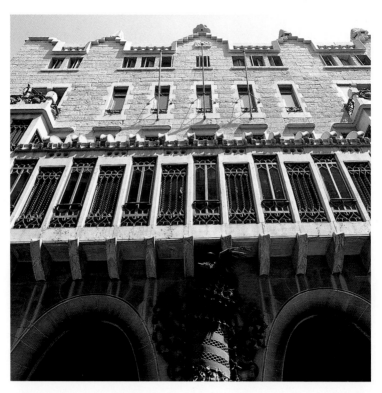

155
Antoni Gaudí,
Palau Güell,
Barcelona,
1886–9

While both Gothic and Moorish elements survive in the Palau Güell, it is the general plasticity that begins to appear in the house that points the way towards Gaudí's less obviously historically inspired *Modernista* aesthetic. This is most visible in the copious and creative use of wrought ironwork. The tone is set by his idiosyncratic rendition of the Catalan coat of arms centring the two arches that constitute the ground floor entrance. Surmounted by a helmet and an eagle, the arms are surrounded by fluid organic forms. From

then on, adventurous linear wrought-iron forms are to be found everywhere: in the gates, the light-fittings, railings and purely decorative wall-brackets. As a whole, the Palau Güell reveals the tension at the heart of the *Modernista* project, the same tension inherent in the Russian *Stil' Modern*. Both Güell and Gaudí wanted to express a fundamental modernity by rejecting conventional historicist styles, but they also sought to evoke a sense of national and spiritual tradition in the same way that Stepan Ryabushinsky wanted to retain an expression of his Orthodox Old Believer faith.

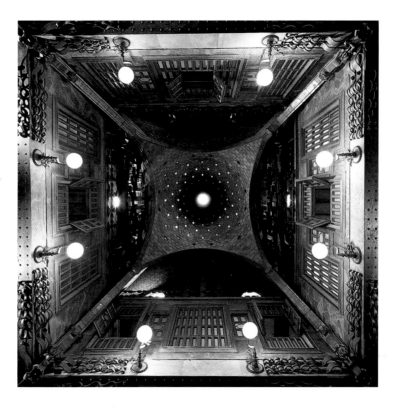

156
Antoni Gaudí,
Ceiling of the
central hall,
Palau Güell,
Barcelona,
1886–9

In many ways, Güell is as central a figure to the Barcelona *Modernista* movement as Gaudí himself. Güell was Gaudí's one fiercely loyal patron whose commissions gave him the creative freedom he needed. Apart from the Palau Güell, Gaudí restored and designed additional buildings for Güell's estate outside Barcelona, Güell Pavilions, for which he created an entrance that exhibits perhaps his most dramatic use of wrought iron in the form of the dragon gate (157). He also designed the chapel for the village Güell built for

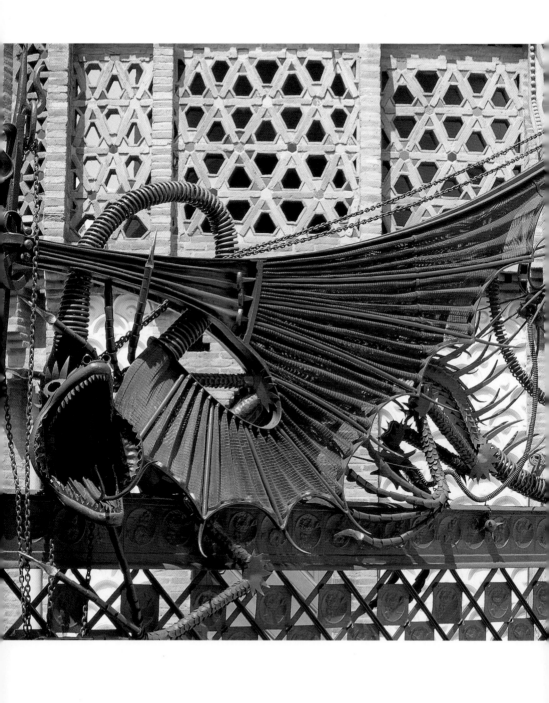

his workers on the outskirts of Barcelona, as well as the Park Güell in the hills overlooking the city. Although never completed, the Park was conceived as a housing development over a twenty hectare site for Barcelona's privileged upper middle classes. As very few houses were ever built, the Park today exists as a landscaped garden with a handful of Gaudí's buildings and features, such as fountains and walkways. Nevertheless, it remains a fascinating insight into some of the intellectual influences on both Gaudí and Güell.

The Park Güell was originally intended as a socially élitist interpretation of the ideas of the English Garden City movement, which around 1900 advocated the building of new planned towns with gardens and green spaces as a response to unhealthy and crowded city life. Although Gaudí's Park Güell was never as politically utopian as a true Garden City, the survival of the English spelling of 'Park' is testimony to its roots. The idea of the semi-rural retreat had a particularly *fin-de-siècle* ring to it, but the Park Güell had a number of distinctly conservative twists. It was planned for a site that at the time was separate from the rest of the sprawling city and was chosen because of its inaccessibility to the masses. Moreover, the fact that the site was walled created a physical separation from modern life. The medieval notion of a walled city to keep marauding hoards at bay was enhanced by Gaudí, who placed two cylindrical towers flanking the gates of the development, evoking the heavy guarded entrances to medieval cities (158). At the same time, however, there is no mistaking the originality of the architecture. In the Park Güell, Gaudí used the technique of cladding structures in broken ceramic tiles (159), and created swelling organic shapes for the gate-houses and the open-air market, with its famous roof terrace, demonstrating an expressive use of forms that was without direct historical precedent and would have been perceived as extremely modern. Once again, Gaudí was mixing visual modernity with a distinctive blend of conservative Romanticism, perhaps best embodied in the market with its vast colonnaded cover, intended as a central meeting-point where everything the inhabitants needed could be

157
Antoni Gaudí,
Dragon gate,
Güell Pavilions,
Barcelona,
1884–7

bought. This one feature shows how, in reality, the plan flew in the face of modern economic and urban development and was thus doomed to failure.

As well as allowing Gaudí to develop the concept of a semi-urban retreat, Eusebio Güell also afforded him one of his two opportunities

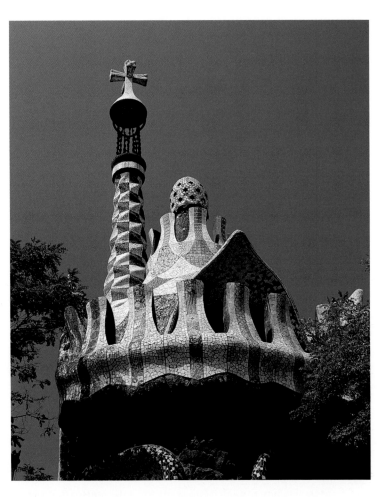

158
Antoni Gaudí,
Entrance
lodge,
Park Güell,
Barcelona,
1900–14

to apply his own piety directly to his art by designing a church. The Chapel Güell was designed for another idealistic housing development, and, like the Park Güell, it was never finished; only the crypt was ever realized, between 1898 and 1917. The chapel was to be the spiritual centre of the Colònia Güell, the workers' village built by the industrialist next to his factory in Santa Colonna de Cervello, a small town south of Barcelona. The crypt (160), which

exists intact without the rest of the proposed chapel, is Gaudí's most convincing expression of organic architecture. It is a fantasy in brick, a magical vaulted space imbued with a timeless sense of piety. Yet it is a distinctly medieval piety. With its dark, cave-like interior, the chapel is a grotto that whole-heartedly rejects the classical ideal. In contrast to Guimard, with his use of industrially produced components (see Chapter 1), Gaudí reverts to bricks, the most traditional of building materials, to achieve his organic shapes and spaces. These forms are echoed in his pews for the chapel which, with their bone-like carving combined with the lightness of form created by the wrought-iron legs and bases, attain the delicacy and grace that much of the more elaborate, heavily carved French Art Nouveau furniture aspired to but rarely achieved.

Gaudí's other religious building, also unfinished, was the cathedral of the Sagrada Familia ('Holy Family'), built in one of the working-class districts of L'Exiample and now the internationally recognized tourist symbol of the city (161). The cathedral had been begun by the architect Francisco de Paula Villar y Lozano (1828–1901), who had conceived it as a purely Gothic Revival exercise. Gaudí was appointed the Director of Works 1883 at the age of thirty-one. His appointment by the Church at such a young age, when relatively few of his buildings had been constructed, was surely related to his commitment to Catholic ideals.

Gaudí immediately set about redesigning the cathedral, just stopping short of actually demolishing what little had already been built. The three portals on the façade, built in 1903, representing Faith, Hope and Charity, are essentially Gothic in their basic construction, but are heavily clad in irregular organic forms with stalactite shapes hanging from the gables, demonstrating Gaudí's unwillingness to be bound by architectural convention. This refusal to follow tradition is manifested most strikingly in the four towers that rise above the surrounding buildings and form the cathedral's distinctive silhouette.

Gaudí's Catholic ideology also led to his involvement in restoration work that begs comparison with one of his intellectual mentors,

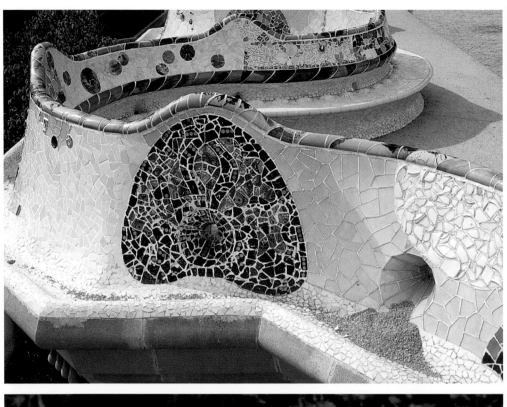

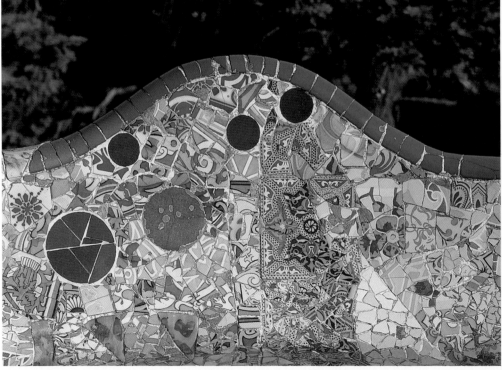

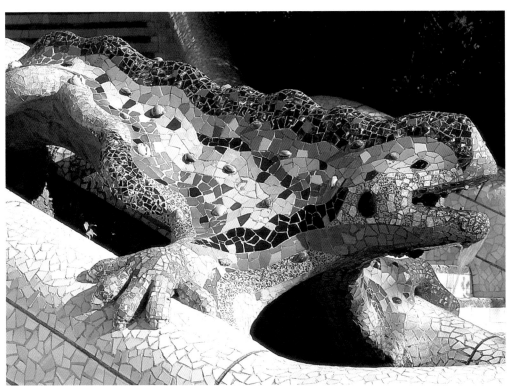

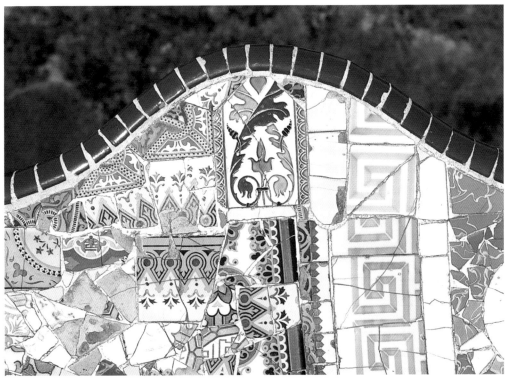

Viollet-le-Duc. Just as Viollet had devoted much of his energies towards the restoration of medieval buildings, such as Napoleon III's castle at Pierrefonds, so Gaudí was heavily involved between 1900 and 1914 with the restoration of the cathedral in Palma, Mallorca. It is fitting that the Sagrada Familia, which is still under construction and many years from completion, is now the best known of Gaudí's works. Together with the chapel at the Colònia Güell, it serves as a symbol of Gaudí's apparently effortless success in achieving the unlikely synthesis of Catholicism and modernity.

The manifestations of Art Nouveau in Finland, Russia and Catalonia demonstrate the variety and consistency of the style. In each place, different *fin-de-siècle* versions of the 'modern' style were used to express the romance and political aspirations of nationalism. In Finland and Catalonia this meant, on one level, a quest for freedom from oppression, a desire to rediscover an authentic cultural voice in a period of bewildering economic expansion and technical progress. Art Nouveau thus represented a positive ideology of progress, rather than the sense of decadence, excess and reaction characterized by certain French interpretations of the style.

160
Antoni Gaudí,
Crypt, Colònia
Güell,
Barcelona,
1898–1908 and
1908–17
(unfinished)

This sense of progress was also coloured by a desire to be accepted as part of mainstream Europe. The role of Paris as a Mecca for visiting foreign artists, together with a transfer of ideas via periodicals from England, France, Germany and Austria across Europe, points to the rapidity with which ideas could spread and the keen attention paid to events in Europe's main cultural capitals. Over a century later, similar dilemmas exist in Europe, with Scotland and Catalonia, for example, both seeking greater political independence at the same time as wanting to be part of a broader European culture.

Around 1900, Europeanization usually meant industrial and technological modernization, and Finland, Russia and Catalonia all underwent rapid economic growth in the second half of the nineteenth century. The foundation of craft-based organizations, such as the Iris Workshop in Finland and the studio-organized Barcelona Centre for Decorative Arts, offers a reminder that Art

Nouveau often ran counter to this trend through its celebration of craftsmanship and distrust of industrial production. Nevertheless, the style was firmly aligned with economic modernization when it came to the clients who commissioned it. Men such as Güell and Ryabushinsky were new-wave bourgeois industrialists, the *fin-de-siècle* equivalent of that most ridiculed of social classes, the *nouveau riche*. For a man such as Güell, Gaudí's work stood for individualism and distinction in an age of increasing anonymity. Art Nouveau's versatility lay in its ability to satisfy both these criteria. The style could embody the finest in craftsmanship and individualistic architectural exuberance on a domestic scale, while at the same time providing a dynamic statement of modernity.

161
Antoni Gaudí,
Sagrada
Familia,
Barcelona,
begun 1882

The United States at the end of the nineteenth century was
expansive, expanding and prosperous. The end of the Civil War in
1865 had heralded a period of rapid economic growth. An important
factor was the construction of railroads across America – the
east and west coasts were linked by railroads in 1869. A host of
entrepreneurs, including J Pierpont Morgan and William H Vanderbilt,
built commercial empires around a backbone of railroad interests.
This unprecedented growth helped to create a newly wealthy upper
middle class whose extravagant spending and leisure habits were
to become legendary. Chronicled by the sociologist Thorstein
Veblen in his famous book *The Theory of the Leisure Class* (1899), their
lives were propelled by an unparalleled spending power. Veblen
observed that in *fin-de-siècle* America, 'abstention from labour
presently comes to be a requisite of decency'. One of the defining
signs of this gentility was an indulgence in what he termed
'conspicuous consumption', a process that involved, among other
things, the self-conscious cultivation of connoisseurial tastes.
According to Veblen, 'conspicuous consumption of valuable goods
is a means of reputability to the gentleman of leisure'. The opulently
furnished palatial mansions that characterized America's 'gilded
age' seem to reflect Veblen's theories.

At first glance, then, it might seem that the United States and
Art Nouveau were made for each other. It was a relatively new
country with vast wealth – fertile ground for a style that, in some
incarnations at least, sought to reject the tired repetitions of the
past and embrace a totally new aesthetic. Yet it was a country with
a complicated and in some ways contradictory relationship with
Europe and its cultural traditions. The United States was largely
a nation of immigrants who hoped to free themselves from the
poverty and factional nationalism that many had experienced in
Europe. America promised new economic opportunities, but those

162
Virginio
Colombo,
Detail of
ironwork,
Edificio Calise,
Buenos Aires,
1911

251 The Americas

who attained wealth tended to look to Europe as a source of art and culture. As the commercial and economic strength of the United States grew in the 1880s and 1890s, surpassing that of many European nations, Americans began to express increasing concern about their perceived cultural inferiority. A growing belief that the United States needed to be liberated from the restraining traditions of the Old World made it potentially fertile ground for artistic innovation. Writing in the *Architectural Record* in 1902, the critic Herbert Croly warned,

If the United States continues to be primarily interested in business and does not take anything else very seriously, she will in the end assume very much the same position towards Europe as the Greek colonies in Sicily did towards their native Greece; she will exchange her material products for the art and thought of her motherland.

Arguing for American innovation, he complained that 'the average American designer is trying to steep himself in traditional forms. He glories in them, he even riots in them. His art frequently seems to be a systematic effort to Europeanize the New World.' Hector Guimard, architect of the new Paris Métro stations, similarly encouraged American innovation: 'I will venture to say that my American confrères have been and are still, in the most favourable position for creating Art Nouveau ... Seeing that Art Nouveau is crossing the Atlantic to your shores, I hope that my American confrères will not rest content to be mere copyists, but will be creators'.

163
Tiffany
Studios,
'Dragonfly'
table lamp,
c.1900.
Favrile glass
and bronze;
h.81 cm,
32 in.
Private
collection

By 1900 Americans had, in fact, already made a significant impact on Art Nouveau, first and foremost in the person of Louis Comfort Tiffany (1848–1933). Tiffany maintained a dominant presence at the succession of exhibitions and world fairs that crowded the *fin de siècle*, becoming particularly renowned for his vividly coloured glass lamps with fashionably stylized natural forms (163). He was appointed a Chevalier de la Légion d'honneur at the Paris Exposition of 1900 and was awarded the Grand Prix at the First International Exposition of Modern Decorative Arts held in Turin in 1902. The Tiffany name had a tradition of innovation in the

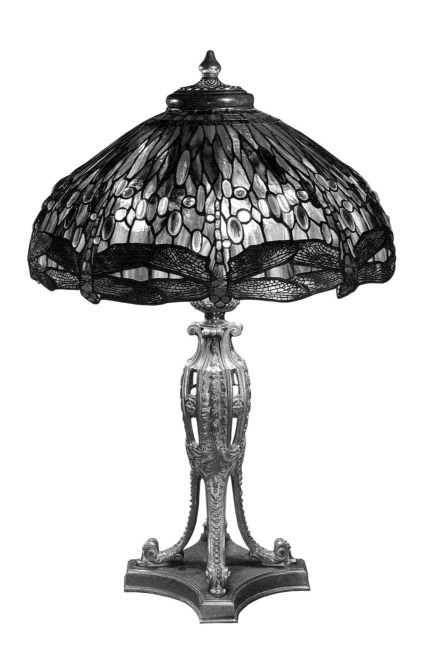

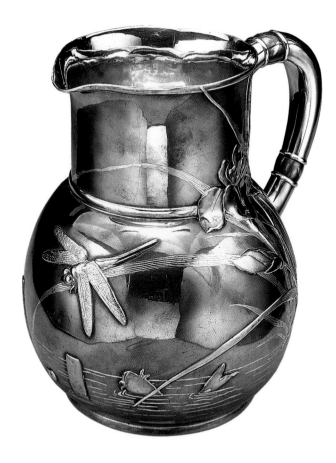

164
Tiffany & Co,
Pitcher,
1880.
Sterling silver,
gold and
copper;
h.19·7 cm,
7³⁄4 in.
Tiffany & Co
Archives,
Parsippany,
New Jersey

decorative arts. Tiffany & Co, the silver and jewellery firm belonging
to Louis Comfort's father, Charles Louis Tiffany (1812–1902), had
been producing pieces influenced by Japanese and Islamic designs
from as early as the 1870s. They had rivalled the finest Parisian
work, winning plaudits at the 1878 Paris Universal Exposition, and
showing a refined appreciation of the same influences that inspired
many great French Art Nouveau designers.

Tiffany & Co's pitcher decorated with dragonflies and carp (164)
demonstrates the firm's success in executing the kind of 'Japoniste'
designs that have subsequently been interpreted as proto-Art
Nouveau. It was the firm's chief designer, Edward Chandler Moore
(1827–91), who was largely responsible for Tiffany & Co's innovation
in this field. Moore mastered the Japanese alloys of *shibuichi* and
shakudō (both made from copper, gold and silver), and the decorative
technique of *mokurne*, meaning 'wood grain', thus ensuring the pieces

had authentic and expensive decoration. Moore, who had become the director of Tiffany's silver department in 1868, was a voracious collector of Japanese objects, as well as a talented designer.

Commodore Matthew Perry had won trading rights for the United States with a previously isolated Japan in 1853 (see Chapter 1). In 1877, in the context of this relatively new climate of cooperation, Moore dispatched his friend Christopher Dresser (1834–1904), an English design reformer and illustrator of Owen Jones' *Grammar of Ornament*, to Japan on behalf of Tiffany & Co. Over a four-month period, Dresser collected numerous examples of Japanese art and design, some of which were auctioned at Tiffany's on his return. But the fact that Tiffany's artists and designers had direct access to such objects clearly aided their Japoniste style. Moreover, Moore's affair with Japan ran concurrent with Bing's (see Chapter 1), evidence that some American firms were at the cutting edge of design in the 1870s.

Moore also played a crucial role in encouraging the young Louis Comfort Tiffany to work in the decorative arts. Louis first worked in partnership with Lockwood de Forest (1850–1932), Candace Wheeler (1827–1923) and the painter Samuel Coleman (1832–1920) as Associated Artists from 1879, then with Tiffany Glass & Decorating Co, which was established in 1892 before changing its name to Tiffany Studios in 1900. All the famous Tiffany glassware was made by Louis' companies. It was not until 1902 that he also worked for his father's firm, Tiffany & Co, which had always produced only silver and jewellery and still trades today.

Louis Comfort Tiffany developed his patent Favrile glass in competition with John La Farge (1835–1910). Born into a well-to-do New York family, La Farge had an interest in Japanese art and had visited both Japan and the South Seas. He made his reputation first as a painter, shifting to mural painting and work in stained glass later in his career. His main contribution to Art Nouveau was the invention of manufacturing processes to create new varieties of glass, including an opalescent variety. Louis Comfort Tiffany's Favrile glass was also industrially produced, yet gave the illusion

165
Tiffany & Co,
Scent bottle,
1900.
Gold,
diamonds,
sapphires,
emeralds,
amethysts and
Favrile glass;
h.12·4 cm,
4⁷₈ in.
Tiffany & Co
Archives,
Parsippany,
New Jersey

of the lustre and beauty of old handmade wares (165). Tiffany
used Favrile glass for lamps and vases, as well as other objects.
The vases particularly impressed Bing, partly because of the beauty
of the technique, which itself seemed natural:

Look at the incandescent ball of glass as it comes out of the furnace; it
is slightly dilated by an initial inspiration of air. The workman changes
it at certain pre-arranged points with small quantities of glass of
different textures and colours, and in the operation is hidden the germ
of intended ornamentation ... If in conclusion we are called upon to
describe the supreme characteristic of this glasswork, the essential
trait that entitles it to be considered as making an evolution in the art,
we would say it resides in the fact that the means employed for the
purpose of ornamentation, even the richest and most complicated,
are sought and found in the vitreous substance itself, without the use
of either brush, wheel or acid.

Bing was emphatic in his appreciation of Tiffany and was in no
doubt that his was a particularly American achievement. Between
1891 and 1894, Bing travelled extensively in America, visiting
New York, Boston, Albany, Chicago, Cincinnati, Pittsburgh
and Washington, DC. In 1896 he published his influential book
Artistic America, which had initially been written as a report to the

Administration des Beaux-Arts in Paris on the state of the arts in America. In it Bing posed the question as to whether one could 'assume that if similar initiatives were to appear in our own country, it could suddenly revive all our talents, dulled for too long?' 'Indeed no,' was the response. He elaborated:

In America, this task has been facilitated, first of all by the fact that the American mind is not haunted by so many memories. What has given them a different destiny is that they do not, as we do, make a religion of these same traditions. It is their rare privilege to make use of our aged maturity, adding to it the bursting energy of youth's prime.

Bing surmised that 'For the American, yesterday no longer counts, while today exists merely as a preparation for tomorrow.' In his book Bing identified the four major players in the development of modern taste in America as Edward C Moore, Louis Comfort Tiffany, John La Farge and Samuel Coleman. Bing brought together what he saw as the vigour and innovation of American industry with French artistry in 1894–5 when he commissioned Tiffany to execute a series of stained glass windows designed by eleven leading French artists, including Pierre Bonnard, Paul Ranson and Henri Toulouse-Lautrec. This collaboration remains the most potent visual reminder of the importance of America to Bing.

In the wake of Bing's book, American design began to receive increasing coverage in European art journals. The English writer Cecilia Waern published a biography on La Farge in 1896, and the following year she contributed two lengthy articles on Tiffany to the *Studio*. In 1897 an article in the London *Art Journal* hailed the American pottery firm Rookwood as 'the most original and beautiful Art Industry in the United States'. Bing was also influential as a dealer. As early as 1888 he had opened a New York showroom at 220 Fifth Avenue where his American agent John Getz staged auctions of Oriental objects. When Bing returned to France in 1894, he brought with him a contract to distribute Tiffany's products across Britain and Europe. He showed Louis Comfort Tiffany's glassware in his Paris gallery in 1895, along with the work of American graphic artist William H Bradley (1868–1962).

For Bing, Tiffany was an enthusiastic innovator at the heart of the new movement. And it was perhaps those same qualities of 'bursting energy' that brought Bing into collaboration with Édouard Colonna, a German-born, Brussels-trained designer who had lived in America since 1882 and considered himself an American. Colonna's work for Bing in his pavilion at the 1900 Universal Exposition in Paris has already been mentioned (see Chapter 1), yet it is worth considering him further. He presents a fascinating figure on the cusp of European and American design, personifying the complexity of the links between the Old and New worlds. At the age of twenty, Colonna had taken the same momentous decision as a generation of Europeans disillusioned by oppression and lack of opportunity, and sailed for New York. After a short spell working for Associated Artists, the design firm of Louis Comfort Tiffany, he moved to the Midwest, where he worked for the Barney and Smith Manufacturing Co in Dayton, Ohio, designing stoves. It was here that he published his *Essay on Broom Corn* in 1887. The essay, which was in fact a collection of decorative engravings, stands as a remarkable testament both to Colonna's own adventurousness as a designer and to the existence of an embryonic Art Nouveau in America by this time.

166
Édouard
Colonna,
Design for a
frieze from
*Essay on Broom
Corn*,
1887

Based on the intertwining strands of broomcorn (a type of sorghum grown in America with long flower stalks used in making brooms), Colonna's intricate little designs (166) are characterized by their waving, stem-like clusters. Still framed within essentially classical devices, such as columns and friezes, the designs represent a first step towards breaking away from the constraints of tradition via an organically inspired free-form linear design. Unfortunately, both for Colonna and for American design, the *Essay on Broom Corn* never reached its intended audience of East Coast artists, for most of the hundred copies Colonna had printed at his own expense were lost by the New York distributors. In the wake of this setback, Colonna returned to Europe, working for Siegfried Bing between 1898 and 1903 on furniture and interiors in the high Art Nouveau style. What is often overlooked is that Colonna brought with him a New World sensibility to Bing's studio. Writing retrospectively in 1936, he claimed that

the *Essay on Broom Corn* proved him to be 'one of the first American designers to break free from the styles of the past', and it is this sense of American innovation that Bing undoubtedly encouraged when Colonna worked for him.

Despite Bing's high regard for the leading American Art Nouveau designers, there is no doubt that much of the work that was being produced in the style there was related to developments in Europe. Writing in the American magazine the *Craftsman* in 1903, the critic Irene Sargent argued that 'It is a single, unmistakable and significant fact that the source of inspiration for the artist ceramicist has been [France]. It is France that has furnished the germ idea from which, in a characteristic individual way, each of these New World experimentalists has developed original results.'

Examples of this influence abound. The distinctively waxy, matt green glaze and the simple naturalistic lotus leaf forms of the ceramics produced from 1894 in the Boston factory of William Henry Grueby (1867–1925) display a close affinity with the work of the French ceramicist Auguste Delaherche (1857–1940). Delaherche had not only perfected a similar matt glaze some years previously, but he also favoured the same bulbous, stylized organic forms that Grueby was later to make his own. A clear example of this line of influence can be seen in two Grueby vases (167, 168), both of which have decorative features and forms that relate to a vase by Delaherche that was illustrated in the *Studio* in 1898 (169).

Grueby's company was by no means alone in drawing on European ceramics. Artus van Briggle (1869–1904), who had been one of the Rookwood pottery's most talented designers, and whose admiration for French Art Nouveau was well known, was acclaimed by contemporaries for his flowing, Symbolist forms. The discovery by Martin Eidelberg of an anonymous French metal vase (170) shows just how direct European influence could be. When placed next to Van Briggle's *Dos Cabezas* vase of around 1900 (171), the American ceramicist's source is clear. Van Briggle had switched medium,

lengthened and narrowed the shape and subdued some of the sharpness of detail, yet little else was changed.

The roll call of personal and business links between American firms and Europe is extensive. Rookwood sent its decorating staff to Europe before 1900, and their most adventurous designer, Van Briggle, was sent to Paris by the firm between 1893 and 1896. Louis Comfort Tiffany visited Europe at least once a year, and from 1897 the *Studio* magazine was published in an American edition. In 1893 there was a large display of European ceramics at the Chicago Columbian Exhibition. It was here that Grueby saw the work of Delaherche, for which his immediate admiration is well documented. Grueby approached Delaherche after the fair to try to buy some pieces. Although he later claimed they were too expensive for him, Delaherche sent him some sketches with his price list, which may have served as a visual reminder over the coming years of what Grueby had seen in 1893.

Furthermore, the fact that many industrial workers were still first-generation immigrants seems certain to have influenced American work. Similarities between Tiffany's ceramics and the pieces of the Danish firm Bing & Grøndahl have been explained by the fact that the head of Tiffany's ceramics department was a Danish immigrant. Certainly the pierced and textured vegetable forms of some of Tiffany's output between 1904 and 1910 share strong similarities with the work of Bing & Grøndahl; a Tiffany vase illustrated here (172) is very redolent of vases produced by the Danish firm. Even Siegfried Bing recognized the importance of French immigrants: 'When one investigates the field of American industrial design, one finds significant traces of our national genius at its base'. Bing described how French glassmakers, skilled in creating 'glass plaques with uneven surfaces and iridescent colours', were, on their arrival in Brooklyn in the 1880s, introduced to Tiffany and La Farge, 'the impatient experimenters'.

Nevertheless, all these instances of Europeanization, even the copying of European prototypes, must be set against a strong streak of national pride in the work of many American factories.

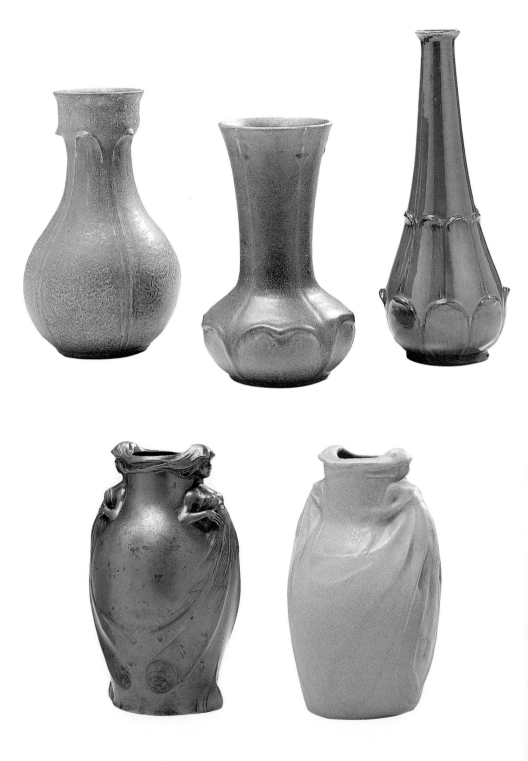

Just as Finnish artists began by looking to the wilderness, to the original state of nature, in order to create a truly national art (see Chapter 4), so American ceramicists attempted to craft their own brand of nationalist naturalism. One way for potteries to allude to the Americanness of their product was to advertise their use of 'native clay', as Rookwood did. The literature of the Newcomb Pottery emphasized that 'clay is quarried in neighbouring territories', suggesting even a regional identity over a national one.

A more obvious device for proclaiming the New World nature of ceramics was through decoration. Mary G Sheerer (1865–1954) of the Newcomb Pottery proclaimed their aim: 'the whole thing was to be a Southern product ... by Southern artists, decorated with Southern subjects.' Native American plants were stylized in the decoration of the Grueby factory (173), while a 1902 article discussing the pottery of the Pacific Coast was emphatic in its belief in the creation of a national tradition from nature:

... lizards are modelled from life ... mushrooms with their delicate filaments; lichens as lifelike as if just gathered from some old stone wall; flowers and ferns special to California, are all reproduced in enduring clay. It is a history of a country written in stone.

Even Van Briggle, whose forms approximated most closely to French Art Nouveau, described his work with the pioneering language of the settlers. After illness forced him to take to the rural wilds of Colorado, where he worked until his untimely death from tuberculosis in 1904, Van Briggle characterized the colours of his ceramics as 'akin to the deep blues & purples of the mountains, to the brilliant turquoise of the skies, to the greens of the summer and to the wonderful rosy and tawny tones of the plains in winter.'

Ceramicists did not have a monopoly on this craft-based romantic streak. Much of the furniture in the United States that can be called Art Nouveau came from the same Arts and Crafts tradition as 'Art Pottery'. The most delightfully idiosyncratic furniture maker of the period, who more than any other exploited the curvilinearity of Art Nouveau, was Charles Rohlfs (1853–1936) of Buffalo, New York.

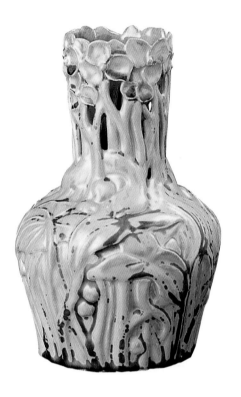

172
Tiffany
Studios,
Vase,
c.1904–10.
Glazed
earthenware;
h.21·6 cm,
8¹₂ in.
Private
collection

Rohlfs had travelled a circuitous route to furniture making. He gave
up his first career as a designer of cast-iron stoves in 1877 to make
his stage début for the Boston Theatre Stock Company. When he
married the novelist Anna Catherine Green in 1884, however, she
stipulated that he must give up acting, so he dutifully renounced the
stage and turned to furniture making. Described as 'queer, dark,
crude and medieval' by *House Beautiful* in 1900, Rohlfs' furniture
married sinuous, naturally inspired abstract designs with a simple
honesty. In his hall chair of 1900, he seized the opportunity to
sacrifice comfort in the name of form and decoration by combining
the vertical angularity used by Mackintosh and, in the United States,
Frank Lloyd Wright (see 187), with unashamedly decorative pierced
curvilinear fretwork. While the decorative vocabulary in this case
owed more to Voysey and other exponents of the English Arts and
Crafts Movement, Rohlfs stood out among his fellow Arts and Crafts

173
**William Henry
Grueby,**
Vase,
c.1905–10.
Buff stoneware
with ochre
matt glaze;
h.30·5 cm,
12 in.
Private
collection

designers in America as someone who was not averse to decoration. A 'fancy chair' he designed for his own residence in around 1898 was a riot of intertwining sinuous tendrils (174), as outlandish as anything designed by Victor Horta or Hermann Obrist.

Rohlfs' designs certainly appear adventurous and flamboyant when compared with the rustic simplicity of the furniture produced by the Gustav Stickley Company in Eastwood, New York, in around 1898. The majority of the firm's output was characterized by plain, unfinished oak surfaces that evoke the undesigned vernacular. It had its ideological and aesthetic roots in the English Arts and Crafts Movement, and it rapidly became known as 'Mission' furniture. This was partly a result of its supposed likeness to the very simple furniture of Spanish missions, but also because Gustav Stickley (1857–1946) employed the rhetoric of a design evangelist

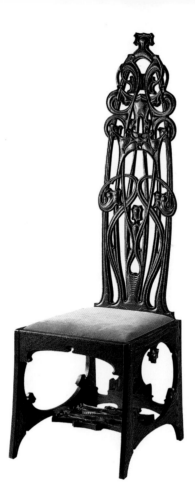

174
Charles
Rohlfs,
Chair,
c.1898.
Oak;
h.140 cm,
55⅛ in.
Art Museum,
Princeton
University

when writing in his magazine the *Craftsman*, where he referred to objects having a 'mission of usefulness.'

Although simple in form, Stickley's furniture was far from the refined radicalism of Hoffmann or Mackintosh. Nevertheless, hints of Art Nouveau shone through. Stickley had visited Paris in 1898, and some of the work of his designer Harvey Ellis (1852–1904), with its subtle decorative inlays, shows the influence of restrained organic Art Nouveau decoration comparable to the stylized ornament of Mackintosh and Margaret Macdonald. Such subtleties were not lost on contemporaries: the *Craftsman* drew attention to the 'fine markings ... of pewter and copper, which, like the stems of plants and obscured simplified floral forms, seem to pierce the surface of the wood from beneath.' Stickley admitted to 'using an

occasional touch of ornamentation', but said that he 'gradually left off all decoration as the beauty of pure form developed and any kind of ornament came more and more to seem unnecessary.'

As in England, the Arts and Crafts Movement in the United States was taken up by social reformers and women's groups, as well as architects and designers. Even well-known, high-quality commercial manufacturers, such as the Tobey furniture company in Chicago, employed it in the late 1890s. In 1896 the firm hired an Englishman, Joseph Twyman (b.1842) to lead its decorating department. In 1902 he established a William Morris room in the company's showrooms to market Morris & Co's textiles and wallpapers. Equally significant is the fact that examples of the company's output showed strong French influences – about as far removed from Arts and Crafts simplicity as possible. Items including a boldly carved card table with swelling foliate scrolling failed to achieve the adventurous asymmetry of the best Art Nouveau, yet such objects provide a fascinating insight into the extent to which the style penetrated mainstream American design.

For Art Nouveau, or at least the aspiration towards it, was not the preserve of an artistically conscious élite who could afford the craftsman's product. In the decade after 1900 many US firms produced both ceramics and furniture on an industrial scale. The Art Nouveau lines of a number of such companies usually took the form of pastiche, sometimes close copies of French pieces, beating a retreat into the kind of eclecticism that Art Nouveau aimed to oppose.

If American Art Nouveau furniture and ceramics were, on the whole, linked with the craft-inspired expression of American national identity, then poster art offered a more uncompromising reflection of America's aggressive modernity. Outside the rarefied environs of Tiffany's galleries and the select band of aesthetically enlightened collectors of art pottery, it was the poster that brought Art Nouveau to the average urban American. It was in America that large-scale posters, printed from woodblocks and stuck together for display, were first produced to advertise popular entertainments. However,

the most eye-catching and innovative posters had been designed in France, where the influences of contemporary art and the flat, simplified shapes in Japanese prints were felt from the mid-nineteenth century (see Chapter 2). Visits to the United States from Parisian artists in the 1880s helped to foster the new style. The magazine *Harpers* had commissioned Eugène Grasset to design covers in 1889, 1891 and 1892, and in April 1893 it initiated a poster craze in the United States when it began printing monthly posters simply displaying the name *Harpers*, the month, and a visually striking image depicting a fashionable middle-class figure. Designed by Edward Penfield (1855–1925), the posters were so successful that other magazines quickly followed the *Harpers* lead. From 1895 a rival publication, *Lippincott's*, hired J J Gould (1870–1966) to produce similarly arresting posters depicting bourgeois scenes. Gould's posters were more informed by French trends, his figures and faces more stylized; some show the influence of Toulouse-Lautrec in their composition and use of blocks of colour (175). Maxfield Parrish (1870–1966) also created posters and illustrations for American magazines, including *Harpers* and the *Century*, showing a wide range of European influence, from Mucha to the Pre-Raphaelite painters.

Bradley, hailed as the 'Dean of American Designers' by the *Saturday Evening Post*, was perhaps the most innovative graphic artist of the period. His work, first for the Chicago printing journal the *Inland Printer*, then for the literary magazine the *Chap Book* (176), and his own eponymous artistic journal *Bradley: His Book*, was informed by Beardsley's intricate style. Bradley shared with Beardsley the influences of Pre-Raphaelite and Arts and Crafts illustration, as well as developing a bold linear style that emphasized the stark contrast of blocks of black with lighter areas. Like that of Tiffany, Bradley's adventurous work was much admired in Europe. In 1894 the *Studio* published an article on Bradley, and his posters, together with Penfield's, were exhibited at Bing's inaugural Art Nouveau exhibition in 1895.

The ubiquitous success of the poster can be measured by the fierce paranoia it aroused in some of those who criticized it. In 1896 the

Chattanooga Sunday Times denounced the poster 'craze' in no uncertain terms:

A certain trend this poster designing has taken brings Max Nordau and his theories prominently to mind. Most of the examples are admirable designs ... but room is given, of course, for some work by Aubrey Beardsley and his likes. Nothing but Nordau's degeneration theory will explain why a man who can draw well deliberately chooses to draw ill – nay, why he draws worse than anybody could ever draw before, and then calls upon the world to see that he has made a discovery in art and founded a new school.

Max Nordau's popular book *Degeneration*, first published in German as *Entartung* in 1892, had been translated into English in 1895. In it he lamented that 'some among these degenerates are revered by numerous admirers as creators of a new art.' Such works, he argued, 'exercise a powerful suggestion on the masses ... a disturbing and corrupting influence on the views of a whole generation'. But it was not just the perceived moral depravity of the new art that offended conservatives such as Nordau. At the heart of their objections was a fear of modernity. An article in the *Chataquan* in January 1897 voiced these fears of its ephemeral immediacy:

Posters are fantastic, disjointed, perverse, uniquely new and diabolically modern ... The poster is a terrible agent of perversion. It exalts all that is frivolous and sensual, dissolves every high idea and strong sentiment ... The poster is indeed the art, and almost the only art, of this age of fever and of laughter, of struggle, of ruin, of electricity and of oblivion. Nothing of it will remain.

While posters offered Art Nouveau a populist, albeit ephemeral, outlet, it was in the architecture of the Midwest that the most original and intellectually coherent American expression of the spirit of Art Nouveau emerged. The architects Louis Henry Sullivan (1856–1924) and Frank Lloyd Wright (1867–1956) are not always thought of as exponents of Art Nouveau; the former is celebrated for his skyscrapers, the latter for the geometric simplicity of his architecture, and both are, like Wagner and Mackintosh, thought

175
J J Gould,
Poster for
Lippincott's
(December),
1896.
Lithograph;
39·6 × 32·8 cm,
16³⁄₄ × 13⁷⁄₈ in

176
**William H
Bradley**,
Thanksgiving,
cover for the
Chap Book,
c.1895

of as modern pioneers. But just because Sullivan and Wright were heralded as proto-Modernists by the Modern Movement after World War I, the Art Nouveau nature of their *fin-de-siècle* work should not be forgotten. Sullivan and Wright were preoccupied by the quest for appropriate decoration rather than the overthrow of ornament, and both shared with many of their European counterparts a tangible sense of Symbolism and mysticism.

Sullivan, the Chicago architect who employed Wright in the early 1890s, rose to prominence in the city during his fifteen-year partnership with the engineer Dankmar Adler (1844–1900). During Sullivan's time with Adler both their names became synonymous with the advent of the high-rise office building. The 1880s saw the birth of the skyscraper, the large-scale commercial building that embodied the spirit of expansion that permeated *fin-de-siècle* America. Made possible by the development of steel frames and practical by the invention of the elevator, these buildings became the focus of the debates within American architecture about style and decoration and the quest for an architecture appropriate to the age.

Sullivan's work in the 1880s and 1890s became a particular focal point, for not only did he build skyscrapers such as the Wainwright building in St Louis (1890) and the Schiller Theatre building in Chicago (1891), but he also decorated them. Sullivan put forward a series of highly original and apparently revolutionary decorative theories in which he argued the case for ornament in modern architecture in a much more coherent way than many of the medievalists and nationalists of European Art Nouveau. For Sullivan, ornament was as essential to his building as Adler's engineering genius. In his 1892 essay 'Ornament in Architecture', which was published, significantly, in the *Engineering Magazine*, Sullivan enthused:

We feel instinctively that our strong, athletic and simple forms will carry with natural ease the raiment of which we dream, and that our buildings thus clad in a garment of poetic imagery ... will appeal with redoubled power, like a sonorous melody overlaid with harmonious voices.

Here Sullivan applied the language of romantic Symbolism to functional architecture without a hint of contradiction. For him, the combination of decoration and engineering soared above mere cladding; it was the culmination of an ideal. Sullivan's creed was unambiguous: 'I believe that architectural ornament brought forth in this spirit is desirable because beautiful and inspiring.' Sullivan's ideas, then, offered a solution to the nineteenth-century dilemma of appropriate ornament that Art Nouveau strove to solve. A closer look at his decoration shows its links with European Art Nouveau, springing from a shared heritage of nineteenth-century design.

The culmination of Adler and Sullivan's partnership was the Guaranty Building (built as the Prudential Building) in Buffalo, New York in 1894–5 (177). It occupies a corner site and is twelve storeys high, plus the attic that housed the all-important elevator mechanisms. The building's steel frame was almost entirely clad in terracotta moulded with stylized organic decoration. This concealment of one material by another – the adornment of the structural, functional elements – was later repudiated by the hardliners of the Modern Movement for its cowardly denial of modernity, in the same way that Mackintosh's decorative work had been dismissed as an aberration.

The lower floor of the Guaranty Building constitutes a riot of stylized floral motifs combined with what Sullivan termed 'inorganic' motifs. On the pilasters flanking the main entrance were 'inorganic' taut, spiky abstractions, while the frieze above, with its circular repeat pattern, is embellished with stylized leaves. From a distance the capitals to the columns that interspace the shop fronts on the ground floor resemble starfish; on closer inspection they comprise intricate scrolling acanthus leaves which appear to lap upwards, almost growing into the decoration of the next storey (178). On the storey above, the decoration becomes bolder, in order to be visible from below, an optical device that is taken to its logical conclusion in the massive decorative portholes which line the cavetto frieze that forms the exterior of the top floor, the attic housing the lift mechanism. Here Sullivan's designs echo the circular

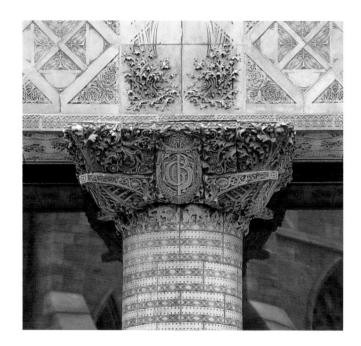

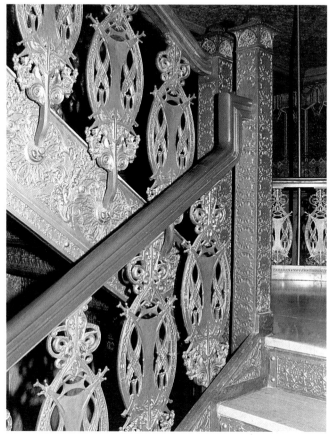

177–179
Louis Sullivan,
Guaranty
Building,
Buffalo,
New York,
1894–5
Left
Exterior
Above right
Pillar capital,
ground floor
Below right
Interior,
pierced
ironwork of
the staircase

motif above the entrance to create a linear web of sinews and tendons. Inside, the ornament continues unabated in the intricate pierced ironwork of the elevators and the staircase (179). Sullivan's building met with critical approval. For the architectural writer Montgomery Schuyler, there was 'no [other] steel-framed building in which the metallic construction is more palpably felt through the envelope of baked clay.' Writing a few years later in 1909, the architect Claude Fayette Bragdon (1866–1946) maintained that the Guaranty Building 'represents perhaps the highest logical and aesthetic development of the steel-framed office building'.

The Guaranty Building is all the more remarkable in that its design began in 1894, only a year after Horta built his first town house in Brussels. It places Sullivan alongside Gallé, Horta and Obrist as one of the pioneers of the use of stylized natural forms in *fin-de-siècle* design. Indeed, Sullivan's retrospective affirmation of his earlier ideas in his book *A System of Architectural Ornament* (published 1924) have a distinctive *fin-de-siècle* ring, long after the ideas they expressed had ceased to be fashionable. As a youth, Sullivan recalled hearing a lecture by the Harvard botanist Asa Gray on the functional morphology of plants. He claimed that this moment shaped his later theories, going so far as to urge his readers to refer directly to Gray's *School and Field Botany*. A more objective view of Sullivan's decorative influence links him with Pugin, Jones and Dresser, the work of all of whom he would have encountered during his brief spell in the office of the Gothic Revival architect Frank Furness (1839–1912) in Philadelphia in 1873. Drawings by Sullivan that survive from this time show him experimenting with stylized foliate forms. Later in his career, these broadly Gothic influences are most clearly demonstrated in the decorative ironwork that clothes the lower two storeys of the department store he designed for Schlesinger and Mayer (later Carson, Pirie, Scott & Co) in Chicago (180). Here Sullivan's combination of organic and geometric ornament reaches new flights of fancy. But it was typical of his bombastic self-confidence in his originality in design to claim that he had looked to science for his inspiration rather than to historical aesthetic traditions. This was, after all, the same

justification given by certain practitioners of Art Nouveau in Munich and elsewhere in their apparent rejection of old styles to create new art.

In true *fin-de-siècle* style, however, Sullivan's science quickly strayed from the rational into the heady world of Romanticism. Indeed, *A System of Architectural Ornament* ranks alongside the work of Gallé and Obrist in its scientifically inspired symbolism (181). The frontispiece sets the tone with its capitalized motto 'The Germ: The Seat Of Power'. Sullivan begins by invoking biology, describing how the seed germ contains the nourishment for growth, and goes on to attempt

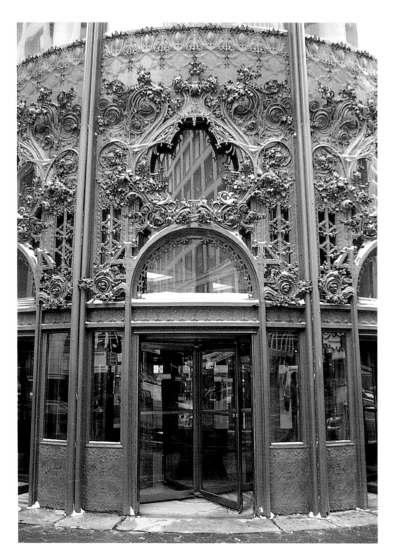

180
Louis Sullivan, Entrance façade, Schlesinger and Mayer Department Store (now Carson, Pirie, Scott & Co), Chicago, 1898–9

181
Louis Sullivan,
*Fluent
Parallelism*,
from *A System
of Architectural
Ornament*,
1922

to encapsulate his ideas in a distinctly mystical stylized prose: 'The Germ is the real thing; the seat of identity. Within its delicate mechanism lies the will to power: the function of which is to seek and eventually find its full expression in form.' Later in the work Sullivan proceeds to espouse an all-encompassing world-view he called 'parallelism', which had much in common with the Monism of Obrist and Haeckel in Munich (see Chapter 2):

Parallelism … calls this domain mystic, for within it art, science and philosophy fuse as it were into a single vital impulse … such considerations open to view a still larger domain of parallelism: namely the parallelism between man and nature, and between man and his works. These are self-contained within the all-embracing domain of life, the universal power, or energy, which forms everywhere at all times, in all places, seeking expression in form, and thus parallel to all things.

Thinking of Sullivan's standing at the time of the book's publication in the early 1920s, it would be easy for us to dismiss all this as the meaningless meanderings of an elderly architect, twenty years past his prime – a broken and embittered man largely forgotten by his peers. While these were indeed Sullivan's circumstances, it is difficult to deny his sincerity. The fact is that these kind of beliefs, no matter how loosely formed and contradictory they may be, did shape a radical set of aesthetic solutions to a modern problem. Most immediately, their influence was felt in the work of Sullivan's former employee Frank Lloyd Wright, who developed Sullivan's ideas into a more coherent yet equally mystic *fin-de-siècle* relationship between man, art and nature.

By 1900 Wright was already establishing himself as a radical artist and thinker who was pushing decoration to its limits. Wright's 1905 house for Susan Lawrence Dana, a Springfield socialite who inherited a fortune from her father's silver- and gold-mining business, may seem to be an unassuming monument to Art Nouveau from the outside, but it represents the culmination of his work during this period and survives today as a rare complete monument to the unity of Wright's vision. The interiors demonstrate the combination

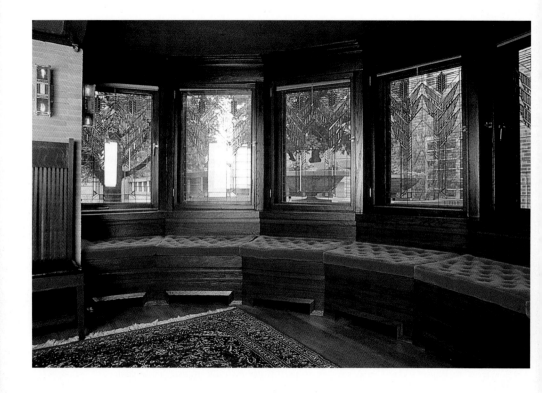

182–183
**Frank Lloyd
Wright,**
Dana House,
Springfield,
Illinois,
1905
Above
Dining room
Opposite
Fountain doors

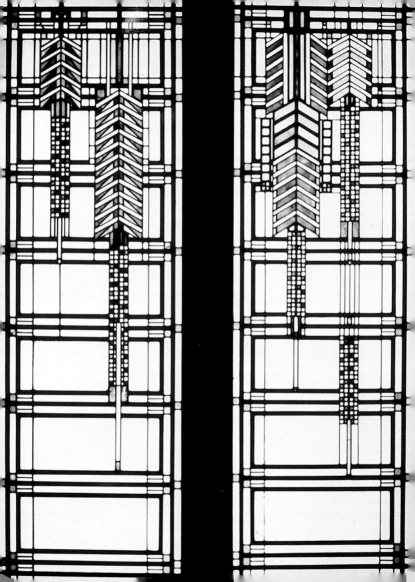

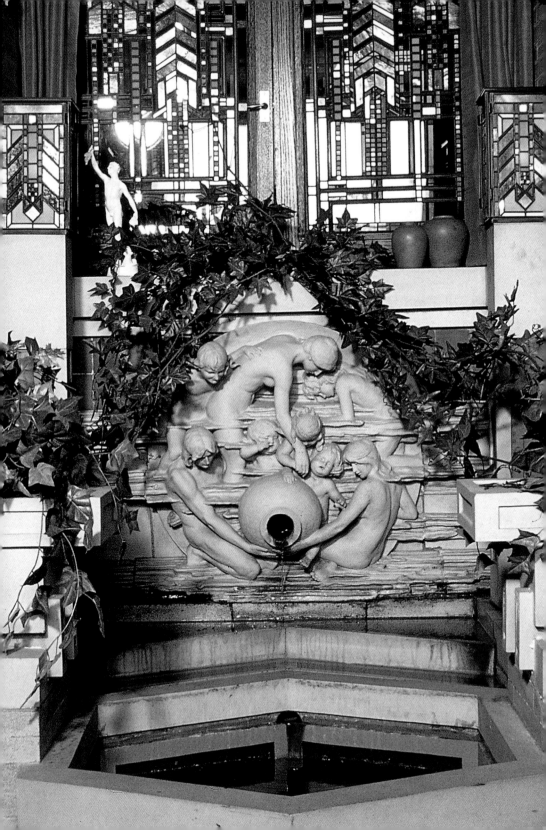

of his theories on the organic nature of interior space, with his use of natural forms as a decorative source. The rich array of art glass Wright used (182, 183), combined with the stylized plant pattern on the frieze of the dining room, reveal his affinity with the Art Nouveau project. Similarly, the two sculptures by Richard W Bock (1865–1949) in the entrance hall, the *Moon Children* fountain depicting naked maidens and cherubs floating in swirling mists (184), and the figure entitled *Flower in the Crannied Wall*, both attest to his continuing flirtations with Symbolism and mysticism, a factor that is often overlooked when Wright is considered in relation to Modernism.

Wright owed his appreciation of the importance of nature to Sullivan, writing of his former employer in 1910 that, 'He sees that all forms of nature are interdependent and arise out of each other.' Wright shared this kind of organic view of the world and humankind's part in it, and it is his belief in the organic nature of design that brings him so theoretically close, not only to Sullivan, but also to Gallé and Obrist. Wright's dedication to nature as a decorative source around the turn of the century can most clearly be seen in the beautiful stained glass windows in many of his 'prairie' houses. A surviving design for a screen from around 1900 (185) also shows his relatively literal stylization of plant forms, and even his continuing similarities with Sullivan – notice the 'seed-germ' motif surmounting the whole design. Perhaps the most Sullivanesque example of Wright's decoration is a ceiling grille from Wright's own house in Oak Park, Illinois, which dates from 1895 (186). Here geometric, almost Gothic, shapes are combined with scrolling oak branches. It is significant, however, that Wright's naturalistic ornament always retains a measured symmetry.

Wright never indulged in the unrestrained exuberance of Obrist and Gallé. His real innovation in applying nature to his art came not only in organically inspired decoration, but in his belief in the organic nature of the very spaces he designed. He was not content with Sullivan's desire to unite ornament and structure. Sullivan's system seemed to address only the building itself, and primarily only the exterior. Wright wanted to unite the exterior with the interior;

184
Richard W Bock,
Moon Children
fountain,
1905.
Brick and
terracotta;
182·9 × 167·6 cm,
72 × 66 in.
Dana House,
Springfield,
Illinois

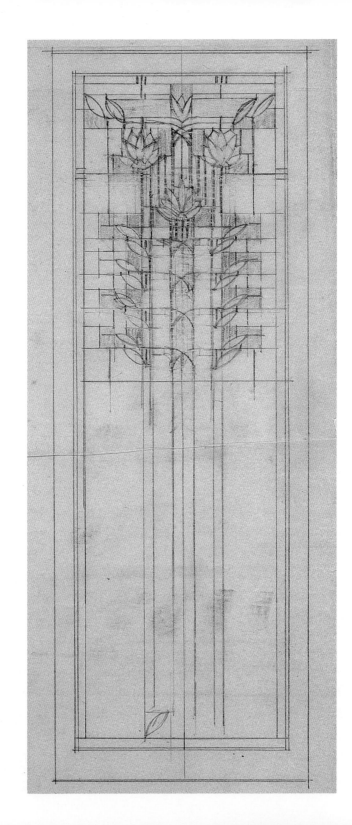

185
**Frank Lloyd
Wright**,
Design for a
screen,
c.1900–10.
Pencil and
coloured pencil
on tracing
paper;
42·2 × 14 cm,
16⁵⁄₈ × 5¹⁄₂ in.
Frank Lloyd
Wright
Archives,
Scottsdale,
Arizona

186
Frank Lloyd Wright,
Plan entitled
Dining Room Ceiling Grill from the Oak Park Home, 1895.
Sepia;
61 × 91·4 cm,
24 × 36 in.
Frank Lloyd Wright Home and Studio Foundation, Oak Park, Illinois

his concern was as much with internal space as with external appearance. Writing in 1910 he explained that,

In organic architecture then, it is quite impossible to consider the building as one thing, its furnishings another and its setting and environment still another. The spirit in which these buildings are conceived sees all these together at work as one thing. All are to be studiously foreseen and provided for in the nature of the structure ... the very chairs and tables, cabinets and even musical instruments, where practicable, are of the building itself, never fixtures upon it. No appliances or fixtures are admitted as much where circumstances permit the full development of the organic character of the building scheme.

So it is Wright who emerges in 1910 with perhaps the most complete expression of the Art Nouveau ideal – the unity of man and nature. It is ironic that, given Wright's commitment to the organic, his geometric forms came to inspire those who later saw the machine as the aesthetic saviour of mankind. By considering Wright as part of Art Nouveau, however, we remind ourselves that he was not an errant visionary waiting for the world to catch up with him, but a central figure on the *fin-de-siècle* scene. Indeed, the similarity of his decorative work to that of Mackintosh and Viennese designers shows he was part of a broader geometric trend within Art Nouveau, which he was far from aspiring to overthrow. In fact, it is Wright's elucidation of his theories of 'organic design' that most completely reconciles two apparently contrasting tendencies of Art Nouveau. His ideas do not reject nature as a source, or even try to temper it with classicism, as in Hoffmann's case (see Chapter 3), but strive to bring together the naturalistic and the geometric.

Furthermore, Wright's aesthetic relationship with Mackintosh and Hoffmann offers another fascinating example of the confusion over influences between Europe and America. Is it possible to discover whether Wright was inspired by Mackintosh's work or vice versa; or did both men simultaneously develop comparable ideas independently? The fact that Mackintosh's designs were published in the *Studio* in the late 1890s has until recently been

187
**Frank Lloyd
Wright**,
Dining room,
Frank Lloyd
Wright Home
and Studio,
Oak Park,
Illinois,
1895

enough to convince most people that Wright was indebted to European developments. But the fact is that Wright had employed his geometric high-backed chairs (187) as early as 1895, before similar designs by Mackintosh. The influence of periodicals was not all one-way: Wright would certainly have eagerly read the *Studio*, yet it was equally likely that European designers saw American magazines such as *House Beautiful*, which illustrated and discussed Wright's distinctive dining room furniture in an issue of 1895. Whatever the case, it is enough to know that Wright considered himself part of developments in Europe, and thus part of Art Nouveau. Although Wright's own writings should not be taken at face value, as he was often the author of his own myth, he did write in the 1950s that his affinities at the turn of the century were with 'The Mackintoshes of Scotland; restless European Protestants also – Van de Velde of Belgium, Berlage of Holland [and] Adolf Loos and Otto Wagner of Vienna.'

It is appropriate that Art Nouveau reached its theoretical apogee in the New World, with Wright's 'organic architecture'; but the New World was more than just the United States. In 1900, the Americas could boast the majority of the world's republics, and the Rio Grande was no barrier for Art Nouveau. Compared with the relative maturity of the United States, the recently independent countries of Latin America were fledgling nations. Culturally, the differences were clear. The élite in the United States was Anglo-Saxon, while Iberian influence dominated in the South. While the United States was enjoying the fruits of a long period of economic growth that had lasted since the end of the Civil War in 1865, the countries of Latin America and the hispanic Caribbean were just emerging from the yoke of Spanish and Portuguese colonialism, which had imported Roman Catholicism and subjugated indigenous populations. They were new countries in search of an identity, and their newly wealthy bourgeoisie was keen to assert its status. When Art Nouveau appeared in South America, it fulfilled different functions and took on different incarnations to those that characterized North American Art Nouveau. In Argentina, Brazil and the Caribbean, Art Nouveau emerges with a wholly different flavour.

To an extent, Art Nouveau in the United States had been home-grown. Wright's organic architecture drew heavily on his mentor Sullivan, while Sullivan in turn was influenced by the Gothic of Furness. Similarly, both Louis Comfort Tiffany and his father's firm Tiffany & Co drew on the same sources as French Art Nouveau, rather than merely following in its wake. In contrast, Art Nouveau in Latin America had a distinctly imported feel. In a country such as Argentina, the style did not grow out of an indigenous Arts and Crafts Movement; nor did the country have an established architectural profession to nurture the new style. Instead, it was the work of myriad European craftsmen and architects, immigrants from Italy in particular, as well as Germany, Catalonia and France.

Argentina provides a useful case study for the experience of Art Nouveau in Latin America. Like many other countries in the region, it had only recently begun to assert itself in a post-colonial era. In Argentina the end of colonialism did not result immediately in political freedom. A revolt in 1810 had established a locally elected government in Buenos Aires, and a formal declaration of independence from Spain followed in 1816. The ensuing years, however, were marked by violent struggle between those trying to unite the country and those, led by local *candillos* ('strong men'), who did not want to be dominated by Buenos Aires. Virtually continuous civil war and dictatorship came to an end only in 1880, when General Julio A Roca became president and made Buenos Aires the capital. The Argentine economy flourished under Roca, though agricultural expansion led to suffering for indigenous peoples as forests were cleared.

The rapid development of the country, and of Buenos Aires in particular, meant that, as in Barcelona (see Chapter 4), urban expansion was taking place as the Art Nouveau style was becoming predominant in Europe. In Buenos Aires an attempt was made to modernize the city as Baron Haussmann had in Paris in the 1850s and 1860s under Napoleon III. Just as Haussmann had cut swathes through the decrepit and potentially revolutionary medieval streets of Paris with his grand boulevards, so two diagonal avenues were

constructed through the heart of the new Argentine capital. This
period of rebuilding, which included many new commercial and
municipal buildings, was accompanied by the rise of the new
haute bourgeoisie. These rich cattle ranchers were keen to express
their new-found prosperity, and turned to architecture as a way
of achieving this.

These factors combined to produce the construction of a number
of buildings with distinctively Art Nouveau façades. Particularly
noteworthy is the house designed by Enrique S Rodríguez Ortega
on Rivadavia Street (188). Built in 1905, it is surmounted by a strange
bearded mask surrounded by root-like carvings. The undulating
façade is decorated with an applied carved relief leaf-and-flower
design, while the curving balconies feature adventurous ironwork,
its technical complexity rivalling any comparable European
examples. A more restrained and sober French-influenced building
is the department store Casa Moussion (now Fundación Banco
Patricios), which was built in 1908 by the French émigré architect
Emilio Hugé (1863–1912) and would not have looked out of place
in any of the great European cities at the turn of the century.
There were few established Argentine architects at the turn of
the century. Juan Antonio Buschiazzo (1846–1917) was the first
locally educated architect. Jonás Larguía (1832–91) had studied in
Rome and Ernesto Bunge (1839–1903) in Germany. It is thus not
surprising that European forms proliferated, mainly in the hands
of immigrant architects. Among the most influential was Alejandro
Christophersen (1866–1945), who was of Norwegian and Spanish
descent and had studied in Brussels and Paris before moving to
Argentina in 1888. Christophersen became the head of Argentina's
first school of architecture, established within the University of
Buenos Aires. Other immigrant architects of the period included
the Italian Vittorio Meano (1860–1904), the Belgian Jules Dormal
(1846–1924) and the Frenchman Louis Dubois (1867–1916).

Art Nouveau was not the only style imported via this influx
of émigrés, and eclecticism became a byword for *fin-de-siècle*
architecture in Argentina. Most new architecture was dominated

188
Enrique S
Rodríguez
Ortega,
2031 Rivadavia
Street,
Buenos Aires,
1905

by Neo-Baroque and Neo-Rococo styles. The French connotations of such forms suited the Argentinians, who were keen to forge an identity free from references to the old Spanish colonialism. Indeed, it was a desire on the part of the new bourgeoisie to express a European identity, over and above a specifically modern one, that encouraged the growth of eclecticism. The theatrical nature of this hectic and often pompous mixture of styles was matched by its comical colloquial name. The 'chorizo' style took its name from a type of Spanish sausage, presumably a reference to its countless mysterious ingredients. Similarly, in Brazil, a country in which architecture also took a turn towards the eclectic, the mixture of aesthetics was popularly called the *bolo-de-novia* ('wedding cake'), because of its elaborate and highly decorative nature. It was an eclectic–academic style building that won the Brazilian Pavilion the first prize for international architecture at the 1904 St Louis World Fair, and in both Brazil and Argentina Art Nouveau formed part of this eclecticism rather than a reaction to it.

In Argentina this trend often took the form of a superficial presence of Art Nouveau detailing, particularly ironwork and stained glass, on historicist buildings. Buildings that took traditional European styles as their first point of reference were embellished with features to give them an air of fashionability. For example, the French-born architect Pablo Pater established himself as a designer of apartment blocks in Buenos Aires. His buildings, such as 1175 Ríobamba Street (1909), combine traditional French Beaux-Arts ornamentation on the façade with elaborate geometric stylizations of floral forms (189). The demand for such detailing was satisfied by an extensive iron-casting industry in Buenos Aires, to the extent that in 1913, *Arlas*, the city's commercial guide, featured twenty-four pages of companies producing iron fittings. Such adverts as that for the Ironwork and Decorations Workshop Genaro Russo, featuring a blacksmith grappling with wrought-iron foliate tendrils, showed that these manufacturers and suppliers were well aware of the decorative possibilities of iron and in particular its suitability for crafting Art Nouveau forms.

189
Pablo Pater,
Cast-iron balcony,
1175 Ríobamba Street,
Buenos Aires,
1909

In addition to Pablo Pater's adaptation of general European trends, there were examples of ironwork in Buenos Aires that seemed to draw on particular sources. On the buildings of Virginio Colombo, the combination of roughly textured naturalistic scrolling with smooth linear forms (see 162) recalls the ironwork of Antoni Gaudí's fantastical dragon gate on the entrance to the Güell Pavilions near Barcelona (see 157). In general, the influence of Catalan *Modernista* style seems to have been no greater than that of any other particular strain of European Art Nouveau, although it did possess a peculiar double attraction in Argentina and elsewhere in Latin America.

While it was of Iberian origin, it embodied Catalonia's own nationalist aspirations and was thus non-Spanish – an appealing trait in post-colonial Latin America. In Argentina a direct link with the Catalan *Modernista* tradition existed in the person of Julián Jaime García Núñez (1875–1944), a native of Buenos Aires who had been educated in Barcelona, where he studied under Lluís Domènech i Montaner. His works bear a strong resemblance to the distinctively Moorish–Gothic blend of styles that characterized Catalan *Modernista* architecture. The Hospital Español, built in 1908 after

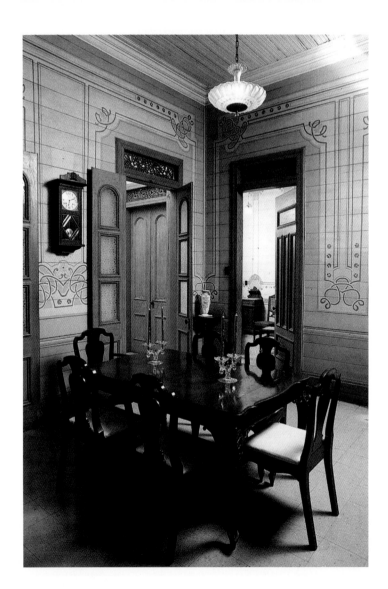

García Núñez's design was chosen in an open competition (now partly destroyed), had minarets and domes that betray a distant Moorish influence. Similarly, the minaret tower (now destroyed) that surmounted the spectacular residence he designed for Celedonio Pereda, also completed in 1908, bears a passing resemblance to that of Domènech's Palau de la Música Catalana, which was designed and built around the same date (see 152).

The Caribbean too felt the influence of developments in Catalonia. In Puerto Rico there was a strong Catalan presence among the

colonial plantation owners who continued to dominate Puerto Rican life throughout the period. During the final phase of Spanish rule, it has been estimated that ninety per cent of the island's trade was concentrated in Catalan hands, and the resulting cultural dominance ensured the presence on the island of books, magazines, newspapers and consumer goods from Barcelona.

When a degree of autonomy from Spain was finally granted in 1898 it was shortlived. During the Spanish–American War that erupted the same year, US troops occupied Puerto Rico, and when the war ended the colony was ceded to the United States. While Puerto Rico was guaranteed an export market in the United States for sugar, there was a shift in ownership of land from small landowners to large sugar corporations. Discontent with the American regime was exacerbated as many Puerto Ricans saw it as a menace to the Iberian roots of their culture. So although Puerto Rico remained a colony, it too fostered its own limited version of the *Modernista* movement in architecture and literature. At a time when Puerto Ricans faced key issues of cultural assimilation (the use of English rather than Spanish was encouraged and US citizenship introduced), the style expressed the continuing importance of Catalan culture.

Art Nouveau came late to Puerto Rico, the most celebrated examples dating from after 1910, but when it arrived it shared one notable function of the style with its European and American incarnations: that of beautifying the homes of the bourgeoisie. Despite its classical pretensions, the interior of the Oritz Perichi House in San Germán, built for the landowner Juan Ortiz Perichi in 1920, is characterized by the distinctive, flowing linear fretwork that frames the circular doorways and emphasizes the curving lines of the ceiling. It shares with the Catalan tradition an extensive use of decorative tiles, a feature that carries more explicitly Art Nouveau decoration in the Acosta y Forés House, the San Germán residence of another landowner, Jaime Acosta y Forés (1917). In the dining room (190), the Art Nouveau decoration combines twisting whiplash forms and floral motifs with stricter geometric lines,

but the effect remains essentially light and playful rather than challenging or exciting. Although tame by the standards of Brussels, as well as being hopelessly out of date for their time, these two houses do represent a bid for a sort of fashionable modernity on an island that had for so long been dominated by the apparently timeless simplicity of cool, heavy whitewashed Caribbean colonial architecture.

The United States, Argentina and Puerto Rico together illustrate the vast contrasts that existed in the New World, but all three were touched by Art Nouveau. The style did not take root in these places simultaneously, nor did it even share a common aesthetic or common meanings. But the fact that traces of it could be found in the Caribbean and the depths of the southern hemisphere as well as the Midwest confirms the international nature of Art Nouveau. As befitted the outlook of those who designed, commissioned and consumed Art Nouveau, the style could express the European identity of an old colonial class, the independent identity of a post-colonial bourgeoisie, and the artistic maturity of a country that would soon assert its status as the world's richest and most powerful nation.

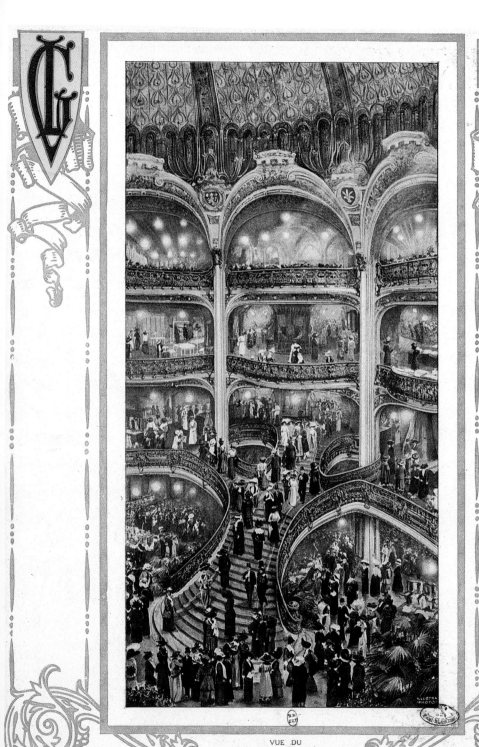

VUE DU

NOUVEAU GRAND HALL

1912

No style can exist unless it is bought and sold. Buildings must be commissioned, furniture and objects displayed for sale and acquired. Without such commercial activity no aesthetic trend can be disseminated or be said to be representative of its age. Of the various paths to understanding Art Nouveau, one of the most interesting is the style's commercial profile. By exploring who was buying and selling the new style, and the methods with which it was marketed and promoted, a sense can be gained of how contemporaries perceived Art Nouveau.

As with so much of the history of architecture and design, it is the large-scale projects resulting from private patronage that one remembers today as the style's great statements. Many of the examples of Art Nouveau architecture encountered in earlier chapters were commissioned by wealthy urban bourgeois industrialists: Fyodor Shekhtel''s Ryabushinsky House in Moscow (see 140–143), Antoni Gaudí's Palau Güell in Barcelona (see 155, 156), Frank Lloyd Wright's Dana House in Springfield, Illinois (see 182–184). Of these patrons, Stepan Ryabushinsky was a young member of a prosperous textiles dynasty; Susan Lawrence Dana was the heiress to a silver- and gold-mining fortune; and although Eusebio Güell was an aristocrat, his title went back only to his father-in-law. Güell himself was first and foremost a textile magnate, and his money was firmly industrial rather than agrarian. It might, then, be tempting to conclude that Art Nouveau was a style favoured by a wealthy urban bourgeoisie and was thus conservative in nature. At a time when social upheaval was in the air, and unease with the inequities of industrial capitalism was growing, Art Nouveau found its home where the money and power were concentrated.

Yet Art Nouveau was not the only style employed by the upper middle classes. Moreover, Art Nouveau patrons were far from

191
Artist's
impression of
the new Grand
Hall, Galeries
Lafayette,
Paris, 1912.
Photo-
mechanical
print;
28·5 × 14 cm,
11¼ × 5½ in

typical members of their class. Ryabushinsky was a refined collector and aesthete, who was only twenty-six years old when he commissioned Shekhtel'; Dana was an art collector and cosmopolitan socialite who developed an interest in mysticism and spiritualism; and Güell was a politically active Catholic paternalist, who built a village for his workers. They employed their architects to make statements of intellectual refinement and artistic adventure, and so by definition were exceptional. Art Nouveau was not widely adopted by the industrial bourgeoisie, many of whom continued to favour a dour, masculine historicism. By contrast, the typical patron of Art Nouveau was not just rich but also saw him or herself as culturally and socially enlightened.

In his *Mémoires*, the Belgian architect Victor Horta recalled the sympathetic relations he enjoyed with Armand Solvay, who was then a manager at the family chemicals firm Solvay & Co. Horta had designed a town house in Brussels for the Solvays in 1894 and later reminisced on the subject of architect–client relations:

[these were] enhanced by the intelligence and charm of [Solvay's] wife who was more open to modernism than her husband, who had always lived in an environment where moderation was favoured over audacity, and art was above all 'well-bred', which as far as architecture was concerned meant 'of a period style'. In fact I was welcomed into that milieu because choosing me was a sign of daring, of energy and independence and was an expression of the energy the Solvay brothers had needed to invent their soda.

As well as being the choice of discerning individuals, Art Nouveau was a public style commissioned by companies, such as the car manufacturer Fiat in Milan, and by organizations, such as the Belgian Workers' Party in Brussels. It was also commissioned by city authorities, such as those of Paris, who chose Guimard's designs for Métro stations (see 2), and nation states, such as Finland, which was represented by Saarinen's Finnish Pavilion at the Paris 1900 Universal Exposition (see 126). As a public style, Art Nouveau signalled a wide-ranging quest for modernity. Finland longed to be a modern independent European nation; the Paris Métro was a

symbol of a truly modern metropolis; and Fiat were at the forefront of a technological development that would come to be seen as emblematic of the twentieth century. Similarly, the Belgian socialists saw themselves as advocates of an educated, egalitarian society, poised at the dawning of a democratic age.

Perhaps the most influential public manifestation of Art Nouveau, however, was in the design of shops and department stores. In Chicago, Sullivan's Carson, Pirie, Scott department store had an adventurous and elaborate wrought-iron Art Nouveau entrance façade, which provided an otherwise austere building with a distinctive and luxurious presence (see 180). This kind of selective and highly deliberate commercial use of modern decoration, on both the exterior and interior of new shops and stores, is important in understanding what Art Nouveau meant to contemporaries, and also how the style found its way to the streets of cities and towns from Brussels to Buenos Aires.

In Brussels, Horta and his fellow Belgian architects Paul Hankar and Paul Saintenoy (1862–1952) were commissioned to design a number of shops in the new style. They demonstrated the commercial viability of iron and glass, as Sullivan had done in Chicago, in the glazed façades of Saintenoy's 1899 Old England (192) and Horta's more aptly named À L'Innovation, built in 1901 (193), two of the city's largest department stores. The front of À L'Innovation appeared to swell up rebelliously from the conventional buildings flanking it. Huge windows eliminated the need for exterior masonry and enticed passers-by with clear views of the vast array of goods within (194). They also provided shoppers with light, airy spaces, reminiscent of Horta's designs for the Maison du Peuple (see 42). Such was the impact of À L'Innovation, that Horta was soon commissioned to design another store, the Grand Bazar Anspach, which was built in 1903. The Grand Bazar offered a more sober architectural solution, eschewing a glass façade and reintroducing masonry on the upper floors to complement the apartment blocks on either side of the store. At the same time, however, a firmly contemporary note was struck in the use of wing-like glass canopies

above the main entrance, similar to some of Guimard's more outlandish Paris Métro stations. Horta's design was evidently considered a success, as the same firm commissioned him to design their Frankfurt branch in 1905. While this building recalled the glass façade of À L'Innovation, it still very much conformed to the nineteenth-century 'mansion block' form.

The significance of these Art Nouveau emporia, and others like them in Milan, Paris and elsewhere in Europe, cannot be underestimated. The advent and rapid expansion of the department store is now

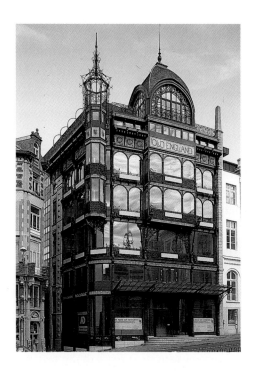

recognized as one of the defining cultural developments of the second half of the nineteenth century. These grand new palaces, often constructed with those quintessentially modern materials, iron and glass, redefined the shopping experience and offered new leisure pursuits to middle-class women, as well as employment for lower middle- and working-class women. Along with many floors of merchandise, some stores boasted rest rooms, cafés and even art galleries. They were new spaces that enabled women to spend more time in the city centre.

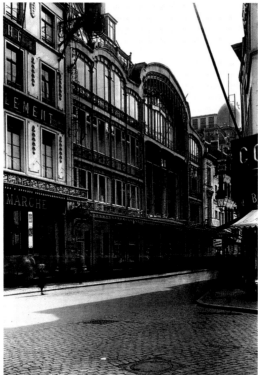

192
Paul Saintenoy,
Old England
department
store, Brussels,
1899

193–194
Victor Horta,
À L'Innovation
department
store, Brussels,
1901
Above
Exterior
Below
Interior

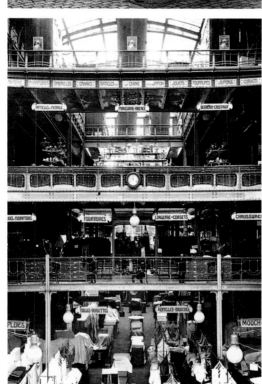

Although department stores predated Art Nouveau – Le Bon Marché, which opened in Paris in 1869, is usually cited as the first – the style provided them with a highly appropriate aesthetic. These buildings were versatile spaces, and Art Nouveau was a versatile style with versatile meanings. For *fin-de-siècle* shoppers, Art Nouveau held strong connotations with the modern artistic domestic interior, yet had at the same time an exoticism that made the retail environment temptingly different. Department stores were spaces where women could buy objects and furnishings for their homes and where they could be sold decorative ideas. It made commercial sense, therefore, for a store such Galeries Lafayette in Paris to commission Louis Majorelle to design its grand new staircase around 1912 (191). Adopting the style of the modern artistic domestic interior, this new feature helped to create the perfect setting to sell modern furniture, fabrics, wallpaper, jewellery and clothes.

Other equally celebrated Art Nouveau retail spaces served a mainly male clientele. In 1899 Henry van de Velde designed the interior decorations of the Havana Tobacco Company Shop in Berlin (195), followed in 1901 by the shop of François Haby, the imperial barber, in the same city (196). Both were bastions of masculinity. The barber's shop offered what one might expect: an apparently functional interior in which such elements as the hot water and gas pipes were left exposed and used as decorative features. Only streets away, the Havana Tobacco Company Shop was an extravagant exercise in fantasy. Its furnishings, fittings and painted decoration were harmonized to create a linear sense of upward movement, culminating around the top of the room with an abstract swirling repeat frieze, emblematic of wafting cigar smoke. Smaller architectural commissions such as these offered designers and architects greater creative freedom: their patrons could afford to be more enlightened because the sums and risks involved were smaller, and the scale of the space offered more scope for complete decorative extravagance and radical experimentation.

One of the most renowned examples of this phenomenon can be found in Glasgow, in the tea rooms commissioned by Catherine

(Kate) Cranston from Charles Rennie Mackintosh and his wife Margaret Macdonald. Art Nouveau was adopted as a decorative style for fashionable restaurants and hotels across the world, from the Metropole Hotel in Moscow to the American Hotel in Amsterdam, but this series of projects resulted in some of the most stunningly innovative rooms of the period. At first glance, Cranston might seem an unlikely patron of the avant-garde – until her death in 1934 she dressed in the fashions of the mid-nineteenth century, a sartorial sobriety that was reflected in her support for the Temperance movement. It was partly as a result of the demand for alternative places of refreshment to the public house that tea rooms flourished in the late nineteenth century. In 1889 the *Bailie*, Glasgow's fashionable weekly magazine, reported that 'the tea room is among the newer features of Glasgow life. Not so long ago there was nowhere for those who desired refreshment beyond the bar of the public house and the parlour of the restaurant.' In this respect, Cranston's choice of Art Nouveau was an expression of innovation and non-conformity in a city dominated by a masculine culture of alcohol drinking.

Cranston's father had been a successful Glasgow tea importer, who had established the first tea room in the city in 1875. As an indication of his success, by 1905 his company, Cranston's Tea Rooms Ltd, issued debenture stock worth £250,000. In 1878 Catherine opened the first of her own tea rooms, independently of her father, at 114 Argyle Street. She started to commission Mackintosh to design elements of, and then complete interiors for, these tea rooms in 1896. His first work for her comprised the Symbolist wall decorations for her Buchanan Street tea rooms (197), followed two years later by furniture and light-fittings designed as part of the refit of the Argyle Street premises. Of Buchanan Street, the *Studio* wrote that it wished Mackintosh 'had been able to control the structural features of the space he adorned. Some iron ventilators of commonplace design ruin at least one of these walls and clash painfully with Mr Mackintosh's work.' This wish was to be granted in 1900, when Cranston commissioned complete new interiors from Mackintosh at her Ingram Street tea

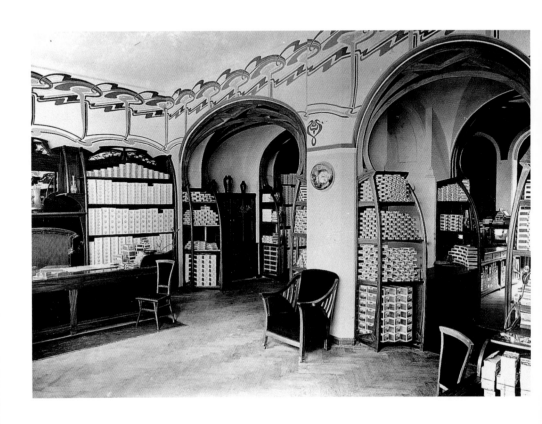

195
**Henry van
de Velde**,
Havana
Tobacco
Company
Shop, Berlin,
1899

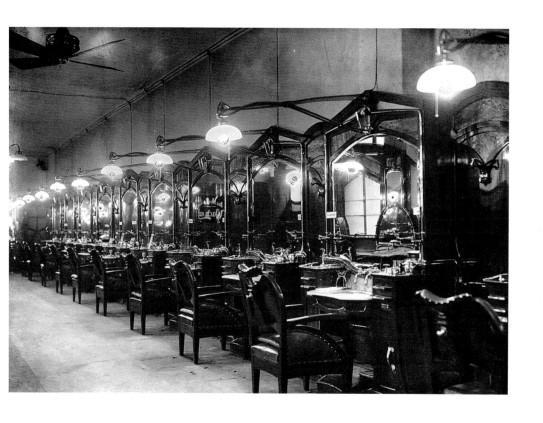

196
**Henry van
de Velde**,
François Haby's
Imperial Barbers,
Berlin,
1901

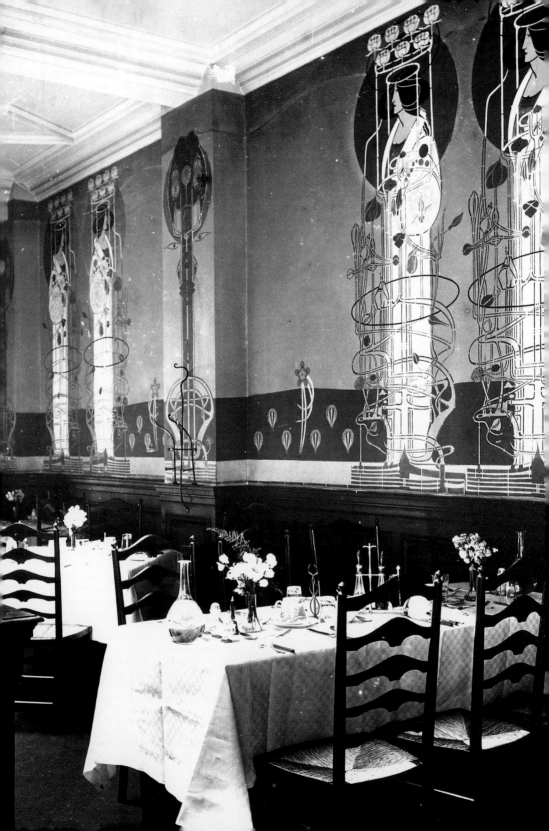

room, and again in 1903, this time on a larger scale at the Willow Tea Rooms on Sauchiehall Street (198).

Soon after the doors opened at the Willow Tea Rooms, the *Glasgow Evening News* enthused: 'until the opening of Miss Cranston's new establishment in Sauchiehall Street today, the acme of originality had not been reached.' Originality and novelty were evidently two of the things that Catherine Cranston hoped her patronage of Mackintosh and Macdonald would bring to her business. She was an astute businesswoman who obviously saw the commercial advantage of adventurous design.

197
Charles Rennie Mackintosh, Buchanan Street tea rooms, Glasgow, 1896. Photographed c.1897 in its original condition

198
Charles Rennie Mackintosh, Front tea room, Willow Tea Rooms, Glasgow, 1903

How were Mackintosh and Macdonald's decorations interpreted by Saturday-afternoon tea-drinkers? Some might have been aware of the mild controversy that had surrounded an exhibition at the Institute of Fine Arts in 1894, which included the work of members of the new Glasgow School. While Glasgow's *Evening News* carried one of the kindest reviews, describing their work as 'quite remarkable', the conservative weekly *Quiz* described the 'ghoul-like designs of the Misses Macdonald'. The *Bailie* railed against the 'weird designs, the impossible forms, lurid colour and symbolism'. This may not represent what the public actually thought, although the artists were popularly known as 'the Spook School'.

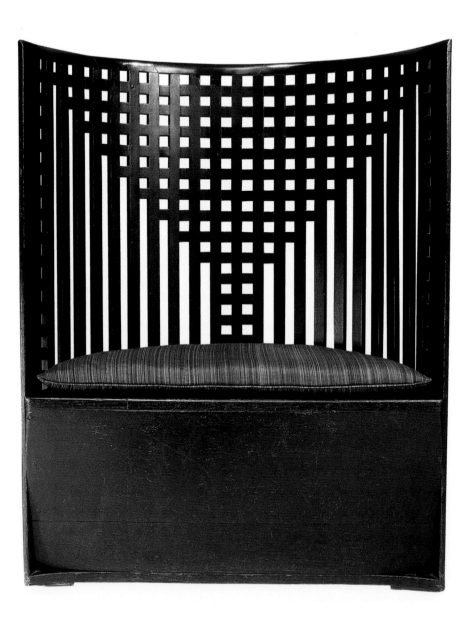

In aesthetic terms, the furnishings of the Ingram Street and Willow tea rooms were uncompromisingly modern. Everything was designed by Mackintosh and Macdonald to contribute to the total visual experience: the geometric forms and unusual scale of the furniture, the adventurous lighting, and even the waitresses' uniforms. A menu card (200) designed by Margaret Macdonald for Miss Cranston's café The White Cockade at the International Exhibition in Glasgow in 1911 demonstrates how this integration of architecture and interior design was extended to graphics. Compared with the expected norms of Edwardian tea rooms, with their ceramic tiles and grand spaces – also artistic in their own way – the scale and intimacy of Miss Cranston's tea rooms struck a more domestic note. Distributed over several floors and in small rooms, the scale and separation of spaces was homely, and the privacy given to individual tables by the surrounding high-backed chairs contributed to this effect. A magnificent cube-shaped chair (199) for the manageress of the Willow Tea Rooms was positioned between the front and back salons, serving the architectural function of dividing the different spaces.

In both the brightly lit modernity of Brussels' department stores, and the intimate and innovative urban refuges of the Glasgow tea rooms, Art Nouveau was used to create successful commercial spaces. Equally important in assessing its significance, however, are the environments in which Art Nouveau objects themselves were bought and sold. The successes and failures of businesses that promoted the style at various levels of the market can be revealing. At the upper end of the market, the most celebrated retailer was Siegfried Bing (see Chapter 1). Given Bing's importance in fostering Art Nouveau, it is easy to forget that he was primarily a businessman – a gallery-owner and shopkeeper – although there is little evidence to suggest his Paris gallery, L'Art Nouveau, was ever a roaring financial success. When it closed in 1904, the large inventory of its unsold stock suggests that by this time business was bad. Indeed, it may never have brought Bing large financial rewards. There is nothing to suggest that he had the kind of big-spending regular clients that an ambitious art and design business would

199
Charles Rennie Mackintosh, Chair for the order desk, Willow Tea Rooms, Glasgow, 1904. Ebonized oak, reupholstered with horsehair; h.118·2 cm, 46 in. Glasgow School of Art

200
Margaret Macdonald, Design for a menu card for Miss Cranston's exhibition café, The White Cockade, at the International Exhibition in Glasgow, 1911. Gouache and watercolour on black paper; 21·8 × 31·6 cm, 8³⁄₈ × 12¹⁄₂ in. Hunterian Art Gallery, University of Glasgow

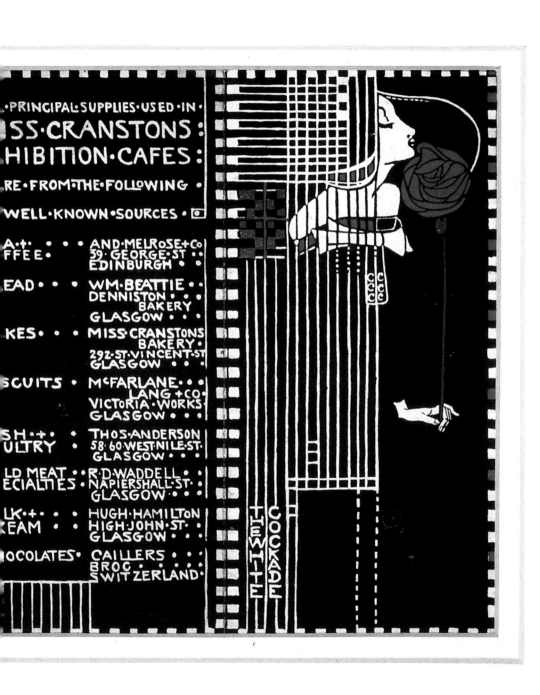

have needed in order to prosper. Works by Édouard Colonna are known to have helped furnish a handful of houses in Brittany and Normandy, but there were no known sales of complete interior schemes such as those exhibited at the 1900 Universal Exposition.

It is ironic that, given Bing's ambition to create the very embodiment of traditional French craftsmanship at the 1900 fair, the largest recorded group of sales from L'Art Nouveau was to foreign decorative arts museums. Three pieces from the Édouard Colonna drawing-room exhibited by Bing in 1900 – a chair, an armchair and a table – were sold to the Kaiser Wilhelm Museum in Krefeld, Germany, indicating that Bing was forced to split sets of furniture that had been designed as unified ensembles. The Finnish Society of Craft and Design bought furniture, ceramics and bronzes by Colonna, de Feure and Gaillard, while the Museum of Decorative Art in Copenhagen bought furniture by Gaillard, as well as a vase by the American ceramicist Grueby, for whom Bing was the European agent. A bill for 14,984 francs survives for this purchase, while the prices paid by the Kaiser Wilhelm Museum give us a further insight into the potential cost of a shopping trip to the L'Art Nouveau gallery. The museum's table alone cost 450 francs, the chair 250 francs.

Bing also made sales to the Musée des Arts Décoratifs in Paris and the Victoria and Albert Museum in London, although both institutions seem to have had ambivalent attitudes towards his wares. The Musée des Arts Décoratifs purchased a selection of objects from Bing in 1902, after his exhibition at the Salon des Beaux Arts. It is misleading, however, to judge his success by the large number of objects with a Bing provenance in the museum's collection today. A sizeable proportion of its collection, including ceramics by de Feure and Colonna, comprises unsold objects that were inherited by Bing's son Marcel in 1905 and given to the museum in 1908. At the time of the Universal Exposition, the Victoria and Albert Museum dispatched the London art dealer George Donaldson to Paris for the purpose of selecting examples of Art Nouveau furniture, 'to illustrate the advance made by foreign

manufacturers in the New Art movement which commenced in England'. Yet the £500 the Victoria and Albert Museum allocated to this foray into Europe was deemed by Donaldson to be so paltry that he himself purchased further examples, which he donated to the museum on his return. Although not all Donaldson's purchases were from Bing (he also bought from Gallé and Majorelle), they did include a table by Colonna.

Bing was undoubtedly Art Nouveau's most eloquent spokesman and impresario, but he was not necessarily its most commercially astute entrepreneur. Despite its pioneering role within the development of Art Nouveau, his business was short-lived. Other, better businessmen realized the potential market for Art Nouveau, and that this market included both wealthy aesthetes and middle-class homemakers. The scale of Louis Majorelle's business, for example, suggests that he enjoyed considerable success and healthy sales.

By 1898 Majorelle had showrooms in Contexille, Cannes and at 56 rue de Paradis, Paris. In 1901 he opened another at 28 rue de République in Lyons, and by 1910 the firm's stationery also listed premises in Lille and a new Paris address, 22 rue de Provençe. The latter address was where Bing's L'Art Nouveau had traded until its demise in 1904. The growth of Majorelle's distribution network across France provides some idea of the relatively broad market he must have been catering for. Moreover, it suggests that Art Nouveau furniture and objects were being bought in the French provinces, and that the style was more than a metropolitan fad indulged in by wealthy Parisian aesthetes. The number of surviving models of Majorelle pieces indicates that the firm would have made four or five versions of celebrated exhibition pieces or private commissions, so that the development of such pieces was commercially viable. But at the same time clients and customers would know that they were buying a kind of 'limited edition', rather than a mass-produced piece. It is significant that Bing's former gallery premises should have been taken over by a successful business promoting an Art Nouveau style through a pragmatic approach to the status of furniture as art.

The fate of Bing's enterprise when compared with Majorelle's success demonstrates that Art Nouveau enjoyed mixed fortunes in the market-place. Opinion was divided on the relative artistic merits of one-off objects and multiples. The German writer Julius Meier-Graefe had strong opinions on the subject and responded in 1899 by opening his gallery La Maison Moderne on the rue des Petits-Champs. Although a keen supporter of Bing's enterprise, as the 1890s progressed he recognized that it suffered from a dual problem. First, Bing's apparent change of taste by 1900 to traditional French craftsmanship based on delicate eighteenth-century forms (see Chapter 1) was viewed by Meier-Graefe as a retreat from the artistic radicalism that had led him to display international examples of modern art and design when L'Art Nouveau opened in 1895. Second, Meier-Graefe realized the implications of the success enjoyed by firms such as Majorelle's, and also of the apparent proliferation of cheaper, industrially produced versions of Art Nouveau objects. Commenting on Bing's decision to set up his own studio to produce luxury objects for his gallery, Meier-Graefe argued that 'Bing [had] underestimated the enormous rise of the market in the new wares; he overlooked the fact that in a commercial sense, a lot of competition was springing up everywhere.' Meier-Graefe saw the necessity of catering for a wider market, but lamented the lack of artistic integrity of most current attempts to produce art objects commercially. He looked forward to a future, 'when what are today still called art objects will be offered for sale in shops that are attractive but completely lacking in artistic atmosphere, when one no longer finds a good lamp in an art shop but in a lamp store, and when pieces of furniture will no longer be treated as works of art'.

In La Maison Moderne, Meier-Graefe hoped to achieve two things: to offer radical modern design, just as he saw Bing retreating from the avant-garde, and to do it in a commercially viable manner, which would encourage artistic excellence. In his business plan for La Maison Moderne, Meier-Graefe outlined his hopes for a marriage of artistry and commerce. 'The artist,' he explained, 'gives exclusive rights for production to the firm and receives a portion of the

201
Entrance way
and stairs,
Siegfried
Bing's gallery
L'Art Nouveau,
Paris,
1895

selling price – which he helps to determine – for each object sold. Moreover, advertising will not remain limited to this single store, but there will be many more agents in France and abroad.' Meier-Graefe wrote that the only way the new art would become truly democratic was through industrial production:

those who today acted as the vanguard, the [directors of] audacious businesses that serve our public, must secure their production not from the position of middlemen but by posing as Fabrikherrn for artists, who buy models from artists and take over the execution of those models ... We know of dozens of excellent artists whose work remains limited or overlooked because it is not industrially produced, because they cannot find businessmen, speculative minds, who employ these artists not to exploit art, but to make a profit from the new furniture.

In establishing La Maison Moderne, Meier-Graefe foresaw 'a new class of "modern art galleries" responding to the needs of a

constantly growing number of people for whom the prices of most objects sold in the existing shops are accessible only with difficulty'. Photographs of both La Maison Moderne and L'Art Nouveau show how objects were displayed, and there does seem to have been some attempt on Meier-Graefe's part to make La Maison Moderne discernibly less like an élite gallery and more like a shop. Unlike L'Art Nouveau, La Maison Moderne was fronted by a shop window in which a selection of objects was displayed in a straightforward manner. First impressions of L'Art Nouveau were far grander: a central entrance hall with parquet floors (201) rose to the full height of a two-storey atrium. Objects were displayed in groups in plain cases, creating a museum-like atmosphere. Off this central hall were the various ensembles and room sets designed by individuals or groups of artists. The more modish fittings in La Maison Moderne, designed by Henry van de Velde, immediately made a more commercial impression, presenting Art Nouveau as the favoured style of the fashionable modern shop, as Horta's work had in Brussels. Furthermore, La Maison Moderne's carpeted floors and fabric hangings, with objects displayed on tables, created a distinctly domestic atmosphere.

Two evocative posters for La Maison Moderne seem to suggest contrasting images being projected by Meier-Graefe. The first, by Maurice Biais, dates from around 1900. It shows a bourgeois woman inspecting ceramics and glassware in one of the display cases designed by Van de Velde, apparently in the process of shopping (202). The second, by Emmanuel Orazi (1860–1934), offers a more mysterious and seductive image. It shows the profile of a stylized, impassive young woman, her hands adorned in Art Nouveau jewellery, her clothes fashionably embroidered with scrolling tendrils, in front of a varied ensemble of glass and ceramics (203). The second poster, in particular, evokes the rarefied atmosphere of an aesthete's den and is apparently at odds with Meier-Graefe's democratizing rhetoric. The two posters encapsulate the ambivalent approach that contributed to La Maison Moderne's eventual decline. Meier-Graefe wanted to be aesthetically avant-garde and commercially viable, but much avant-garde design did not lend

itself to commercial production. The very nature of Art Nouveau's materials and forms meant that the pieces that fulfilled Meier-Graefe's high aesthetic standards could never be mass-produced.

While La Maison Moderne initially enjoyed success, selling out within three weeks, it too was forced into liquidation in 1904, within a month of the demise of L'Art Nouveau. Contemporaries could see the trends that ultimately caused both enterprises to fail – an inability to appeal to a broad enough market, and the negative effect of poor-quality imitations of art objects. In 1906 the writer and critic Camille Mauclair argued that the style had failed to produce affordable high-quality products. 'There were indeed attempts to create useful objects,' he conceded, 'but if a particular fork costs two hundred francs per piece, the problem is hardly advanced towards a solution.' He also saw that the style had fallen victim to the very kind of commercial pastiche that Meier-Graefe had sought to replace: 'this overly refined style quickly fell to the lowest point of ridicule as a result of vulgar imitation at the hands of bourgeois commerce ... even the smallest haberdasher sells "modern style" hatpins for twenty sous.' While it was not competition from the popular, mass-produced end of the market that forced Bing and Meier-Graefe out of business, the fact that Art Nouveau was being used to appeal to a much wider public would have made the objects in which both were dealing seem far less attractive to rich buyers.

Another approach to selling Art Nouveau is represented by Georges Fouquet's jewellery shop in Paris, which demonstrated particularly well the imaginative possibilities of an unrestrained Art Nouveau interior in which to display refined Art Nouveau objects for sale. Fouquet had inherited a well-established Parisian family jewellery business in 1895, and he immediately set about transforming its output to engage with the new style. He employed the designer Charles Desroisiers, noted for his pieces based on flowers and insects, and his clientele soon included the actress Sarah Bernhardt, for whom he made a brooch designed by Mucha in 1899.

The pinnacle of Fouquet's collaboration with Mucha came in the designs the jeweller commissioned in 1901 for his shop in the

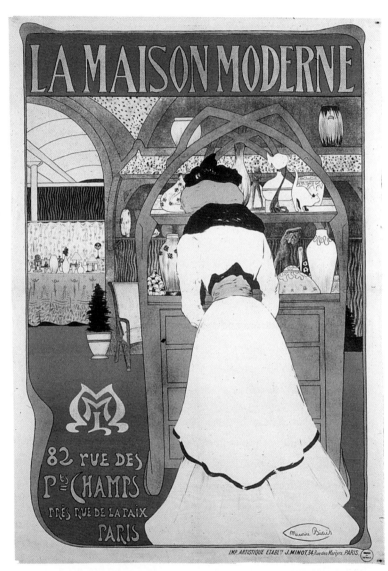

202
Maurice Biais,
*La Maison
Moderne,*
c.1900.
Lithograph;
114 × 78·5 cm,
44⁷⁸ × 30⁷⁸ in

203
**Emmanuel
Orazi,**
*La Maison
Modern,*
1900.
Lithograph;
83 × 117·5 cm,
32⁵⁸ × 46¹⁴ in

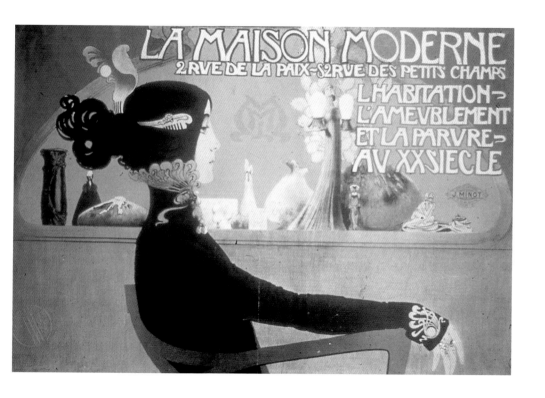

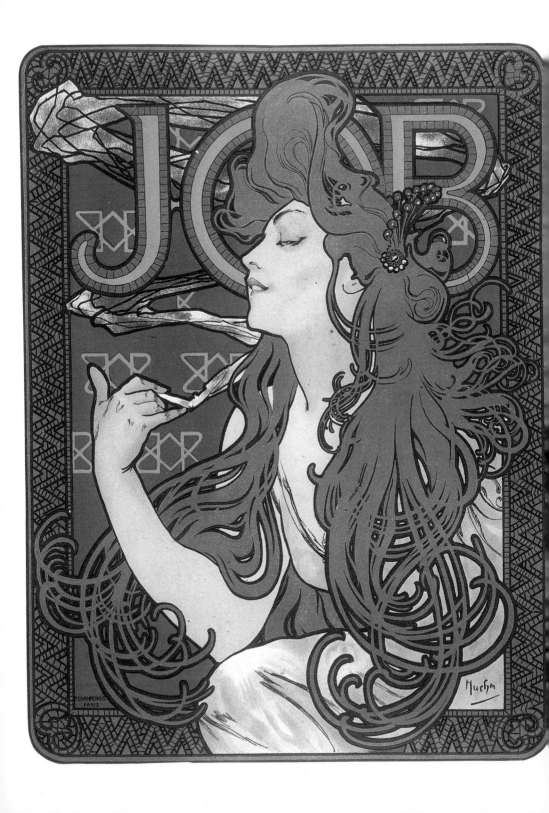

rue Royale (205). Following the success of his posters for Sarah Bernhardt in the mid-1890s (see 56, 57), a stream of commercial work had found its way to Mucha. In posters for products such as Job cigarette papers (204) he continued to present the public with romanticized images of women in varying states of seduction and abandon, resplendent with their hair in tumbling arabesques. In Fouquet's shop such fantasies were rendered in three dimensions. The shop counter featured two statues of peacocks, one displaying all its finery with tail fanned out (206). The peacock had been a highly popular motif with the Aesthetic Movement in the 1870s and 1880s, and had its origins in the fascination with Japanese art. Stylized representations of the bird had appeared in the work of many designers, most famously in Whistler's Peacock Room of 1877 (see 25). As well as its Oriental associations, the peacock had the added connotations of vanity and display, central themes of the Aesthetic Movement that were to live on in the romantic individualism of Art Nouveau. Embodying fashionable and conspicious opulence, the peacock was thus the perfect motif for the Fouquet shop.

Hardly an exercise in subtlety, the interior also contained a prominent sculpture of a nymph rising from a bubbling spring and a fantastical fireplace, taking the female form as its central motif (207). Flanked at its base by two crouching figures, the mollusc-shaped fire surround is surmounted by a standing female figure with arms raised, clad in a translucent robe. The painted overmantel depicts a young woman crouching and peering down, continuing the theme of the female body. As a jewellery maker, Fouquet may have revelled in the high fashionability of the decadent ensemble he had commissioned, and it was surely intended to appeal to a clientele for whom opulence and conspicuous display were as important as any notion of progressive design. Nevertheless, such ornamentation did not completely dominate Fouquet's *oeuvre*. Relatively inexpensive materials such as horn and enamel were combined with precious metals in Orientally inspired pieces such as his comb of around 1900 that maintained an exotic appeal yet also suggested a curiously sophisticated simplicity (208).

204
Alphonse
Mucha,
Job,
1897.
Lithograph;
52 × 39.8 cm,
20^16 × 11^34 in

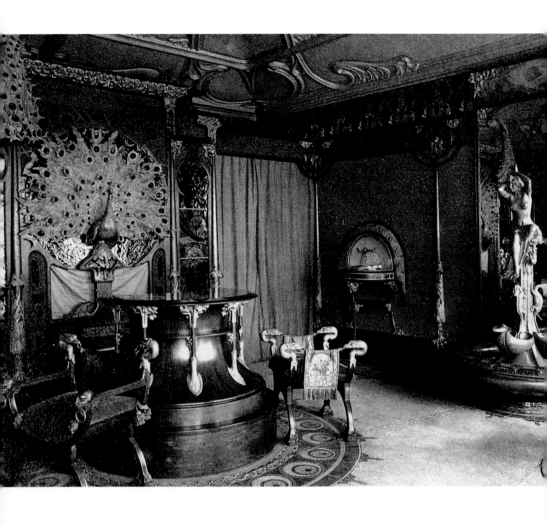

205
Alphonse
Mucha,
Georges
Fouquet's
jewellery shop,
Paris,
1901

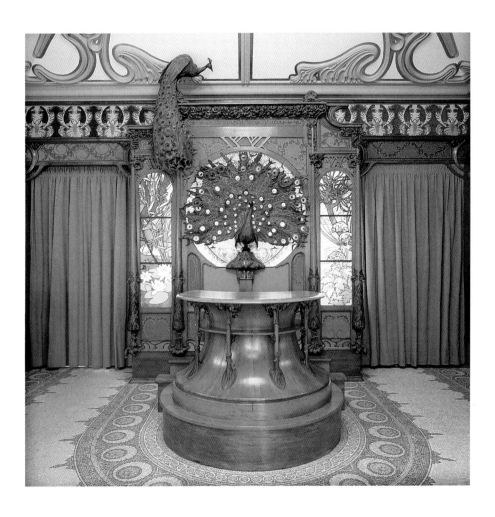

206
Replica of
Georges
Fouquet's
jewellery shop.
Musée
Carnavalet,
Paris

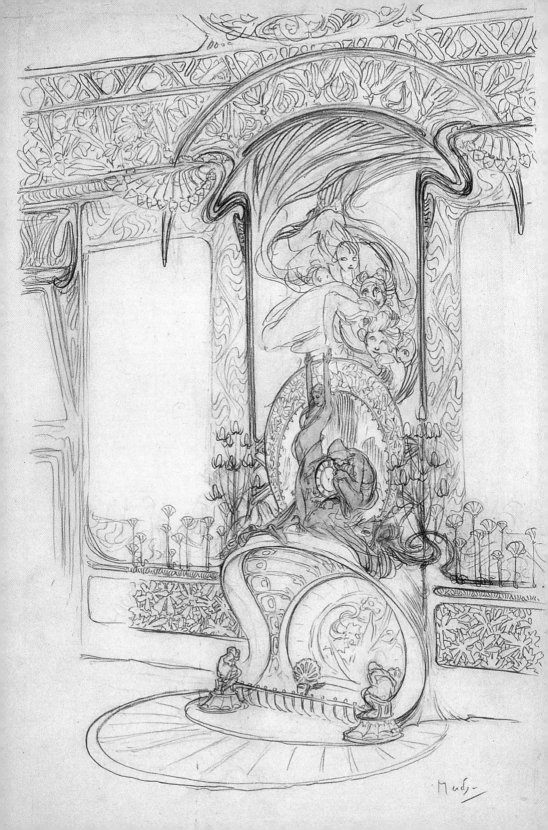

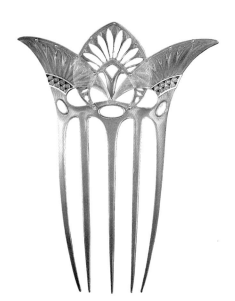

207
Alphonse
Mucha,
Sketch for a
fireplace in
Georges
Fouquet's
jewellery shop,
1901.
Chalk and
watercolour
on paper;
65 × 48·5 cm,
25⁵⁄₈ × 19¹⁄₈ in.
Musée
Carnavalet,
Paris

208
Georges
Fouquet,
Comb,
c.1900.
Horn, opal,
enamel
and gold;
h.14 cm,
5¹⁄₂ in.
Private
collection

Whatever Fouquet's motives, his shop is equally far removed
from Bing's museum-like gallery and Meier-Graefe's restrained
showcase of avant-garde applied arts.

One of the most successful retailers of Art Nouveau to affluent
middle-class consumers was Liberty & Co in London. It is curious
that the most celebrated Art Nouveau shop was to be found not in
Paris but on London's Regent Street (the famous neo-Tudor building
on the corner of Regent Street and Great Marlborough Street which
now houses the shop was not built until 1924). After all, England did
not generally provide a fertile ground for Art Nouveau; there are few
buildings in the style, and the decorative arts of the period were still
dominated by the Arts and Crafts Movement. Artists and critics
alike tended to shun Art Nouveau as a French over-elaboration of
this earlier English idea. Even Arthur Liberty himself was keen to
distance his products from the 'fantastic motifs which it pleases
our continental friends to worship as L'Art Nouveau'.

Liberty opened his first shop at East India House in 1875, the year
after the London shop in which he had previously been working
closed down. He styled himself 'The East India Merchant', and began
selling imported Oriental ceramics, carpets and other objects, at

the same time as Bing was dealing in comparable objects in Paris.
His venture coincided with the rise of the Aesthetic Movement (see
Chapter 1), and, with its Orientalist leanings, the shop was soon a
commercial success. As Liberty & Co expanded, the firm began to
sell its own range of furniture, which consisted of commercial
versions of more artistically celebrated pieces by named designers.
According to one of Liberty's catalogues, the rationale behind the
firm's furniture and fabric patterns was, 'to combine utility and
good taste with modest cost'. The type of well-to-do middle-class
customers who were being targeted can be seen in a description
of a group of houses designed for Liberty's by the architects Kemp
and How, complete with Liberty's own fittings. Priced between
£300 and £2,000, they were described as having 'rooms [that] have
been arranged with the idea of dispensing with the services of
a domestic if desired'.

The scale of the success of Arthur Liberty's venture suggests that
his firm's policy of producing its own, more affordable versions of
'artistic' furniture succeeded in reaching a middle-class market.
In 1894, when the business was floated on the stock market, it raised
share capital of £200,000. Liberty's was also important in the way
it influenced taste beyond its own immediate market. Liberty & Co
soon found itself the subject of comment in the press. The cartoons
published in the British magazine Punch satirized the artistic tastes
of the day; they reveal how, even among those who could not afford
to shop there, Liberty's was seen as the standard of modern artistic
style to which one should aspire. One cartoon dating from 1894
depicts a hostess in the decidedly middlebrow London suburb of
Upper Tooting, showing off her new decorative scheme resplendent
with 'art furniture', Oriental-style pots and heavily patterned
wallpaper (209). 'All our friends think it was Liberty!' she enthuses,
while her less than impressed guest sighs under her breath,
'Oh, Liberty, Liberty, how many crimes are committed in thy
name!' The aspirational use of 'artistic' decoration is cruelly
revealed here, suggesting that the style could become a superficial
attempt to give a veneer of fashionability and sophistication where
none existed.

209
Felicitous
Quotations,
from Punch,
20 October
1894

FELICITOUS QUOTATIONS.

Hostess (of Upper Tooting, showing new house to Friend). "WE'RE VERY PROUD OF THIS ROOM, MRS. HOMINY. OUR OWN LITTLE HOLSTERER DID IT UP JUST AS YOU SEE IT, AND ALL OUR FRIENDS THINK IT WAS *LIBERTY!*"

Visitor (sotto voce). "'OH, LIBERTY, LIBERTY, HOW MANY CRIMES ARE COMMITTED IN THY NAME!'"

Liberty's widespread influence was also noted by commentators with a less cynical view of middle-class taste. In 1900, the *Art Journal* described Arthur Liberty's success as 'the exercise of the right kind of judgement', resulting in his 'personal observation and preference' being 'imposed upon the community'. The author saw the results as both positive and widespread: 'In less than twenty-five years,' it was claimed, '[Liberty] has built up an influence that has laid hold of almost every section of society, and has been responsible for a radical change in the general opinion on aesthetic questions.'

The impact of Liberty's on English style formed part of the broader phenomenon of the fashion for 'artistic homes'. This was fuelled by the drive for utility promoted by the Arts and Crafts Movement, coupled with the sometimes contradictory quest for rarefied beauty pursued by the Aesthetic Movement. According to Mrs Haweis, whose book *The Art of Decoration* (1899) was one of the many decorating manuals of the period, 'Most people are now alive to the importance of beauty as a refining influence. The appetite for artistic instruction is now ravenous.' In domestic architecture a fashion for simpler domestic forms emerged as architects tried to implement Arts and Crafts ideals on a large scale. But Art Nouveau decorative elements were more likely to be found in less rigorously designed houses in the forms of tiles, stained glass and fire surrounds, which enabled suburban builders to give their houses a badge of contemporaneity.

As a retailer of artistic wares, Liberty & Co was also an inspiration for many of the key figures in European Art Nouveau, including Gallen-Kallela in Finland and Serrurier-Bovy in Belgium. In 1890, Liberty & Co opened a shop at 38 avenue de l'Opéra in Paris, which survived until 1931, and its products, in particular its fabrics and wallpapers, were available across Europe, from Helsinki to Milan. Conversely, the London shop also provided one of the few outlets for continental Art Nouveau in London. Liberty's sold versions of the chair exhibited by the Munich designer Richard Riemerschmid at the Universal Exposition, which they also used to furnish the Regent Street shop; distinctive lustred vases from the

Zsolnay ceramics factory in Pecs, Hungary; and German *Jugendstil* metalwork, such as candlesticks of stylized plant forms made by the firm Johann Peter Kayser & Sohn (210). The firm even bequeathed its name to Art Nouveau in Italy, where it is still known as the *Stile Liberty*.

In 1899 Liberty & Co launched its own celebrated 'Cymric' range of silver and jewellery, followed in 1901 by the 'Tudric' range of pewter objects. Both metalwork ranges, which featured items from jewellery boxes to belt buckles and hatpins, adopted a distinctive Art Nouveau idiom that showed strong Celtic Revival and Renaissance influences. A Cymric jewel box, designed by Archibald Knox (1864–1933) and dating from around 1900 (211), shows how a simple form could be given subtle contemporaneous curves and decorated with restrained linear motifs to transform it into an understated Art Nouveau object, still obviously close to its Arts and Crafts roots. Another prominent designer of these wares was Rex Silver (1879–1965), although Liberty's policy of not crediting their artists and designers often makes it difficult to determine who designed what.

The relative affordability of these smaller objects was important. Even in the Cymric catalogue of gold and silverware, a silver brooch with sinuous Art Nouveau lines could be bought for the relatively modest sum of five shillings and sixpence. This marketing of small pieces in the new style was probably calculated to appeal to people who wanted to express fashionable modernity without having to redesign their homes. Such pieces could exist as beautiful and prized objects for display without demanding the kind of *Gesamtkunstwerk* interiors that only the wealthy *haute bourgeoisie* could ever contemplate. The note of combined novelty and artistry was struck in Liberty's own promotional literature. Despite the obvious Celtic influences, a catalogue of around 1900 described the Cymric range as 'a complete breaking away from convention in the matter of design and treatment'. Moreover, it was a range 'which is calculated to commend itself to all who appreciate … artistic productions in which individuality of idea and execution is the essence of the work'. It is clear here what desires Liberty's was attempting to satisfy. Again, in terms of broad appeal, the

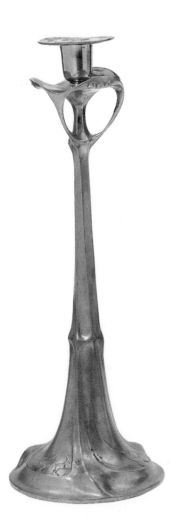
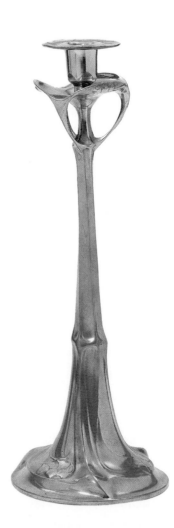

210
Hugo Leven for
Johann Peter
Kayser
& Sohn AG,
Pair of
candlesticks,
c.1902.
Pewter;
h.42 cm,
11¼ in.
Victoria
and Albert
Museum,
London

211
Archibald Knox,
'Cymric' jewel
box,
c.1900.
Silver, mother-
of-pearl,
turquoise
and enamel;
7·3 × 28·5 ×
15·2 cm,
3⅞ × 11¼ × 6 in.
Museum of
Modern Art,
New York

Tudric pewter range was also significant, in that it used a cheaper material and was therefore more affordable than Cymric objects. Arthur Liberty himself was particularly proud of this aspect of his firm's production, which encapsulated the company's aim to 'tend towards the production of useful and beautiful objects at prices within the reach of all classes'.

For all Liberty's influence on the tastes of middle-class England, it is important to remember that it was not typical of English retailers. In Britain, where the new art was often perceived as the embodiment of pernicious French influence, commercial 'art furniture' was toned down to such a degree that it became a flat pastiche even of the restrained English aesthetic it drew upon.

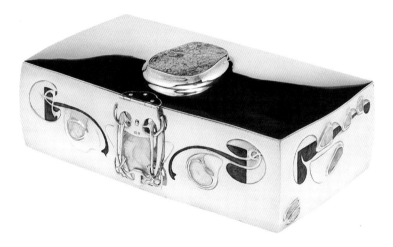

Rooms illustrated in the catalogues of the London home furnishings shop Heals illustrated the degree to which Art Nouveau could be reduced to the smallest of features, announced by no more than a passing reference to the style. The 'St Ives' suite of 1901, for instance, featured cupboards with boldly shaped hinges and a bed with pierced heart motifs, vaguely reminiscent of earlier furniture by Voysey.

A comparison of such depressingly mediocre examples of the style with the adventurousness of Cranston's tea rooms or the delicacy of Knox's Cymric designs for Liberty highlights the sheer diversity of Art Nouveau. It could express both radicalism and conservatism,

represent both intellectual gravity and fashionable aspirations, and stand for domestic sanctuary and modern commerce, as well as various points in between. The rich could commission entire villas, the more modest consumer could acquire a silver jewellery box. Art Nouveau objects were marketed as exclusive items for the connoisseur as well as affordable and available: a table could be bought for 450 francs at Bing's gallery, a hatpin for 20 sous from a haberdasher. For all these contrasting and conflicting meanings, consumers of Art Nouveau were joined by their desire for decoration, artistry and contemporaneity. Chapter 7 will consider the conflicts and consensus of these aims by exploring the relationship between Art Nouveau and industry – whether the desire for artistic decoration could be compatible with modern methods of production and business organization as the twentieth century dawned.

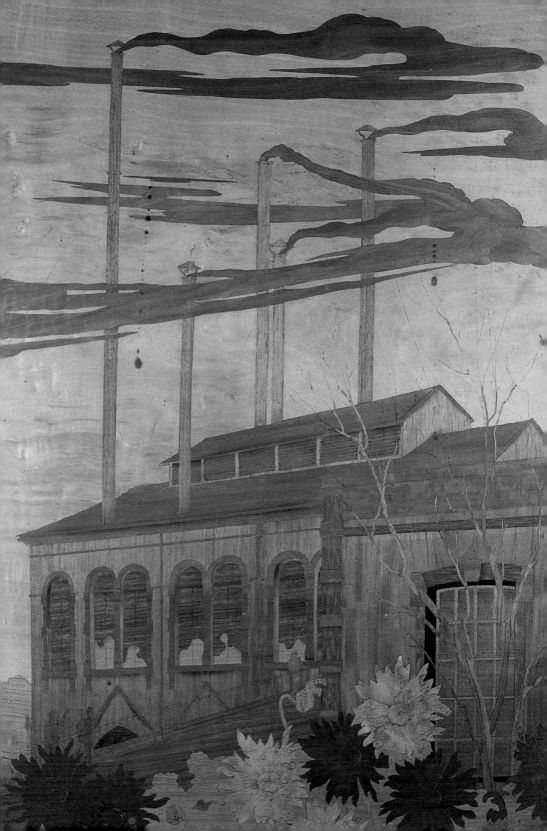

Between 1875 and 1914, technological progress proceeded at an unprecedentedly rapid pace. The inventions that had powered industrialization from the late eighteenth century onwards, namely the steam engine and steam-driven machinery, were superseded by the development of turbines, electricity and new production techniques. The internal combustion engine revolutionized transport, new processes made possible the wider use of steel and chemical industries flourished. A concurrent growth in economic activity resulted in what, for the first time in history, can be confidently called mass production and mass consumption.

At first glance many of the examples of Art Nouveau encountered so far seem to have existed in a world far removed from this aggressive industrialization and economic expansion. Charles Rohlfs and Artus van Briggle in the United States produced hand-crafted pieces, while European designers such as Victor Horta and Antoni Gaudí worked for wealthy patrons, enjoying the kind of private patronage not readily associated with twentieth-century Europe. Art Nouveau appears to have been a paradox – self-consciously modern, but shy of modern methods. This chapter explores the extent to which Art Nouveau engaged with the industrial process. It examines a series of different types of manufacturers of Art Nouveau objects, and weighs up the persistence of élitist patronage and the craft tradition against the adoption of new practices.

The Union Centrale des Arts Décoratifs was the official body that promoted the decorative arts in France in the 1880s and 1890s. It eschewed the developments being made in mass production in favour of encouraging traditional features of French craftsmanship – quality and luxury (see Chapter 1). France's factories had not been successful in the 1890s, and this helps explain why French Art Nouveau was encouraged as a craft style. In 1885, France had been

the world's second most powerful industrial producer behind Britain, yet by 1896 she had been overtaken by both the United States and Germany. The French government's answer to this decline was economic protection, an attempt by the prime minister Jules Méline to bolster France's traditional strengths, which included the decorative arts. Méline believed that 'French taste conflicted with mass-production', and that economic success lay in 'a multitude of small workshops, best suited to making varied and individual goods'.

Nevertheless, one should be cautious of dismissing French Art Nouveau as anti-industrial and technophobic. Moreover, it is not true to suggest that French artists were only producing unique pieces for wealthy aesthetes. Two firms capable of catering for a broader, middle-class market were those of Émile Gallé and Louis Majorelle (see Chapter 6). Gallé had a number of wealthy private patrons, yet, unlike Bing, he realized that a handful of clients, no matter how wealthy, would not keep him afloat. He needed to cater for a larger clientele too. Roger Marx, one of the most prominent campaigners for the renewal of the decorative arts in France, observed the results when he visited Gallé's furniture workshops in 1894: 'Whereas a select number of pieces were designed for museums', Marx observed, 'others were vulgar, commercial and industrial, assembled with measured economy to reach every home.' That Marx considered the commercial and industrial 'vulgar' emphasizes the value-judgements made about industry in French artistic circles at the time, but Gallé, nevertheless, famously celebrated his own production methods. A series of marquetry panels, which were mounted around the base of a vitrine (a display cabinet for artworks), depicted the glassmaking process, although the scenes chosen admittedly present the artistic elements of production (213) rather than the industrial. Another marquetry panel by Gallé, dating from around 1900, depicts the exterior of his glassworks (212). With wild flowers in the foreground and smoking chimney stacks rising from the factory, the scene suggests the harnessing of the industrial process to produce objects that reflect the beauty of nature.

In the production of his furniture, Gallé certainly outgrew the romantic notion of the artisan craftsman. His large factory comprised a two-storey main building, a mechanical sawmill, a central lodge on three floors, steam sheds, and storage areas for both the carcass woods and the vast array of veneers the factory stocked to produce the intricate scenes inlaid on the furniture. Furthermore, Gallé was not averse to using machine tools in the production process. Limbs and other structural parts of the furniture were created with preshaped blades fitted to a plane to

213
Auguste Herbst, Marquetry panel on a vitrine by Émile Gallé showing artisans and Gallé (far left) examining a vase, 1906. Walnut and exotic woods; panel: 38 × 27 cm, 15 × 10⁵8 in. Conservatoire National des Arts et Métiers, Paris

give a basic shape, which could then be hand finished. Using this process, the complex forms of Art Nouveau could be produced relatively inexpensively. As well as modern production techniques, Gallé also employed modern approaches to management. The workshops were organized around a division of labour that offered maximum efficiency and ease of supervision for the management. Two systems of clocking existed for the workers, depending on whether they were being employed on private commissions or general output. This allowed for both control over the workers

and the accurate pricing of jobs. A rigid system of control also existed over the ordering, storage and use of the woods, particularly the expensive veneers. The designers chose veneers from numbered sample sets, and a full-time storeman made sure that all the different types of wood were available at any one time.

This kind of shop-floor organization put Gallé at the leading edge of developments in the management of industry, even if his factory was only a semi-industrialized workshop rather than a fully-fledged exercise in mechanized production. At the same time as Gallé was producing his furniture along these lines, American management theorists, led by F W Taylor, began to formulate what in 1910 became known as 'scientific management', a rationalist response to the problems of large-scale production. 'Taylorism' involved the division of labour by task and the removal of control over this task from the worker to management personnel, who told the worker exactly how to proceed – a process instituted by Gallé through the separation of the design process from that of the craftsmen in his factory. Taylor also encouraged 'time and motion' studies of the production process and the weighting of the payment system to encourage increased productivity. While there is no evidence that Gallé practised either of the latter methods, or indeed that he had even heard of Taylor, his factory was certainly a far cry from the fulfilling workplace for the contented artisan that was promoted by the English Arts and Crafts Movement and that influenced other Art Nouveau workshops around Europe.

Paradoxically, Gallé was acutely aware of the need to modernize in order to be able to produce the kind of artistic furniture that graced the Neo-Rococo boudoirs of the Parisian aesthetic élite. Nor was it only the production of furniture that demanded such a rigorous approach. Gallé's glass factory was run on similar lines. Photographs of his glass-decorating studios give a sense of the scale of production. The massed ranks of seated decorators are hunched over their work in separate booths, while objects are arranged in trays on a central table (214). But this operation, which was concerned with the decoration of the more standard smaller

pieces, formed only part of the process. The raw materials and chemical additions were blended in drums and melted in one of the four giant furnaces at temperatures of up to 1450°C. All the glass was hand-blown, and the size of Gallé's workforce can be seen in photographs of the glass-blowing workshops (215). Enamelling and engraving was done by different artisans, the sexes also being segregated in the workshops, leaving the women and girls to work on the lighter pieces while the heavier vases were decorated by men. Although the various stages of production were all carried out on an artisanal basis, Gallé's glassworks again made use of a strict division of labour. The sheer scale of production emphasized his quest to respond to a modern market as well as cater for traditional patronage from the *haute bourgeoisie*.

Gallé was not alone in his rational approach to the production of objects, many of which at the same time remained visually loaded with Symbolist motifs. The other great Nancy-based glassmakers of the *fin de siècle* were Daum Frères (see Chapter 2), whose firm took its lead from Gallé's endeavours and shared his commercially successful approach. Like Gallé, the Daum works produced objects that depicted elements of the manufacturing process, such as the 1908 vase entitled *Le Verrier à la halle* (*The Glassmaker*; 216), and were not concerned with disguising the technical realities behind the production of such naturalistic, organic pieces – indeed *Le Verrier à la halle* creates a bold and heroic image of the intense heat and discomfort of the glass-blowing process. The Daums also shared with Gallé a talent for organization, which possibly derived from the fact Auguste, who took responsibility for the firm's financial and commercial affairs, had had a legal rather than artistic training.

After 1889, the Daum brothers opened a decorating studio and, like both Gallé and Majorelle, attained commercial success by continuing to produce cheaper, more readily available goods alongside the artistic commissions and exhibition pieces that brought them critical acclaim throughout the Art Nouveau period. By the early 1890s their factory employed three hundred workers and comprised twelve crucibles and two furnaces. Despite their success, it is

14–215
Émile Gallé's
Glassworks,
Nancy,
1913
Opposite
Glass-decorating
studio
Right
Glass-blowing
workshop

significant that the Daums' approach to production seems not to have been as ruthlessly prescriptive as Gallé's, perhaps explaining why, unlike Gallé's business, Daum Frères continued to be successful after the brothers' deaths. One critic described the Daum studio as,

a model of artistic cooperation, for which there is no known prototype. Under the direction and stimulus of Antonin, the unique pieces of art were elaborated in a common effort by all the participants in the factory. It is surprising and without parallel to find painters, designers, acid and wheel engravers, technicians, chemists and team leaders all collaborating in close and profound intercommunion, responding to the general inspiration ...

It was one of the Daums' collaborations with another Nancy workshop, that of Louis Majorelle, which produced some of the most artistically successful attempts by Art Nouveau designers to harness the new and still unreliable technology of electric light. The joint venture apparently began in the early 1890s and combined

216
Daum Frères,
Vase entitled
The Glassmaker,
1908.
Glass;
h.39.5 cm,
15$\frac{1}{2}$ in.
Private
collection

the Daums' specially produced opalescent glass shades with Majorelle's elegant sinuous stands, in which the electric cable could be concealed (217). Innumerable designs were produced until the collaboration was suspended during World War I. The lamps were exhibited at various Salons, but also more widely marketed (with no mention of the Daum name) through a series of catalogues. Yet although the lamps were artistically successful, it is questionable how effective a response to new lighting technology they really were. They had to be illuminated using Thomas Edison's recently introduced bulbs, which had a strength of only seven to ten watts, and the deep hues of their coloured glass shades meant that it is unlikely that the lamps could ever have provided more than an ambient light sufficient to illuminate themselves as art objects.

Another example of the Daums' technological innovation was their willingness to experiment with new decorative techniques. For the Daums glassmaking was an alchemic process, combining experiments with coloured powders and multi-layered glass materials with decorative techniques such as wheel engraving, hammering and acid etching. In the field of progressive technology, the Daums' most interesting experiment, although by no means the firm's most artistically successful, was mould blown glass. By blowing the glass into a closed mould that could then be opened on hinges, it became possible to regulate the previously erratic glass-blowing process to produce a potentially endless series of identical pieces. This technique was never widely used, because, ironically, the finished object needed so much handwork to disguise its production-line origin that the process ended up being as time-consuming as more traditional methods.

The model of production adopted by Gallé and Daum, which combined traditional craft techniques with organization on an industrial scale, is a paradigm that is often overlooked today. A tendency to contrast the kind of modern mass production pioneered by Henry Ford with the notion of the skilled artist-craftsman weaving or carving a piece from start to finish makes it easy to forget what was, in effect, industrial craft production. This process

was at the heart of the most commercially successful exponents of Art Nouveau. Louis Comfort Tiffany, like Gallé and the Daums, combined craft techniques and industrial production to offer a variety of products, some of which were specially commissioned while others could be chosen from a catalogue or even bought over the counter in authorized outlets. In this way a degree of exclusivity was preserved, but at the same time a broader market could be reached. Tiffany himself, like Arthur Liberty before him (see Chapter 6), alluded to the importance of the broad availability of his products created by this approach. In his 1914 biography by Charles de Kay, which Tiffany commissioned and is thought to have had a significant hand in writing, it is argued that the firm's 'things of daily use like lamps, flower vases and toilet articles reached a wider public than do paintings and sculpture.' His jewellery, furthermore, appealed 'to the very widest imaginable circle of buyers'.

This is not to say that Daum, Gallé and Tiffany were the first to apply these large-scale production methods to the decorative arts. Josiah Wedgwood (1730–95) is widely recognized as one of the true innovators of the large-scale production of his Neoclassical ceramics in late eighteenth-century England, employing similar techniques of division of labour and the distinction between the production of specially commissioned pieces and standard output. Gallé's use of the division of labour also followed in the tradition of French craft production. Even in the eighteenth century, a cabinet would have been the product of a number of specialized artisans. The French tradition had never equated with the romantic vision of William Morris's idyll, in which one craftsman would see a piece through from start to finish. The sheer scale, efficiency and purpose of Daum and Gallé, as well as Tiffany & Co, presents a picture of dynamic companies that were able to come to terms with the pace of modern economic growth at the turn of the century.

As commercialization increased, however, so did anxiety about its potential negative effects. In 1902 Charles Robert Ashbee, the Arts and Crafts designer whose work was so influential in the evolution of Art Nouveau (see Chapter 1), expressed his unease

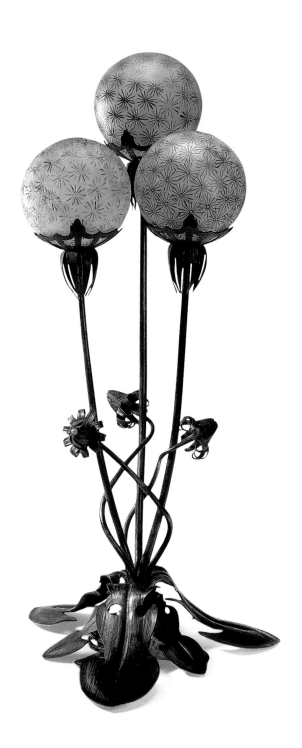

217
Daum–Majorelle,
'Dandelion'
lamp,
c.1902.
Wrought iron
and etched glass;
60 × 28 cm,
$23^5\!/_8$ × 11 in.
Musée de l'École
de Nancy

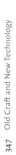

in verse, concluding that Art Nouveau itself was a culmination of the debasement of art through commercial production:

I'm in the fashion – non controversial,
And the fashion is nothing if not commercial,
Pre-Raphaelite once, with a tiny twist
Of the philosophical hedonist,
Inspired by Whistler – next a touch
Of the 'Arts and Crafts', but not too much.
Then Impressionism, the daintiest fluke;
Then the German squirm, and the Glasgow spook,
A spice of the latest French erotic,
Anything new and studiotic,
As long as it tells in black and white,
And however wrong comes out right,
'Id est' as long as it pays you know,
That's what's meant by L'Art Nouveau!

Concerns about art being reduced to fashion through the actions of the unsympathetic Philistines of industry were vociferously expressed by many of those now celebrated as the leading exponents of Art Nouveau. This fact helps to explain why the qualities of economic and social modernity are often denied to the style. In 1907 Hermann Obrist, whose 'whiplash' embroideries had pushed the *Jugendstil* to new levels of fantasy and abstraction (see Chapter 2), issued a passionate denunciation of modern industry:

O Pharisees! Are you doing anything different from what you have always done? Before ... you rummaged in pattern books; you exploited the draughtsmen from the much maligned but (for you) indispensable art schools, you repeated the designs of the famous architects of the past watered down one hundred times, always unable to create anything of your own out of the old styles. And now you subscribe to all the art magazines like pulp tabloids; you go to all the exhibitions; you have the catalogues of all the English, French and American firms; you catch wind of every new fashion and, as ever, force your draughtsmen to sketch Jugendstil today, Neo-English tomorrow, then Biedermeier, Neo-Viennese or Neo-Dresden. Are you 'modern'?

Do you have good 'taste'? … A sight for the Gods! And whence do you have these wonderful things if not from us artists?

Many manufacturers were content to adapt forms they had encountered in periodicals or at design exhibitions and thus save money by only having to pay jobbing draughtsmen rather than talented designers. According to an article in the German periodical *Deutsche Kunst und Dekoration (German Art and Decoration)* in 1901, 'A group of producers … finds it much easier … simply to take artists' designs already on the market and have their draughtsmen alter them just enough so that they do not come into conflict with the law – then they throw these onto the market much cheaper than the original artists' designs.' This suspicion of the motives of large-scale industry led many prominent artists to found or join a variety of organizations that attempted to bypass Obrist's 'Pharisees'. However, in commercial terms the results were mixed.

The Wiener Werkstätte, founded in 1903 in Vienna by the architect Josef Hoffmann and the designer Koloman Moser, was one such organization (see Chapter 3). Their aim was to maintain control over the production process and to preserve the role of the craftsman. Hoffmann held an idealistic vision of the sanctity of individual craftsmanship. In a lecture in 1911, he described the craftsmen of the Werkstätte in heroic terms. They possessed 'heartfelt perseverance, deep understanding and manly strength.' He continued:

We see with pride that they stand at the worktable with pleasure and without distaste, and that they gladly help us realize ideas they apparently sense as made for their dexterity. But we feel how for us the forces grow, through them, and how we must not lose respect for the sanctity of work.

So, while the design and production process was sometimes divided, it seems difficult to imagine the Wiener Werkstätte employing the clocking in and out system Gallé used to control his workforce.

Hoffmann's concern for the workers of the Wiener Werkstätte echoed the romantic socialist views of Ashbee, whose Guild of

Handicraft, founded in 1888 in the East End of London, provided inspiration for the founders of the Werkstätte. The promotion of good social conditions was as important to Ashbee as the quality of the workmanship; he even went as far as admitting that 'the real thing is life, and it doesn't matter so very much if their metalwork is second rate.' Hoffmann visited the Guild in 1902, the year before the foundation of the Wiener Werkstätte, and also the year in which Ashbee took the decision to move the Guild to the rural setting of Chipping Campden, a small town in the Cotswolds. This turned out to be a terrible business decision that proved to be the death-knell of the organization. But Hoffmann was impressed by what he saw and declared in 1903 in the Werkstätte's founding manifesto, 'Our aim is to create an island of tranquillity in our own country, which, amid the joyful hum of arts and crafts, would be welcome to anyone who professes faith in Ruskin and Morris.'

In the rhetoric of a public address, Hoffmann elevated the employees of the Werkstätte with the highest praise. 'Our craftsmen are an élite of the first rank,' he insisted, 'they are not slaves of a machine but creators and shapers, makers of form and masters.' In an apparent reference to the kind of processes employed by Gallé, Daum and Tiffany, Hoffmann emphasized how his craftsmen's labours 'are not a loveless patchwork by various hands but the work of one man'. The Werkstätte's first large-scale workshops were set up on a disused factory site at Neustifgasse 32–4 and included studios for cabinet-making, bookbinding, leatherwork, gold- and silversmiths and an architectural office. A description by the critic J A Lux in *Deutsche Kunst und Dekoration* described them in terms that echo Hoffmann's eulogy of the craftsman: '"Factory" and "Workshop" are usually words that prompt a slight shudder in civilized people ... [but] upon entering the Wiener Werkstätte, one is pleasantly surprised to discover that the workshops are optimally furnished from an aesthetic point of view, and provide a happy setting for creative activity.'

So the Wiener Werkstätte's approach was a reaction against what was seen as the tyranny of the production line: all its objects

were signed with the symbol of an individual craftsman. This had inevitable implications for cost and commercial viability; yet Hoffmann seems to have accepted this – a fatal premise for any organization which is to be run along business lines. 'We know that we do not work for individual profit but for the cause,' he conceded, at the same time maintaining, 'that makes us free.' Lux described how 'The characteristic principle of the Werkstätte, and one that must be instilled into every craftsman if he is to achieve the most perfect result possible, is that it is better to work for ten days on one item than to produce ten items in one day.' This is where the idealistic streak in the Werkstätte shines through. Hoffmann proclaimed: 'We know no differences in rank; we recognize only an order of work and the higher quality of performance ... We hope for and dream of garden-rich, beautiful, bright cities, without oppressive ugliness; we dream of handsome rooms and of the open cheer of positive work.'

In contrast to the Guild of Handicraft, which did not actually uphold the highest standards of craftsmanship, the artistic output of the Wiener Werkstätte was of a very high quality. The objects produced by its silver studios combine both luxury and craftsmanship. Hoffmann's serving spoon of 1905 provides an exquisite example of the delicacy of craftsmanship that was achieved, enriched to sumptuous effect by mother-of-pearl, turquoise and other semi-precious stones (218). But the financial results of Hoffmann's idealistic approach were grimly inevitable. The Waerndorfer family eventually sent the Werkstätte's initial backer, the manufacturer Fritz Waerndorfer, to America to try to recoup some of the losses he had incurred. In 1912 the Werkstätte became a limited company, and the main shareholders became the Primavesi family, wealthy clients who owned thirty percent of the Werkstätte and who were eventually to be bankrupted by their commitment. The cost of Werkstätte products was also prohibitive, something that seems not to have troubled Hoffmann. Luckily he found in Adolphe Stoclet a patron who was willing to foot the bill for the luxurious Palais Stoclet (see 101–105), but the wrangling over the bill that followed the completion of the Purkersdorf

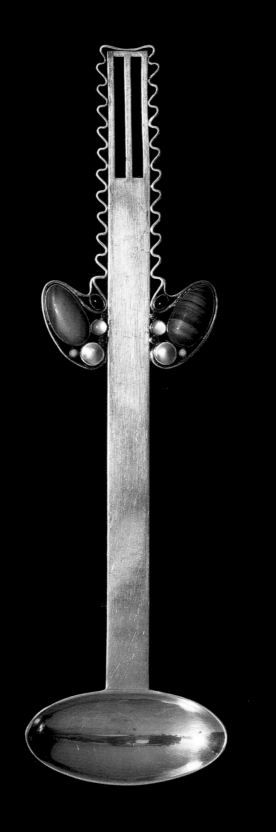

Sanatorium in 1906 gives an insight into the cavalier attitude to cost in the quest for beauty and perfection of Hoffmann and his collaborator Koloman Moser. The Sanatorium's owner, Viktor Zuckerkandl, was so appalled by the discrepancy between the initial quote and the final bill that a number of lawsuits were filed which eventually resulted in the architectural wing of the Werkstätte being separated from the main workshops. Another example of Hoffmann's dubious approach to economy concerns a certain Herr Nebehay, who commissioned Hoffmann to redecorate his business premises. He resolved to pay up to twice Hoffmann's initial estimate, but the final bill was in fact four times greater.

The Wiener Werkstätte was not alone in its attempt to provide a sympathetic environment for artistic production. In 1899, three years before the establishment of the Werkstätte, an artists' colony was founded in the town of Darmstadt by the province's ruler Grand Duke Ernst Ludwig von Hessen. The Darmstadt colony offers another model for artistic production, if only for the select few who were invited to take up posts by its founder. The Grand Duke was a grandson of Queen Victoria (r.1837–1901), and during his cosmopolitan upbringing, he had spent considerable time in England, where he encountered the writings of Ruskin and Morris and had been impressed by the revival of the crafts that was taking place there.

In 1897 Ludwig commissioned Ashbee and the English architect Mackay Hugh Baillie-Scott (1865–1945) to decorate a series of rooms in his palace at Darmstadt, but his most important act of patronage was the creation of the colony two years later. The two most significant artists the Grand Duke brought to Darmstadt were Olbrich, the architect of the Vienna Secession Building (see 81), and the painter, graphic artist and designer Peter Behrens from Munich. All seven artists who were initially appointed were awarded a three-year stipend, and their first task was to build themselves houses on a hill above the city, the Mathildenhöhe, which would form the nucleus of an exhibition to be staged in 1901.

The artists' houses were to be erected around a studio building designed by Olbrich (219), which was given an inflated sense of

218
Josef
Hoffmann,
Serving spoon,
c.1905.
Chased silver,
mother-of-
pearl,
moonstone,
turquoise,
coral, blue and
black stones;
l.21 cm, 8¼ in.
Private
collection

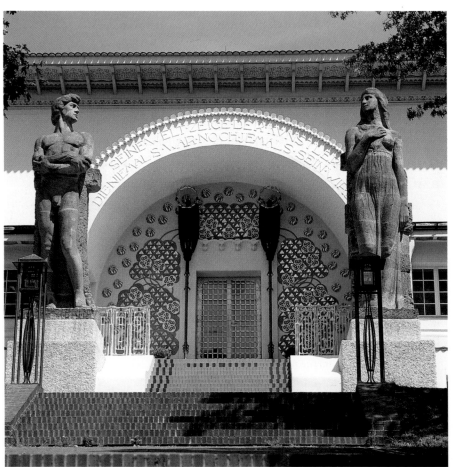

219
Joseph Maria Olbrich, Entrance, Ernst Ludwig House, Darmstadt, with the figures of *Strength* and *Beauty* by Ludwig Habich, 1901

220
Peter Behrens, Behrens House Mathildenhöhe, Darmstadt, 1901. Contemporary photograph

221
Caricature of the Behrens House from the exhibition Das Überdokument 1901, devised by the Darmstadt artists in anticipation of public criticism. The caption read: 'Stand fast, my house, in the tumult of the storm!'

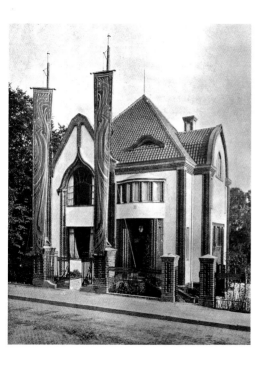

grandeur by monumental figures gazing at each other as they flanked the huge entrance. Behrens responded by constructing and decorating one of the most celebrated Art Nouveau expressions of *Gesamtkunstwerk*. The house had a relatively modest brick and plaster exterior (220); the stylistic excesses within were suggested only by the curving line of the roof and the stylized decoration on the door. Members of the artists' colony addressed public criticism of even this subtle manifestation in a cartoon (221) showing a jelly-like structure quivering with nervous energy. The interiors constituted an unrestrained exercise in linear Art Nouveau. In the dining room (222), the relief decorations of the ceiling were echoed in the stems of the chandeliers, the forms of the dining chairs and the shapes of the french windows and cupboard doors.

The Grand Duke's aim was not merely to beautify the capital of his principality, or to indulge his artistic sensibility through patronage on a peculiarly intimate scale. Darmstadt had developed during the nineteenth century from a quiet garrison town into one with chemical, engineering and manufacturing industries. The Grand Duke wanted to enhance the city's design-based industries by bringing successful artists to the town, who could stimulate both production and ideas. Although an admirably benevolent notion, the concept of an artist's colony sponsored by the local nobleman was hardly a modern one. In the context of modern Germany, Darmstadt seemed little more than an outdated gesture of patronage, and it had a predictably feeble commercial impact. When their contracts expired in 1902 and 1903, Behrens and four more of the original seven decided to leave the colony. Appropriately, one of Behrens' best-known *Jugendstil* designs from his years at Darmstadt was not an affordable, industrially produced object but a jewel-like table lamp made especially for the Grand Duke, conceived in the form of mystical winged and hooded figure (223).

On the occasion of the colony's first exhibition in 1901, the critic and art dealer Julius Meier-Graefe, who had recently

established his gallery La Maison Moderne in Paris (see Chapter 6), lambasted the whole idea of the artists' colony. His fundamental doubts concerned 'the realistic aspects, the practical possibility of turning a town of limited means ... into a centre of commercial importance.' The impracticality of the Duke's artistic fantasy was epitomized in the fate of the three houses designed by Olbrich for the second Darmstadt exhibition in 1904. Although Behrens and the others had left, Olbrich stayed on, responding to a commission from the Grand Duke to build houses that would provide 'examples of private homes for citizens of not overly abundant means.' The houses were duly built: the Blue House and the Grey House (224), designated the official residence of the court chaplain, displayed the necessary quirky forms of the 'modern style', while the Corner House adopted more vernacular features, reminiscent of the romantic rusticity of contemporary Finnish architecture. Predictably, neither the Blue House nor the Corner House, which were both offered for sale after the exhibition, were within the grasp of any 'citizens of not overly abundant means.' The Blue House was acquired by Frau Knöckel, the wife of the Councillor of Commerce, while the Corner House was bought by Count Büdingen, an employee of the Grand Duke.

On the opposite end of the spectrum, mass-produced Art Nouveau objects illustrate the way that the style could engage with the growing industrial might of Germany, while also confirming the artists' concerns about the bastardization of the new style by big business. The German metalware company Württembergische Metallwarenfabrik (WMF) was founded in 1853 with sixteen employees. By 1914 the firm had grown to the extent that it employed 6,000 workers in factories in Germany, Austria and Poland. An engraving of 1895, depicting the firm's Geislingen factory (225), and a photograph of one of the same factory's workrooms around 1900, a hive of activity (226), reveal something of the scale of WMF's operation. Central to the firm's success was its exploitation of the technology of electroplating, which enabled it to produce the elaborate forms of Art Nouveau at commercially viable prices.

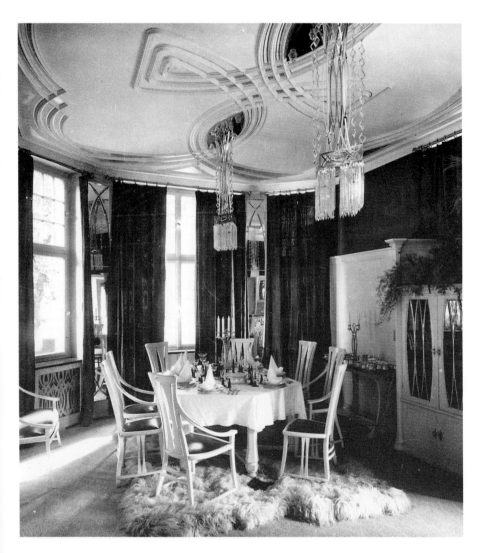

222
Peter Behrens
Dining room,
Behrens
House,
Mathildenhöhe
Darmstadt,
1901

223
Peter Behrens
Table lamp,
1902.
Bronze and
coloured glass
h.70 cm,
27⁵⁸ in.
Private
collection

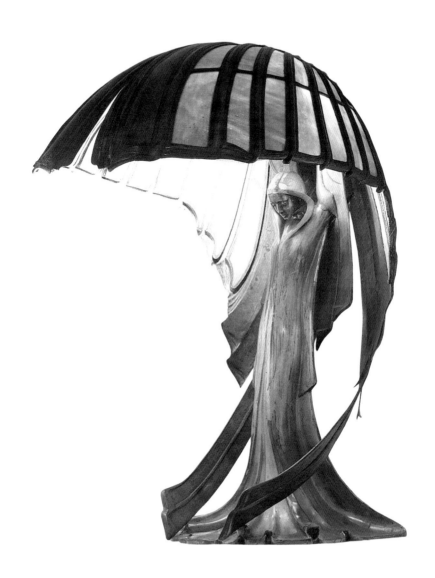

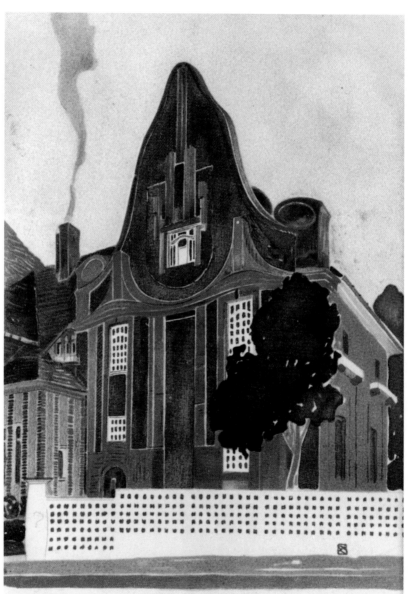

KÜNSTLER · KOLONIE · DARMSTADT · 1904 ·
DAS · GRAUE · HAUS · ERBAUT · VON · OLBRICH ·

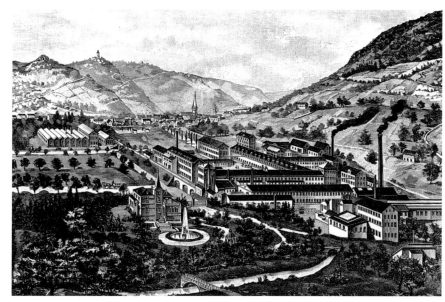

224
Joseph Maria
Olbrich,
The Grey
House,
Mathildenhöhe,
Darmstadt,
1904.
Postcard

225
Württemberg
Electroplate
Factory,
Geislingen,
1895.
Photographic
print;
13·5 × 21·5 cm,
5¹⁄₄ × 8¹⁄₂ in

226
WMF
workshop,
Geislingen,
c.1900

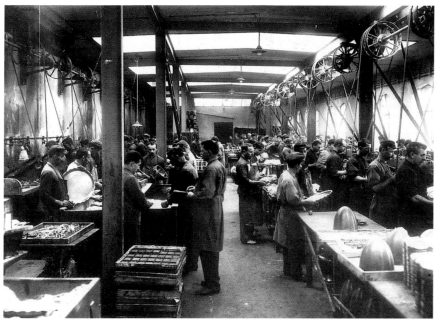

Electroplating was no longer a new development by the end of the nineteenth century: it had been invented in the 1830s and first applied to industry in the 1840s by a firm called Elkington & Co, based in Birmingham. The technique allowed objects of cheap, malleable base metals, such as nickel-silver, brass or Britannia metal, to be coated with silver by a process of electrolysis. Electroplated objects began to make their presence felt at the great exhibitions of the second half of the nineteenth century, with firms exploiting the process to produce elaborate pieces in historicist styles. Harnessing the technique to similar ends, WMF consistently focused on the possibility of large-scale manufacture that electroplating offered. A report on the WMF stand at the 1881 Württemberg State Industrial Exhibition observed that the firm was 'trying to attract the widest possible number of consumers, as well as to serve an art-loving public which likes genuine gold and silver household objects, but simply cannot afford them'.

As tastes changed, WMF realized that electroplating was ideally suited not only to ornate historicism but also to the elaborate forms of the modern style. The company produced pieces such as an elegant Art Nouveau claret jug (227) at reasonable prices – it was listed at 26 shillings in their 1906 English catalogue. The apparently seamless transition between the production of historicist and Art Nouveau pieces is reflected in the artwork of WMF's catalogues, which marketed their products at home and abroad. The cover of their 1895 catalogue displayed the company's name within an elaborately scrolling Rococo cartouche, while its 1899 equivalent had a female figure with flatly stylized abundant tresses, her head framed within a circular 'halo' inspired by Mucha's graphic art. These covers offer an interesting barometer of stylistic change. Although there is considerable continuity in the products they contain (the 1906 catalogue combines every style from Neo-Rococo to Jugendstil on a single page), the covers represent the changing fashionability of Art Nouveau as perceived by a provincial German manufacturer. By 1904, the Mucha-esque frivolity of the Parisian woman had been discarded, and the

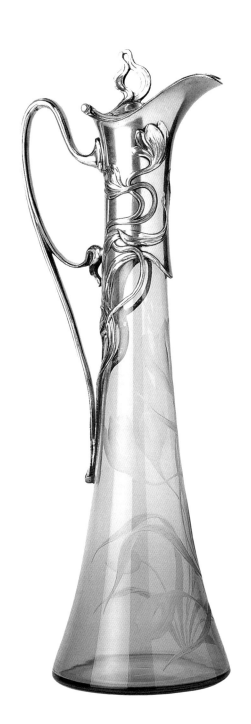

227
WMF,
Claret jug,
c.1900.
Acid-etched
glass;
h.40 cm,
15³⁴ in.
Private
collection

WÜRTTEMB. METALLWARENFABRIK

GEISLINGEN

NACHTRAG

1899.

catalogue of WMF's Göppingen branch adopted a geometrically abstract *Jugendstil* design reminiscent of some of the work of Henry van de Velde.

Like Gallé and the Daums, WMF was also keen to assert its industriousness. Nevertheless, despite the thoroughly modern scale of its operation, the firm's representations of its own manufacturing process show a changing attitude to the iconography of machine production. There is little sign of doubt on the cover of

228
Cover of a WMF catalogue, 1899

229
Cover of a WMF catalogue, 1902

the supplement to the 1899 catalogue (228), which loosely adopts the form of Klimt's first poster for the Vienna Secession (see 94), although in this instance the classical figure watches over the smoking stacks of WMF's factory, signalling the ongoing march of production through the night. The 1902 catalogue (229) again focuses on the production process, but this time a heroic craftsman works in front of a blazing forge, an attempt to reintroduce the image of the artisan into the industrial process.

WMF embodied the two central tensions of mass-produced Art Nouveau: the questionable appropriateness of mass production to art objects, and the status of the style as fashion. The firm had an ambiguous view of the attractiveness of large-scale production to the consumer. In 1914, company literature claimed that the firm was 'sufficiently well equipped ... to supply half the globe with Electro-Plate and Art Metal Ware unaided'. The change in the cover style of the WMF catalogues, from Neo-Rococo in 1895 to abstract Jugendstil in 1904, signifies the other tension between Art Nouveau and industry – the belief that industry reduced artistic endeavour to the level of fashionable accessory. Such transformations chimed with the perceptions of contemporaries that manufacturers such as WMF were using Art Nouveau as yet another style to complement the canon of historicism, rather than as a part of a design solution to the problem of the proliferation of historicist styles.

Three further Werkstätte-type organizations in Germany, two in Munich and one in Dresden, provide yet another model for the meeting of art and industry. All emerged in 1897–8, five years before the formation of the Wiener Werkstätte, from which they differed in that they were not indebted to Morris and Ashbee's romantic ideal of the artist-craftsman. In particular, Munich's Vereinigte Werkstätten für Kunst im Handwerk (United Workshops for Art and Handicraft) evolved into a dynamic commercial organization. Werner Sombart, a prominent German academic economist, commented in *Der moderne Kapitalismus* (1902): 'What makes the Vereinigte Werkstätten so interesting is that ... they created an organization and publicized the manufacture of "artistic" applied arts on the basis of a modern industrial business organization and ... modern technology.' Yet it is important to remember than many of the most celebrated examples of Munich Jugendstil were not produced in this manner, but by hand for specific commissions, such as Pankok's pieces for the Villa Obrist (see 76). Moreover, the scale of the Werkstätten sounds less impressive when compared with a manufacturer such as WMF. Although by 1907 the Vereinigte Werkstätten could boast 600 employees, this workforce was distributed between the production of many different kinds

of objects, and is only one-tenth of the 6,000 employed by WMF by 1914.

In the development of the work of some Art Nouveau artists of the German Werkstätten, however, there was a specific attempt to address the problem of scale of production. Richard Riemerschmid's work, first in Munich and then in Dresden, shows him concentrating his efforts on designing a range of furniture that could be produced from modular units. In 1905 he developed his 'Maschinenmöbel', which represented a deliberate rejection of the concept of style in the production of pieces that were pared-down and simple (the rectangular cupboards proudly display their construction bolts). According to one critic writing in *Deutsche Kunst und Dekoration*, Riemerschmid's new range, 'is far more reasonably priced than those pieces made with such effort by machines trying to copy handwork. Here a problem of great significance has been seized with unusual energy and success.'

In 1908 the Vereinigte Werkstätten in Munich launched a similar line under the name Typenmöbel, emphasizing the interchangeable components from which the furniture was made. But such a radical programme of designing for ordinary households did not necessarily mean the rejection of styling. The year after the launch of his 'Maschinenmöbel', Riemerschmid designed porcelain for Meissen, decorated with simplified leaf forms with an unmistakably Art Nouveau idiom. Europe's oldest porcelain factory, Meissen had commissioned him to design a table service 'in the same spirit as the best furniture and interior furnishings', and although its simplicity appealed to the critic Eduard Heyk, writing in 1907, it remained 'rather expensive'. Unfortunately, no records survive that could attest to the commercial success or otherwise of Riemerschmid's design, although without the backing of a firm such as Meissen, such projects would probably only have had a limited impact.

Although Art Nouveau artists generally encountered mixed fortunes as they attempted to combine art and industry, there were examples, even in Vienna, of very successful collaborations.

Between 1901 and 1914, Hoffmann designed furniture for the Viennese manufacturer J&J Kohn. The firm had exploited the expiry of Thonet's patent on bentwood (an innovative technique of bending and laminating wood) in 1869 and had grown by 1907 to be an international company employing 6,000 people and producing over 7,000 pieces of furniture daily. J&J Kohn manufactured Hoffmann's designs for the chairs at Purkersdorf Sanatorium around 1905 (see 98), as well as one of his most famous designs, the 'Sitzmachine' (230), an adjustable armchair that was first introduced in 1908 and was still in production in 1916. Wagner and Moser also designed for J&J Kohn, while the original pioneers of bentwood, by now known as Gebrüder Thonet, also collaborated with Wagner, producing the furniture used in his Post Office Savings Bank in Vienna (231). On one occasion, the Munich designer Obrist, who in 1907 had condemned manufacturers as 'Pharisees', had even worked with WMF to produce a fruit dish, as well as a wall fountain that featured in Riemerschmid's 'Room for an Art Lover' exhibited at the Universal Exposition in 1900.

The ongoing problem of the relationship between artists and industry was played out in the years before World War I in Germany with the formation of the Deutsche Werkbund, an organization that hoped to bring artists and designers together with industry. The Werkbund occupies a special place in the history of modern design, but its story is equally relevant to Art Nouveau, not least because it attracted so many of the style's leading exponents, such as Van de Velde, Riemerschmid and Behrens. Although many of the objects produced under its auspices were far removed from the Jugendstil manner of 1900, it offers a conclusion of sorts to Art Nouveau's dialogue between art, technology and industry.

As the mixed fortunes of the various Werkstätten have shown, there remained a gap between theory and practice in the commercial endeavours of the more progressive proponents of Art Nouveau. The Deutsche Werkbund was an attempt to bridge this gap. Founded in 1907, it initially comprised a group of twenty-four artists and firms who shared their reforming views. Unlike the

Werkstätten, which were formed as companies within which artists could produce their own work, the Werkbund was an umbrella organization that set out to represent artists, designers and architects, and aid businesses by providing them with a central index of these 'approved' artists. In this way, it was hoped that artists and industry could mutually benefit each other. A statement issued by the Werkbund in 1910 expressed the aim of encouraging 'the best in art, industry, craftsmanship and trade', in order to 'achieve quality ... evident in industrial endeavour'. By 1908 the Werkbund had 500 members, including artists and industrialists, a figure that had risen to almost 2,000 by the time its activities were effectively curtailed by the outbreak of war.

Many of the Art Nouveau designers already encountered in chapters 2 and 3 were among those who signed up to the Werkbund. Behrens, Riemerschmid, Obrist and Endell had all been crucial figures in the development of *Jugendstil* in Munich, while Henry van de Velde, who had been working in Germany since 1900, was also a founder member. Hoffmann and his former colleague Olbrich, who was coming to the end of his time at Darmstadt, both joined the new organization. The Werkstätten of Munich, Dresden and Vienna were among the manufacturers affiliated to the Werkbund, along with major commercial firms such as Krupp, Daimler and the AEG (Allgemeine Elektricitäts-Gesellschaft), Germany's huge monopolistic electricity company.

The work of these designers during the Werkbund years before World War I shows a varied response to the challenges of industry. Even in 1900, Riemerschmid's work had never indulged in the fantastical excesses of the *Jugendstil*; by 1907 he had attempted to abandon any obvious stylistic references with his Typenmöbel for the Vereinigte Werkstätte. A more apparently abrupt change came in Behrens' work. By 1907 he had made the transition from court artist to corporate designer for AEG. After the company joined the Werkbund, Behrens was appointed 'artistic adviser' in 1907, a position that eventually made him responsible for the company's entire visual culture, from its trademark and posters to its products,

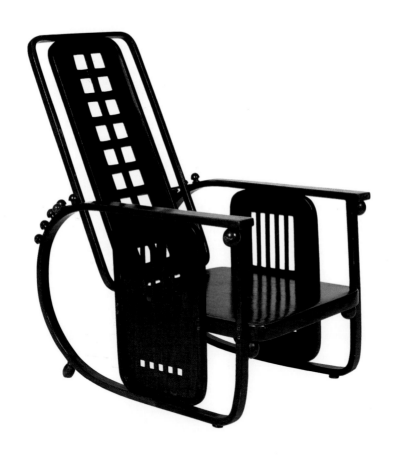

Josef Hoffmann,
Adjustable
armchair,
manufactured by
J&J Kohn,
c.1908.
Beechwood
stained mahogany
colour; plywood
seat, back and
sides; brass
rods for back
adjustment;
h.110 cm,
43³⁸ in.
Private collection

231
Otto Wagner,
Armchair,
manufactured by
Gebrüder
Thonet,
*c.*1904–6.
Beechwood
stained olive
brown,
aluminium
fittings;
h.79·5 cm,
31³⁸ in.
Victoria and
Albert Museum,
London

shops, factories and even its workers' housing. This was the ultimate corporate answer to the domestic *Gesamtkunstwerk* desired by enlightened bourgeois patrons of Art Nouveau. Behrens' early products for AEG retain a suggestion of his past work. A brass electric kettle designed in 1908 (232) was machine manufactured but has a finish that imitates handwork, and at this time AEG was still producing goods that possessed a hint of the *Jugendstil* flair that was soon to be eradicated from his work. Behrens' poster of 1907 (233) maintains a delicacy of line that echoes the designer's earlier Art Nouveau work, yet for the turbine hall he designed for AEG in 1909 he dispensed with all traces of decorative excess, providing an early vision of the functional aesthetic that was to be so appealing to post-war architects such as Walter Gropius (1883–1969) and Le Corbusier (1887–1965).

Van de Velde's work during his association with the Werkbund preserved the distinctive vocabulary of Art Nouveau. The theatre (234) he designed for the Werkbund's exhibition in 1914 retained the smooth, curving, linear style he had used in the interior of the Havana Tobacco Company Shop in Berlin in 1899 (see 195), albeit in a more simplified form. After the foundation of the Werkbund in 1907, while Behrens was working for AEG, Van de Velde continued to work for wealthy patrons, most notably the rich aesthete Karl Ernst Osthaus. The house for he designed for Osthaus, the Villa Hohenhof, comes from the same tradition as Behrens' Darmstadt house, but still displays the linear forms characteristic of his earlier work in Brussels (see Chapter 2) in the unsettling irregularity of the panelling in the stairwell, for instance, and the fretwork of the bannister support (236). Similarly, Van de Velde's design for the interiors of the proposed renovation of the Grand-Ducal Museum in Weimar (235), also dating from 1908, show him experimenting with the kind of austere yet decorative Art Nouveau that Wagner had made his own in Vienna.

To some extent, these stylistic developments were mirrored in the debate that ultimately polarized the Werkbund artists on the eve of the opening of the 1914 exhibition. The debate epitomized the

problems that had beset the experience of Art Nouveau in industry; its two sides were led by the architect, theorist and critic Hermann Muthesius and Van de Velde. Muthesius, an anglophile who combined an admiration for English design reform with an awareness of the importance of the machine and industry, advocated the development of standardized designs as a response to the challenges of mass production. By contrast, Van de Velde maintained that the artist and designer should always be an individual, driven from within rather than by the constraints of the market. In his address of 1914, Muthesius argued that 'Architecture together with all the activities of the Werkbund is moving towards standardization; only by means of standardization can it achieve that universality characteristic of ages of harmonious culture.'

This promotion of standardization ran counter to the experiences of industry of many of the older designers associated with the Werkbund. They had seen their designs borrowed and standardized by firms such as WMF, which had taken elements from Art Nouveau creations and thrown them together in endless combinations with less than satisfactory aesthetic results, and with no direct benefit to the artists themselves. Van de Velde and his supporters came to be known as the 'individualists'; they included such Jugendstil luminaries as Endell and Obrist, and they were supported by Osthaus. The fact that they were also joined by the young Gropius should caution against equating the 'individualists' with a particular aesthetic, but at the same time they can be seen to be expressing three of the defining concerns of Art Nouveau: the romantic notion of the artist as creator; a suspicion of the motives of modern industry; and a belief that the creative artist can make a business commercially as well as aesthetically successful.

Van de Velde invoked the romanticism that had been a cornerstone of Art Nouveau and had formed the nucleus of the Jugend manifesto in Munich fifteen years earlier (see Chapter 2). He proclaimed that, 'So long as there are artists in the Werkbund, and so long as they are influenced by its fate, they will protest against the imposition of orders or standardization. The artist is in essence a total

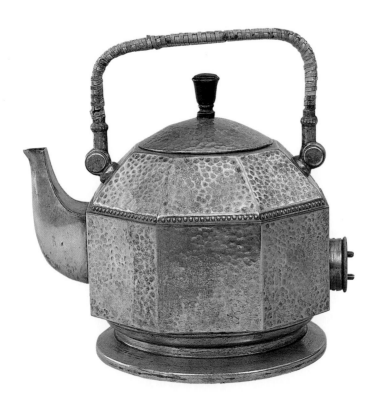

232
Peter Behrens,
Electric kettle,
manufactured
by AEG,
1912.
Brass;
h.20·6 cm,
8¹⁸ in.
British Museum,
London

233
Peter Behrens,
Poster
advertising an
AEG metal
filament light,
1907.
Lithograph;
67 × 52 cm,
26³⁸ × 20¹² in

ALLGEMEINE ELEKTRICITÆTS GESELLSCHAFT

A·E·G·METALLFADENLAMPE

ZIRKA EIN WATT PRO KERZE

individualist, a free spontaneous creator: he will never of his own accord submit to a discipline which imposes on him a canon or a type.' He went on to cite the work of Louis Comfort Tiffany, as an artist who had developed in his own idiosyncratic way to produce commercially successful products that were exported around the world but which retained artistic integrity.

It is a measure of the decline of the movement that by 1914 its German practitioners had finally become divided over an issue that had troubled many Art Nouveau artists since the 1890s. A caricature of the debate between Muthesius and Van de Velde (237) presents

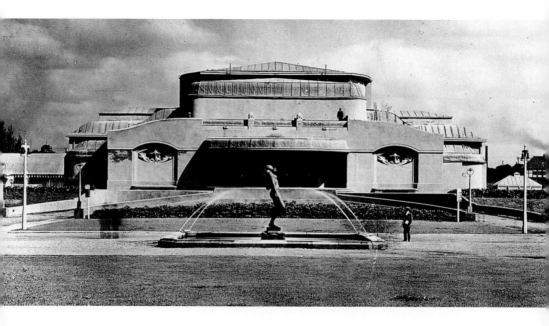

Muthesius (centre) as a hunched, slightly sinister figure, clutching his plans for a pared-down mass-produceable chair, while the dandyish Van de Velde (left) measures the flamboyant curves of his 'individualist' chair. Next to them a carpenter (right), with no ideological baggage, has produced the 'real' chair. While Van de Velde's theatre at the 1914 exhibition was proof that *Jugendstil* forms lived on, the architect was more preoccupied with fighting a theoretical battle regarding the nature of design. Twenty years earlier in Belgium, he had been in the vanguard against historicism and ugliness. Yet as the politics of the Werkbund became

234
**Henry van
de Velde**,
Theatre for
Werkbund
Exhibition,
Cologne,
1914

235
**Henry van
de Velde**,
Design for a
stairwell for the
Grand-Ducal
Museum,
Weimar,
1908.
Watercolour;
42 × 33·5 cm,
$16^{1}2 × 13^{3}8$ in.
Kunst-
sammlungen,
Weimar

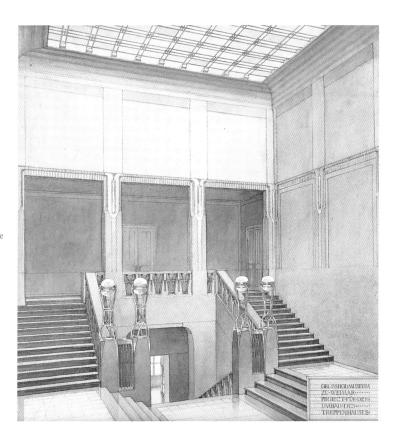

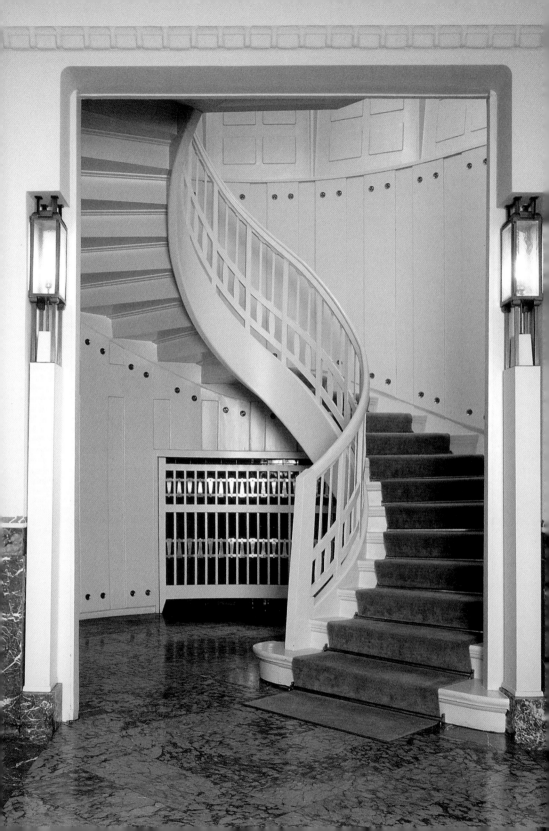

increasingly acrimonious, he found himself fighting a rearguard action on behalf of apparently old-fashioned ideas of individualism against an onslaught of standardization.

The picture that emerges is one of an ambiguous relationship between Art Nouveau, technology and modern production. Although some forms, particularly in glass and metalwork, relied on new manipulations of relatively new materials or techniques, and many of the artists and designers were driven by a radical political and social agenda premised on the notion of 'art for all', there was also a deep suspicion of the speed of change and the growth of scale that this modernity entailed. The 'high' decorative arts in general retained a system of individual production for specialist commissions, and the folk styles that characterized the modern quest for nationhood in many areas of Europe (see Chapter 4) also retained a deep-rooted association with a pre-industrial golden age. The workshop-based approach that Art Nouveau artists adopted, particularly in Austria, was inspired by the romantic socialist ideology of the English Arts and Crafts Movement. The Wiener Werkstätte, which attempted to unify the artist and the production process along these lines, did so very much on the artists' terms with little compromise to the challenges of modern business and commercial life, or the demands of an expanding middle-class market.

Even in Vienna, however, there was an awareness of the importance of somehow forging positive links between art and industry, even if the Werkstätte itself was never able to achieve this successfully. Moreover, there were examples of Art Nouveau that did manage to achieve a degree of success by embracing the modern. Both Gallé and the Daums took organization and management as seriously as the artistry of their production, and designers such as those employed by WMF embraced the new technologies that were changing the way people lived. But the role of the artist, particularly in a commercially successful firm such as WMF, was still a source of unhappiness among Art Nouveau designers. Behrens' work in the first decade of the twentieth century shows

236
Henry van
de Velde,
Staircase to the
second storey,
Villa Hohenhof,
Hagen,
1908

how a career with one of the corporate torchbearers of modernity
developed from the concerns with domestic beautification fostered
in Darmstadt. It also demonstrates how the tension between
art and decoration on the one hand, and the forward march of
modernity on the other, marked the end of Art Nouveau. Beyond
this, however, the fact that the tension was never fully resolved
ensured that Art Nouveau's influence continued to be felt
throughout the twentieth century.

237
Caricature
entitled *From
the Werkbund
Exhibition*, from
Simplicissimus,
1914. The
caption read:
'Van de Velde
has the
individual
chair –
Muthesius the
type-chair –
and the
carpenter has
the real chair.'

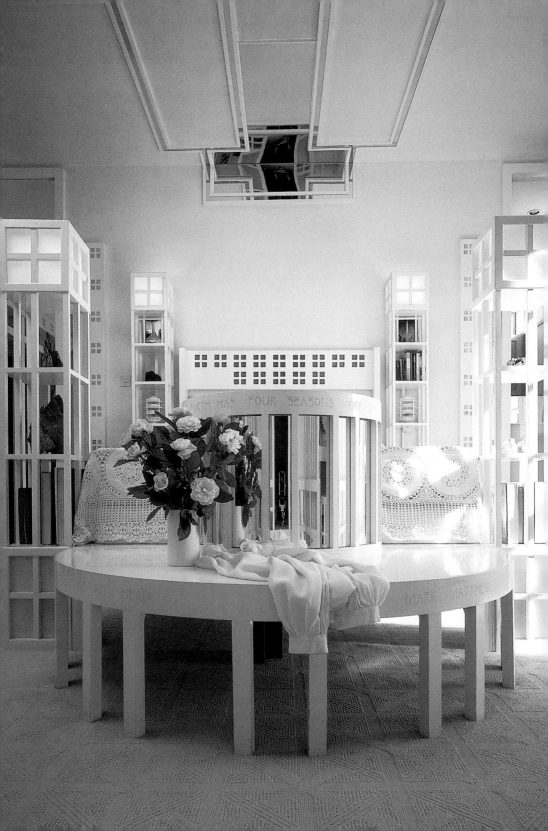

Art Nouveau is famous for its brevity. Horta's Tassel House (see 32, 37–41), designed in 1893, heralded what seemed to be a revolutionary new aesthetic, yet by 1905 the style was on the wane. Bing and Meier-Graefe had closed their galleries, and Gallé had died. Sullivan's commissions had dried up; Mackintosh had finished the Hill House, and he too faced a period of dwindling work. Ten years later, Walter Blackie, Mackintosh's patron at the Hill House, visited him and encountered an apparently broken man:

I found him sitting at his desk, evidently in a deeply depressed frame of mind. To my enquiry as to how he was keeping and what he was doing, he made no response. But presently he began to talk slowly and dolefully. He said how hard he found it to receive no general recognition; only a very few saw the merit in his work and the many passed him by.

In mainland Europe the experience of the Deutsche Werkbund (see Chapter 7) showed how the old Art Nouveau designers were having to change or face increasing marginalization in a world where Muthesius' rhetoric of standardization was growing ever more powerful. However, Art Nouveau lived on in various guises until World War I: the Palais Stoclet (see 101–105) was completed as late as 1911, and Van de Velde's cinema at the 1914 Werkbund Exhibition continued to display the distinctive linear style of the *Jugendstil*. Art Nouveau remained the dominant style in some European countries where it had been relatively late in developing and where it emerged as a more eclectic idiom. Thus Gaudí and his contemporaries in Barcelona continued building in their often idiosyncratic fashion well into the twentieth century (see Chapter 4). In other cities, such as Prague, Budapest and Riga, buildings that were considered to be in the 'modern style' were erected throughout the years before World War I. Meanwhile, an Italian

variation, *Stile Liberty*, was developing that, while not innovative in the way that Art Nouveau in Belgium, France or Austria had been, would have a profound influence on the decorative arts and architecture in years to come.

Prague in particular now enjoys a reputation as an Art Nouveau city, as a result of the large amount of new building that took place in the first decade of the twentieth century, much of it in a hybrid Neo-Baroque–Art Nouveau style. As early as 1880, plans to modernize the centre of Prague were conceived, but these were not finally realized until the 1900s. A city of the Austro-Hungarian Empire, Prague was alive with nationalist sentiments of the kind that so troubled the Viennese political establishment (see Chapter 3). Czech nationalism became increasingly radicalized in the 1890s, resulting in violent clashes on the streets of Prague in 1897 between ethnic Germans and Czechs. As in Vienna, as a way of countering nationalism, the liberal establishment encouraged new international styles in literature, art and architecture. By funding the cultural rejuvenation of Prague, Ernst Koeber, prime minister between 1900 and 1904, hoped to offer a positive cultural alternative to Czech nationalism. In 1901 a modern art gallery was founded, and support for the Prague School of Applied Arts was increased in order to enable it to participate at the major international exhibitions.

Despite this encouragement of internationalism, Czech Art Nouveau retained a distinctly local flavour. Artists such as the sculptor Josef Václav Myslbek (1848–1922) provided a link between Prague and Paris – he had visited the city in the 1870s – and Myslbek's work in the 1890s shows him grappling with the two primary influences on Czech Art Nouveau. A bronze such as *Music* of 1892–4 employs an almost pure Art Nouveau vocabulary to depict a delicate female figure draped in flowing robes, entwined within the caressing branches of a tree (239). In contrast, *Záboj and Slavoj* of 1892–5, one of a series of figures designed for the Palachy Bridge in Prague, represents romanticized heroic nationalist figures enhanced by subtly modern decorations, such as the male figure's Art Nouveau breastplate (240).

239
Josef Václev Myslbek,
Music,
1892–4.
Bronze;
h.108 cm,
42 in.
National Gallery, Pragu

240
Josef Václev Myslbek,
Záboj and Slavc
1892–5.
Sandstone;
h.250 cm,
98$\frac{1}{2}$ in.
Vyšehrad, Prague

The most successful Czech expressions of a truly international Art Nouveau style occurred in the applied arts, especially in Bohemian glassware. As early as 1890, the Harrach Glassworks in Nov'y Svet, close to the Polish border, was producing elaborate organic pieces akin to Gallé's exaggerated Neo-Rococo fantasies, while in the later 1890s the factory established by Josef Riedel (1862–1924) produced works in a more controlled geometric style. Riedel's *Prismatoid Vase* of 1898–9 (241) shows obvious Oriental influences in the decoration, evidence that Bohemian artists were open to the full range of international influences that fed into Art Nouveau. Foreign influences of a different sort are evident in the output of the Johann Lötz Witwe ('Widow of Johann Loetz') glassworks to the south of Prague. The Lötz factory was particularly adept at producing iridescent glass, drawing on the technical advances made by firms such as Tiffany, whose work many Bohemian glassmakers had seen when a collection of the American firm's glassware was exhibited in Vienna and Liberec in 1897. The Lötz factory's mastery of this technique is displayed in a

241
Josef Riedel,
Prismatoid Vase,
1898–9.
Shaded,
etched and
gilt glass;
h.33·3 cm,
13⅛ in.
Muzeum skla
a bizuterie,
Jablonec nad
Nisou

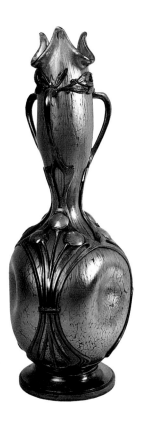

242
Johann Lötz
Witwe,
Vase,
1898.
Green glass
and metal;
h.40 cm,
15³⁄₄ in.
Moravská
galerie, Brno

swelling organic vase dating from 1898 (242). A further strand of
international artistic influence can be discerned in the vase's sinuous
metal mount, made by the Viennese firm Moritz Hacker.

A Czech national tradition was stronger in Prague's architecture of
the 1890s. Buildings by architects such as Antonín Wiehl (1846–1910)
and Friedrich Ohmann (1858–1927) employed an eclectic vocabulary
of historic forms with floral and figurative decorations, which,
although akin to Art Nouveau, did not make the imaginative leap
of Horta, Guimard or Gaudí. These Baroque influences are still
apparent in Ohmann's Hotel Central (243), one of the first Art
Nouveau structures to be erected in Prague. The spreading trees
and gilded stylized floral decoration lend the building a distinctly
modern air, which is balanced by the scrolling Baroque roof and
the traditional rustication flanking the façade.

The Hotel Central was completed by Ohmann's students, Alois Dryák
(1872–1932) and Bedřich Bendelmayer (1872–1932), whose slightly

later work exemplifies the eclectic Art Nouveau architecture that continued in Prague until the end of World War I and beyond, and for which the city is celebrated today. On the façade of the Hotel Europa, completed in 1904, Bendelmayer and Dryák adopted classical motifs, akin to those used by Wagner in Vienna, which are offset by the massive sculpted flowers that flank the pediment. Inside the decoration continues in a Viennese Secessionist vein, with scrolling geometric stair railings. This combination of Art Nouveau ornament

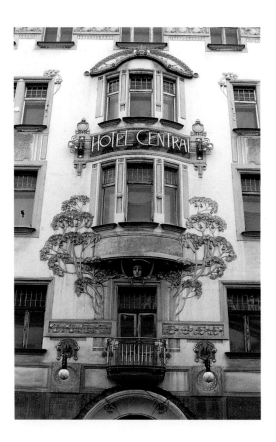

with a Neo-Baroque and Neoclassical grandeur emerges as a theme of *fin-de-siècle* Prague. It expresses the conflicting currents of nationalism and internationalism that informed the cultural politics of the city.

The fact that this eclecticism represented a political compromise made it an appropriate style for many of the city's new public buildings. The most celebrated example is the Municipal Building (244, 245) by the architects Antonín Balšánek (1865–1921) and

243
Friedrich
Ohmann,
Hotel Central,
Prague,
1898–1900

244–245
Antonín
Balšánek and
Osvald
Polívka,
Municipal
Building,
Prague,
1905–12
Above
Façade
Below
Detail of
stained glass

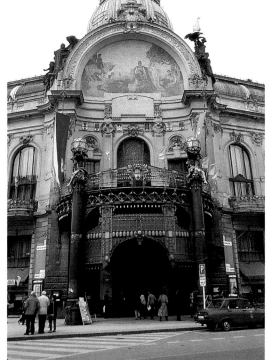

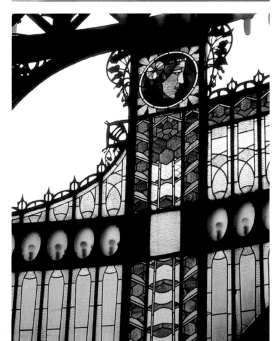

Osvald Polívka (1859–1931). The building, which was not completed until 1912, occupies an imposing corner site. Surmounted by a Neo-Baroque cupola, it has an elaborate polychrome wrought-iron entrance and a Symbolist-inspired allegorical mosaic of the city above. The interiors display the same interplay between modernity and tradition as the exterior. Gilt and white plasterwork throughout displays a combination of classical and natural forms, again reminiscent of Wagner's work. The chandeliers demonstrate a tendency towards Viennese geometry, as do much of the surviving furniture and fittings. Murals by Polívka depict heroic mythological scenes and portraits of civic figures in an uninspired academic style. More fascinating from an Art Nouveau perspective are the decorations of the Mayorial Hall (246) created in 1911 by Mucha. Still working in the distinctive style he developed in the 1890s in Paris (see chapters 2 and 6), Mucha depicted themes similar to those of Polívka, but in a dreamlike, Symbolist style imbued with *fin-de-siècle* mysticism. The city authorities were keen to commission such work to express both the historical and modern aspects of the city. In an age when easel painting had undergone a host of avant-garde developments such as Cubism (an art movement in which objects, landscapes and people were represented by multi-faceted, often monochromatic planes), it is significant that an old-fashioned Symbolist such as Mucha was seen as the appropriate choice for a civic project, the kind of work that any self-respecting Cubist would consider artistically anachronistic.

Having worked in Paris from 1888 and having made several visits to America, Mucha returned to settle in his homeland in 1911. His career in Prague represents the twilight of Art Nouveau and Symbolism. In 1909 he secured financial backing from a wealthy American patron, Charles R Crane, to execute a series of massive historical paintings depicting the history of the Slav people. Mucha travelled extensively around eastern Europe researching his subjects, and although he drew on international links in creating the series, its pan-Slavism was an expression of more narrow ethnic politics. Paintings from *The Slav Epic*, as the series was titled, were exhibited at the Brooklyn Museum in 1921, attracting some 600,000

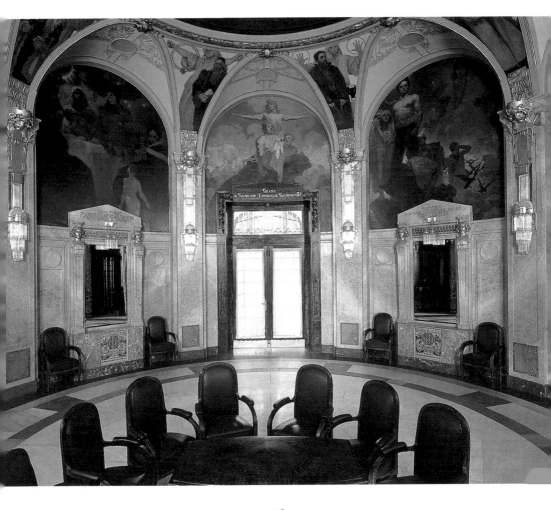

246
**Alphonse
Mucha**,
Murals in the
Mayorial Hall,
Municipal
Building,
Prague,
1911

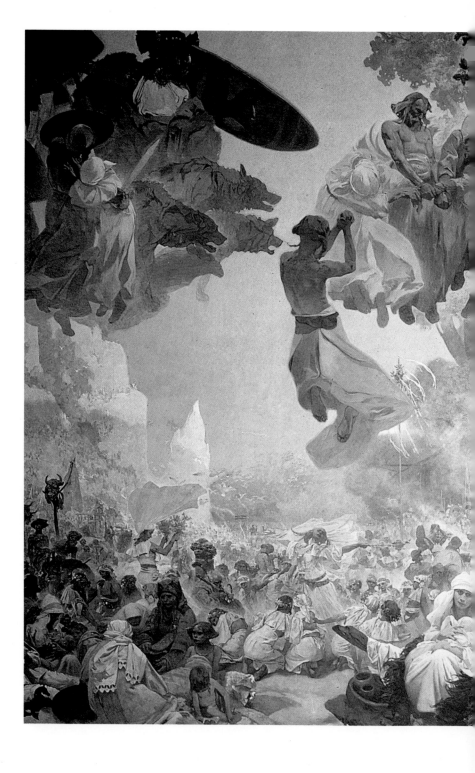

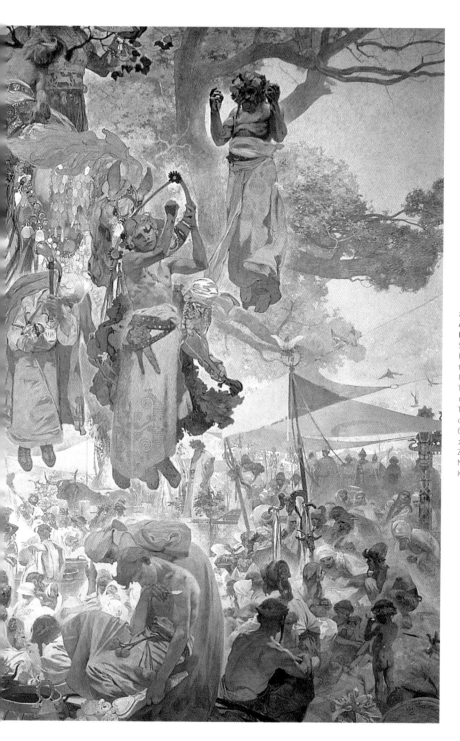

247
Alphonse Mucha, *Svantovít Festival on the Island of Rügen*, from *The Slav Epic*, 1915. Tempera and oil on canvas; 610 × 810 cm, 240⅛ × 318⅞ in. Zámek, Moravský Krumlov

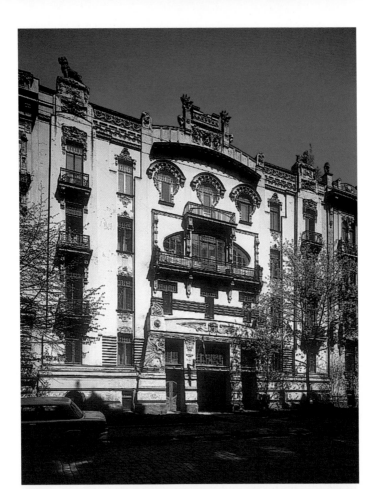

248
Mikhail
Eisenstein,
Alberta Iela 4,
Riga,
1904

249
Ödön Lechner,
Post Office
Savings Bank,
Budapest,
1902

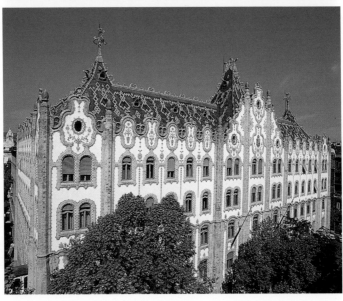

visitors; they were eventually given to the Czech state in 1928. The paintings varied in style from relatively uncomplicated historical scenes, such as *The Abolition of Serfdom in Russia* of 1914, to hallucinatory Symbolist compositions replete with fleets of floating figures, such as the 1915 *Svantovít Festival on the Island of Rügen* (247).

In other central and eastern European cities, such as Budapest in Hungary and Riga in Latvia, Art Nouveau was also adapted to local traditions. A construction boom in Riga in the years before World War I resulted in a large number of buildings after 1900 being erected in a variety of hybrid Art Nouveau styles. The most decoratively extravagant architect working in Riga during this period was Russian-born Mikail Eisenstein (1867–1921), who built around twenty apartment buildings in the city. Five such blocks designed by Eisenstein on the same street, Alberta Iela, reveal his eclecticism. No. 4 (248) has arches and shaped windows reminiscent of the work of Paul Hankar in Belgium, while no. 2a adopts a more classically inspired aesthetic. Historically, Latvia had felt the pull of both German and Russian influences. Riga was a port within the Hanseatic League (a commercial association with ties to northern German towns), which also had close links to St Petersburg. These influences are mirrored in Eisenstein's career: he trained in St Petersburg and drew many of his ideas from contemporary German periodicals (the plan applied to all of the Alberta Iela apartments was adapted from a German architectural journal). As in Finland and Russia, the traditional aspects of Latvian Art Nouveau derived from National Romanticism. Apartment blocks with steep pitched roofs, turrets and plain façades were enhanced with decorative details derived from ethnographic sources.

In Hungary, too, Art Nouveau was blended with local traditions of building and decoration, and, as in Prague, there was an element of official sponsorship. But while the liberal authorities in Prague sought to inject a spirit of internationalism into the city's culture, after 1903 the Hungarian government responded to a crisis in relations with Vienna by promoting Hungarian nationalism in all walks of life. While this meant that only a handful of buildings

adopted a Viennese Secession style, buildings with an Art Nouveau character continued to be built up until World War I, often displaying Oriental or National Romantic characteristics in order to reflect the prevalent nationalism.

Art Nouveau in Budapest was never viewed as a radical or wholly modern style. Ödön Lechner (1845–1914), the leading Art Nouveau architect in Hungary, adopted exotic Oriental forms in his buildings as a conscious reference to the Asiatic origins of the Magyar race. Lechner's national style is most apparent in the Museum of Applied Arts in Budapest, begun in 1896. The minarets, shaped windows and some of the interior stucco decoration inject a strong Indian flavour, while the polychrome façade is achieved through the use of tiles from the Zsolnay factory in Pécs, southern Hungary, which became an internationally recognized producer of Art Nouveau ceramics. By 1902 Lechner's work had evolved into a more recognizably Art Nouveau idiom. His Post Office Savings Bank of that year (249) displays an undulating plasticity, which continued inside with the pulsating lines of the stairwell decoration. Yet Hungarian elements remain, for instance in the bull's head that surmounts the central tower, symbolizing the Magyars' glorious past.

Many Hungarian artists and designers had worked in the Art Nouveau centres of Europe in the 1890s, some returning home after 1900. Most notable in this respect was József Rippl-Rónai (1861–1927), a painter turned decorative artist who had been a member of the Nabis and contributed work to Bing's gallery in Paris. Returning to Budapest, he designed the first Art Nouveau *Gesamtkunstwerk* interior in the city, a dining room for the aristocratic collector Count Tivadar Andrássy. English ideas were also important in Hungary. The Museum of Applied Arts was conceived by anglophile officials who were also responsible for inviting Walter Crane (see 21) to exhibit in Budapest in 1900. From here, Crane was taken around rural Hungary, where he responded enthusiastically to the folk traditions he saw. 'The peculiar character of the Hungarian people', Crane wrote, 'lies in their rich and endless imagination in floral decoration.' This advocation of the national style by an

Englishman was typical of what Lechner saw as the strength
of English taste. After visiting England, Lechner wrote:

The English, when they build something in their Indian colonies, make
an effort to adjust to local tastes ... and if the highly cultured English
feel no shame in studying the culture of their colonies ... striving to
adapt it and combine it with their own, then the Hungarians are all the
more obliged to study the art of our people and to find some synthesis
between it and our general European sense of culture.

In the event, it was a National Romantic version of Art Nouveau that
continued to thrive in Hungary until World War I. In 1909 Wekerle,
a new 'garden-city', was built on the outskirts of Budapest. The
buildings of the central square combine such features as steeply
pitched roofs, turrets, exposed wooden beams and decorative folk
motifs to produce a style comparable to the National Romanticism
of Finland, Russia and Latvia, while the 'directorial buildings' that
occupy a number of corner sites in the planned town draw on
Lechner's national Art Nouveau style. Back in the town centre,
a more confidently urban expression of the style appeared in the
form of the Grand Parisian Department Store, built between 1908
and 1912. Modern steel-framed construction techniques were used
to create an imposing parabolic arch and gable, again evoking
traditional rural forms within a modern context.

As in Prague, Budapest and Riga, designers in Italy were not among
the pioneers of Art Nouveau, but they embraced the style with
enthusiasm. Italy had been assured of its position in the history
of Art Nouveau by the First International Exposition of Modern
Decorative Arts held in Turin in 1902, at which many of the
major figures of European Art Nouveau exhibited. The country
was still politically a relatively young nation at the turn of the
nineteenth century, having been created from separate kingdoms
with unification in 1861. While Britain, France and Germany
were industrially advanced, Italy was still largely rural, although
northern, more cosmopolitan cities such as Milan and Turin were
expanding and developing rapidly. It was here that Art Nouveau
was most popular with industrialist patrons, who wanted a

modern international style. Giuseppe Sommaruga (1867–1917), Giuseppe Brega (1877–1929) and Ernesto Basile (1857–1932) were among the architects who designed opulent buildings in a variation of Art Nouveau known as *Stile Floreale*, which featured elaborate floral motifs and drew on Italian Baroque. Art Nouveau also provided hope for those artists who were interested in promoting design reform. An admiration of Arts and Crafts developments in England led to the establishment of a periodical entitled *Emporium*, based on the *Studio*, while Art Nouveau itself was sometimes called *Stile Liberty*, after the London department store (see Chapter 6). In 1901 another journal, *Novissima*, this time based on *Ver Sacrum* in Vienna (see Chapter 3), again confirmed Art Nouveau's internationalist credentials in Italy.

As in Hungary, Oriental styles also fed into Italian Art Nouveau, although in this case the links were contemporary rather than ancient, forged by Italian designers and their patrons from the Near East. The main pavilion for the Turin exhibition was designed by Raimondo D'Aronco (1857–1932), an architect who had worked extensively in Constantinople (now Istanbul) in Turkey. There he had overseen restoration to the former Byzantine church of Hagia Sophia (since 1453 the city's congregational mosque) and other Islamic buildings, as well as working on his own designs that fused Art Nouveau with neo-Oriental elements. On his return to Italy, D'Aronco continued in the same vein: a watercolour study for the Rotonda d'Orore pantheon for the Turin exhibition features a dome and painted walls that show the influence of both Viennese Secession architecture and Eastern and Byzantine decorative traditions (250).

250
Raimondo
D'Aronco,
Design for
the interior
decoration of
the Rotonda
d'Onore,
1901.
Watercolour;
55 × 43·8 cm,
21⁵⁄₈ × 17¹⁄₄ in.
Galleria d'Arte
Moderna,
Udine

Another Italian designer with connections with the Islamic world was the furniture maker Carlo Bugatti (1856–1940), who was commissioned by the Viceroy of Egypt to design pieces for his villa in Constantinople. Bugatti created fantastical pieces of wooden furniture with brass and pewter inlays and exotic polychrome decoration (251). The geometric forms of many of his pieces clearly draw on the work of European Art Nouveau designers such as Olbrich, but Bugatti's style was always fiercely individual,

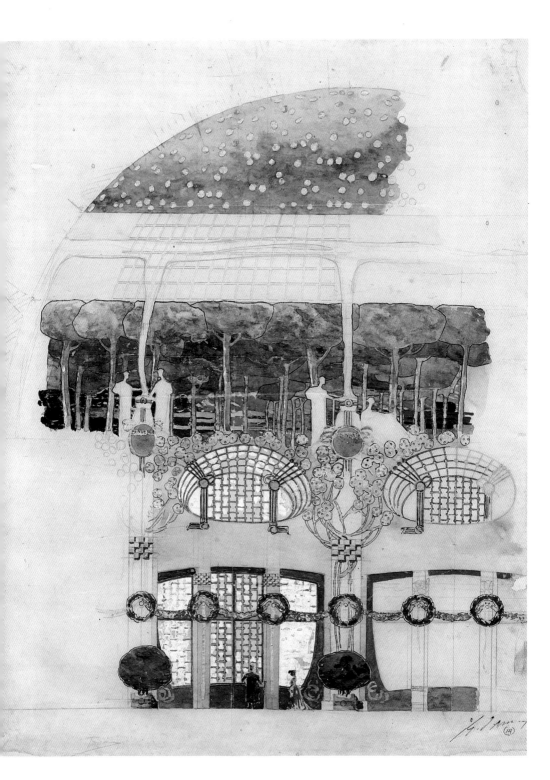

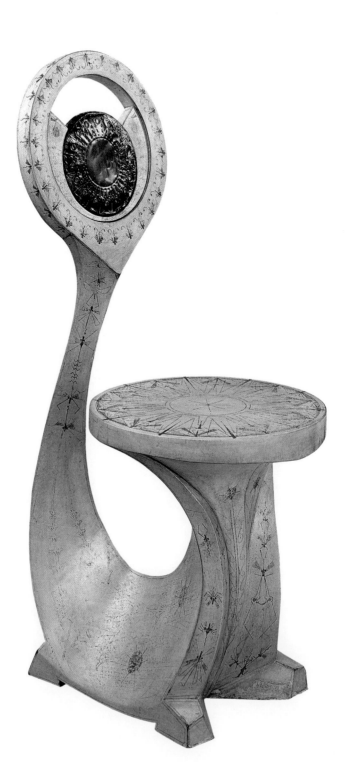

251
Carlo Bugatti,
Snail-shaped
chair,
1902.
Tropical wood,
painted vellum,
appliqué work in
beaten copper;
h.97 cm,
38⅛ in.
Musée d'Orsay,
Paris

incorporating African and Turkish elements such as tassels and minarets. Just as Tiffany and Bing had looked to Japan to escape from historicism, so Bugatti exploited a non-European aesthetic in his quest for originality.

The brief career of the architect Antonio Sant'Elia (1888–1916) illustrates how the echoes of Italian Art Nouveau were present in Futurism, an art movement founded by the writer Filippo Tommaso Marinetti (1876–1944). The Futurists aimed to encompass all art forms, and were inspired by an enthusiasm for speed and technological progress, sharing with certain exponents of Art Nouveau a desire to break with the past and create a new style for the modern age. Sant'Elia was first attracted to Symbolism and Art Nouveau while he was studying architecture at Milan and Bologna, and was particularly influenced by the Vienna Secession. His early buildings, such as the Villa Elisi (1910–11), designed for the industrialist Romeo Longatti, were in *Stile Floreale*. By 1912 he had begun a series of drawings of utopian futuristic cityscapes, known as the *città nuova*, in which all traces of Art Nouveau rapidly disappeared. Instead, he looked to the skyscrapers of New York for a monumental vision of the modern world.

The dawn of the machine age did not, however, mean the eradication of Art Nouveau's influence. Some of the ornamental exuberance of the style was carried on in Art Deco, the decorative alter ego of the Modern Movement that was not identified as a coherent style until the 1960s. While Le Corbusier (1887–1965) was promoting the idea of the house as a 'machine for living in' and reminding the world of the Viennese architect Adolf Loos's maxim that 'ornament is crime', the creators of Art Deco were continuing the quest for expression that was unquestionably modern, but also decorative. The results of this search were in many respects vastly different from Art Nouveau. Furniture makers such as Jacques Émile Ruhlmann (1879–1933) rejected the ornate carving of Art Nouveau in favour of smooth surfaces veneered in exotic woods, and adapted the controlled lines of classicism, simplifying his forms while retaining a sense of craftsmanship and luxury that

distanced him from the Modernists. Other responses included the adoption of stylized exotic decoration taken from Ancient Egypt or Africa, or the decorative adaptation of the abstract shapes created by the avant-garde Cubist painters.

Nevertheless, the dividing line between Art Nouveau and Art Deco remains a hazy one. A project such as the Palais Stoclet could be claimed for both, while beginnings of Art Deco have been detected

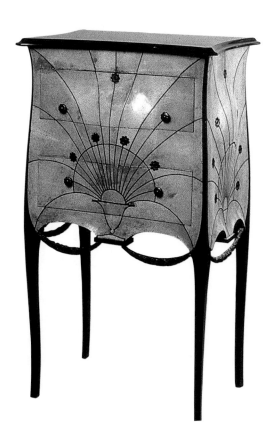

252
Paul Iribe,
Commode,
c.1912.
Mahogany,
ebony and
shagreen with
marble top;
h.91 cm,
35⁷⁸ in.
Musée des Arts
Décoratifs, Paris

253
René Lalique,
The Firebird,
1922.
Moulded glass
and bronze;
h.43 cm,
16⁷⁸ in.
Private collection

in the Parisian Salons as early as 1910. Paul Iribe (1883–1935), for instance, a furniture maker who rose to fame in Paris before World War I, had seemed to reject Art Nouveau from the outset, adopting a stylized Louis XVI mode (a mid-eighteenth-century French decorative style that harked back to the restraint and geometry of classical Greece). Pieces such as his shagreen veneered commode of around 1912 (252) led to him being cited after the

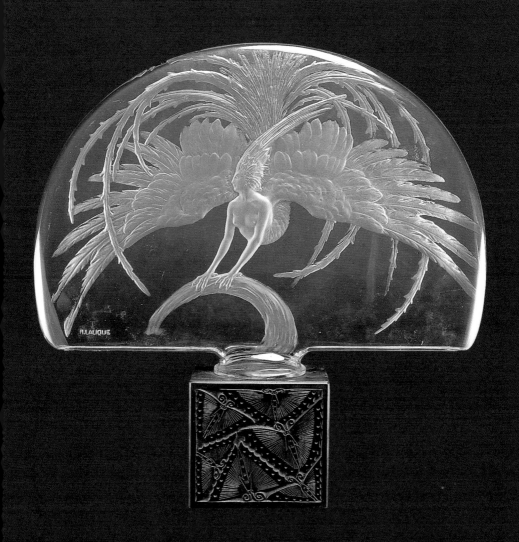

war by Art Deco makers such as Ruhlmann as a formative influence. Yet Iribe's use of traditional French forms and his love of opulent and luxurious materials also place him firmly in the tradition of French craftsmanship promoted by the Union Centrale des Art Décoratifs (see Chapter 1).

The most obvious examples of continuity between Art Nouveau and Art Deco can be detected in the work of many Art Nouveau designers and architects whose careers carried on into the 1920s. Majorelle, Hoffmann, Saarinen and Horta all continued to produce work, with varying degrees of critical acclaim and financial reward. Perhaps the most successful transition was made by Lalique. Celebrated in the Art Nouveau period for his jewellery, Lalique began working in glass around 1901 after becoming increasingly concerned at the cheap copying of his jewellery designs. His breakthrough in his newly adopted field came in 1908, when he gained a commission to design perfume bottles for François Coty. His glass-making business grew, and at the 1925 International Exposition in Paris his illuminated glass fountains became one of the exhibition's hallmarks, featured on advertising posters and subsequently becoming one of the icons of Art Deco. His glassware from the 1920s shows a number of decorative continuities with Art Nouveau. For example, a lamp of around 1925 in the form of a giant bottle was decorated with naturalistic organic forms in intaglio (sunken or incised ornamentation), while another lamp of the same date entitled *The Firebird* (253) is similarly designed, this time with a metamorphosing bird-woman, the kind of subject matter dear to the hearts of Symbolist painters in the 1880s.

Art Nouveau's stylistic and intellectual influence was also felt by designers too young to have made an impact in 1900. By the late 1930s, a crisis within the Société des Arts Décoratifs, the organization to which most French designers of the period belonged, led to the breakaway of those with Modernist sympathies to form the Union des Artistes Moderne (UAM). Those who remained held true to Iribe's view on the importance of luxury and craftsmanship in the decorative arts. By this time, however, the architects, designers and polemicists

of the Modern Movement were in the ascendancy from Helsinki to Los Angeles. The Swiss architect Le Corbusier had heralded the machine aesthetic as the saviour of modern man – finally architecture and design could offer the same rational solutions to life as science, industry and medicine. In Germany the architect Ludwig Mies van der Rohe (1886–1969), who had worked for Behrens earlier in his career, was designing groundbreaking buildings such as the Barcelona pavilion of 1929. Alongside Le Corbusier, Mies van der Rohe was a seminal figure of the Modern Movement and another proponent of uncompromising functionalism. His open-plan building rejected the traditional function of such pavilions – the promotion of a country's products – to create a tranquil oasis of simplicity within the bustle of the exhibition. After 1932 this style of architecture, which produced buildings that were predominantly white in colour, rectilinear and undecorated, was also known as the International Style after the first architectural exhibition at the Museum of Modern Art in New York. These developments inevitably contributed to the backlash against Art Nouveau.

In 1936 the historian Nikolaus Pevsner, one of the Modern Movement's most eloquent and convincing advocates, published *The Pioneers of Modern Design*, which traced the roots of Modernism's rationalism back to the Arts and Crafts writings of William Morris. Art Nouveau was afforded a place in Pevsner's history but was ultimately dismissed as a 'blind alley' down which many well-intentioned and hopeful young artists of the *fin-de-siècle* period had travelled. Pevsner did find in Art Nouveau certain innovations that he felt had contributed to the evolution of the Modern Movement, but he tended to hive them off and treat them separately. Denied to Art Nouveau in this way are Hoffmann, Endell, Wright and Sullivan's later work, such as the Carson, Pirie, Scott department store. Those Pevsner left for Art Nouveau included such names as Horta and Guimard. This selectivity allowed him to characterize the style as a decoratively eccentric frivolity. In his eyes, Sullivan was undoubtedly an architect of intellectual standing, while Horta remained 'if not wholly, at least partially a decorator'. Pevsner thus took from Art Nouveau what he saw as serious contributions

254
Eric
Mendelson,
Einstein Tower,
Potsdam,
1917–21

to modern design and let it keep that which he viewed as weak, unhealthy and decadent. In short, he wrote off the style:

It directs its appeal to the aesthete, the one who is ready to accept the dangerous tenet of art for art's sake. In this it is still emphatically nineteenth century, even if the frenzy of insistence on unprecedented form places it beyond that century of historicism. A universally accepted style could not issue from its endeavours.

Nevertheless, despite the vociferousness of many of the more radical Modernists, who were keen to erase the very notion of decoration from the architectural vocabulary, the influence of Art Nouveau continued to be felt throughout the apparently hostile ascendancy of the Modern Movement. The desire for an aspirational and decorative response to the twentieth century, which had begun with Art Nouveau, found another embodiment during the inter-war years in the form of Expressionism. This was a trend in inter-war architecture, particularly in Germany, which sought to

express modernity through imaginative plastic forms. In the work of two of its most celebrated practitioners, Eric Mendelsohn (1887–1953) and Hans Poelzig (1869–1936), can be seen a style that, although undeniably modern, has organic and playful qualities that drew on *fin-de-siècle* precedents.

Poelzig was older than many of the other Expressionists, and his architecture after World War I continued to refer to earlier styles. His design for the interior of a large theatre, the Grosse Schauspielhaus in Berlin, proposed a cavernous undulating interior, enhanced by stalactite-like decorative forms, typifying his aversion to the notion of pure function. Poelzig acknowledged in 1921 that he 'glorified the almost impracticable', claiming that, 'what matters to me is form and form alone.' Eric Mendelsohn hit the headlines in Germany in 1919 with an equally strange building that was erected near Potsdam. Mendelsohn was a young and previously unknown architect, and the building was the Einstein Tower (254), an observatory designed for a private client. The tower had been commissioned after the client had seen an exhibition of Mendelsohn's drawings, many of which had initially been sketched while he was on guard duty in the trenches of the Western Front. Mendelsohn described his drawings, which included visionary designs for a car factory and a railway station, as 'skirted by one contour, bulging, protruding and retracting – suggesting the elastic tension of the steel and concrete structure'. Like Poelzig, he questioned the current preoccupation with function, claiming that 'function without sensibility remains mere construction.'

Aesthetically, there are clear links between the work of architects such as Poelzig and Mendelsohn and the Art Nouveau tradition. Both share an organic, linear sense of form, as well as a strong sense of the fantastical as opposed to the merely utilitarian. And such similarities are more than mere coincidence: Mendelsohn had received his initial training in Munich before the war, where he had known Obrist and been influenced by Van de Velde. In the Exhibition for Unknown Architects, which was held in 1919 and provided a showcase for many Expressionist architects, tombs designed by

Obrist were included that displayed smooth linear qualities similar to Mendelsohn's wartime drawings. Mendelsohn also admired Van de Velde's theatre at the 1914 Werkbund exhibition, his wife later recalling that 'When [Mendelsohn] moved to Berlin we asked to see [Van de Velde's] work in the library and Eric was deeply affected.' But Mendelsohn reserved his greatest admiration for another Art Nouveau architect, Olbrich, whose Gebäude für Fluachenkunst in Darmstadt, an exhibition hall that adopted a distinctive curved, keel-like form, he found particularly inspiring: 'It seems to me,' he wrote, 'that this is simply an inkling of future possibilities.'

There are many examples of Art Deco and Expressionist architecture that illustrate how the ideals of Art Nouveau, and to some extent its decorative language, lived on throughout the period that is now seen as having been dominated by the Modern Movement. Surrealism – yet another alternative to the rational solutions of Modernism – inherited some of the irrationality of Symbolism. The paintings of Gustave Moreau were admired by the writer André Breton (1896–1966), who lived only a few minutes' walk from the Moreau Museum in Paris, and wrote that it was the place where 'beauty and love were first revealed to me'. In his *Manifeste du Surréalisme*, published in 1924, one of Breton's definitions of Surrealism was that it was the expression of 'the true function of thought. Thought dictated in the absence of all control exerted by reason, and outside all aesthetic or moral preoccupations.' Here was an echo of Art Nouveau's decadent anti-classical streak, its late Romantic, individualist element. The spiritualism of Art Nouveau artists such as Mucha also found echoes in the pseudo-religious dabblings of the Surrealists and their interest in magic and superstition.

The Catalan Surrealist artist Salvador Dalí (1904–89) attempted to revive interest in the great *Modernista* architect Gaudí in Paris in the 1930s. In 1933 he published an article 'De la beauté terrifiante et contestible de l'architecture "modern style"' in the magazine *Minotaure*. For Dalí and the Surrealists, Gaudí in particular and Art Nouveau in general could be summoned as a weapon against the stultifying 'good taste' of the Modern Movement:

Those who have not tasted [Gaudí's] supremely bad taste ... have knowingly committed treason by disregarding the major role it holds in Gaudí's works. The common mistake is to see bad taste as something sterile: it is good taste and good taste alone that holds the power to sterilize and which exists as the prime handicap to any creative function.

As well as sharing a number of theoretical premises, a penchant for Art Nouveau was part of the Surrealists' glorification of kitsch as by this time it was widely perceived as outmoded and even tawdry.

The aesthetic reaction against Art Nouveau that had emerged by the 1930s gained a further political dimension with the rise to power of the National Socialists in Germany in 1933, under the leadership of Adolf Hitler. While *Jugendstil* embodied many of the cultural trends in *fin-de-siècle* Germany from which fascism evolved, the style's free forms were the antithesis to the disciplined Neoclassicism of official Nazi architecture. Its internationalism, too, flew in the face of the folk vernacular style that was also acceptable to the Third Reich. The Nazis reserved their most vigorous efforts to censor what they saw as the degenerate evils of modern painting, Cubism and Expressionism in particular. As an art movement from before the democratic Weimar Republic (which had governed Germany since the end of World War I), *Jugendstil* was not a prime target in the Nazi crusade for artistic purity, but when it got in the way it was dismissed as undesirable. In 1937, when the Nazis were building their cultural complex the Haus der Deutschen Kunst in Munich, the Local Buildings Commission reported that August Endell's Elvira photographic studio (see 73, 74), which was situated on the main road to the Haus, was a 'foreign' eyesore and recommended that the relief plaster decoration on the façade should be replaced with a plain surface. Later that year this imaginative architectural manifestation of Art Nouveau was destroyed. The Slav nationalist element of Art Nouveau in central and eastern Europe also ran counter to the Nazi belief in Aryan supremacy. Although the style was not necessarily perceived as a threat, when the Germans partitioned Czechoslovakia in 1939, the aging Alphonse Mucha was among the first people questioned by the Gestapo.

After World War II Art Nouveau gradually showed signs of attaining some degree of respectability. In 1957 the Museum of Modern Art in New York staged a ground-breaking exhibition of Gaudí's work. Its rationale at this time was made clear in the foreword of the exhibition catalogue, which hinted at the murmurings of dissatisfaction with 'pure' functionalism that were growing ever louder within the modern architectural community. It conceded that:

255–256
Le Corbusier,
Chapel of
Notre Dame-
du-Haut,
Ronchamps,
1955
Left
Exterior
Opposite
Interior

The architect working within the discipline of the rectangular grid, and its related aesthetic form derived from pure structure, finds it increasingly difficult to give each building the singularity it deserves. This difficulty accounts in part for the current renewal of interest in an architecture of expressive plastic form.

Even Le Corbusier, the great prophet of functionalism, confirmed his admiration of Gaudí in 1957 when he recalled having been enchanted by the Catalan architect's work when he had visited Barcelona in 1928:

There I found the emotional capital of 1900. 1900 was the time when my eyes were opened to things of art, and I have always retained memories of it. As a 'soap box' architect, my attitude puzzled my friends at the time.

Antagonism [between] 1900 and 'soap boxes'? There was no question of that for me. What I had seen in Barcelona was the work of a man of extraordinary force, faith and technical capacity, manifested throughout his life in the quarry ... Gaudí is the constructor of 1900, the professional builder in stone, iron and brick.

Le Corbusier's Chapel of Notre Dame-du-Haut at Ronchamps in southern France (255), completed in 1955, saw him playing with similar decorative forms to those employed by Gaudí. The interior of the chapel (256), with its irregularly placed stained glass windows casting shafts of light through the heavy walls, evoked a medieval sanctity and imbued Le Corbusier's previously hard-edged functionalism with a spiritual dimension. It has an atmosphere akin to that created by Gaudí at the Colònia Güell crypt (see 160).

257
Alvar Aalto,
Fireplace,
upper hall,
Villa Mairea,
Noormarkku,
1938–9

Le Corbusier and the grandees of the Museum of Modern Art were not the only Modernists to appreciate elements of the *fin-de-siècle* style. The Modern Movement in Scandinavia, and in particular the work of Alvar Aalto (1898–1976), had always retained an affinity with organic forms and natural materials, and had never succumbed to the pure functionalist aesthetic promoted by Mies van der Rohe and Le Corbusier in the inter-war years. The Finnish Art Nouveau tradition had seen simplicity as a virtue, and the fusion between Art Nouveau and the indigenous rural tradition produced a version of the style characterized by its aversion to unnecessary elaboration.

It should, therefore, come as little surprise that Scandinavian interpretations of modern design from the 1930s onwards should possess an organic, humanizing element. Direct parallels can be drawn between the Villa Mairea, one of Aalto's most celebrated buildings, and 'Kalela' and 'Hvitträsk' (see 122, 128 and 129), the houses built for the Finnish painter Gallen-Kallela and the architects Gesellius, Lindgren and Saarinen. Commissioned in 1938, Aalto's

Villa Mairea was an exercise in *Gesamtkunstwerk* in the Art Nouveau tradition. It was also an essay in the use of natural materials within the historical framework of traditional vernacular styles. Aalto made extensive use of wood as opposed to the steel and concrete advocated by the Modern Movement, alluding to the natural surroundings of the forest in his use of narrow wooden columns leading to the doorway and surrounding the staircase. His use of space displays an awareness of the open-plan designs of both 'Kalela' and 'Hvitträsk', while a number of features of the interior seem to draw directly on the *fin-de-siècle* period. The fireplace of the upper hall (257) shares its distinctive vernacular shape with those that graced the interiors of houses by Gesellius, Lindgren and Saarinen, while the unashamed use of distinctly non-functional decoration on details such as the door handles betrays Aalto's debt to the preceding generation.

258
Tapio
Wirkkala,
Vase,
1946.
Glass;
h.21·5 cm,
8½ in.
Private
collection

Scandinavian modern design from the 1930s onwards displays an appreciation of traditional materials, accompanied by an organic approach that set it apart from the dogmatism of the International Style, so that it made a very successful export in the immediate post-war era. The organic, almost floral, form of the famous glass vase designed by the Finnish glassmaker and sculptor Tapio Wirkkala (1915–85) for the Karhula-Ittala firm illustrates a dissatisfaction with the aesthetic of pure functionalism (258).

From the 1960s onwards, a scholarly and connoisseurial revival of Art Nouveau was matched by the style's impact on fashion and popular culture, particularly in London and San Francisco. Popular culture had developed a disrespect for the dull safety of the post-World War II consensus in politics and aesthetics. As with the Surrealists in the 1930s, dissatisfaction was expressed by borrowing from Art Nouveau to challenge conventional good taste and decency. Many of the 'hippy' generation identified with the hedonism and decadence of the *fin de siècle* and idealized youthful freedom and non-conformity, in the face of the polarized politics of the Cold War.

In London the Art Nouveau revival was most popularly encapsulated by Barbara Hulanicki's fashion boutique Biba, which opened in

Kensington in 1963. It sold many styles of clothes that drew on the slender linearity of Art Nouveau's female sexual ideal, as well as accessories with Art Nouveau-inspired graphics (259) and packaging. Even more direct was the revival of Art Nouveau graphic styles, and particularly that of Aubrey Beardsley in the psychedelic culture of the late 1960s and early 1970s. Advertisements for the Head Shop, which appeared in the underground magazine Oz in 1967, offered a range of posters for sale, some reprints of designs by Beardsley himself, alongside contemporary Beardsley-esque designs.

In the late 1960s, two small yet influential exhibitions held at the Victoria and Albert Museum, London, explored the graphic work of

259
John
McConnell,
Biba logo,
1968

260
Wes Wilson,
BG 57,
1967.
Lithograph;
57·2 × 34·3 cm,
22^12 × 13^12 in

Beardsley and Alphonse Mucha. Curated by Brian Reade, a pioneer in the appreciation of the 1890s, the Beardsley exhibition rivalled even Oz in the moral outrage it provoked. A police operation was staged to remove a number of the works in the exhibition, which were considered to be in contravention of the Obscene Publications Act due to the sexually explicit nature of some of Beardsley's later illustrations. This move backfired when a photographer from the Guardian was tipped off in advance, and pictures of state censorship in action were spread across the papers, further fuelling the Beardsley craze.

TICKETS SAN FRANCISCO: City Lights Bookstore; S.F. State College (Box Y-1); The Town Squire (1318 Polk); Kelley Galleries (2661 Sacramento); Wild Colors (1416 Haight); Bally Lo (Union Square); BERKELEY: Campus Records; Discount Records; Shakespeare & Co.; SAN MATEO: Town & Country Records; REDWOOD CITY: Redwood House of Music; SAN RAFAEL: Sherman Clay; SAUSALITO: The Tides Bookstore.

It was in San Francisco that the adaptation of Art Nouveau sources in pop posters reached its creative peak, as a range of artists stretched psychedelic graphics and forms often beyond recognition. Artists such as Wes Wilson (b.1937) and Lee Conklin (b.1938) encapsulated the new style in their posters advertising rock concerts in the Bay Area with designs that defied all the modern conventions of readability and colour theory. Conklin also drew on Beardsley's intricate linear style, while Wilson borrowed a broad range of Art Nouveau themes and devices. A 1967 poster for the Byrds (260) returns to the peacock, a favourite decorative motif of Art Nouveau, and draws heavily on the work of Bradley (see Chapter 5). Text was displayed in a tortured curvilinear manner, exhibiting the qualities of much Art Nouveau design of around 1900. Wilson himself readily acknowledged his influences and, as in London, academic attempts to reassess Art Nouveau were also an important factor in the revival. Wilson had come across *fin-de-siècle* design in the catalogue for an exhibition at the University of California at Berkeley, and had been particularly impressed by the lettering used by the Secessionists in Vienna, admitting that, 'I was able to adapt it on almost all my posters from that moment on.'

The revival of academic interest in Art Nouveau was matched by the increasingly buoyant performance of the style in the salerooms. Objects from the *fin-de-siècle* period had always had a dedicated band of connoisseurs – even in the 1930s there were collectors of Gallé and Daum glass. However, the 1960s saw a collecting boom, with a number of dealers specializing in Art Nouveau and Art Deco by the end of the decade. The big auction houses began to hold sales dedicated to Art Nouveau, and prices have continued to rise ever since. In the mid-1970s a chair by Mackintosh fetched the then phenomenal sum of £9,000 in the London salerooms; by 1996 a pair of Mackintosh chairs were being offered for sale by the Fine Art Society for £40,000 each.

An affinity with Art Nouveau forms could also be detected in post-war Italian design, where the reaction against rationalism was given a political dimension by the latter's fascist connotations since

its adoption by the dictator Benito Mussolini, who ruled Italy from 1922 to 1943. Organic design offered a credible modern alternative, and Art Nouveau was evoked even more overtly than in Scandinavia. The designer Claudio Mollino (1905–73) produced furniture with whiplash lines reminiscent of the inventions of Endell and Obrist, heralding the beginning of the 'Neo-Liberty' movement, which was initiated in the late 1950s by two of his pupils, the Turin-based architects Roberto Gabetti (b.1925) and Aimaro d'Isola (b.1928). Neo-Liberty design constituted a fully fledged, self-conscious Art Nouveau revival: articles began to appear in the magazine Domus, established by the designer Gio Ponti (1891–1979), exploring the history of Art Nouveau across Europe rather than specifically in Italy. Eschewing the historical selectivity attempted by the purists of the Modern Movement, they sought to reclaim the apparently lost tradition of modern decoration.

In the 1970s and 1980s, Art Nouveau featured among the eclectic array of historical styles that Postmodern designers drew on and 'modernized'. Postmodernism is a term that was first applied to literature in the 1960s, to developments in architecture and design in the 1970s, and to painting in the 1980s. It characterizes work that integrates contemporary styles with an eclectic range of sources, ranging from Neoclassicism to popular culture. Art Nouveau had laid claim to be thoroughly modern in its day without purging itself of ornament. Postmodernism was part of this same project, and in many respects shared the aims of the Neo-Liberty movement in Italy. The Italian architect and designer Paulo Portoghesi (b.1931) later recalled the influence Art Nouveau had had on him: the memory of discovering an Art Nouveau figure among the junk in his mother's attic in Rome combined with the glimpses of the style he gained from flicking through the pages of Pevsner's Pioneers of Modern Design provoked an 'early passion for Art Nouveau':

I ... followed the rediscovery of Gaudí with great interest, and the re-evaluation of Van de Velde, Horta, Mackintosh. In the mid 1950s, already close to graduating, I became a strong supporter of the so-called Neo-Liberty, a trend that originated from the claim to a

certain right: that of re-designing the boundaries of the modern ...
and also the attempt at the beginning of the century (in the form of
Art Nouveau, Nordic Neoclassicism and Expressionism) to find origins
for the modern in historical inheritance and local traditions.

Some of Portoghesi's designs show clear Art Nouveau influences.
A lamp he designed in 1982 for Fratelli Tavani can be compared to
Behrens' table lamp for Grand Duke Ernst Ludwig von Hessen in
Darmstadt (see 223). Portoghesi also paid homage to Viennese
Art Nouveau with his Liuto sofa, designed in the late 1970s for the
Italian company Poltranova, which bears comparison to Hoffmann's
upholstered suite in the drawing room of the Palais Stoclet and to
furniture produced by J&J Kohn in 1905.

Another rich seam for Postmodern designers in the 1970s and
1980s was Mackintosh. The Thematic House in London, owned
by the designer and architectural writer Charles Jencks (b.1939),
who had originally used the term 'Postmodernism' with regard to
architecture, and designed and built between 1979 and 1984 by
the architect Terry Farrell (b.1938), was an essay in the eclectic
sources plundered by Postmodern designers. It was living proof
of Jencks's claim that in twenty years of mature existence,
Postmodernism had 'reintroduced the full arsenal of expressive
means such as ornament, polychromy and metaphor'. The library
of the Thematic House adopted Neoclassicism with its array of
pedimented bookcases, while one of the smaller bedrooms was
resplendent in the Egyptian style, complete with pylonic bedside
cabinets. The master bedroom (see 238) was strongly informed by
Mackintosh and Macdonald's bedroom at the Hill House.

261
Wendy
Maruyama,
*Mickey
Mackintosh*
chair,
1981.
Maple and
lacquer;
h.152·4 cm,
60 in.
Private
collection

In 1972 the Japanese architect and designer Arata Isozaki (b.1931)
unveiled his *Marylin* chair, which referred back to Mackintosh's
high-backed chair. Ironically, Isozaki gave Mackintosh's chair the
very curvilinearity that the Modernists claimed he had managed
to banish in his later work, enhancing Mackintosh's geometry with
curves based on a nude photograph of the Hollywood sex symbol
Marilyn Monroe. Isozaki explained the chair by stating 'If Marilyn
Monroe was my muse in the 1950s of my youth ... then Charles Rennie

Mackintosh was one of my most important teachers in the 1960s. My chair pays homage to both.' 'Homage' was a Postmodernist buzzword, and Mackintosh was again on the receiving end of this dubious honour in 1986 when Wendy Maruyama (b.1952) designed her *Mickey Mackintosh* chair (261). This time it was 'my personal homage to both Rennie and Mickey and a hybrid of two time zones!'

The decorative geometry of Hoffmann and the other Wiener Werkstätte designers provided a further Art Nouveau source for designers in the 1980s. The use of the square motif by Hoffmann and Moser proved a particularly rich decorative seam for those producing jewellery and other metalware. The silver candlestick designed by the American architect Richard Meier (b.1934) for the manufacturers Swid Powell in 1984, together with his office accessories for the same firm the following year, both use the idea of the pierced square motif, culled from the vocabulary of the Wiener Werkstätte's silverware department.

The popular evocation of Art Nouveau continued in the 1980s, this time as part of the heritage movement in cities such as Barcelona and Glasgow. Both places sought to relaunch their identities as 'designer' cities underpinned by the *fin-de-siècle* traditions of Gaudí and Mackintosh respectively. A cultural regeneration in Barcelona commenced in the years after the dictatorship of the fascist General Franco, who ruled Spain from 1939 to 1969 and suppressed Catalan culture. It was spearheaded by both sport and heritage, and Gaudí's buildings have figured highly. The project to restore the Palau Güell was begun in 1982 with funds provided by the city authorities, the Spanish Ministry of Culture and the European Community, which Spain had recently joined. Also subject to significant restoration, sponsored by a Catalan bank, was another of Gaudí's designs, the Casa Milà, which now houses an art gallery and gift shop. The 1992 Olympic Games provided an economic catalyst for further development and put the city firmly on Europe's tourist map, with Gaudí's buildings providing a series of star attractions.

In Glasgow the Willow Tea Rooms were reconstructed in the early 1980s, and in 1982 the survival of the Hill House and its interiors

was assured when the property became the responsibility of the National Trust for Scotland. Glasgow's post-Industrial rejuvenation has been comparable to that of Barcelona, and Mackintosh's posthumous role in this has been as pivotal as Gaudí's. At the Princes Square shopping centre on Buchanan Street, opened in 1988, the architects invoked Mackintosh's distinctive style in the railings and lighting, even designing litter bins and shoeshine stands in a faux Mackintosh style in an attempt to create a fin-de-siècle ambience. Across the city a bewildering array of Mackintosh-related souvenirs and merchandise began to be sold.

The restoration and renovation of Art Nouveau buildings has not been restricted to Barcelona and Glasgow. In Brussels, Horta's Tassel House was renovated between 1982 and 1985 by the architect Jean Delhaye (1908–93). The project involved a wholesale recreation of some of the interior details, including stained glass that was restored from a 1903 illustration. Meanwhile in Vienna, the Secession Building (see 81) was saved from near dereliction in the 1980s and transformed into a vibrant space for the display of contemporary art, as well as providing a permanent home for Klimt's Beethoven Frieze (see 96).

In a further development of the Art Nouveau architectural heritage movement, there are also instances in Vienna and Glasgow of new 'fin-de-siècle' buildings being erected, of very uneven architectural and historical merit. In Vienna, where the Purkersdorf Sanatorium underwent private renovation in the 1990s, developers added to the complex by building 'Hoffmannpark', seventy-three new apartments in the style of the Sanatorium. Glasgow University made amends for its demolition of 78 Southpark Avenue, the Victorian house that the Mackintoshes decorated and then resided in after 1906, by recreating the interiors in a concrete extension to the Hunterian Gallery, which was fashioned as a representation of the house. Finally, and more bizarrely, the mid-1990s saw the eventual realization of a project to create Mackintosh's 'House for an Art Lover', from the architect's celebrated 1902 competition entry. As Mackintosh did not win, the house was never built; but in 1988 Graham Roxburgh, a Glasgow engineer, announced his

intention to realize the designs with the help of the architect Andy MacMillan (b.1928), who was at the time the head of the Mackintosh School of Architecture in the city. Roxburgh's aim was faithfully to recreate some of the interiors and let out parts of the building as office space. The project was awarded civic funds, much to the frustration of campaigners who had watched Glasgow's existing architectural heritage erode by private and public neglect over the decades.

From this brief survey of the twentieth-century repercussions of Art Nouveau, it is apparent that the style exerted a tremendous influence on art and design after 1900. Art Nouveau not only provided direct inspiration for individual designers and artists, but also paved the way for a decorative tradition in modern design: Art Nouveau, followed by Art Deco, the applied arts of the 1950s and Postmodernism, continued to prove that design and architecture could be at once contemporary and decorative. The rejection of ornament, however, was only one of the cornerstones of the Modern Movement that Art Nouveau was subsequently evoked to combat. Modernism also aimed to transcend petty national considerations via the all-conquering values of rationalism and functionalism. And although Art Nouveau was international in its scope, it comprised a diverse range of stylistic varieties that, as in Prague and Budapest, were often specifically national. These various national traditions in Art Nouveau have been a major force behind its continued relevance, particularly in the 1980s and 1990s. With the collapse of communism in Eastern Europe after 1990, newly independent countries began again to piece together their pre-communist cultural heritage, and *fin-de-siècle* architecture and design was an obvious place to look. Scholarship, restoration, heritage and to some extent commercial pastiche have all contributed to ensuring the lasting influence of a style that, by 1914, had seemed to most contemporaries likely to be confined forever to its brief yet spectacular flowering.

Glossary | Brief Biographies | Key Dates | Maps |
Further Reading | Index | Acknowledgements

Glossary

Aesthetic Movement A fashionable British and American artistic and literary movement that emerged in the 1870s and 1880s. Aesthetes championed the supremacy of beauty and the notion of 'art for art's sake'. Among its leaders were the critic Walter Pater, the playwright Oscar Wilde and the painter James Abbott McNeill Whistler. The Aesthetic Movement drew inspiration from **Japanese art** and, in its promotion of a decadent lifestyle and the creation of 'artistic' interiors, had an impact in the 1890s on the evolving Art Nouveau style.

Arts and Crafts Movement A movement in the decorative arts and architecture that developed in Britain and spread to the United States and northern Europe, spanning the period from the 1860s to the early twentieth century. Taking a lead from the designer and socialist **William Morris** and the art critic John Ruskin, Arts and Crafts artists and designers professed a belief in the primacy of the artist-craftsman, challenged the hierarchy of the arts and strove for simplicity and fitness for purpose in design. Though they often drew on medieval styles, they rejected historicism. The movement was essentially anti-industrial, and many of its followers attempted to revive traditional crafts through utopian guilds and societies.

Bergère French term describing an armchair in which the sides are filled below the arms, often creating a tub-shaped form.

Darmstadt German town in which Grand Duke Ernst Ludwig von Hessen founded an artists' colony in 1899 in order to invigorate artistic industry in the area. Darmstadt became a centre for *Jugendstil* and was led by the Austrian architect **Josef Maria Olbrich**, who also designed most of the colony's buildings, workshops and fittings.

Daum Frères French glassmaking business established in 1875 and based in Nancy. Auguste and Jean-Antonin Daum took over the running of the family glassmaking firm in 1887. Inspired by the success of **Émile Gallé** at the 1889 Paris **Universal Exposition**, they began producing coloured, etched and moulded glass in the Art Nouveau style. Many designs for the firm were provided by the botanical illustrator Henri Bergé. Daum Frères experimented with modern large-scale production techniques, and during the 1890s they collaborated with **Louis Majorelle** to create a series of lamps and vases. The firm won a Grand Prix at the 1900 Paris Universal Exposition, and in 1901 the brothers helped found what became the **École de Nancy**.

École de Nancy Decorative arts college in Nancy founded in 1901 by the Alliance Provinciale des Industries d'Art, whose members included **Émile Gallé**, **Louis Majorelle** and the **Daum** brothers. The college ensured Nancy of its status as one of the major centres of Art Nouveau. The Musée de l'École de Nancy today houses an important collection of Art Nouveau produced in the area.

Favrile Glass Hand-blown iridescent glass developed separately by the American designers John La Farge and **Louis Comfort Tiffany**. The Favrile trademark was registered by Tiffany in 1894 and is thought to be a derivation of an Old English word meaning 'handmade'.

Femme Nouvelle Term meaning 'new woman' current in French cultural and political debates in the late nineteenth century regarding the role of women in society. The *femme nouvelle* was a figure who personified the perceived rejection by some women of the stereotyped ideals of domesticity, subservience and feminine beauty. She might ride a bicycle, go out to work, or campaign for female suffrage.

Gesamtkunstwerk German word translating as 'total work of art', applied in the nineteenth century to the synthesis of art forms achieved by the German composer Richard Wagner in his 'music-dramas'. It also describes an architectural and interior commission in which a variety of art forms make a complete whole.

Gothic Revival Term applied to the various revivals of medieval architecture and design that took place during the eighteenth and nineteenth centuries in Europe and the United States, most prominently in Britain. The Gothic Revival usually combined a suspicion of modernity with religious and political zeal. The style was applied most widely to churches, university buildings and country houses.

Japanese Art The stylized flat surfaces of Japanese prints and decoration became increasingly popular in Europe in the second half of the nineteenth century after centuries of Japanese isolation came to an end when trade relations were established with the United States in the Treaty of Friendship of 1854. Japanese art had a profound impact on many Western art movements, including Impressionism, **Post-Impressionism**, the **Aesthetic Movement** and Art Nouveau.

Lithography A printing technique that allows the mass reproduction of coloured images. A series of stone or metal plates are made, each of which has the elements of a design in a certain colour drawn in on a substance that adheres to the ink. Paper passed over the inked plates is thus printed with a multi-coloured design.

Majolica Brightly coloured glazed earthenware that originated from Majorca and was widely used from the time of the Italian Renaissance.

Marquetry The technique of inlaying a variety of wood veneers onto the surface of a piece of furniture to create a decorative pattern or scene. If the pattern is geometric the term 'parquetry' is used.

Monism Spiritual belief which maintains that the creator and all creation are one, thus imbuing man and nature with unrivalled spiritual significance. Although the term has been used to describe a wide range of beliefs throughout history, Monism underwent a revival in the late nineteenth century. Many **Symbolist** and Art Nouveau figures shared a mystical Monist worldview. It was adopted by the German biologist Ernst Haeckel and the Monist League in Munich in the 1890s.

Nabis The Nabis were an international group of artists based in Paris, including Pierre Bonnard, Maurice Denis and Paul Ranson, who worked within a broadly **Symbolist** tradition. They first exhibited together in 1891 and took their name from the Hebrew word meaning 'brotherhood', suggestive of the esoteric leanings of some of the members.

National Romanticism In the nineteenth century National Romanticism emerged in areas of eastern and northern Europe as writers and artists from circumscribed ethnic groups sought to draw spiritual and political strength from indigenous art and mythology. Obscure folk traditions were revived, embellished or even invented to suit contemporary political aspirations. In Norway, Sweden and Finland in particular this tendency was prevalent among designers and architects working in an Art Nouveau style.

Neo-Rococo During the nineteenth century there were various revivals of the Rococo, the eighteenth-century style that was prevalent in France and featured ornate, organic asymmetry and luxurious materials. The Rococo was championed by the nineteenth-century writers Edmond and Jules de Goncourt and J K Huysmans, for whom it had associations of cultural refinement.

Post-Impressionism Loose term given to (mainly French) painters of the 1880s and 1890s whose art reflected a return to the importance of subject. While they absorbed many of the Impressionists' developments in technique, they reacted against the concern with capturing the fleeting effects of light and colour. The phrase encompasses such stylistically varied artists as Vincent van Gogh, Paul Cézanne and **Paul Gauguin**, and included painters who were also considered **Symbolists**.

Poster Art The poster was the most effective advertising tool of the late nineteenth century and brought Art Nouveau to a wide audience. The printing technique of **lithography** lent itself to the flat, simplified and stylized images of **Symbolist** painting and Art Nouveau.

Pre-Raphaelites A self-styled 'Brotherhood' of English artists founded in 1848 by the artists Dante Gabriel Rossetti, John Everett Millais and others. They looked back to painting before Raphael to the art of the middle ages, and produced paintings, often of biblical subjects, in a naturalistic style rich with colour and detail, and heavy with symbolic meaning.

Salon de la Rose+Croix The Salon de la Rose+Croix was set up in 1892 by Joséphin Péledan in opposition to the official Salon, offering exhibiting opportunities for many **Symbolist** painters. Péledan named his Salon after Rosicrucianism, the esoteric doctrines of the fifteenth-century visionary Christian Rosenkreuz. The Belgian Fernand Khnopff and the Swiss Carlos Schwabe were among the artists who joined the group.

Symbolism Late-nineteenth-century European movement in literature and the visual arts that concentrated on symbolic meaning, often through the portrayal of mythical, mystical and esoteric subjects. Although Symbolist artists did not share a coherent style, they were united by their rejection of Impressionist preoccupations with colour and light in favour of the importance of the subject. A number of Symbolist painters, including **Georges de Feure** and **Gustave Klimt**, also contributed to the Art Nouveau aesthetic when they turned to the decorative arts.

Theosophy An esoteric religious philosophy that came to prominence after the Theosophical Society was founded in the United States by Mme Helena Blavatsky in 1875. Theosophy was popular in artistic circles and helped revive interest in archaic mystical and esoteric traditions. As a form of **Monism**, Theosphy promoted the belief that creator and creation are one.

Union Centrale des Arts Décoratifs The official organization devoted to promoting the applied arts in France.

Universal Expositions International fairs held by governments that were at once entertainment spectacles, showcases for achievements in the arts, industry and science, and exhibitions of artistic and industrial wares from other countries. The first Universal Exposition took place in London in 1851, and the French government held such shows in Paris from 1855.

Werkstätte The German word for 'workshop'. Various Werkstätten were established in German-speaking countries between 1896 and 1910. These organizations attempted to provide a common meeting point between art and industry by giving designers a sympathetic commercial structure in which to produce and market their work.

Charles Robert Ashbee (1863–1942) English designer and architect. A central figure in the **Arts and Crafts Movement**, Ashbee was moved by the ideas of John Ruskin and **William Morris** to set up the Guild and School of Handicraft in the East End of London in 1888. Ashbee designed much of the Guild's output, some of which represented the finest English Art Nouveau. He exhibited alongside **Charles Rennie Mackintosh** at the Vienna Secession exhibition in 1900, where his geometric furniture was praised. In 1902 the Guild moved to Chipping Campden in the Cotswolds. It soon fell into decline, though it survived until 1919.

Aubrey Vincent Beardsley (1872–98) English graphic artist. Beardsley's linear style, rendered in pen and ink, was among the earliest manifestations of mature Art Nouveau. He came to widespread attention through his illustrations for Sir Thomas Malory's *Le Morte d'Arthur* in 1893 and 1894. His 1894 illustrations for Oscar Wilde's play *Salomé* remain his most famous work; in the same year he became art editor of *The Yellow Book*, the flagship of the **Aesthetic Movement** in London. By 1896 Beardsley had adopted a more intricate manner to depict the finery and decadence of eighteenth-century France. In 1897 the tuberculosis he had suffered from since childhood worsened, leading to his death at the age of twenty-five.

Sarah Bernhardt (1844–1923) French actress. The most celebrated actress in Paris during the 1890s, she commissioned the artist **Alphonse Mucha** to design posters of her plays in an Art Nouveau style. Among the plays for which he provided posters were *Gismonda*, *Medée* and *Hamlet*. She also commissioned jewellery from **Georges Fouquet** that was designed by Mucha.

Siegfried Bing (1838–1905) German-born French art dealer. After training as a ceramics decorator, Bing built up a business selling **Japanese art**, opening a shop in Paris in the late 1870s. He began editing the periodical *Le Japon Artistique* in 1888. In 1894 the French government asked him to write a report on the industrial arts in the United States, which was published in 1896. Inspired by the work of **Louis Comfort Tiffany** and others, Bing began to promote contemporary design. He was aware of the burgeoning Art Nouveau scene in Brussels, and in 1895 he opened a gallery in Paris called L'Art Nouveau, at which he exhibited work by international artists and designers, most notably **Henry van de Velde**. Around 1898 Bing began organizing the production of furniture and objects by designers such as **Georges de Feure**, **Édouard Colonna**

and **Eugène Gaillard**. These three created interiors for Bing's pavilion at the 1900 Paris **Universal Exposition** that received huge acclaim. He was never successful on a large scale, however, and in 1904 he sold his gallery.

William H Bradley (1868–1962) American graphic artist. Bradley's work drew on the contrasting influences of **William Morris** and **Aubrey Beardsley** and his illustrations were among the earliest examples of American Art Nouveau. Trained as a wood engraver in the mid-1880s, he turned to line engraving as his first technique became obsolete. His covers for the Chicago journal *Inland Printer* in 1894 established him as an exponent of the new style, and he gained widespread acclaim for his posters for another Chicago publication, *The Chap Book*. In 1895 he returned to his birthplace Massachussets, where he turned to traditional printing methods, the result being his own periodical *Bradley: His Book*. He exhibited work at the Paris gallery of **Siegfried Bing** in 1895, but by 1900 his career was in decline and thereafter he worked largely in commercial printing and type design.

Édouard Colonna (1862–1948) German-born American designer. Colonna trained in Brussels and moved to the United States in 1882. After briefly working for Associated Artists, the company of **Louis Comfort Tiffany**, he moved to Ohio, where he produced a series of designs published as the *Essay on Broom Corn*. The book reveals Colonna to have been a visionary designer. He returned to Paris in 1898 to work for **Siegfried Bing**. Along with **Georges de Feure** and **Eugène Gaillard**, his designs formed the nucleus of Bing's pavilion at the 1900 Paris **Universal Exposition**.

Walter Crane (1845–1915) English painter, illustrator and designer. Prominent in the **Arts and Crafts Movement** and strongly influenced by the **Pre-Raphaelites**, Crane was both a fierce critic of Art Nouveau and an early inspiration for many artists who adopted the style. His illustrations for *Flora's Feast* (1889) display many of the features of Art Nouveau. Crane exhibited in Belgium in the early 1890s, where his work reached a progressive audience, and from 1894 he produced designs for the Kelmscott Press, set up by **William Morris**. He became principal of the Royal College of Art in London in 1898, and travelled and lectured extensively across Europe and the United States.

August Endell (1871–1925) German architect and designer. Endell moved to Munich from Berlin in 1892, where he studied aesthetics, philosophy and psychology, before turning to architecture and art with the encouragement

of **Hermann Obrist**. His designs and illustrations, which appeared in journals such as *Pan*, featured abstract natural shapes that show Obrist's influence. Endell is most renowned for the distinctive façade and interiors of the Elvira photography studio in Munich (1897–8), his first architectural design. As well as being a major figure of German *Jugendstil*, Endell anticipated abstract art in his writings on art theory in books such as *Um die Schönheit* (*On Beauty*) of 1896. He returned to Berlin in 1901 and set up a school in 1904. In the years before World War I his work displayed a trend towards greater simplicity.

Georges de Feure (1868–1928) French painter and designer. De Feure worked as an actor, a costumier and then as an interior decorator. He also painted watercolours and oils, often of delicate women in a sensuous **Symbolist** style that illustrates the links between Symbolism and Art Nouveau. De Feure first exhibited furniture in Paris in 1896 and began working for **Siegfried Bing** in 1899. In 1900 he designed elements of Bing's pavilion for the 1900 Paris **Universal Exposition**, where his work was praised for its French refinement. De Feure continued to design commercially until the outbreak of World War I in 1914.

Fidus (Hugo Höppener; 1868–1948) German graphic artist. Fidus trained in Lübeck and then Munich, where he lived on the commune of the painter W Diefenbach. In 1892 he moved to Berlin and set up another commune. His early illustrations contained dreamlike *Jugendstil* abstractions, and his work appeared frequently in *Jugend*. Fidus held mystical **Theosophical** beliefs and during the 1890s he became interested in German mythology. His engravings of peasants and warriors evoked an insular worldview at odds with the internationalist outlook promoted by many German artists after 1900. He continued working in an Art Nouveau style long after it was fashionable.

Ivan Fomin (1872–1936) Russian architect and designer. Suspended from the Academy of Arts in St Petersburg in 1894 for participating in student unrest, Fomin joined the office of **Fyodor Shekhtel'** after working for the architect Lev Kekushev. During his time with Shekhtel' he contributed to the 1902 New Style exhibition. His designs display a monumental simplicity that alludes to traditional Russian styles as well as the modern geometry of Art Nouveau from Vienna and Glasgow. In 1905 Fomin returned to his studies and after 1917 he designed a number of modern classical buildings, most famously the headquarters of the Moscow Soviet in 1928.

Georges Fouquet (1862–1957) French jeweller. The son of a goldsmith, Fouquet took over the family firm in 1895 and soon adopted the Art Nouveau style. In 1900 he produced jewellery designed by **Alphonse Mucha** and won a gold medal at the Paris **Universal Exposition**. Mucha also created the interiors of Fouquet's shop in 1901. Although initially inspired by nature and **Japanese art**, he went on to make more geometric pieces with Egyptian motifs, resulting in a revival in his fortunes in the 1920s with the advent of Art Deco.

Loïe Fuller (1862–1928) American dancer and muse. By the age of fifteen Fuller was touring America with a theatrical company. She moved to London in 1889 and, following limited success as an actress, began to develop her expressive dances. After briefly returning to New York, Fuller went to Paris in 1892, where she danced at the Folies-Bergère. Her performances to the music of Claude Debussy and Fryderyk Chopin involved swirling fabrics, coloured lights and mirrored stage sets. She was celebrated by **Symbolist** writers and became an icon of Art Nouveau as her dances revolved around the themes of femininity and metamorphosis. During the 1890s a plethora of Art Nouveau bronze sculptures and lamps were made of her.

Eugène Gaillard (1862–1933) French designer and architect. Gaillard rejected a career in law to take up interior design and decoration. **Siegfried Bing** employed him alongside **Georges de Feure** and **Édouard Colonna** to create interiors for his pavilion at the 1900 Paris **Universal Exposition**. The abstract natural forms of his furniture reflected a mistrust of historicism and he became a vocal advocate of modern design. Around 1903 he left Bing's atelier and set up his own firm. In 1906 he published *À Propos du Mobilier* (*On Furniture*).

Émile Gallé (1846–1904) French glassmaker, ceramicist and furniture designer. Gallé studied botany and mineralogy in Germany before taking over the family glassmaking firm in Nancy in 1874. His work demonstrates his interests in botany, **Symbolism** and **Japanese art**. He first exhibited furniture at the 1889 Paris **Universal Exposition**, where his style displayed a debt to French traditions. Gallé was an astute businessman and his workforce expanded rapidly in the 1890s. His unrivalled stature in the French decorative arts was confirmed in 1900 when he was awarded the Légion d'honneur. In 1901 he helped set up the **École de Nancy**. After his death, the firm continued until the 1930s.

Akseli Gallen-Kallela (1865–1931) Finnish painter and designer. Trained in Helsinki and Paris, Gallen-Kallela painted **National Romantic** landscapes, before adopting a **Symbolist** style in the 1890s. He was intrigued by traditional art and life in rural Karelia, and turned his artistic attention to the Finnish epic the *Kalevala*. Gallen-Kallela was a defining figure of Finnish Art Nouveau. His country house 'Kalela' combined traditional and modern ideas, as did his designs for textiles and stained glass. Murals for the Finnish pavilion at the 1900 Paris **Universal Exposition** brought his work to an international audience. During the 1910s and 1920s he had close ties with the German Expressionists, but he later returned to the *Kalevala*, embarking on a plan to fully illustrate the story.

Antoni Gaudí i Cornet (1852–1926) Catalan architect. Gaudí was a devout Catholic whose faith was an integral part of his creative vision. He trained in Barcelona and became the most

famous architect of the *Modernista* movement, drawing on Gothic and Moorish traditions to create a unique plastic-organic style. Through his involvement in conservative Catholic nationalist politics he gained commissions from the industrialist Eusebio Güell and the Catholic Church. In 1883 he was appointed Director of Works for the Sagrada Familia cathedral in Barcelona, which had been begun by the architect Francisco de Paula Villar y Lozano. Gaudí set about redesigning the building and he continued working on it until his death.

Paul Gauguin (1848–1903) French artist. Gauguin was born in France and brought up mainly in Peru. He became a banker in Paris, but painted in his spare time and exhibited with the Impressionists from 1878. In 1883 he gave up his job and his relations with his family broke down. Gauguin worked with Camille Pissarro and Paul Cézanne in Pontoise. He became the leader of the Pont-Aven group in Brittany between 1886 and 1889, and developed a distinctive brand of **Symbolism**, using simplified decorative lines and flat bright colours inspired by **Japanese art** to represent mystic and primitive subjects. From 1891 he lived for extended periods in Tahiti.

Hector Guimard (1867–1942) French architect and designer. Guimard studied at the École Nationale des Arts Décoratifs and the École des Beaux-Arts in Paris. He then embarked on an architectural career that produced some of the most innovative buildings of Art Nouveau. The influence of **Eugène-Emmanuel Viollet-le-Duc** was apparent in his use of ironwork, and his designs for the new Paris Métro stations of 1900 combined daring linear forms with industrial methods of construction. Guimard also designed a number of houses during this period, as well as a range of furniture and objects that reflected the contrast between his abstract flowing style and the more figurative Art Nouveau of Nancy. In later years Guimard was uncomfortable with Modernism. He left France for the United States in 1939.

Josef Hoffmann (1870–1956) Austrian architect and designer. Hoffmann studied under **Otto Wagner** in Vienna, and in 1896 began working in his office. He joined the Secession in 1897 and became a professor at the Kunstgewerbeschule in Vienna in 1899. He was initially attracted to the sweeping decoration of *Jugendstil*, however, his style soon became more geometric. In 1903 Hoffmann set up the Wiener Werkstätte, to which he contributed a vast range of furniture, metalwork, glass, ceramics and textile designs. He also provided the backbone of its architectural practice. His best-known buildings were the Purkersdorf Sanatorium outside Vienna (1904–6) and the Palais Stoclet in Brussels (1905–11), one of the last great Art Nouveau *Gesamtkunstwerk*.

Victor Horta (1861–1947) Belgian architect. After studying in Ghent and Brussels, Horta joined the office of the architect Alphonse Balat. In 1890 he set up his own firm, and in 1893 designed what is widely regarded as the first architectural expression of mature Art Nouveau, Tassel House in Brussels. The innovative use of exposed ironwork and open-plan space characterized Horta's style. A series of houses in Brussels consolidated his reputation, perhaps the most spectacular being a house for Baron van Eetvelde (1895–7). Like many artists in Brussels, Horta had socialist leanings and between 1896 and 1899 he built the Maison du Peuple, a complex of shops, offices and halls for the Belgian Worker's Party. His Brussels department store À l'Innovation (1901) demonstrated the suitability of Art Nouveau for retail buildings. His work after 1903 was less adventurous and made use of classical forms.

Gustav Klimt (1862–1918) Austrian painter and designer. Klimt opened a studio in 1883 after training at the School of Arts and Crafts in Vienna. His early paintings were academic in style, but he became increasingly influenced by **Symbolism**, provoking bitter criticisms from Vienna's artistic establishment. Klimt was one of the founders of the Secession in 1897, becoming the group's first president; he also set up the journal *Ver Sacrum*. The *Beethoven Frieze*, painted in 1902 to decorate the Secession Building, signalled an even more stylized aesthetic. Klimt remained a prominent figure in the Secession until he resigned in 1905. He was associated with the Wiener Werkstätte, his most notable contribution being his friezes for the Palais Stoclet in Brussels designed by **Josef Hoffmann** in 1905–11.

René Lalique (1860–1945) French jeweller. Lalique trained in Paris and London, and in 1885 took over the workshop of the Parisian jeweller Jules d'Estape. He embarked on a career that revolutionized jewellery design, rejecting traditional materials such as diamonds in favour of vividly coloured gemstones. Motifs such as nymphs and flowers were typical of Lalique's Art Nouveau work, and his clients included the actress **Sarah Bernhardt**. In 1898 he began glassmaking, which gradually replaced jewellery as the focus of his talent. His glassware came to embody the flamboyant 1920s Art Deco style.

Arthur Lasenby Liberty (1843–1935) English merchant. In 1875 Liberty opened his first shop, East India House, on Regent Street in London. His imported Oriental wares helped define the fashionable **Aesthetic** taste in London. Liberty's also stocked **Arts and Crafts** goods. In 1890 a Paris branch of his shop opened. The company both sold and produced English Art Nouveau objects, most notably the 'Cymric' and 'Tudric' ranges by designers including Archibald Knox. Liberty also introduced continental Art Nouveau to London shoppers, stocking such objects as chairs by **Richard Riemerschmid** and ceramics by the Hungarian firm Zsolnay.

Charles Rennie Mackintosh (1868–1928) and **Margaret MacDonald** (1865–1933) Mackintosh was a Scottish architect, designer and painter who worked closely with his wife, the painter and designer Margaret MacDonald, whom he met at the Glasgow School of Art. He was taken on by the architects Honeyman and Keppie in 1888, where he met the artist

Herbert MacNair. Mackintosh developed an individual style with Symbolist overtones. In 1894 he exhibited with MacNair, Macdonald and her sister Frances for the first time. Mackintosh is best remembered today for his post-1895 work, beginning with the Glasgow School of Art (begun 1896) and followed by tea rooms for Catherine Cranston. Mackintosh and MacDonald also received decorative commissions, the most celebrated being the Hill House (1902–4) in Helensburgh. His success declined in the years after 1905.

Arthur Heygate Mackmurdo (1851–1942) English architect and designer. Mackmurdo studied at Oxford and was a disciple of John Ruskin. He was a leading figure in the **Arts and Crafts Movement**, yet, like **Walter Crane**, his work also contained the seeds of Art Nouveau. His designs for wallpaper and textiles, together with his chairs for the Century Guild, display the flowing linear style of Art Nouveau. The Century Guild, of which he was a founding member, ceased its activities in 1892, and he gradually turned towards classical architecture.

Louis Majorelle (1859–1926) French designer. Majorelle took over his family's cabinet-making business in Nancy in 1879, where he continued the firm's production of **Neo-Rococo** furniture. Influenced by **Émile Gallé**, he developed a style characterized by heavy abstracted organic carving embellished with gilt-bronze mounts. In the 1890s he worked with **Daum Frères** to produce lamps and vases. His furniture was well received at the 1900 Paris **Universal Exposition**, and the years around this time represented the height of his achievement. He turned to mechanized production after 1908, but his factory was destroyed in World War I.

Julius Meier-Graefe (1867–1935) German art critic and dealer. After studying engineering in Munich, Zurich and Liège, Meier-Graefe went to Berlin in 1890. He became involved in the art scene, and in 1894 he co-founded the journal *Pan*. In 1895 he moved to Paris, where he started another periodical, *Dekorative Kunst*, in 1897. Committed to the design reform aspects of Art Nouveau as well as its aesthetic, he resolved to put his ideas into practice when, in 1899, he set up La Maison Moderne. The aim of this shop was to promote modern design to a broad public. Though initially successful, it folded in 1904 as Art Nouveau became unfashionable.

William Morris (1834–96) English designer, writer and socialist. Trained as an architect, Morris mixed in **Pre-Raphaelite** circles before founding his own firm in 1861, which became Morris & Co in 1875. Through his ideas on utility and beauty in design, coupled with his socialist principles, he became the defining figure of the **Arts and Crafts Movement**. He drew on medieval motifs and designed furniture, stained glass, wallpaper and fabrics. His use of stylized floral and organic forms in his patterns was influential in the evolution of Art Nouveau, and his ideas on the primacy of craftsmanship also had resonance for many Art Nouveau artists. However, his deep distrust of modernity, encapsulated in his novel *News from Nowhere*

(1890), seemed retrograde to those who sought to exploit new materials and modern methods of production.

Hermann Obrist (1862–1927) Swiss-German designer. Perhaps the pivotal figure in the development of *Jugendstil* in Munich, Obrist encountered the **Arts and Crafts Movement** when travelling in Britain in 1887, where he trained as a ceramicist. His work gained a gold medal at the 1889 **Universal Exposition** in Paris. Following his move to Munich in 1894, Obrist came to prominence in 1896 with an exhibition of thirty-five embroideries that exemplified his abstract approach to nature in art. A founder of the Munich Vereinigte Werkstätten für Kunst im Handwerk in 1897, he was also a prolific writer and teacher. His ideas about abstraction influenced the Russian artist Wassily Kandinsky.

Joseph Maria Olbrich (1867–1908) Like **Josef Hoffmann**, Olbrich worked in the office of **Otto Wagner** in Vienna from 1894, becoming chief assistant in 1896. In 1897 he was involved in founding the Secession, and his design for the Secession Building, begun 1898, announced the importance of the classicism in Viennese *fin-de-siècle* architecture. In 1899 he was invited to join the artists' colony at **Darmstadt**, where he designed a series of houses, studios and galleries. Olbrich helped set up the Deutsche Werkbund in Munich in 1907.

Bernhard Pankok (1872–1943) German painter, architect and designer. Pankok trained as a painter in Münster and moved to Munich in 1892. After some time as a portraitist, he began contributing to *Jugend* and *Pan*. He turned to furniture design in 1897, and in the same year he helped set up the Vereinigte Werkstätten für Kunst im Handwerk. In 1899 he created adventurous *Jugendstil* furniture for the villa of **Hermann Obrist**. Pankok exhibited at the 1900 Paris **Universal Exposition**, and in 1901 he moved to Stuttgart, where he lectured and continued his design and architectural career.

Richard Riemerschmid (1868–1957) German architect and designer. Though he trained as a painter at the Munich Academy, Riemerschmid was best known for his furniture designs, which he turned to in 1895 after being inspired by the **Arts and Crafts Movement**. In 1897 he co-founded the Vereinigte Werkstätte für Kunst im Handwerk. He displayed an interior scheme, the 'Room for an Art Lover', at the 1900 Paris **Universal Exposition**, and in 1901 he designed one of Munich's most celebrated *fin-de-siècle* buildings, the Schauspielhaus. In 1903 he joined the Dresden **Werkstätte**. His designs betrayed a simplicity that set them apart from more elaborate Art Nouveau, and his series of Machinenmöbel ('machine-made furniture'), first exhibited in 1906, showed his engagement with modern manufacturing. In 1907 he helped found the Deutsche Werkbund.

Fyodor Shektel' (1859–1926) Russian architect and designer. After studying in Moscow, Shekhtel' worked for the architect A Kaminsky, a member of the *Mir Iskusstva* artists' group.

His early work combined traditional styles with Art Nouveau to create a specifically Russian variant. Between 1900 and 1902 he built mansions in Moscow, and in 1901 designed the Russian pavilions at the Glasgow International exhibition. His office was behind the 1902 New Style exhibition in Moscow, which showcased Western and Russian designers.

Gustave Serrurier-Bovy (1858–1910) Belgian architect and designer. Serrurier trained in Liège in the 1870s, where he encountered the teachings of John Ruskin, **William Morris** and **Eugène-Emmanuel Viollet-le-Duc**. In 1884 he set up a company in Liège selling imported wares and his own furniture. Serrurier exhibited at La Libre Esthetique in 1894 and 1895, and in 1897 he contributed to the Congo pavilion at the Brussels **Universal Exposition**. He opened a branch of his business in Paris in the same year. The Pavillon Bleu, a restaurant built for the Paris Universal Exposition of 1900, was one of the few examples of unrestrained Art Nouveau architecture. After visiting **Darmstadt** in 1901 he adopted more simplified forms.

Louis Henry Sullivan (1856–1924) American architect. Sullivan studied in Boston and worked for Frank Furness in Philadelphia, before joining the engineer Dankmar Adler in 1880, where he became a partner in 1883. In the late 1880s they built steel-framed skyscrapers that combined Adler's engineering skills with Sullivan's decorative genius. His stylized forms derived from the **Gothic Revival**, yet they offered a radical new style for modern buildings and constituted a uniquely American Art Nouveau. Sullivan's retrospective explanation of his ideas, the *System of Architectural Ornament* (1924), reveals an element of mysticism.

Louis Comfort Tiffany (1848–1933) American designer. Son of the silversmith Charles Lewis Tiffany, he trained as a painter in the 1860s with the artist Samuel Coleman. Tiffany began working with glass in 1873. In 1879 he established Associated Artists, designing opulent interiors for wealthy East Coast families. He set up Tiffany Glass and Decorating Co (later Tiffany Studios) in 1892, and in 1894 registered his **Favrile glass** patent. Tiffany had close ties with European Art Nouveau: he made a series of windows designed by leading French artists in 1895, and his lamps and glassware appeared at the Paris gallery of **Siegfried Bing** three years later. His signature leaded glass lamps were first shown in 1899. In 1902 he became design director of the family silver firm Tiffany & Co. He turned to jewellery around 1904.

Henri de Toulouse-Lautrec (1864–1901) French painter and graphic artist. Toulouse-Lautrec began painting in Paris in the 1880s and studied under the **Symbolist** Émile Bernard, exhibiting at the Salon des Indépendants from 1889. In 1891 he designed his first posters, for which he received widespread acclaim. His posters brought his stylized representations of decadent Parisian life to a broad public.

Henry van de Velde (1863–1957) Belgian architect, designer and painter. After studying painting in Antwerp and Paris, Van de Velde turned to the decorative arts in the early 1890s, inspired by **William Morris**. He was opposed to historicism and created designs based on flowing, abstract forms. In 1895 he built and decorated a house in Brussels, Bloemenwerf, for himself and his wife. He met **Siegfried Bing** and designed rooms for his gallery in Paris. Following an exhibition of Bing's rooms in Dresden in 1897, and partly as a result of the dealer's increasing preference for French styles, Van de Velde moved to Germany. He received commissions in Berlin and met his patron Karl Ernst Osthaus in 1900. He helped found the Deutsche Werkbund in 1907, but clashed with the critic Hermann Muthesius because Van de Velde saw standardization as a threat to the creativity of the individual artist.

Eugène-Emmanuel Viollet-le-Duc (1814–79) French architect and writer. The self-taught architect Viollet-le-Duc was the most famous proponent of the **Gothic Revival** in France. He was best known for restorations at Pierrefonds and Notre Dame cathedral in Paris, but despite his reverence for the Gothic, he was also a critic of eclectic historicism. His lectures *Entretiens sur l'architecture* (*Treatises on Architecture*; 1863–72) advocated the adventurous use of iron and glass. Art Nouveau architects including **Victor Horta**, **Hector Guimard**, **Antoni Gaudí** and **Louis Sullivan** all cited Viollet as an influence.

Charles Francis Annesley Voysey (1857–1941) English architect and designer. After working for the **Gothic Revival** architect J D Seddon, Voysey began his own firm in 1882. He was a central figure in the **Arts and Crafts Movement**, joining the Art Workers Guild in 1884 and showing at the Arts and Crafts exhibitions in London from 1893. Chiefly remembered for his simple houses, he also designed patterns and furniture during the 1880s that displayed a lyricism which anticipated Art Nouveau.

Otto Wagner (1841–1918) Austrian architect. Wagner encountered the work of Karl Friedrich Schinkel while studying in Berlin, and his work in Vienna illustrates the importance of classicism to Viennese Art Nouveau. In 1894 he was commissioned to design stations for the city, and in 1898 his two apartment blocks at 38 and 40 Linke Wienzeile were among the earliest examples of *Jugendstil* architecture in Vienna. Wagner joined the Secession in 1899, allying himself with the younger radical artists. His Post Office Savings Bank (begun 1903) exemplifies his modern classicism.

Frank Lloyd Wright (1867–1959) American architect and designer. Between 1888 and 1893 he worked in Chicago for **Louis Sullivan**, and the influence of Sullivan's organic forms is apparent in his designs and writings. Wright's early work displays close parallels with the development of Art Nouveau in Europe. From 1901 to 1913 he built a series of 'prairie houses' that combine low geometric forms and spaces with stylized ornament. For Wright, natural setting was crucial to his designs.

Key Dates

Numbers in square brackets refer to illustrations

Art Nouveau	A Context of Events
	1849 A W N Pugin, *Floriated Ornament* [12]
	1854 Treaty of Friendship between the United States and Japan
	1856 Owen Jones, *The Grammar of Ornament* [13]
	1859 Charles Darwin, *The Origin of Species*
	1861 William Morris founds Morris, Marshall, Faulker & Co (from 1875 Morris & Co)
1871 Émile Gallé visits London	**1871** France defeated in the Franco-Prussian war. Wilhelm I crowned Emperor of a united Germany
	1873 Walter Pater, *Studies of the History of the Renaissance*
1874 Gallé takes charge of his family's firm	
1875 Arthur Liberty opens his first shop in East India House, London	
	1876–7 James Abbott McNeill Whistler completes the Peacock Room [25]
	1878 First Congrés International du Droit des Femmes held in Paris
1879 Louis Comfort Tiffany establishes Associated Artists with Candace Wheeler, Lockwood de Forest and Samuel Coleman	**1879** Thomas Edison invents the electric light bulb in the United States
	1881 Legislation in France eases censorship on posters in many public places
1883 C F A Voysey thought to have designed his 'Lily' textile [15] and 'Swan' chair [16]. Arthur Heygate Mackmurdo, *Wren's City Churches* [18]. Antoni Gaudí appointed Director of Works for the Sagrada Familia, Barcelona [161]	**1883** Émile Zola, *Au bonheur des dames*. Deaths of Karl Marx in London and Richard Wagner in Venice
1884 Mackmurdo designs his 'Cromer Bird' fabric pattern [20]. The Société des Vingt (Les XX) is founded in Brussels. Gustave Serrurier-Bovy opens a shop in Liège	**1884** J K Huysmans, *À Rebours*. First underground railway opens in London
	1885 First automobile powered by an internal combustion engine invented by Gottlieb Daimler and Karl Benz in Mannheim, Germany. Foundation of the Belgian Worker's Party. Congo Free State established under the personal rule of King Leopold of Belgium
1886 Gaudí's Palau Güell, Barcelona (to 1889) [155, 156]	**1886** Workers demonstrations and uprisings in several Belgian cities.
1887 Édouard Colonna, *Essay on Broom Corn* [166]	
1888 Charles Robert Ashbee sets up the Guild of Handicraft in London's East End. Siegfried Bing begins editing *Le Japon Artistique* in Paris [26]	

Art Nouveau	A Context of Events
1889 Walter Crane, *Flora's Feast* [21]. Gallé exhibits furniture at the Universal Exposition in Paris	**1889** Universal Exposition in Paris
1890 Akseli Gallen-Kallela and Louis Sparre visit Karelia on the Finnish–Russian border. Louis Sullivan and Dankmar Adler build the Wainwright building in St Louis, one of the earliest skyscrapers	**1890** Massacre of Native Americans by US troops at Wounded Knee. William Morris, *News from Nowhere*. Julius Langbehn, *Rembrandt als Erzieher*
1891 Crane exhibits his children's book illustrations in Brussels. Publication of the *Modernist Almanac of Catalan Literature* marks the beginning of the *Modernista* movement in Catalonia	**1891** Morris establishes the Kelmscott Press in London. First exhibition of the Nabis in Paris
1892 Tiffany Glass and Decorating Company established in New York. Alfred William Finch introduces Henry van de Velde to the work and writings of John Ruskin and William Morris	**1892** Joséphin Péladan stages the first Salon de la Rose+Croix in Paris. Opening of Oscar Wilde's play *Lady Windermere's Fan* in London
1893 Tiffany begins experimenting with Favrile glass. Victor Horta's Tassel House, Brussels [32, 37–41]. *Harpers* magazine launches its striking new posters in the United States. Aubrey Beardsley begins illustrations for Sir Thomas Malory's *Le Morte d'Arthur*	**1893** New Zealand the first country to give women the right to vote. Universal male suffrage granted in Belgium
1894 Beardsley illustrates Wilde's play *Salomé* [28]. Bing reports on the state of the industrial arts in the United States for the French Government (published in 1896). Ashbee exhibits work at the first show organised by La Libre Esthétique in Brussels. Alphonse Mucha meets Sarah Bernhardt. Lluís Domènech i Montaner sets up the Barcelona Centre for Decorative Arts	**1894** Tsar Nicolas II appoints Nicholas Bobrikov as Govenor of Finland, heralding a period of repression. Captain Alfred Dreyfus sentenced in Paris to life imprisonment on the charge of military espionage
1895 Bing opens his gallery L'Art Nouveau in Paris. Tiffany exhibits stained glass designed by eleven French artists in Paris. Horta's Maison du Peuple, Brussels (to 1899) [42]. Van de Velde builds his family home, Bloemenwerf, in Brussels and designs interiors and furniture for Bing. Earliest known examples of Frank Lloyd Wright's high-backed chairs. *Pan* first published in Berlin	**1895** Trial and conviction of Wilde in London for homosexual practices. Thomas Hardy, *Jude the Obscure*. Motion pictures shown in public for the first time by Auguste and Louis Lumière. Wireless telegraph invented by Guiglielmo Marconi
1896 Hermann Obrist exhibits embroidery designs in Munich, Berlin and London. Otto Wagner, *Moderne Architektur*. Josef Hoffmann employed in Wagner's office. *Jugend* first published in Munich. Charles Rennie Mackintosh contributes designs to Kate Cranston's tea rooms in Glasgow [197], first phase of the Glasgow School of Art [107]	**1896** First performance of Anton Chekhov's *The Seagull* in Russia
1897 Founding of the Vienna Secession. Vereinigte Werkstätten für Kunst im Handwerk established in Munich. Van de Velde, Serrurier and Paul Hankar contribute to the Congo display at the Brussels Universal Exposition. August Endell's Elvira photographic studio, Munich (to 1898) [73–74]. Iris Workshops set up in Helsinki	**1897** Czech language granted equal status with German in Bohemia
1898 Joseph Maria Olbrich's Secession Building, Vienna [81]. Bing exhibits Tiffany's electric lamps and glassware and begins to produce furniture in his own studio. Death of Beardsley. René Lalique begins experimenting with glassware. Wagner's apartment blocks at 38 and 40 Linke Wienzeile, Vienna [85–88]. *Mir Iskusstva* first published in St Petersburg. Gaudí begins work on the Chapel Güell, Barcelona [160]	**1898** Spain defeated by the United States in the Spanish–American War. Marie and Pierre Curie discover radium in Paris. Boxer Rebellion in China (to 1900). Auguste Rodin completes his sculpture *The Kiss*

Art Nouveau	A Context of Events
1899 Darmstadt artists' colony founded by Grand Duke Ernst Ludwig von Hessen, attracting Olbrich from Vienna and Peter Behrens from Munich. Wagner joins the Secession. Meier-Graefe opens La Maison Moderne in Paris. Ernst Haeckel, *Kunstformen der Natur* [71]	1899 Boer War begins between Britain and the Boer Republics of South Africa. Joseph Conrad, *The Heart of Darkness*. Thorstein Veblen, *The Theory of the Leisure Class*. European statesmen and intellectuals sign the 'Pro-Finlandia' petition
1900 Art Nouveau triumphs at the Universal Exposition in Paris. Bing receives acclaim for his pavilion, while Gallé and Majorelle are among those awarded the Légion d'honneur. Hector Guimard's Métro stations opened in Paris [2]. Mackintosh, Margaret MacDonald and Ashbee exhibit at the eighth Secession exhibition, Vienna	1900 Sigmund Freud, *The Interpretation of Dreams*. Ferdinand Graf von Zeppelin invents the dirigible airship
1901 Mucha designs a new interior for Georges Fouquet's jewellery shop. First Darmstadt exhibition. Foundation of the Alliance Provinciale des Industries d'Art, (later the École de Nancy) by Gallé, the Daum brothers, Majorelle and others. Horta, A' l'Innovation department store, Brussels [193, 194]. Fyodor Shekhtel' designs the Russian pavilions at the Glasgow International Exhibition [144]. Gaudí's Park Güell, Barcelona (to 1914) [158, 159]	1901 Death of Queen Victoria and accession to the British throne of Edward VII. Commonwealth of Australia proclaimed. Marconi invents the radio transmitter in London
1902 Ashbee's Guild of Handicraft moves to Chipping Campden in the Cotswolds. First International Exposition of Modern Decorative Arts held in Turin, Italy. Gesellius, Lindgren and Saarinen, Hvitträsk, Finland [128, 129]. Mackintosh's Hill House, Helensburgh (to 1904) [116, 117]	1902 Henry James, *The Wings of the Dove*
1903 Foundation of the Wiener Werkstätte	1903 First flight in the United States by the Wright brothers
1904 Bing's gallery L'Art Nouveau closes. Wagner's Post Office Savings Bank, Vienna (to 1906) [91–2]. Hoffmann's Purkersdorf Sanatorium, Vienna (to 1906) [97, 98]	1904 Gustav Mahler conducts the first performance of his Symphony No. 5 in Cologne. Giacomo Puccini's opera *Madame Butterfly* opens in Milan
1905 Wright's Dana House, Springfield, Illinois [182–184]. Hoffmann's Palais Stoclet, Brussels (to 1911) [101–103]	1905 Albert Einstein develops his special theory of relativity. Japan victorious in the Russo-Japanese war
1907 Founding of the Deutsche Werkbund. Second phase of the Glasgow School of Art by Mackintosh (to 1909) [112–115]. Gustav Klimt paints *The Kiss* (to 1908)	1907 Pablo Picasso completes *Les Desmoiselles d'Avignon*. First exhibition of Cubist works in Paris
1908 Adolf Loos's essay 'Ornament and Crime'. Majorelle turns to mechanized production	1908 E M Forster, *A Room with a View*
1914 Rift in the Werkbund between Herman Muthesius and Van de Velde. Van de Velde's theatre for the Werkbund exhibition, Cologne [234]. Closure of the Darmstadt artists' colony	1914 Opening of the Panama Canal. Beginning of World War I (to 1918). James Joyce, *Dubliners*
	1917 Russian Revolution. Finland gains independence from Russia
1921 Exhibition of Mucha's *Slav Epic* paintings at the Brooklyn Museum, New York	
1922 Sullivan, *A System of Ornament*	1922 Benito Mussolini forms a government in Rome

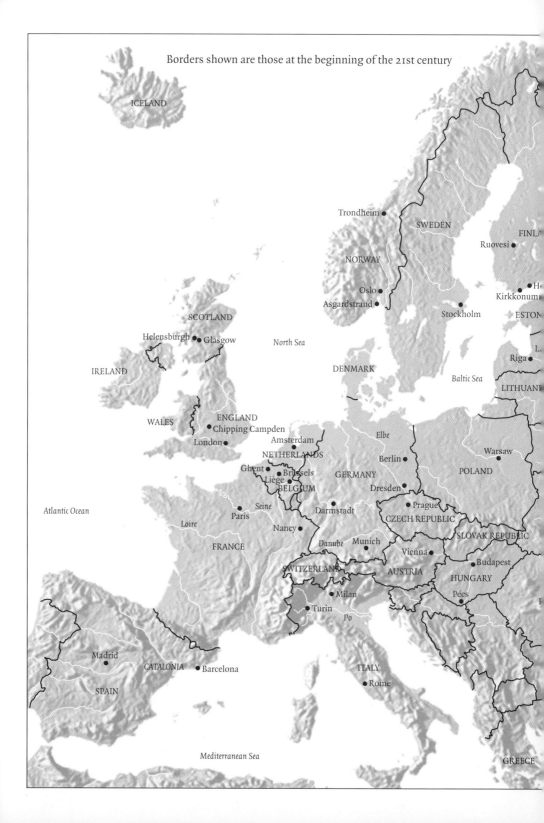

Borders shown are those at the beginning of the 21st century

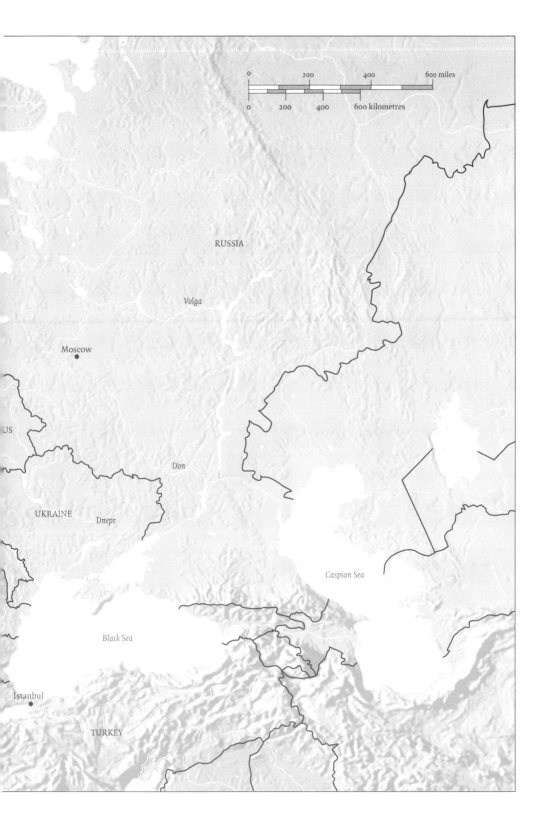

CANADA

Missouri

Chicago ●
Springfield ● Cincinnati
St Louis ●

Buffalo ● ● Boston
● New York
● Philadelphia

San Francisco ●

Colorado

UNITED STATES OF AMERICA

Rio Grande Mississippi

● New Orleans

Gulf of Mexico

Atlantic Ocean

MEXICO

CUBA

PUERTO RICO

Caribbean Sea

Pacific Ocean

Amazon

BRAZIL

● Rio de Janeiro

● Buenos Aires

ARGENTINA

| 0 | 500 | 1000 | 1500 | 2000 miles |

| 0 | 500 | 1000 | 1500 | 2000 kilometres |

Further Reading

Clotilde Bacri et al., *Daum: Master of French Decorative Glass* (London, 1993)

Roger Billcliffe, *Charles Rennie Mackintosh: The Complete Furniture, Furniture Drawings and Interior Designs* (Guildford, 1979)

Siegfried Bing, *Artistic America, Tiffany Glass and Art Nouveau* (Cambridge, MA, 1970)

Janine Bloch-Dermant, *The Art of French Glass 1860–1914* (London 1980)

Elena A Borisova and Grigorii Lurevich Sternin, *Russian Art Nouveau* (New York, 1988)

John Boulton-Smith, *The Golden Age of Finnish Art: Art Nouveau and the National Spirit* (Helsinki, 1985)

David Brett, *C R Mackintosh: The Poetics of Workmanship* (London and Harvard, 1992)

William Craft Brumfield, *The Origins of Modernism in Russian Architecture* (Berkeley, 1991)

Stephen Calloway, *Aubrey Beardsley* (London and New York, 1998)

Alan Crawford, *C R Ashbee: Architect, Designer and Romantic Socialist* (Princeton, 1985)

—, *Charles Rennie Mackintosh* (London, 1995)

Peter Davey, *Arts and Crafts Architecture* (London, 1980)

Alastair Duncan, *Art Nouveau* (London, 1994, repr. 1999)

—, *Louis Majorelle: Master of Art Nouveau Design* (London, 1991)

Stuart Durant, *The Decorative Designs of C F A Voysey* (London, 1990)

—, *C F A Voysey* (London, 1992)

Gabriele Fahr-Becker, *Art Nouveau* (Cologne, 1997)

—, *Wiener Werkstätte* (Cologne, 1995)

Phillipe Garner, *Emile Gallé* (London, 1990)

David A Hanks, *The Decorative Designs of Frank Lloyd Wright* (New York, 1979)

Thomas A Heinz, *Dana House: Frank Lloyd Wright* (London, 1995)

Wendy Hitchmough, *C F A Voysey* (London, 1997)

Jeremy Howard, *Art Nouveau: International and National Styles in Europe* (Manchester, 1996)

Thomas Howarth, *Charles Rennie Mackintosh and the Modern Movement* (London, 1952)

Simon Jervis, *Furniture of about 1900 from Austria and Hungary in the Victoria and Albert Museum* (London, 1986)

Diane Chalmers Johnson, *American Art Nouveau* (New York, 1979)

Philippe Julian, *The Symbolists* (London, 1973)

Wendy Kaplan (ed.), *Designing Modernity: The Arts of Reform and Persuasion 1885–1945* (London, 1995)

David W Kiehl, *American Art Posters of the 1890s in the Metropolitan Museum of Art including the Leonard A Lauder Collection* (New York, 1987)

Robert Koch, *Louis C Tiffany, Rebel in Glass* (New York, 1964)

—, *Louis C Tiffany's Art Glass* (New York, 1977)

Lionel Lambourne, *The Aesthetic Movement* (London, 1986, repr. 1999)

—, *Utopian Craftsmen: The Arts and Crafts Movement from the Cotswolds to Chicago* (London, 1980)

Joan Ainaud de Lasarte, *Catalan Painting: From the Nineteenth to the Surprising Twentieth Century* (New York, 1992)

—, *Joseph Maria Olbrich* (London 1978)

Robert McCarter, *Frank Lloyd Wright* (London, 1997)

Stephen Tschudi Madsen, *Sources of Art Nouveau* (Oslo, 1956)

Maria Makela, *The Munich Secession: Art and Artist in Turn-of-the-Century Munich* (Princeton, 1990)

Jiri Mucha, *Alphonse Mucha: His Life and Art* (New York, 1989)

Gillian Naylor and Yvonne Brunhammer, *Hector Guimard* (London, 1978)

Timothy Neat, *Part Seen, Part Imagined: Meaning and Symbolism in the work of Mackintosh and MacDonald* (London, 1993)

Peter Noever, *Josef Hoffmann Designs* (Vienna, 1992)

Nikolaus Pevsner, *Pioneers of Modern Design* (New York, 1949)

— and J M Richards (eds), *The Anti-Rationalists* (London, 1973)

Brian Reade, *Art Nouveau and Alphonse Mucha* (London, 1967)

Frank Russell (ed.), *Art Nouveau Architecture* (London, 1979)

Robert Scmutzler, *Art Nouveau* (New York, 1962)

Carl Schorske, *Fin-de-Siècle Vienna: Politics and Culture* (London, 1979)

Frederic J Schwarz, *The Werkbund: Design Theory and Mass Culture before the First World War* (New Haven, 1996)

W Schweiger, *Wiener Werkstatte: Design in Vienna 1903–1932* (London, 1984)

Eduard Seckler, *Josef Hoffmann: The Architectural Work. Monograph and Catalog of Works* (Princeton, 1985)

Deborah L Silvermann, *Art Nouveau in Fin-de-Siècle France* (Berkeley, 1989)

Mikulás Teich and Roy Porter (eds), *Fin de Siècle and its Legacy* (Cambridge, 1990)

Adrian Tilbrook and Gordon House, *The Designs of Archibald Knox for Liberty and Company* (London, 1976)

Nancy J Troy, *Modernism and the Decorative Arts in France: Art Nouveau to Le Corbusier* (New Haven, 1991)

Robert Twombly, *Louis Sullivan, His Life and Work* (Chicago, 1986)

Peter Vergo, *Art in Vienna 1898–1918: Klimt, Kokoschka, Schiele and their Contemporaries* (3rd edn, London, 1993)

Marie Vitochová et al., *Prague & Art Nouveau* (Prague, 1995)

Otto Wagner, *Modern Architecture* (Santa Monica, 1988)

Gabriel P Weisberg, *Art Nouveau Bing: Paris Style 1900* (New York, 1986)

— and Elizabeth Menon, *Art Nouveau: A Research Guide for Design Reform in France, Belgium, England and the United States* (New York and London, 1998)

Peter Wittlich, *Art Nouveau Drawings* (London, 1991)

—, *Fin-de-Siècle Prague* (Paris, 1992)

Exhibition Catalogues

L Ahtola-Moorhouse et al., *Dreams of a Summer Night: Scandinavian Painting at the Turn of the Century* (exh. cat., Hayward Gallery, London, 1986)

Arts Council of Great Britain, *French Symbolist Painters: Moreau, Puvis de Chavannes, Redon and their Followers* (exh. cat., Hayward Gallery, London, 1972)

—, *Homage to Barcelona: The City and its Art 1888–1936* (exh. cat., Hayward Gallery, London, 1986)

—, *Twilight of the Tsars: Russian Art at the Turn of the Century* (exh. cat., Hayward Gallery, London, 1991)

Gyöngyi Éri and Zsuzsa Jobbágyi (eds), *A Golden Age: Art and Society in Hungary 1896–1914* (exh. cat., Barbican Art Gallery, London, 1989)

Paul Greenhalgh (ed.), *Art Nouveau 1890–1914* (exh. cat., Victoria and Albert Museum, London; National Gallery of Art, Washington, DC, 2000–1)

Kathryn Bloom Hiesinger (ed.), *Art Nouveau in Munich: Masters of the Jugendstil* (exh. cat., Philadelphia Museum of Art; Stadtmuseum, Munich, 1988)

Wendy Kaplan (ed.), *Charles Rennie Mackintosh* (exh. cat., McLellan Galleries, Glasgow, 1996)

Mary Anne Stevens and Robert Hoozee (eds), *Impressionism to Symbolism: The Belgian Avant Garde 1880–1900* (exh. cat., Royal Academy of Arts, London, 1994)

Richard Thomson et al., *Henri de Toulouse-Lautrec* (exh. cat., Hayward Gallery, London, 1991)

Articles

Martin Eidelberg, 'Edward Colonna's "Essay on Broom Corn": A Forgotten Book of Early Art Nouveau', *Connoisseur*, February 1971, pp.123–30

—, 'Myths of Style and Nationalism: American Art at the Turn of the Century', *Journal of Decorative and Propaganda Arts*, 1994, pp.84–110

Margaret Haile Harris, 'Loïe Fuller: the Myth, the Woman, the Artist', *Arts in Virginia*, 1979, pp.16–29

Kerrtue Karvonen-Kannas, 'Akseli Gallen Kallela – The Creator of Finnish Design', *Journal of the Decorative Arts Society*, 1987, pp.1–4

Mikhail Kiselev, 'Graphic Design and Russian Art Journals of the Early Twentieth Century', *Journal of Decorative and Propaganda Arts*, 1989, p.50

A Pagel, 'Jugendstil and Racism: An Unexpected Alliance', *Canadian Art Review*, 1992, p.99

José Maria Pena, 'Art Nouveau Stained Glass and Ironwork' [In Argentina], *Journal of Decorative and Propaganda Arts*, 1992, p.223

Galina Smorodinova, 'Gold and Silverwork in Moscow at the Turn of the Century', *Journal of Decorative and Propaganda Arts*, 1989, pp.30–49

Rory Spence, 'Lars Sonk', *Architectural Review*, 1982, pp.41–9

Gabriel P Weisberg, 'Samuel Bing: Patron of Art Nouveau'; Part 1, *Connoisseur*, October 1969, pp.119–25; Part 2, *Connoisseur*, December 1969, pp.294–5; Part 3, *Connoisseur*, January 1970, pp.61–8

—, 'Samuel Bing: International Dealer of Art Nouveau': Part 1, *Connoisseur*, March 1971, pp.200–5; Part 2, *Connoisseur*, April 1971, pp.274–83; Part 3, *Connoisseur*, May 1971, pp.49–55; Part 4, *Connoisseur*, July 1971, pp.211–19

Contemporary Journals

Architectural Record (USA)

Architectural Review (Britain)

L'Art décoratif (France)

Art et decoration (France)

Art Journal (Britain)

L'Art moderne (Belgium)

The Craftsman (USA)

The International Studio (Britain)

Jugend (Germany)

Magazine of Art (Britain)

Mir Iskusstva (Russia)

Pan (Germany)

Pèl & Ploma (Spain)

Revue des arts décoratifs (France)

The Studio (Britain)

The Studio Yearbook (Britain)

Van nu en straks (Belgium)

Ver Sacrum (Austria)

Index

Aalto, Alvar 412–15; **257**
Acosta y Forés, Jaime 295
Acosta y Forés, San Germain 295–6; **190**
Adler, Dankmar 272, 273
AEG 369–72; **232–3**
Aesthetic Movement 8, 21, 49–50, 53–7, 187–8, 323, 328, 330
Alberta Iela, Riga 395; **248**
Alexander I, Tsar 192
Alexander II, Tsar 209
Alexandria, Tsarina 209–13
À l'Innovation, Brussels 301, 302; **193–4**
Amerikantsev, Pavel Dmitrievich 215; **137**
Andrássy, Count Tivadar 396
Architectural Record 29, 252
architecture 299, 405–6
 Argentina 291–6; **188–90**
 Austria 141–53, 161–3, 168; **79–82, 84–8, 90–2, 97–8**
 Belgium 72–80, 84, 165–7, 301–2; **32, 36–42, 44, 101–3, 192–4**
 Catalonia 229–30, 232–46; **119, 152–61**
 Czech Republic 387–8; **243–6**
 Finland 199–207, 412–15; **126–9, 131, 257**
 France 304, 323–7; **205–7, 255–6**
 Germany 122, 353–6, 406–8; **73–4, 195–6, 219–22, 224, 234–6, 254**
 Hungary 395–7; **249**
 Latvia 395; **248**
 Russia 215–28; **136–46, 148**
 Scotland 175–7, 180–7, 304–9, 422–4; **106–8, 112–17, 197–8**
 United States 269–88; **177–80, 182–3, 187**
Argentina 288–94, 296
Art Deco 5, 8, 401–4, 408, 424
L'Art décoratif 83, 84
Art Journal 11, 19, 57, 134, 257, 330
L'Art moderne 6, 67, 68
L'Art Nouveau, Paris 6, 17, 26, 68, 84, 311–16, 318, 319; **201**
Arts and Crafts Exhibition Society 44, 48–9
Arts and Crafts Movement 5, 8, 21, 32–9, 44–9, 53, 54, 69–70, 112, 165, 177, 181, 197, 204, 232, 263, 264–7, 327, 330, 340, 379, 398
Ashbee, Charles Robert 35, 40–4, 45–9, 66, 67–8, 72, 134, 156, 172, 173, 346–8,

349–50, 353, 366; **22–4**
Auclert, Hubertine 86
Austria-Hungary 135–72, 384
Autrique, Eugène 73, 76

Bahr, Hermann 141–2
Bailie 305, 309
Baillie-Scott, Mackay Hugh 353
Bakst, Léon 213; **134**
Balat, Alphonse 72; **36**
Balsánek, Antonín 388–90; **244–5**
Barcelona 191, 229–46, 295, 383, 412, 422
Barry, Charles 29
Basile, Ernesto 398
Baudelaire, Charles 87
Beardsley, Aubrey 49, 54–8, 66, 72, 165, 213, 268, 416, 418; **28, 29**
Beethoven, Ludwig van 157–61; **95**
Behrens, Peter 129, 353–6, 357, 368, 369–72, 379–80, 405, 420; **220–3, 232–3**
Behrens House, Mathildenhöhe, Darmstadt 356; **220–2**
Belgian Workers' Party 67, 73, 77–9, 300, 301
Belgium 6, 66–84, 108, 129–30, 301–2, 423
belle époque 11–12, 21, 85
Bendelmayer, Bedrich 387–8
Bergé, Henri 114; **68**
Berlage, Hendrik Petrus 288
Berlin 304
Bernard, Émile 67
Bernhardt, Sarah 97–101, 102, 319, 323; **56–7**
Bernheim, Hippolyte 107, 110
Biais, Maurice 318; **202**
Biba 8, 415–16; **259**
Biedermeier style 149–52
Bing, Siegfried 6, 14, 17, 24, 26, 52, 59–60, 68, 84, 255, 256–60, 261, 268, 311–16, 319, 327, 328, 334, 383, 396, 401; **5, 201**
Bing & Grøndahl 261
Bismarck, Otto von 115, 138
Blackie, Walter 181, 185, 383
Blake, William 58
Blavatsky, Helena 126
Blomstedt, Väinö 196
Bobrikov, Nicholas 192
Bock, Richard W 283; **184**
Böhm, Adolf 137, 157; **83**
Bonnard, Pierre 104, 257
books 39, 48; **18, 21, 23, 176**
Boucher, François 25
Bradley, William H 257, 268,

418; **176**
Bragdon, Claude Fayette 276
Brazil 292
Brega, Giuseppe 398
Breton, André 408
Britain 29–52, 54–7, 172–88, 327–33, 346, 415–16, 422–3
Brussels 4, 44, 73–9, 301–2, 423
Brussels Universal Exposition (1897) 83
Buchanan Street tea rooms, Glasgow 304; **197**
Budapest 396–7, 424
Buenos Aires 289–91, 292–3
Bugatti, Carlo 398–401; **251**
Bunge, Ernesto 291
Burges, William 52
Buschiazzo, Juan Antonio 291

Carabin, François Rupert 94–5; **52**
Caribbean 288, 294–6
Carson, Pirie, Scott & Co building, Chicago 276–7; **180**
Casas, Ramón 232; **149**
Catalonia 191, 229–46, 293, 294–5, 422
Celtic Revival 331
Century Guild 39–40
ceramics 199, 230–1, 260–1, 263, 267, 367; **30, 125, 167–9, 171–3**
Chalon, Louis **46**
Charcot, Jean-Martin 107, 195
Chéret, Jules 95; **53**
Chicago Columbian Exhibition (1893) 261
Christophersen, Alejandro 291
Circol de Sant Lluch 235
classicism 144, 149–57
Coleman, Samuel 255, 257
Collinson and Lock 39
Colombo, Virginio 293; **162**
Colònia Güell, Barcelona 242–3, 246; **160**
Colonna, Édouard 14, 60, 258–60, 314, 315; **166**
Compagnie Générale des Transports 19–20
Conklin, Lee 418
Cormon, Fernand 195
Coty, François 404
Courbet, Gustave 104
Craftsman 260, 266
Crane, Charles R 390
Crane, Walter 44–5, 48, 68, 396–7; **21**
Cranston, Catherine 304–11
Croly, Herbert 252
Cubism 390, 402, 409

Curie, Pierre and Marie 85
Czech Republic 384–95, 409

Dabault, Henri-Ernest 90–3;
 49
Dalí, Salvador 408–9
Dana, Susan Lawrence 279,
 299, 300
Dana House, Springfield,
 Illinois 279–82; **182–4**
Darmstadt 129, 213, 353–7, 380
D'Aronco, Raimondo 398; **250**
Darwin, Charles 65
Daum Frères 113–14, 341–6,
 350, 379, 418; **67, 216–17**
de Forest, Lockwood 255
Delaherche, Auguste 260,
 261; **169**
Delhaye, Jean 423
Delville, Jean 178–80
Denis, Maurice 104
Dent, J M 57, 58
department stores 276,
 301–4, 311; **180, 192–4**
Desraimes, Maria 87–8
Derozhinskaia House, Moscow
 228; **148**
Desroisiers, Charles 319
Deutsche Kunst und Dekoration
 349, 350, 367
Deutsche Werkbund 368–76,
 383; **237**
Diaghilev, Sergei 213, 227
d'Isola, Aimaro 419
Domènech i Montaner, Lluís
 230, 233–5, 293, 294; 119,
 152–4
Donaldson, Sir George 44,
 314–15
Dormal, Jules 291
Dresden 369
Dresser, Christopher 255, 276
Dreyfus Affair 85
Dryák, Alois 387–8
Dubois, Louis 291
Dulong, René **4**

École des Beaux-Arts 73
École de Nancy 108
Edelfelt, Albert 193, 195
Edificio Calise, Buenos
 Aires **162**
Edison, Thomas 345
Eetvelde, Baron van 79, 80,
 107, 108
Eidelberg, Martin 260
Einstein Tower, Potsdam 407;
 254
Eisenstein, Mikhail 395; **248**
electroplating 357–66
Elkington & Co 362
Ellis, Harvey 266
Elvira photographic studio,
 Munich 122; **73–4**
Endell, August 20, 122–4, 221,
 369, 373, 405, 409, 419; **73–4**
Ernst Ludwig House,
 Darmstadt 353–6; **219**
Expressionism 406–8, 409

Fabergé, Carl 213
Farrell, Terry 420

Felix, Eugen 137
feminism 86, 87–8; **48**
Feure, Georges de 14–17, 19,
 26, 60, 314; **6, 31**
Fiat 300, 301
Fidus 127–8; **77–8**
Le Figaro Illustre **3**
Finch, Alfred William 68, 199,
 203; **124–5**
Finland 191–207, 235, 246,
 300, 412
Flammarion, Camille 103
Fomin, Ivan 227; **147**
Ford, Henry 345
Foucard, Louis de 60, 88,
 112–13
Fouquet, Georges 319–27;
 205–8
Fragonard, Jean-Honoré 25
France 11–29, 52–3, 58–62,
 84–114, 130, 191, 315, 337–45
Francis Joseph, Emperor 135,
 136, 139
Franco, General 422
Franco-Prussian war (1870–1)
 13, 25, 84
Frantz, Henri 52
Freud, Sigmund 107, 134, 139
Fuller, Loïe 101–2; **58–9**
Furnémont, Léon 77
Furness, Frank 276
furniture
 Austria 19, 368; **7, 230–1**
 Belgium 26, 70–2; **35**
 Catalonia 232; **151**
 England 35–9, 48–9, 328;
 16–17, 19, 24
 Finland 197–8, 206; **123, 130**
 France 14–17, 21–4, 94–5,
 114, 314–16, 339–40, 401–4;
 6, 8–9, 52
 Germany 124–6; **76, 99**
 Italy 398–401, 419; **251**
 Japan 420–2
 Norway 208; **132**
 Russia 227; **147**
 Scotland 185–6, 311; **199**
 United States 263–7, 422;
 174, 261
Futurism 401

Gabetti, Roberto 419
Gaillard, Eugène 14, 60, 314
Galeries Lafayette, Paris 304;
 191
Gallé, Émile 17, 52–3, 107–13,
 114, 130, 232, 276, 277, 283,
 315, 338–41, 344, 346, 349,
 350, 376, 383, 386, 418; **27,
 62–6, 212–15**
Gallen-Kallela, Akseli 193,
 194–7, 198, 199, 203, 206,
 207, 230, 232, 330, 412; **120–2**
Garcia Núñez, Julián Jaime
 293–4
Garden City movement 241
Garnier, Jean-Louis-Charles 19
Gaudí i Cornet, Antoni 230,
 232–4, 235–46, 248, 293,
 299, 337, 383, 387, 408–9,
 410–12, 419, 422; **155–61**
Gauguin, Paul 58, 67, 104,

195, 196; **30**
Gautier, Théophile 49–50
Germany 115–29, 191, 353–67,
 368–76, 406–8, 409
Gesellius, Herman 199–206,
 223, 412, 415; **126–9, 131**
Getz, John 257
Glasgow 133–4, 172–88, 228,
 304–11, 422–4; **106**
Glasgow Boys 178
Glasgow International
 Exhibition (1901) 223–4,
 228; **144**
Glasgow School of Art 175–8,
 180–1; **107–8, 112–5**
glass
 Czech Republic 386–7; **241–2**
 England 45; **22**
 Finland 415; **258**
 France 112–14, 261, 340–5,
 404; **27, 63–5, 67, 214–17, 253**
 Germany 227
 United States 255–6, 261;
 163, 165
Godwin, Edward William 52
Goncourt, Edmond de 24–6,
 87, 88, 95, 107
Goncourt, Jules de 24–5, 107
Gothic Revival 8, 21, 26–32,
 35, 37, 62, 70, 112, 238
Gould, J J 268; **175**
Grand Bazar Anspach, Brussels
 301–2
Grand-Ducal Museum, Weimar
 372; **235**
Grasset, Eugène 58–9, 268
Gray, Asa 276
Grey House, Mathildenhöhe,
 Darmstadt 357; **224**
Gropius, Walter 372, 373
Grueby, William Henry 260,
 261, 263, 314; **167–8, 173**
Guaranty Building, Buffalo
 273–6; **177–9**
Güell, Eusebio 235, 239–42,
 248, 299, 300
Guilbert, Yvette 97; **54**
Guild of Handicraft 45, 48, 49,
 156, 172, 349–50, 351
Guimard, Hector 19, 20, 29,
 60, 84, 108, 227, 243, 252,
 300, 302, 387, 405; **2**

Habsburg Empire 135, 138–9
Hacker, Moritz 387
Haeckel, Ernst Heinrich 119,
 120, 121–2, 126–7, 128, 130,
 279; **71**
Haiger 149
Hallet, Max 77
Hankar, Paul 69, 72, 80, 301,
 395
Hansen, Frida 208
Harpers 268
Harrach Glassworks 386
Haussmann, Baron 289
Havana Tobacco Company
 Shop, Berlin 304; **195**
Haweis, Mrs 330
Heals 333
Hellwig 149
Hendrickx, Ernest 72

Henry, George 178; **111**
Herbst, Auguste **212–13**
Heuvci, Ludwig 148, 161, 171
Heyk, Eduard 367
Hill House, Helensburgh
 181–7, 188, 422–3; **116–17**
Hitler, Adolf 409
Hoenschel, Georges 107
Hoffmann, Josef 133–4, 137,
 138, 141, 152, 154–6, 161–3,
 167, 168, 172, 173, 187, 286,
 349, 350–3, 368, 369, 404,
 405, 420, 422; **97–8, 101–3,
 218, 230**
Holme, Charles 196
Homar, Gaspar 232; **151**
Hornel, Edward 178; **111**
Horta, Victor 70, 72–80, 83–4,
 107, 108, 227, 265, 276, 300,
 301–2, 318, 337, 383, 387,
 404, 405, 419, 423; **32,
 37–42, 44, 193–4**
Hotel Central, Prague 387; **243**
House Beautiful 264, 288
Howarth, Thomas 187
Hugé, Emilio 291
Hulanicki, Barbara 8, 415–16
Hungary 395–7
Huth, Georg 127
Huysmans, J K 25
Hvitträsk 204–6, 412, 415;
 128–9
hypnotism 105–7, 195

Iaroslavl Railway Station,
 Moscow 224; **145–6**
Image, Selwyn 40
Imperial Barbers, Berlin 304;
 196
Impressionism 7, 50, 89, 104,
 232
industry 337–80
Ingram Stréet tea rooms,
 Glasgow 305–9, 311
Iribe, Paul 402–4; **252**
Iris Workshops 198–9, 203,
 206, 246; **124**
Isozaki, Arata 420–2
Italy 384–5, 397–401, 418–20

Japan 50–3, 254–5, 268, 323
Le Japon Artistique 52; **26**
Japonisme 52–3
Jencks, Charles 420; **238**
jewellery 83, 90–3, 215, 319,
 323, 331; **45, 49–51, 208**
Jones, Owen 30–2, 108, 255,
 276; **13**
Jozé, Victor 87, 97
Jugend 116–17, 118–19, 124,
 127, 373; **69**
Jugendstil 4, 115–29, 153, 168,
 191, 331, 348, 356, 362–5,
 366, 369, 372, 376, 383, 409

Kafka, Franz 136
'Kalela' Wilderness Studio,
 Ruovesi 196–7; **122**
Karhula-Iittala 415
Karlsplatz station, Vienna 143;
 84
Kayser, Johann Peter & Sohn

331; **210**
Kelmscott Press 57
Khnopff, Fernand 105
Klimt, Gustav 137, 154,
 156–60, 167–8, 173, 187,
 223, 365, 423; **83, 94, 96,
 103–5**
Klinger, Max 157; **95**
Know, Archibald 331, 333; **211**
Koeber, Ernst 384
Kohn, J&J 368, 420; **230**
Korovin, Konstantin 213, 227;
 134
Krafft-Ebing, Richard von 87
Kunstlerhaus, Vienna 137–8
Kurliukov, Orest Fedorovich
 214–15; **136**

La Farge, John 255, 257, 261
Lalique, René 93, 404; **50–1,
 253**
Lamb, James 40
lamps 108, 404, 420; **58, 62,
 223, 253**
Langbehn, Julius 128
Larche, François-Raoul 102; **58**
Larguía, Jonás 291
Latvia 395
Le Corbusier 372, 401, 405,
 410–12; **255–6**
Leblond, Marius-Ary 89–90
Lechner, Ödön 396, 397; **249**
Léopold II, King of Belgium
 79–83
Lethaby, William Richard 180
Leven, Hugo 210
Levillan, Fernand 83
Leyland, Frederick 50
Liberty, Arthur 327–30, 333,
 346
Liberty & Co 5, 54, 70, 77,
 198, 199, 327–33, 398; **209**
La Libre Esthétique 67–8, 72
Lindgren, Armas 199–206,
 223, 412, 415; **126–9, 131**
Linke, François 21, 24; **8**
Linke Wienzeile apartments,
 Vienna 143–5, 148; **85–8**
Lippincott's 268; **175**
Liszt, Franz 157
Lliga de Catalunya 235
London 415–16
Longatti, Romeo 401
Lönnrot, Elias 194
Loos, Adolf 134, 156, 288, 401
Lötz, Johann Witwe 386–7; **242**
Louis XVI, King of France 85
Ludwig von Hessen, Grand
 Duke 129, 209–13, 353, 356,
 357, 420
Lueger, Karl 139
Luksch, Richard 172
Lutyens, Edwin 181
Lux, J A 350, 351

McConnell, John **259**
Macdonald, Frances 172, 178,
 186; **110**
Macdonald, Margaret 172–3,
 174, 178, 181, 185, 186, 187,
 227–8, 266, 305, 309–11,
 420; **118, 200**

Mackintosh, Charles Rennie
 4, 68, 133–4, 172–88, 198,
 227–8, 264, 266, 273, 286–8,
 305–11, 383, 418, 419,
 420–4; **107–9, 112–17, 197–9**
Mackmurdo, Arthur Heygate
 35, 39–40, 44; **18–20**
MacMillan, Andy 424
MacNair, Herbert 172, 178
Mahler, Gustav 135, 141, 156,
 157, 161
Maison du Peuple, Brussels
 77–9, 301; **42**
La Maison Moderne, Paris
 316–19; **202–3**
Majolika House, Vienna 145;
 87–9
Majorelle, Louis 17, 19, 21–4,
 114, 304, 315–16, 338,
 344–5, 404; **9, 217**
Malory, Sir Thomas 57
Mannerheim, Eva 197, 198
Marinetti, Filippo Tommaso 401
Maruyama, Wendy 422; **261**
Marx, Roger 112, 338
Mauclair, Camille 319
Maus, Octave 67
Meano, Vittorio 291
Meier, Richard 422
Meier-Grafe, Julius 116, 128,
 209, 316–19, 327, 356–7, 383
Meissen 367
Méline, Jules 338
Mendelson, Eric 407–8; **254**
Mesmer, Friedrich Anton 105
metalwork
 Argentina 292–3; **162, 189**
 Austria 165; **100**
 Belgium **40–1**
 Czech Republic **239**
 England 331–3; **210–11**
 France 29; **11, 46, 170**
 Germany 372; **232**
 Scotland 177–8; **108, 110**
 United States 254–5, 422; **164**
Metzner, Franz 168
Mies van der Rohe, Ludwig
 405, 412
Mir Iskusstva 213; **133–4**
Mission furniture 265–7
Modern Movement 8, 133,
 134, 165, 272, 273, 401,
 405–6, 408, 412, 415, 419, 424
Modernista movement 4,
 229–32, 235–9, 293, 295
Moll, Carl 139; **83**
Mollino, Claudio 419
Monism 126–7, 128, 130, 168,
 208, 279
Moore, Edward Chandler
 254–5, 257
Moreau, Gustave 408; **47**
Morgan, J Pierpont 251
Morris, William 32–5, 39, 44,
 57, 60, 67, 68, 72, 196, 199,
 267, 346, 350, 353, 366,
 405; **14**
Morris & Co 32, 199, 267
Moscow 209, 213, 214–15,
 227, 305
Moser, Koloman 137, 138, 141,
 153, 156, 162–5, 173, 349,

353, 368, 422; **83, 93, 99**
Mourey, Gabriel 24
Mucha, Alphonse 97–101,
102–4, 130, 268, 319, 362,
390–5, 408, 409, 416; **56–7,
60, 204–5, 207, 246–7**
Munch, Edvard 196, 208–9; **133**
Munich 4, 117–18, 145, 196,
277, 366–7, 369, 409
Municipal Building, Prague
388–90; **244–6**
Munthe, Gerhard Peter 207–8;
132
Musée des Arts Décoratifs,
Paris 314
Mussolini, Benito 419
Muthesius, Hermann 188,
373, 376, 383; **237**
Myslbek, Josef Václav 384;
239–40

Nabis 104-5, 178, 396
Nancy 4, 108, 113, 341–4
Napoleon III, Emperor 26,
246, 289
National Romanticism 5,
196–7, 199, 206, 215, 235,
395, 397
Nazis 409
Nebehay, Herr 353
Neo-Liberty movement 419–20
Neoclassicism 5, 21, 409, 419,
420
Neues Wiener Tagblatt 165, 172
Nicholas II, Tsar 192
Nordau, Max 269
Nordic Incorporated Bank,
Helsinki 206; **131**
Norway 207–9
Notre Dame-du-Haut,
Ronchamps 412; **255–6**

Obrist, Hermann 119–22, 124,
126-7, 128, 130, 223, 265,
276, 277, 279, 283, 348–9,
368, 369, 373, 407–8, 419; **72**
Ohmann, Friedrich 387; **243**
Olbrich, Joseph Maria 19, 129,
134, 137, 138, 141-3, 145, 152,
153, 157, 167, 168, 173, 187,
223, 227, 353–6, 357, 369,
398, 408; **7, 81-2, 219, 224**
Old Believers 220–1, 239
Old England department store,
Brussels 301; **192**
Orazi, Emmanuel 318; **203**
Osthaus, Karl Ernst 128,
372, 373

paintings 6–7, 89–90
Austria 167–8; **103–5**
Belgium 178–80
Czech Republic 390–5; **246–7**
Finland 193, 195; **120–1**
France 60; **31, 47, 66, 68**
Norway **133**
Scotland **109, 111, 118**
Palais Stoclet, Brussels
165–72, 187, 351, 383, 402,
420; **101–5**
Palau de la Música Catalana,
Barcelona 234–5; **119, 152–4**

Palau Güell, Barcelona 235–9,
299, 422; **155–6**
Pan 116, 196
Pankok, Bernhard 124–6, 128,
168, 366; **75–6**
Paris 84, 195–6, 232, 246, 289
Paris Commune 13–14, 84
Paris Métro 4, 8, 19-20, 108,
300–1, 302; **2**
Paris Universal Exposition
(1900) 4, 7, 11–19, 24, 26,
59–60, 80, 105, 112, 191,
199–203; **3–6, 126–7**
Park Güell, Barcelona 241–2;
158
Parrish, Maxfield 268
Pasteur, Louis 84–5
Pater, Pablo 292–3; 189
Pater, Walter 50
Paul, St 108
Paul, Bruno 117–18
Péladan, Joséphin 104
Penfield, Edward 268
Perichi, Juan Ortiz 295
Perry, Commodore Matthew
50, 255
Pevsner, Nikolaus 133, 405–6,
419
Pey i Farriol, Josep 232; 151
Picard, Edmond 68
Poelzig, Hans 407
Polijoka Insurance Company,
Helsinki 206
Polívka, Osvald 390; **244–5**
Poltranova 420
Ponti, Gio 419
Pope, Alexander 54
Portoghesi, Paulo 419–20
Post-Impressionism 58, 66,
67, 68, 137
Post Office Savings Bank,
Budapest 396; **249**
Post Office Savings Bank,
Vienna 148–9; **90–2**
posters
Austria 154; **94**
Belgium 69; **34**
Catalonia 232; **149**
France 95–101, 318, 323;
53–7, 202–4
Germany 372; **233**
United States 267–9, 418; **175**
Postmodernism 419–22, 424
Powolny, Michael 172
Prague 383, 384–95, 424
Pre-Raphaelites 32, 58, 232,
268
Primavesi family 351
Prouvé, Victor 112; **66**
Puerto Rico 294–6
Pugin, Augustus Welby
Northmore 29–30, 32, 37,
60, 70, 72, 108, 276; **12**
Puig i Cadafalch, Josep 233–4,
235
Pujol, Jaime 231
Punch 328; **209**
Purkersdorf Sanatorium
161–3, 165, 187, 351–3, 368,
423; **97–8**
Puvis de Chavannes, Pierre-
Cécile 58

Ranson, Paul 104, 257
Reade, Brian 416
Renaixença movement 229–30
Revue des Arts Décoratifs 24, 88
Riedel, Josef 386; **241**
Riemerschmid, Richard 118,
129, 330, 367, 368, 369
Riga 385
Rippl-Rónai, József 396
Riquer, Alejandro de 232; **150**
Rivadavia, Buenos Aires 291;
188
Robida, Albert **1**
Roca, General Julio A 289
Rochas, Albert de 102–3
Rococo 5, 21
Rococo Revival 8, 21–6, 62, 87
Rodenbach, Georges 102
Rodríguez Ortega, Enrique S
291; **188**
Rogent, Elías 233, 234, 235
Rohlfs, Charles 263–5, 337; **174**
Roller, Alfred 137, 139–41, 157,
173; **95**
Roman Catholic Church 85,
126, 243–6
Romanov family 209–13
Romanticism 207, 277
Rookwood Pottery 257, 260–1,
263
Rosicrucianism 104–5
Rossetti, Dante Gabriel 52
Roxburgh, Graham 423–4
Royal College of Art 44
Royal glasshouses, Laeken 72;
36
Ruchet, Berthe 120
Ruhlmann, Jacques Émile 401,
404
Runeberg, Johan 195
Rusiñol, Santiago 229, 232
Ruskin, John 32, 39, 60, 67, 68,
72, 108, 196, 199, 350, 353
Russia 191, 192, 209–28, 246
Ryabushinsky, Stephan 217,
239, 248, 299, 300
Ryabushinsky House, Moscow
217–23; **140–3**

Saarinen, Eliel 199–206, 223,
300, 404, 412, 415; **126–31**
St Petersburg 209–13
Sagrada Familia, Barcelona
243–6; **161**
Saintenoy, Paul 301; **192**
Salon 104
Salon de la Rose+Croix 104–5,
178
San Francisco 418
Sant'Elia, Antonio 401
Sargent, Irene 260
Schiele, Egon 157
Schiller, Friedrich 160
Schinkel, Karl Friedrich 152–3
Schlesinger and Mayer
Department Store, Chicago
276–7; **180**
Schoenberg, Arnold 134, 156
Schuyler, Montgomery 276
Schwabe, Carlos 105; **61**
Scotland 133–4, 172, 88, 228,
304–11, 422–4; **106**

Scotson-Clarke, G F 54, 57
Secession 4, 137–43, 153–61,
165, 172–3, 187, 365, 388,
398, 401, 418, 423; **94–5**
Secession Building, Vienna
141–3; **81–2**
Serrurier-Bovy, Gustav 17, 26,
68, 69–72, 80, 84, 330; **4, 35**
Sert, José María 14
Sérusier, Paul 104
Seurat, Georges 68
Sheerer, Mary G 263
Shekhtel', Fyodor 215–28,
233, 299, 300; **140–6, 148**
shops 301–4, 311–34; **192–6,
205–7**
silver 165, 213–15, 254–5, 331,
422; **100, 136–8, 164, 211, 218**
Silver, Rex 331
Simplicissimus 118; **70**
Société des Arts Décoratifs 404
Society for the Protection of
Ancient Buildings 39
Solvay, Armand 300
Sombart, Werner 366
Sommaruga, Giuseppe 398
South America 288–94
Spain 191, 229–46, 295, 422
Sparre, Louis 197–9, 203, 230;
123
stained glass 232, 257, 283;
38, 150, 154, 183, 245
Stickley, Gustav 265–7
Stil' Modern 209, 214, 215,
223–8, 235, 239
Stile Floreale 398, 401
Stile Liberty 398, 401
Stoclet, Adolphe 165–7, 351
Stoclet, Jacques 167
The Studio 55, 196, 198, 257,
260, 261, 268, 286–8, 305,
398
Sullivan, Louis Henry 269–79,
283, 289, 301, 383, 405;
177–81
Surrealism 408–9, 415
Swid Powell 422
Symbolism 21, 50, 57–60, 66,
67, 87, 89, 102, 104–5, 137,
177–80, 185, 187, 193, 195,
208, 232, 273, 283, 390–5,
408

Takacyma 52–3
Tarasov, Mikhail Yakovlevich
215; **138**
Tassel, Émile 73, 76
Tassel House, Brussels 76–7,
83; **32, 37–41**
Tavani, Fratelli 420
Taylor, F W 340
tea rooms 305–11; **197–9**
textiles 120; **15, 20, 72**
Thematic House, London **238**
Theosophy 126, 128, 180
Thiis, Jens 60, 208
Thonet, Gebrüder 368; **231**
Tiffany, Charles Louis 254
Tiffany, Louis Comfort 252–4,
255–8, 261, 289, 346, 376,
401
Tiffany & Co 254–5, 289, 346,

350, 386; **164–5**
Tiffany Studios 255, 261; **163,
172, Frontispiece**
Tobey furniture company 267
Toulouse-Lautrec, Henri de
58, 67, 95–7, 195, 257, 268;
54–5
Tretyakov Gallery, Moscow
217; **139**
Twyman, Joseph 267

Union Centrale des Arts
Décoratifs 17–18, 88, 337,
404
Union des Artistes Moderne
(UAM) 404
United States 251–89, 295,
296, 418
Uzane, Octave 87

Van Briggle, Artus 260–1, 263,
337; **171**
Van de Velde, Henry 26, 35,
60, 67, 68–70, 72, 76, 80, 84,
108, 128–9, 199, 288, 304,
318, 365, 368, 369, 372–9,
383, 407–8, 419; **33–4,
195–6, 234–7**
Van Eetvelde House, Brussels
79–80, 83; **44**
Van Gogh, Vincent 68
Vanderbilt, William H 251
Vasnetsov, Viktor 215–17; **139**
Veblen, Thorstein 251
Ver Sacrum 251
Vereinigte Werkstätten für
Kunst im Handwerk 118,
129, 366–7, 369
Victoria, Queen of England
353
Victoria and Albert Museum,
London 314–15
Vienna 133–73, 174, 187,
367–8, 369, 379, 395–6, 423;
80–3
Villa Hohenhof, Hagen 375;
236
Villa Mairea, Noormarkku 415;
257
Villar y Lozano, Paula 243
Les Vingt 6, 67, 68
Viollet-le-Duc, Eugène-
Emmanuel 26–9, 32, 58, 60,
72, 73, 108, 234, 246; **10–11**
Vogt, Carl 86
Voysey, Charles Francis
Annesley 35–9, 40, 70, 76,
264, 33; **15–17**

Waern, Cecilia 257
Waerndorfer, Fritz 165, 172,
173, 351
Wagner, Otto 139, 142, 143–9,
152, 153, 156, 157, 175, 288,
368, 372, 388, 390; **79,
84–92, 231**
Wagner, Richard 157, 161, 207
wallpaper **33**
Wedgwood, Josiah 346
Weimar Republic 406
Werkbund Exhibition, Cologne
(1914) 372; **234**

Wheeler, Candace 255
Whistler, James Abbott McNeill
50, 323; **25**
White Cockade café, Glasgow
311; **200**
Wiehl, Antonín 387
Wiener Werkstätte 4, 156,
161–7, 349–53, 366, 379, 422
Wightwick Manor,
Staffordshire 32; **14**
Wilde, Oscar 49, 50, 54, 55–7
Wilhelm I, Kaiser 115
Wilhelm II, Kaiser 116
Willow Tea Rooms, Glasgow
309–11; **198**
Wilson, Wes 418; **260**
Wirkkala, Tapio 415; **258**
Wolfers, Philippe 83; **45**
women 86–95, 97–102; **47–59**
World War I 11–12, 115
Wright, Frank Lloyd 264,
269–72, 279–88, 289, 299,
405; **182–3, 185–7**
Württembergische
Metallwarenfabrik (WMF)
357–67, 368, 373, 379;
225–9

The Yellow Book 57; **29**

Die Zeit dispatch office, Vienna
79
Zola, Émile 85
Zsolnay 331, 396
Zuckerkandl, Viktor 353
Zumbush, Ludwig von **69**
Zweig, Stefan 136

Acknowledgements

This book is for Hannah Andrassy, with my thanks for her constant and invaluable support and encouragement, and for spending her last three holidays in the great Art Nouveau cities of Europe. It is also dedicated to the memory of Clive Wainwright, whose generosity and friendship will be missed by me and a great many others. I owe a great debt to Pat Barylski, Ros Gray and Zoë Stollery at Phaidon for their unstinting help, and to Debbie Lewer for her advice on the German sources.

SE

Photographic Credits

AA Publishing, Basingstoke: 159; AEG, Frankfurt am Main: 233; AKG, London: 58; Annan Gallery, Glasgow: 106, 197; Arcaid, Kingston on Thames: 81, 91, 97, 238; Artur, Cologne: 236; Bastin and Evrard Photographes, Brussels: 32, 36, 44, 92, 192, 256; David Bellis, Hartsdale, N Y: frontispiece, 163; Bibliothèque Nationale de France, Paris: 48, 59, 191; Bildarchiv Foto Marburg: 73, 74, 193, 195, 196, 234; Birmingham Central Reference Library: 23; Christian Brandstätter Verlag, Vienna: 80, 96, 98; Bridgeman Art Library, London: 16, 21, 22, 24, 28, 29; British Museum, London: 232; Butterfield and Butterfield, San Francisco, sold June 1997, photo: Anita Bowen: 8; Alastair Carew-Cox, Abbots Morton: 37, 38, 39, 40, 41; Chicago Architectural Photographing Company: 179; Christie's Images, London: 65, 231; Conservatoire National des Arts et Métiers, Paris: 213; Drouot-Montaigne, Paris: 49; Edifice, London: 180, 243, 244, 245; Martin Eidelberg, New York, photo: Richard P Goodbody: 167, 168, 169, 170, 171, 172, 173; E T Archive, London: 252; Étude Tajan, Paris: 216; Dr G Fahr-Becker, Munich: 77; Finnish National Gallery/Ateneum, Helsinki: 120; Foto Elio e Stefano Ciol, Udine: 250; Freer Gallery of Art, Smithsonian Institution, Washington DC: 25; Philippe Garner, London: 253; Photographie Giraudon, Paris: 54; Glasgow Museums and Art Galleries: 109, 110, 111; Glasgow Picture Library: 107, 108, 112, 113, 114, 115, 117, 198; Glasgow School of Art: 118, 199, 200; Helga Lada Fotoagentur, Berlin: 254; Hillstrom Stock Photo Inc, Chicago, photo: Marc Murphy, Buffalo: 177, 178; Historisches Museum der Stadt Wien: 79; Gabor Holanszky, Budapest: 249; Index, Barcelona: 152, 158; Institut Amatller d'Art Hispanic, Barcelona: 161; Institute Mathildenhöhe, Darmstadt: 219, 220, 222, 224; J Allan Cash Photolibrary, London: 255; John Jesse, London: 208; Jean-Loup Charmet, Paris: 5, 31, 53, 61, 66; Kharbine-Tapabor, Paris: 1, 3, 55, 204; Janis Krastins, Riga: 248; Kunstbibliothek, Berlin: 82; Kunstsammlungen zu Weimar: 235; MAK Reproduktionsabteilung, Vienna: 93, 94, 100, 104, 105; Wendy Maruyama, San Diego: 261; Mary Evans Picture Library, London: 176; Metropolitan Museum of Art, New York, Leonard A Lauder Collection of American Posters, gift of Leonard A Lauder, 1985 (1984.1202.47) photo: Bobby Hansson: 175; William Morris Gallery, London: 18, 19, 20; Mountain High Maps © 1995 Digital Wisdom Inc: 436, 437, 438; Mucha Foundation, London: 56, 57, 60, 205, 206, 207, 246, 247; Museu Nacional d'Art de Catalunya, Barcelona: 149, 151; Moravská Galerie, Brno: 242; Musées de Strasbourg: 52; Musée des Beaux-Arts de Nancy: 67, 68; Musée de l'École de Nancy: 9, 62, 64, 212, 217; Musée Horta Saint-Gilles, Brussels: 42; Musées Royaux d'Art et d'Histoire, Brussels: 30; Museum of Finnish Architecture, Helsinki: 122, 128, 129, 130, 131; Museum of Modern Art, New York, gift of the family of Mrs John D Rockefeller Jr: 211; Nasjonalgalleriet, Oslo: 133; National Gallery, Prague: 239; Newark Public Library: 166; Norsk Folkemuseum, Oslo: 132; Frank Nowikowski, Buenos Aires: 162, 188, 189; Österreichische NationalBibliothek, Vienna: 83, 95; Jarmila Pankova, Prague: 240, 243; Pentagram Design Limited, London: 259; Petrushka, Moscow: 134, 135, 136, 137, 138,139, 140, 141, 142, 143, 144, 145, 146, 147, 148; Pictor International, London: 87, 88; Princeton University Art Museum: 174; Punch Cartoon Library, London: 209; Pushkin State Museum of Fine Arts, Moscow: 47; Riedel Crystal, Kufstein: 241; Royal Institute of British Architects, London: 15, 181; Robert Harding Picture Library, London: 84, 85, 86, 102, 116, 159; Roger-Viollet, Paris: 4, 126, 127, 214, 215; RMN, Paris: 10, 35, 63, 230, 251; Michel and Sylvia Saudan, Geneva: 119, 153, 154, 155, 156, 157, 160; Jon Sievert, San Francisco: 260; Sotheby's Picture Library, London: 46, 99, 218; Staatliche Graphische Sammlung, Munich: 70; Stadtsbibliothek, Antwerp: 43; Stadtmuseum, Munich: 69, 76; Stedelijk Museum, Amsterdam: 34; Studio für Fototechnik, Darmstadt: 223; Style, London: 227; Taideteollisuusmuseo, Helsinki: 121, 123; Tiffany & Co Archives, Parsippany: 164, 165; Rauno Träskelin, Helsinki: 257; Turku Art Museum: 121; Union Centrale des Arts Décoratifs, Paris: 27, 50, 51, 202, 203; Courtesy of the Trustees of the Victoria and Albert Museum, London: 7, 17, 124, 125, 210; Vienna Art Auctions: 89; Matthew Weinreb, London: 2; Ole Woldbye, Copenhagen: 6; Woodmansterne Publications Ltd, Watford: 14; Frank Lloyd Wright Archives, Scottsdale: 185; Frank Lloyd Wright's Dana-Thomas House State Historic Site, Springfield, photo: Doug Carr: 182, 184, photo: Tom Owen: 183; Frank Lloyd Wright Home and Studio Foundation, Oak Park: 186, 187; Würtemberg Electroplate Factory, Geislingen: 225, 226, 228, 229

Phaidon Press Limited
Regent's Wharf
All Saints Street
London N1 9PA

Phaidon Press Inc.
180 Varick Street
New York, NY 10014

www.phaidon.com

First published 2000
Reprinted 2002, 2005
© 2000 Phaidon Press Limited

ISBN 07148 3822 5

A CIP catalogue record for this book is available
from the British Library.

Typeset in Quadraat Sans

Printed in Singapore

Cover illustration Georges Fouquet, Comb,
c.1900 (see p.327)